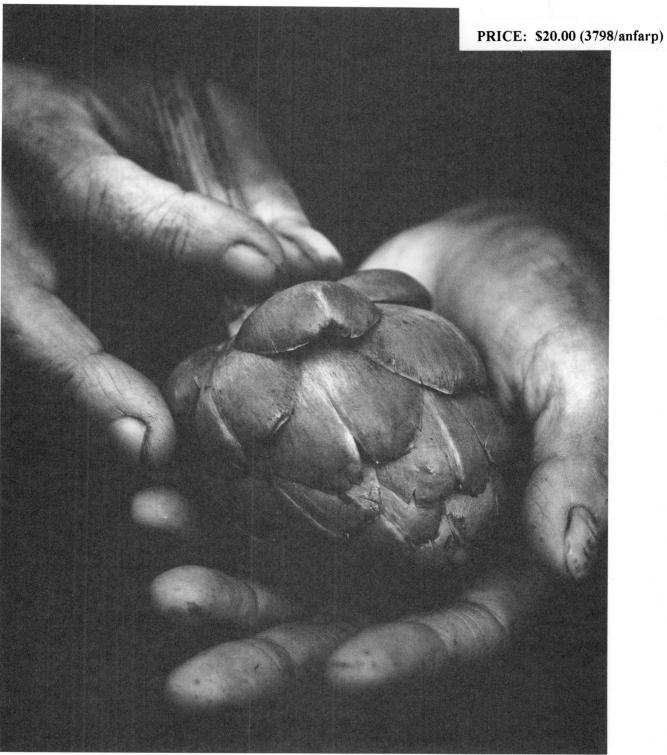

GROWING
BEAUTIFUL
FOOD

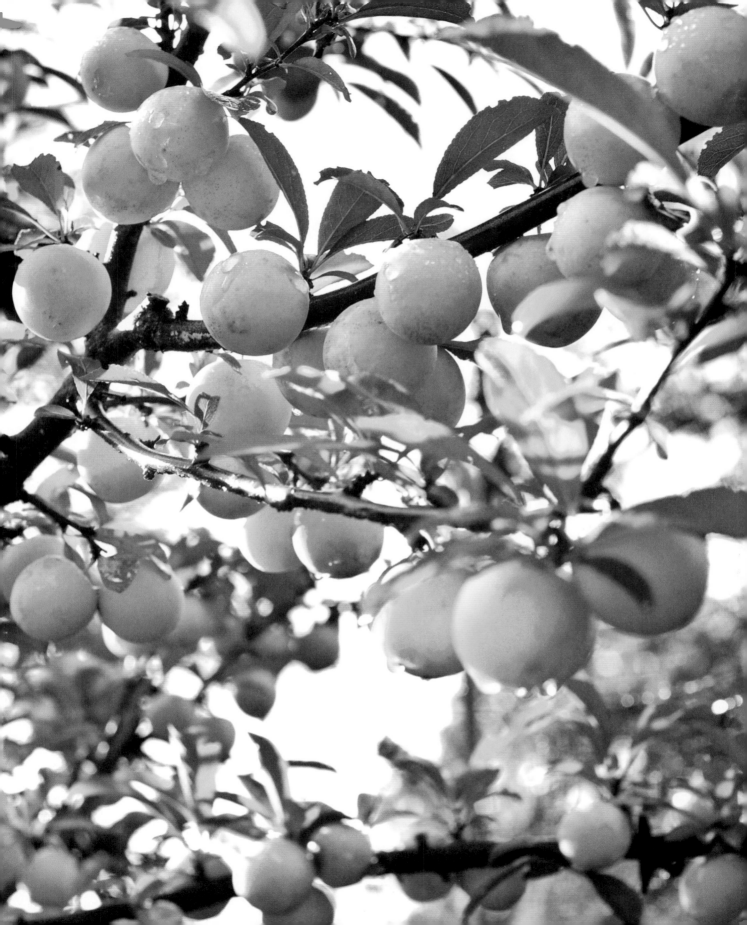

GROWING BEAUTIFUL FOOD

A Gardener's Guide to Cultivating Extraordinary Vegetables and Fruit

Written and Photographed by
Matthew Benson

RODALE

Rodale books may be purchased for business or promotional use or for special sales.
For information, please write to:
Special Markets Department, Rodale Inc., 733 Third Avenue, New York, NY 10017

Printed in China

Rodale Inc. makes every effort to use acid-free ♾, recycled paper ♻.

Photographs by Matthew Benson

Library of Congress Cataloging-in-Publication Data is on file with the publisher.

ISBN 978–1–62336–356–7 hardcover

Distributed to the trade by Macmillan

2 4 6 8 10 9 7 5 3 1 hardcover

We inspire and enable people to improve their lives and the world around them.
rodalebooks.com

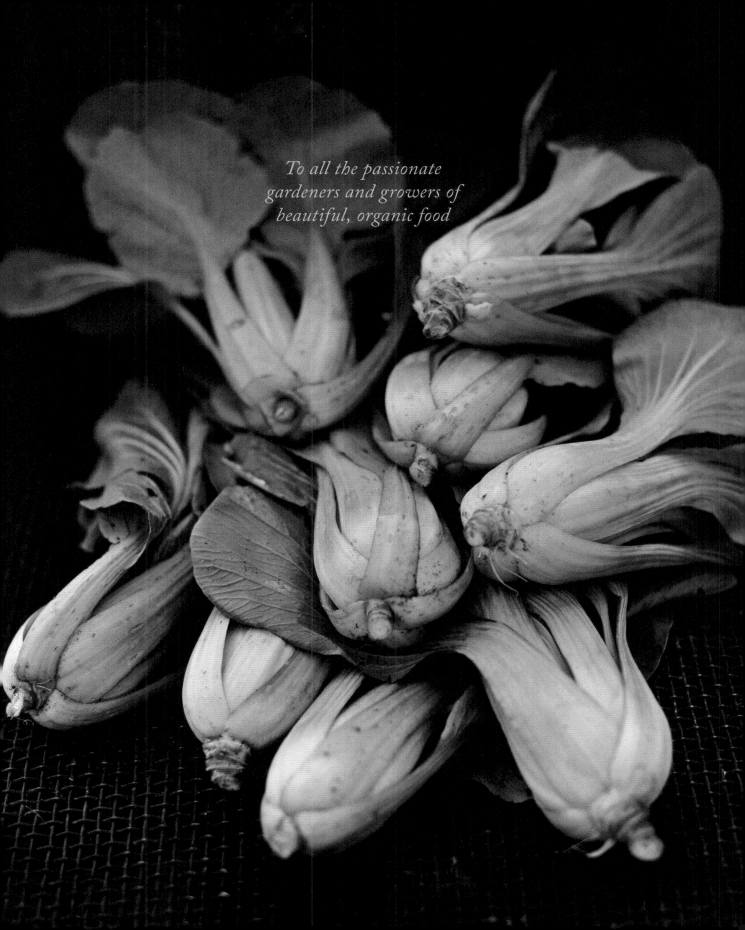

*To all the passionate
gardeners and growers of
beautiful, organic food*

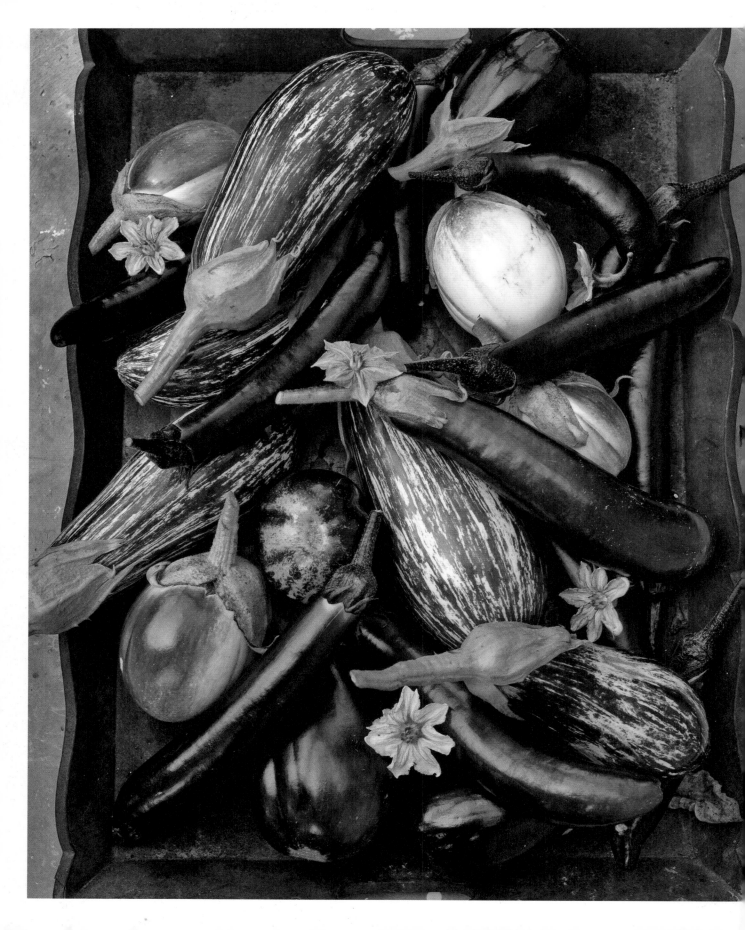

CONTENTS

If heaven gave me choice of my position and calling, it should be on a rich spot of earth. . . . No occupation is so delightful to me as the culture of the earth. . . . Such a variety of subjects, some one always coming to perfection, the failure of the one repaired by the success of the other.

—THOMAS JEFFERSON, IN A LETTER TO CHARLES PEALE, 1811

INTRODUCTION

It's late spring at Stonegate Farm and I'm out in my orchard, ankle deep in henbit and clover, thinning heirloom pear trees of last season's exuberant growth. The luster of the previous night's rain is still visible in the grass; the air is luminous and warm. Chickens are murmuring in the coop, and a few foraging bees are wandering about, drifting on the slow current of the coming day. Sunlight begins to reach through the fragrant, unfolded bloom of apple, plum, and quince. Twenty years ago, I never could have imagined a morning like this.

I came from cities—physically, psychologically. From the bump and bustle of urbanism. No planting, no growing, no harvesting. A city park was my closest proxy for cultivated ground. And yet here I am in midlife, an organic farmer, feeding my family, feeding friends, neighbors, strangers; a hardworking steward of a small parcel of agricultural land and unable to imagine any other life.

The idea of farming, like so many of life's diversions, came to me without much forethought; no tracing the arc of my urban life forward and imagining the weight of organic dirt caked into worn boots, the midnight rustling up of lost and frightened chickens, the fussy coddling of heirloom fruit in an orchard of my own making. Starting a farm for me was an indirect line, a loose scribble in the margins of an established career, but it has helped me to discover something fundamental that was lacking: finding purposeful work that's connected and deeply rooted to *place*. If, as Jon Kabat-Zinn said in his meditation on everyday life, "wherever you go, there you are," then *I am here* and plan to stay. Planting an orchard or building barns presumes longevity.

So how did I get here? At some point, I'd grown weary of cities, of the strange burdens they levy, the false mythology they impose. Life in them had become more like maintenance than real experience. I wanted intimacy with the natural world, to feel connected to forces unknown

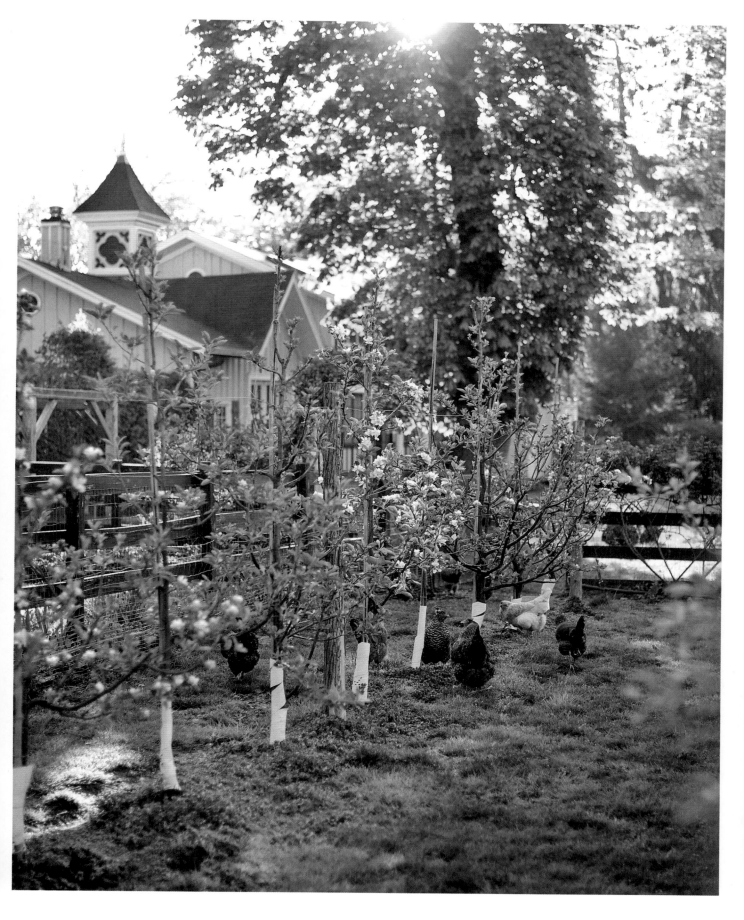

and perhaps beyond knowing. I wanted a relationship with real, purposeful work, with meaningful sweat. What I didn't know was how to get there. I'd never lived off the urban grid, run a hoe across dirt or grubbed at weeds, planted seed, or pruned orchard fruit.

Then I met someone. Someone unique and magical whom I would one day marry. Like me, she had connections with the Old World (her mother was from Munich, and I grew up in Europe), but she was of the earth, not concrete and steel. She had grown up in the gatehouse of a rambling old estate property in the Hudson Valley, outside of Newburgh, New York, in the hamlet of Balmville, and after traveling the world had returned. The home and family she knew had changed. Her only brother had died in a climbing accident, and her mother was battling the last stages of pancreatic cancer, so I came into her life when it was broken by grief, and I was determined to try to make things right for her, and for us.

The healing began with a garden. Set in the stone foundation of an old barn on the property, we cleared back decades of obstinate weeds; built a formal parterre for herbs, vegetables, and flowers; and even patiently espaliered fruit trees against a foundation wall. Friends from the city visited and helped paint fences, fork over garden beds, and move stone. We ambitiously took on other projects on the property, as though they were metaphors for change and renewal, and were soon deeply taken in by the restoration of the place. We were both being restored, of course, by the process: she from the heartbreak of loss, and I from the frazzle and dislocation of urban life. The idea of a future farm, though only a faint glint of an idea at the time, had already begun its provocative dance.

Soon, a few colorful bantam hens arrived to animate the garden, laying their half-size eggs and happily clucking about. They took up roost in the old potting shed (christened "La Cage aux Fowl"), and my young children named them all. We marveled when eggs as smooth and blue as beach glass were laid, or when our hens would be murmuring softly around the garden table at dinner—a meal that we'd harvested only 20 feet away. Of course, once you've started to grow your own and had the transformative experience of eating as locally as your backyard, there's really no turning back. Perennials borders will soon be interplanted with tomatoes and eggplant, decorative trees will lose out to those that bear fruit, and fussy rose beds and clematis will make way for compost. This is the beautiful, dangerous progression: where nothing is more local, delicious, and fulfilling than your own edible garden, and *more truly is more*. You'll run out of space long before you run out of appetite and desire.

My own aspirations to live a more balanced, sustainable life were met the moment I first visited Stonegate. When I first came through the estate's massive stone gates, an entranceway that would one day impose itself on the naming of the farm, I was taken in. There was something about this place, the way the buildings stood on the land; so easily clustered, as though in casual conversation. How they played with shadow and light with everything reaching up— the vertical battens, the Gothic finials, the cupolas. Like the perennials in the future garden,

or the fruit trees on the farm I'd conjured but had yet to make, or—even—*me,* they were all reaching upward toward the light, toward something better and brighter.

I had the immediate sense that I could reinvent my life here, that joy and purpose and meaning would happen here, that this was where I would "build, therefore, [my] own world," as Emerson said. The scruffy courtyard between the old barn, potting shed, and stable, where carriages had rutted gravel into hardpan, would become a series of successive garden rooms. The old stable, smelling of horses and tack, would become a guesthouse for friends and farm help. The hollow interiors of service buildings, glazed in creosote, turpentine, and motes of rust, would be filled with flea market salvage and antique garden tools. The timber-framed bones of outbuildings that had come loose at the tenons, their battened skin hanging slack, would be restored. An orchard heavy with organic fruit and a farm rich with organic vegetables would be planted.

The property seemed to almost cry out for intervention. The once-grand estate, with its formal gardens and winding carriageways, had become a worn-down and faded reflection of 19th-century domestic life. Melancholy seemed to enfold everything. The place had been slowly lost, like so many others, to time and indifference. The estate grounds, in particular, had seen the ravages of neglect. What was once 37 acres of thoughtfully planned and articulated landscape had been undone by bittersweet, wild grapevine, and bindweed that had tangled themselves everywhere, while gangly lilac and twisted honeysuckle loomed.

What would become Stonegate Farm is an 1850s estate, formerly known as Echo Lawn, in New York's Hudson River valley, 60 miles north of New York City. It wasn't meant to be farmed any more than I was meant to be a farmer. Like me, it was new to agriculture, so whatever hoeing and growing would take place, we would be in it together. The collection of 19th-century Carpenter Gothic outbuildings—carriage house, stable, icehouse, manger, barn, gatehouse, and greenhouse—were there to support the lifestyle of the estate's first owners and to make life in the 1850s work for the patrician class. The cows surely grazed, as did the horses, but the estate's 37-plus acres were a pleasure ground meant to be meandered through by carriage, appreciated in evening jackets and jodhpurs, but never plowed under.

The estate was conceived and developed in the mid-19th century at a high point in American architecture and landscape design by contemporaries of Andrew Jackson Downing, and it's been Downing's influence, in particular, that has deeply affected how we've approached the restoration of Stonegate. Andrew Jackson Downing was a prominent 19th-century horticulturist, architect, landscape designer, and author who just happened to be born and raised in Newburgh, and his spirit and ideas have profoundly shaped ours. His groundbreaking book, *A Treatise on the Theory and Practice of Landscape Gardening Adapted to North America* (1841), was one of the first gardening books I read, and his books on architecture, including *Cottage Residences* (1842) and *The Architecture of Country Houses* (1850), seem to be speaking directly to the

150-year-old Gothic outbuildings at Stonegate, built in Downing's neighborhood during his short lifetime.

It's no wonder that Downing's restless ghost seems to haunt and prod much of what goes on at Stonegate. Were this 1850, we would have been neighbors, maybe even friends, as his home and nursery were only a few miles south of me in Newburgh. And he's buried a mile or so up the road from our farm, where his tomb implores him to "put on immortality." And so he has; his unsettled soul seems to course through me, and Stonegate, like a tonic.

I had been drawn out of my urban life by a kind of transcendental desire, the longing for a relationship with nature and with a piece of land that was absolute and reciprocal, the sort of bond a ragged old property with aspirations and needs creates. And if ever there were a transcendent occupation, an archetype for self-reliant connectedness that Emerson and Thoreau would applaud, it is the intimate relationship to nature that small-scale farming gives you.

More purposeful than gardening alone, which is largely about aesthetics, growing food connects you to the steady, nurturing pulse of the earth, to the source of human health, wellness, and fulfillment. In *Walden,* Thoreau exhorts the experience of growing his own food, not just the food itself. He wanted direct contact with nature, out in his bean field, which nurtured both his body and spirit. His farming, metaphorically, "yielded an instant and immeasurable crop."

It's no wonder that the concerns of the rapidly industrializing 19th century are resurfacing in the 21st. With so much of our attention turning to eating locally and organically, as well as looking for meaning beyond the dulling routine of jobs and commutes and hyperconsumerism, there is a countercultural pushback now against industrialized and commodified food. People are going to farmers' markets, buying local, and joining community-supported agriculture (CSA) programs. According to LocalHarvest, an online database of organic farms and CSAs, there are more than 4,000 CSA farms in the United States, and in some areas, there is more demand than there are CSAs to fill it. People are starting to grow some of their own food, buy organic, and shop for local produce, turning away from the overprocessed, synthetic food churned out by agribusiness.

My farm is located in what social scientist Leo Marx, in his seminal work on the literature of the 19th century, *The Machine in the Garden,* referred to as "the middle ground": the place between the "over-civilization of the city" and the "violent uncertainties of nature." Downing, too, was speaking to a mobile and aspirational middle class that had fled from the rapidly industrializing cities of the mid-19th century to the pastoral "middle ground." This is where I find myself: Not of the city or the rural countryside, but farming in between; my small, sustainable farm fully integrated into a residential community. I may have the smallest agricultural district in the county, but it's not wanting for ambition. And one must be immensely ambitious to till under a manicured suburban lawn, or break from the usual patterns and rhythms of residential life, in order to grow food.

Restoring the architecture of an old place has an endpoint, or at least an ellipsis, when most of the major work is done and only the maintenance remains, but the challenge and joy of farming and food growing, of course, is that no matter what the scale, you will never be done. You will falter and prevail. You will press your will against the vicissitudes of weather and temperamental plant habit, against fungal disease and the relentless, destructive hunger of insects and critters. You will grasp to know enough, and it will never be. "Though I am an old man, I am but a young gardener," said Thomas Jefferson at the end of his life, and you will do no better. You will leave this world wanting one more season, one more heirloom tomato to grow and swoon over, one more squash or melon variety to trial and taste.

Growing Beautiful Food proposes that growing your own is not only healthy and delicious but can be a beautiful, transformative life experience, as well. With insight into the history and practice of farming and the broken politics of our food system, as well as practical advice on starting and maintaining your own food garden, *Growing Beautiful Food* argues that the idea of integrating edibles into your suburban lot is a first step toward a healthier, more sustainable lifestyle. And whether it's only a postage-stamp front lawn or an unproductive back acre, almost anyone can take their preened, green patch of grass and turn it into a vibrant, local foodshed. Choosing to grow some of your own produce and being a responsible steward of your own land will change your life in profoundly deep and meaningful ways.

Mostly, *Growing Beautiful Food* is an incantation to meaningful work, to the grace of growing healthy food on good land, and to the family and community that gather around it.

—Matthew Benson

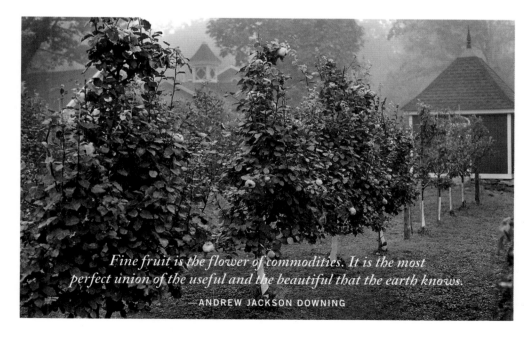

Fine fruit is the flower of commodities. It is the most perfect union of the useful and the beautiful that the earth knows.
—ANDREW JACKSON DOWNING

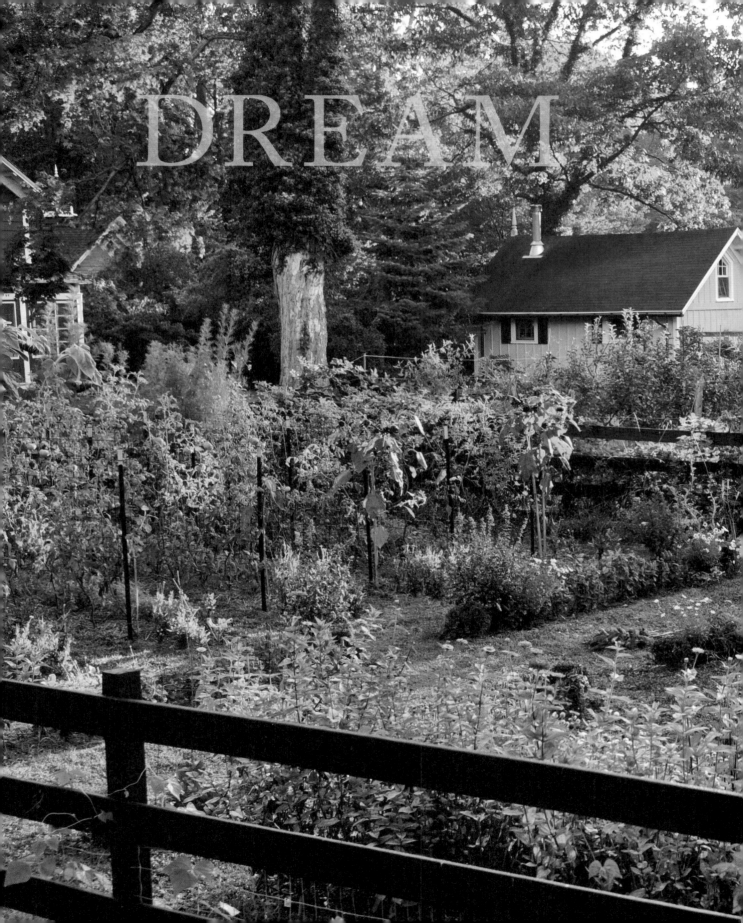
DREAM

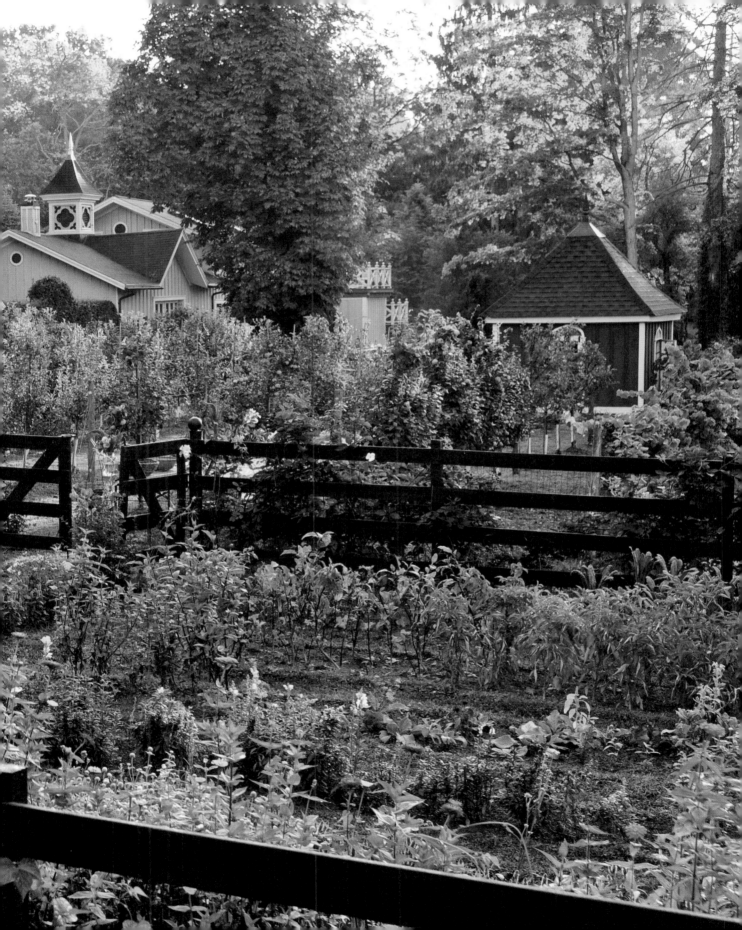

*This is the most beautiful place on Earth. There are many
such places. Every man, every woman, carries in heart and mind
the image of the ideal place, the right place, the one true home,
known or unknown, actual or visionary.*

BEGINNINGS

Dreams are often most profound when they seem the most absurd, Freud said, and if you had told me almost 20 years ago that I would one day unbind my deeply urban soul and become an organic farmer, I would have thought you'd swilled a few too many. For me, farms were remote, monosyllabic places where dour resignation over the quirks of weather or crop and pest management seemed to prevail; where lives were surely lived close to nature, but also close to penury; where long, labor-burdened days distilled themselves into desolate quiet and dark.

What I didn't know about farming, apparently, was everything. But I knew something about cities, about the seductive fabric of urbanism and how it had already begun to fray. Photographing gardens and horticulture had taken me outside of urban walls and started to reshape my values. The aesthetic landscape of cultivated ground became a preoccupation; cement and steel surrendered to the compelling magic of plants and soil and mixed perennial borders.

Dreams can linger for years, of course, as a slow, metaphysical incubation in the psyche until they're broken open to become something lucid and inevitable. Thoreau said that our truest life is lived when we are in dreams awake, and I had finally woken up to the fact that cities like New York, for all their vitality and exuberance, were someone else's dream.

Ironically, it was an exhibit of Hudson River school painters at the very urban Metropolitan Museum of Art in New York in the late 1980s, called *American Paradise,* that started me imagining living fully in worlds that were outside the grid. This landscape wasn't to be found only in the grand but distant vistas of the American West, in the monumental work of Moran or Bierstadt, but in the nearby, accessible acres of New York's Hudson River valley; a place—judging from the sublime landscapes of Thomas Cole, Asher Durand, Frederic Church, and Jasper Cropsey—of heroic, transcendent beauty. These artists were extolling the incomparable mountains and valleys of a paradise next door; I only had to head upriver from Manhattan to find it.

When I finally left the city for a small, timeworn property in New York's Hudson Valley, it was a terrifying, exhilarating experience. To leave a place where art and commerce pulsed for someplace pastoral and remote seemed like professional suicide. Of course, in the end, it was the transformative opposite. Freud was right: What had seemed absurd at first had become profound.

I began to imagine boldly, far beyond what I knew. Hollow and frail outbuildings would be restored, land would be cleared, gardens and farms would be built and cultivated, community would form. The beautiful and the practical, what 19th-century landscape designer and architect Andrew Jackson Downing called *il buono e il bello,* the two bonded elements of human experience, would become a consuming idea.

Period ornament was designed and added where it fit, drawing on 19th-century architectural pattern books for inspiration, turning ball-and-point finials on lathes and scrolling fleur-de-lis vergeboard for the eaves. We followed instinct and approached the restoration of the old Carpenter Gothic property as though it were livable sculpture, building the new so that it looked like it had always been there, so that it harmonized with the disposition and character of the place. We learned from others, but mostly we listened to ourselves; to our own obsessive, creative intuition. The architect Jonathan Hale defines the best design as a deeply intuitive process. In his book *The Old Way of Seeing,* he refers to it as innate judgment, where you guide yourself almost unconsciously through the process. The goal, according to Hale, is ultimately to express something that is proportional and alive, that plays with pattern and form, that unites the practical and the visionary—and vision is ultimately a relationship with a place, of what it means to truly *be there.*

All joy and wonder of working on a small piece of earth, of how it is to really be

somewhere, has meant deep personal change. I'm bound to my property in ways that are profound and unflinching. Like atoms building themselves up to become a strand of something bigger, we're more complete by collaborating, my farm and me; more fulfilled. Years later, as Stonegate Farm has begun to feed a small community, and as interest in eating healthful, locally grown organic food has entered the mainstream, the lives of others have also been changed.

At Stonegate today, we grow organic vegetables, orchard fruit, cut flowers, and herbs, and we raise chickens for eggs and keep bees for honey. Though the farm is only 3 acres, with 1 acre in active production, it's a model of local, community-integrated farming that is central to our philosophy and ideas about the future of food. Along with heirloom vegetables and organic cut flowers, a historic orchard provides us and CSA (community-supported agriculture) share members with heirloom apples, pears, quinces, plums, and cherries, as well as unusual bramble fruit such as black currant, gooseberry, and aronia. There are beehives, too, and a flock of deep brown– and blue–egg laying Ameraucana and Cuckoo Maran hens. Biointensive, diverse, and ambitious, Stonegate tries to cultivate not only delicious food but also ideas about the possibilities of small-scale, community-integrated farming.

WHY THIS MATTERS

A small farm is as much a proposition, a cultural idea, as an actual place. The idea of organic farming, of sustainable environmental stewardship, is a model for responsible living, for doing something necessary and grounded with your time. There's nothing facile or superfluous about it. There aren't a lot of neurotic farmers out there: You just can't be type A high-strung when you're working with all the vexing unknowables of the natural world. The work you do is purposeful and real, removed from the virtual ether of ones and zeroes. A hoe hitting the dirt resonates in ways that a finger swiping a track pad or screen never can. Farming will change how you think and will reorder your values and priorities. "The fatal metaphor of progress, which means leaving things behind us, has utterly obscured the real idea of growth, which means leaving things inside us," said G. K. Chesterton, and despite all the admirable gains of technology, the carbon universe that lies within all of us wants a connection to realities that are meaningful and deep, beyond progress, beyond ourselves, even.

By farming and growing food, we learn to listen to worlds outside of our own and begin to think and imagine like plants. We start to sympathize with their needs and desires, to nurture and protect them. Our dreams become lucid and almost photosynthetic as we tune in to the plant world's seasonal patterns of growth and decline, to their strange and sentient cellular networks. It's arcane science, to be sure—the subtle whispering between cells—but the most poetic and meaningful things usually are.

Even some of the nutrients we add to the farm come from deep, otherworldly places. There are times at Stonegate when you might feel as though you're walking through the salty savor of

(continued on page 10)

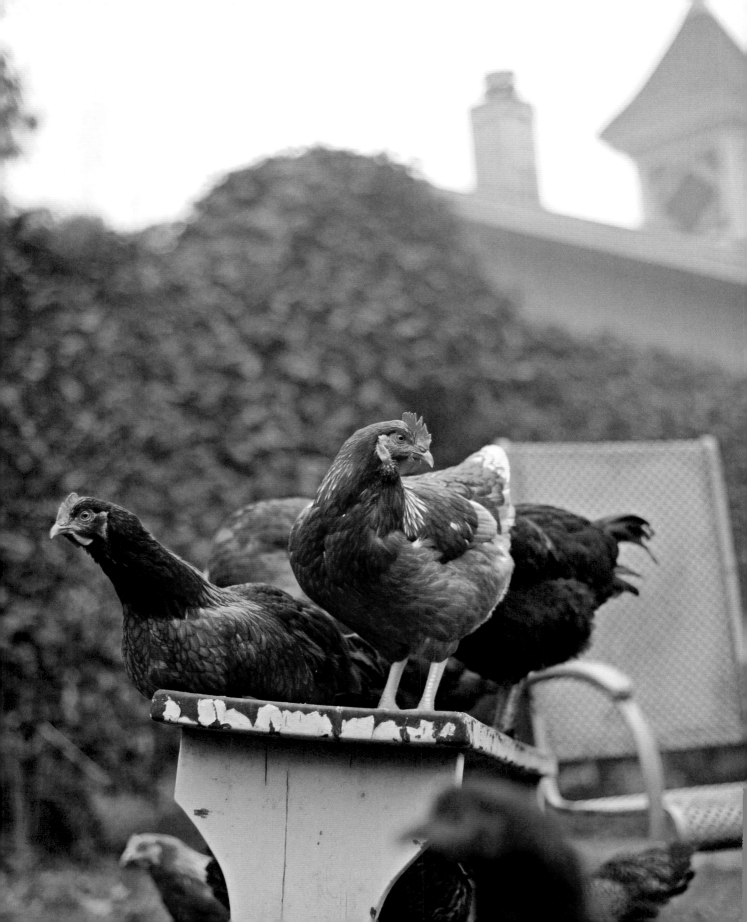

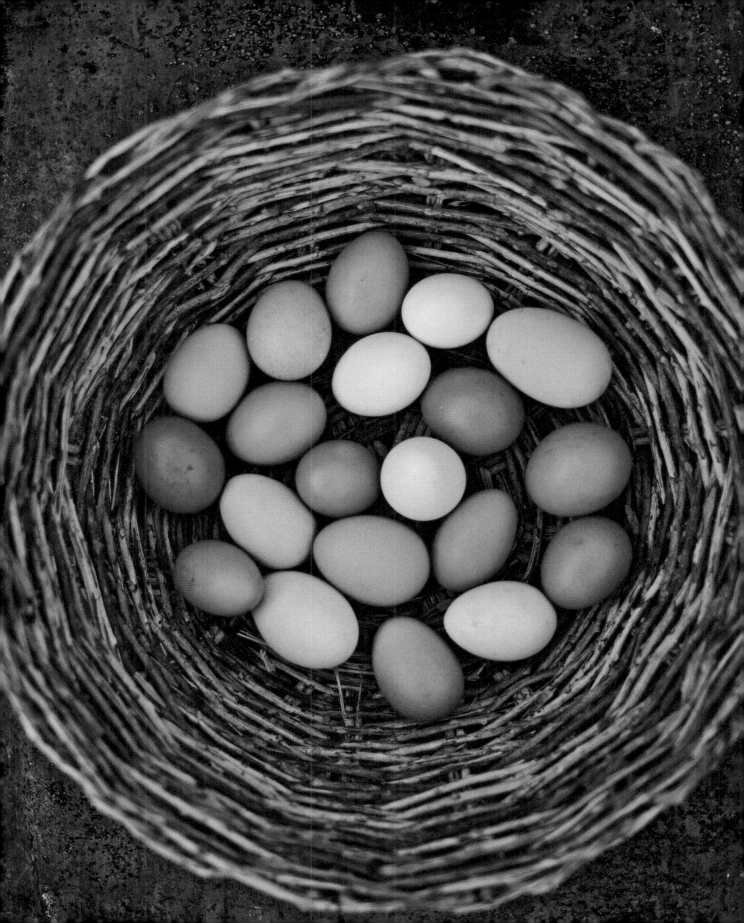

Farming under the Influence

September—elliptical month, month of transitions—and the farm is truly, madly beautiful at the moment: late fruit hanging ripe and slack, sun jetting through the thinning trees, the primal clarity of the light.

The whole place seems high on itself, and at levels well beyond the legal limit. It doesn't help that I photograph food and gardens for a living (and what is a farm if not a food garden?), so I'm tuned in and turned on to all this beauty at insanely high decibels.

Once the visual dopamine pulses, it takes me and wastes me and I'm left to photograph and farm under the influence (an agricultural misdemeanor in most states). They don't call us Stoned-Gate Farm for nothing.

If I'm not careful, my license to farm might be revoked or, worse, I may be sent to ag rehab, where compulsive locavores, foodies, and organic microfarmers sit in sad, slump-shouldered circles and come clean about their obsessions.

Stonegate was restored and designed with the camera in mind, with frameable views and an attention to the pattern language of agricultural land and outbuildings that create opportunities for image making. It's been a long process, more than 15 years now, of creating a visual dialogue with this place, and just when I think there can't possibly be another pixel's worth, more images get made. Apparently, if you don't photograph it, it *never existed*. Spooky.

It's an occupational hazard to fall hard for a farm. Once it's got hold of you, it's like a badger and won't let go until it crushes bone, or spirit, or energy. If you're lucky (and luck is as much a part of farming as planning and planting), you get to the end of the season, as we have, and are truly thankful for your magical and productive piece of earth.

This late-season buzz is the farm's way of deeply imprinting, before the big chill of winter, how important it will be to start all over again next spring. Like any organism, its MO is just to keep on keepin' on.

My MO is to keep this small farm going strong, in all of its permutations. Besides creating a venue for exquisite organic food, the broader aim of a CSA farm is education and inspiration, about turning people on to eating locally and well, and about building an audience for sustainability.

Ironically, when I lose a CSA member because they've decided to grow their own, I feel as though I've done my job. We'll continue to serve it up, and we plan to bring it on year after year—unless, of course, we lose you to your own backyard.

Mornings in the flower farm are an experience to be savored, particularly in September, with its long, low shadows and luxuriant growth. Before the sleep of winter, the farm is out to make a lasting impression.

low tide. We spray with an organic fish and seaweed fertilizer that leaves plants high on ancient minerals unlocked from the bones and bodies of fish, from seagreen ribbons of brine and whatever else the mysterious tide brings up. This nutrient-rich emulsion is spread across the farm as a foliar feed, where it works its slow, deep, delicious magic.

"The sea does not reward those who are too anxious, too greedy, or too impatient," said Anne Morrow Lindbergh in *Gift from the Sea*. "Patience, patience, patience, is what the sea teaches. Patience and faith." So, too, with farming. Patience and faith are persistent mantras—patience in bringing seed to leaf and fruit, faith that it will all actually work and that weather and pests won't undo you.

I love bringing the tidal sea back to the farm, the same sea that once moved as glaciers and created the very topsoil I'm cultivating. It quickens the biodynamic pulse of the place and deepens its wonder.

There is a mycorrhizal consciousness in the soil just beneath us, a kind of mystery that brings us back to growing, year after year, for the extraordinary awe of it, and maybe even—by extension—to broaden our understanding of what the larger earth needs. By thinking like both plant and planet, we tune in to the kind of stewardship that realigns us with the natural world. We allow ourselves to be shaped by the places we inhabit, as much as we shape them.

If you begin to imagine farming and growing food as an art form, where your aspirations move beyond the supply and demand of feeding yourself and others and into the realm of aesthetics, where gorgeous heirloom vegetables, fruit, and flowers fill the canvas between fence-rows each season as a kind of delicious landscape painting, then you begin to cultivate beauty as well. And beauty is a fundamental human need, as essential as breath.

Beauty isn't just a visual sensation, of course; it informs and shapes how our faculties of smell, taste, hearing, and touch interpret the world. The senses constantly share and interact. It's said, for example, that the first bite is taken with the eyes. Other senses do their part, to be sure, but it turns out you eat as much with your visual brain as you do with your tongue and that how things taste is a multisensory process, with the eyes playing a much bigger part in taste perception than previously thought. According to Oxford experimental psychologist Charles Spence, "Half the brain is visual in some sense, versus just a few percent for overall taste senses. So in cortical real estate, vision is always going to win." It's no wonder, then, that color and form shape so much of how we experience food, and why presentation actually makes food taste empirically better; perception is reality. Just the act of growing your own food, the story of that seed transforming itself from a mere speck into something wholesome and delicious under your care, will transform your experience of eating it. Taste and flavor are intimately connected to your own narrative, your own memory and emotions. Farming food organically clearly ramps up its nutrient value and lessens its environmental debt, but if you farm for beauty as well, with attention paid to aesthetics and form, what you grow will be delicious both to the eyes and tongue. This is why blind taste tests miss the point; taste is never blind.

"Everybody needs beauty," said the naturalist John Muir. "Places to play in and pray in, where Nature may heal and give strength to body and soul alike." The beauty of the farm and garden is that they are never finished; never matted and framed and hung on a wall. Each season is an embellishment on the last, another stroke on a vibrant and nourishing canvas that is never complete.

The art forms that seem to last and remain relevant are those that mark a moment of change in perception, that break through the old way of seeing and challenge *what is* with *what could be,* encouraging us to think. A small organic farm can be a work of political art, particularly in a time of fractious food politics, co-opted supply, and compromised nutrition. You are not only farming for food, but you're also using sustainable agriculture as an act of conscience and ecological resistance. By farming in a nonfarm community—urban, residential, suburban— you are encouraging people to reconnect with where their food comes from and, by extension, to where nature is, which is powerfully important. Once food ceases to be some abstract commodity, with no apparent source or season, and becomes an understood and valued part of the ecosystem of everyday life, then you begin to tune in to the flow of your natural environment, and it regains value. "The earth delights to feel your bare feet and the winds long to play with your hair," said Kahlil Gibran, and it remains so.

FUTURE FARMS

When you dream outside the present urban matrix, you think of the future, as you do when you grow food for others on microfarms integrated into communities. These farms, in the most utopian sense, should connect cities and communities directly with their food sources, specializing to some degree, rotating their annual crops from farm to farm each season, and be designed as concentric, radial "farm belts" fanning out from a common urban or suburban center. The garden city movement in the late 19th century proposed something similar. In Ebenezer Howard's groundbreaking *Garden Cities of To-Morrow*, published in 1902, he conceived of a wheel-shaped urban model that was entirely self-sufficient, with a balanced mix of residential, industrial, and agricultural lands. The new utopian ideal would be to assimilate healthy, organic food access into residential urban and suburban planning, a kind of "farm city." Unlike the failed model of the outlying suburban cul-de-sac, where the only way to get anywhere is to drive, or the urban reality of separation from food sources and the carbon debt of shipping and trucking food into urban centers, the new farm city movement would make healthy food access a priority and an intimate part of everyday life.

We keep wanting the cheap and plentiful resource party to last, of course; for the long, ecstatic binge to continue without a hangover. But the days of seemingly unlimited natural

resources are behind us. Nonrenewable means just that. The farm of the future will need to be far more sustainable than its current iteration. With increasing demand and fewer resources, future farms will have to be smarter, more efficient, and far less exploitive.

In the last half century, we've become very efficient at farming large tracts of synthetically managed monocultures that feed millions, but we're completely incompetent at managing our food security, biodiversity, soil health, and natural environment. The strongest argument for taking back our food supply from the "agropoly" of industrial agriculture, besides the obvious human health concern, is environmental degradation and food security.

By growing organically, we build sustainable nutrient systems in the soil that are biodiverse, we decrease the fossil fuel emissions that are inherent in chemical farming (eliminating synthetic nitrogen alone reduces fossil fuel consumption by 33 percent), and we sequester more carbon in the soil as organic matter, which removes CO_2 from the atmosphere. These practices have a significant impact on climate change. According to the 2008 Rodale Institute study *Regenerative Organic Farming: A Solution to Global Warming*, moving away from synthetic and toward organic agriculture is one of the most effective strategies for mitigating the effects of CO_2 emissions.

In fact, it's an environmental emergency as much as a human health crisis that shapes many of the arguments for a global shift to organic agriculture. According to IFOAM (International Federation of Organic Agriculture Movements), "Organic agriculture is a production system that sustains the health of soils, ecosystems, and people. It relies on ecological processes, biodiversity, and cycles adapted to local conditions, rather than the use of inputs with adverse effects. Organic agriculture combines tradition, innovation, and science to benefit the shared environment and promote fair relationships and a good quality of life for all involved. . . . " Sounds right to me.

Farm cities, of a sort, are beginning to flourish on urban rooftops and in reclaimed schoolyards, and empty lots, giving urban communities access to local food. These rooftop farms build awareness and local access and can be vital oases of fresh organics in an urban food desert. Though many of these urban efforts struggle with contaminated soils and water, high levels of atmospheric lead and mercury (leafy greens are particularly vulnerable to contamination by heavy metals in urban environments), or tenuous rights to land use, they are moving in the right direction.

Some urban centers are also served by community gardens, usually cultivated by neighborhood groups on vacant lots. There's a long history of this type of land use, beginning in the late 19th century with Detroit setting aside plots, or "potato patches," for residents in an effort to stem urban hunger. There were other movements that followed, usually in response to war or economic crises, including the school gardens movement (1900–20), garden city plots (1905–10), liberty gardens (1917–20), relief gardens (1930–39), victory gardens (1941–45), and community gardens (1970–present).

The developed world has been very good at crisis management with our food supply in the

(continued on page 16)

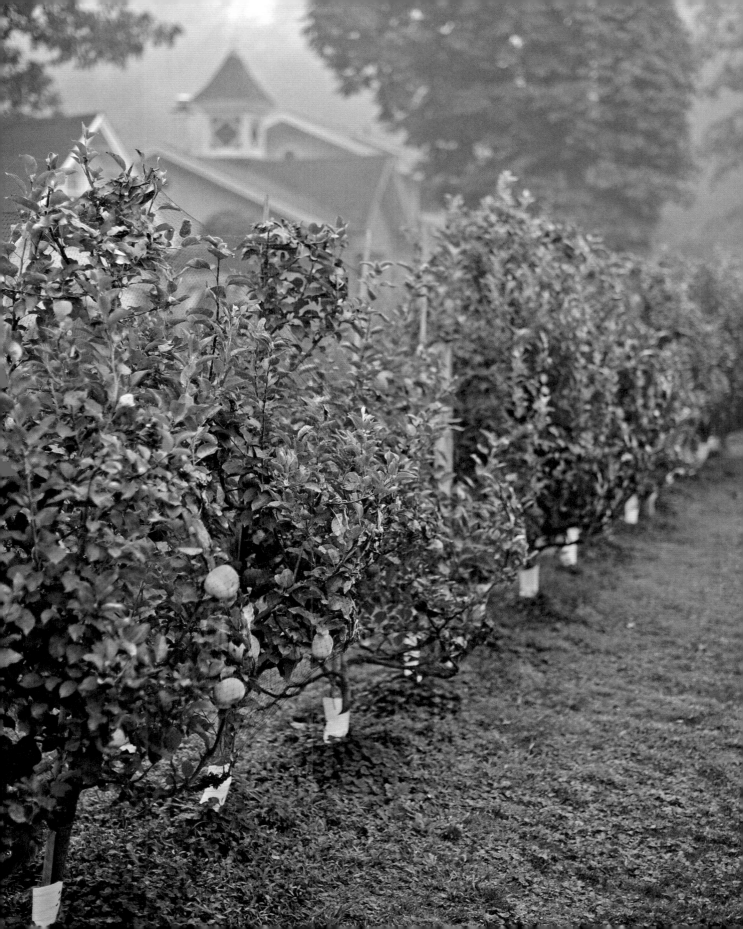

past, but the slow and looming emergency that haunts us now is more complex and, ultimately, harder to solve. Climate change, population growth, land depletion and pollution, water shortages, and the dependence of industrial agriculture on nonrenewable and dwindling petroleum supplies means whole paradigms will need to change.

With US Census Bureau data showing that 82 percent of Americans are now living in cities and suburbs (the global urban rate is 52 percent), that means that more than three-quarters of the US population shares just about 3 percent of the US land, and these are the places at greatest risk of food instability. The more "farm city" urban and suburban planning we can begin to introduce now, the better shape we'll be in by midcentury, when the US population will have swollen to census estimates of 439 million (an almost 40 percent increase from today). The only way to feed that many Americans a decent, healthy diet is to put more land into production, or even to turn some of our sacred federally protected land into arable use. It's not just land use, of course, it's also other resources like energy and water that will be tapped out by increasing population demands. A portent of the looming food crisis can be found in California, the

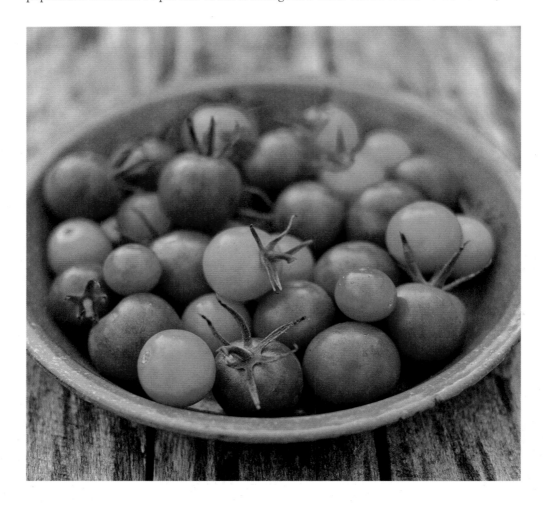

nation's leading agricultural producer, which has been breaking drought records (2013 was the driest ever) and will continue to see severe droughts as a result of climate change. Their primary water source for their agricultural irrigation, the Colorado River, is only a trickle of its former self, with 78 percent of its vitality diverted to grow crops, according to the USDA. It used to run, massive and wild, from the Rocky Mountains to the Sea of Cortez, carving out the Grand Canyon in its wake. It now ends in a mudflat somewhere in the Mexican desert.

Outside of urban centers, some progressive developers have begun to build residential communities around working farms, a sort of "agri-burbia" where there are fields of Asian greens and organic kale and farm-to-table restaurants instead of golf courses and tennis courts. Dozens of these developments have sprung up across the country, fueled by the local-food movement, with evocative names like Prairie Crossing, Hidden Springs, Harvest, Serenbe. Residents share in their locally grown produce, take vegetarian cooking classes, and often volunteer on the farms. Though this is a new—and rare—suburban model, it's an encouraging alternative to the SUV-bound developments that burden residents with long drives to Costcos and Walmarts for their food.

In parts of northern Europe, zoning restrictions won't allow new housing developments to be built in a food-access vacuum, and they are mandated to be within walking, cycling, or public transport to a market. Europe is more bound by laws and more populous, of course, and the cultures are more abiding, so what works there may not work within the free-market opportunism of the United States. It's the entrepreneurs in this country who are left to conceive of and build an "agri-topian" option, motivated as much by profit as by any kind of sustainable idealism. These are still the suburbs, mind you, but unlike the usual nondescript clusters of sameness in the middle of nowhere, these communities are centered around and connected to the shared, progressive idea of access to local, organic food.

Food should not only bind us intimately to the rhythms of the natural world, but should also bring us together collaboratively, creating systems of supply that work for all. Food urbanist and architect Carolyn Steel proposes in her book *Hungry City* that food access is a way to reconsider cities and the way we live in them, and she calls her new urbanism "sitopia," a reimagining of utopia. *Sitopia* is a word she cobbled from the Greek word for food (*sitos*) and the word for place (*topos*), so sitopia is a "food place." And unlike a utopia, which means "good place" or "no place" (a Platonic ideal that is ultimately unattainable), urban places that are shaped by fair access to healthy food are a workable goal.

Allotment gardens are a form of "sitopian" idealism. Allotments, or *Schrebergärten* in German, are small plots of land affordably leased for gardening and growing food outside of urban centers. Almost unknown in the United States, allotments are common in Europe, where access to fresh air and food is considered a civil right, not a luxury.

There are millions of small, patchwork, 50-square-meter plots of productive land cultivated by individual families throughout Europe. You see them on the outskirts of cities—bordering

rail lines or encircling suburbs; in Italy, I've even seen orchards and vineyards flourishing on highway medians. These microfarms not only improve the quality of life for urbanites but also serve as a form of social cohesion and added food security. Outside of Berlin alone, there are nearly 900 allotment garden complexes. From the air, Berlin's urban center seems to be intimately woven into a beautiful checkered tapestry of food.

WHAT HAPPENED?

In the United States, unlike the integrated and managed infrastructure of Western Europe, the accident of massive geography and cheap oil has created a landscape of distance and isolation. We shop once a week, not daily, in vast, nondescript warehouses. We eat in faceless restaurants that each serve the same overprocessed food. We exist in cars, not in the social mix of public transport. Geography and oil may have played a part in the making of our modern predicament, but so have lack of imagination and foresight. Imagine if our cities had set aside suburban land for allotment gardens and farm belts instead of shopping malls. Now we find ourselves—before we've had the time to transition to a more sustainable model—one oil or climate shock away from oblivion.

The 2,000-mile salad from Salinas, California, or the long-distance avocado or kiwifruit

from Chile in mid-December will one day become a relic of cheap oil, as will petroleum-based pesticides, fertilizers, and industrial farms. Oil created the world we know, particularly in America, and the dwindling supply will undo it.

In his alarming dirge to our present lifestyle, *The Long Emergency: Surviving the Converging Catastrophes of the Twenty-First Century*, dystopian futurist James Howard Kunstler argues that the end of cheap and available oil will radically alter our lives, that Walmart and suburbs and globalism are not long for this world, and that the landscape of the future will be shaped by walkable, interdependent communities centered around local food production. "Fifty years ago, 30 percent of us were farmers and now only 1.6 percent of us are. This will reverse as growing food locally will become the most important job around." This is a long emergency, mind you, and if we're fortunate, we'll find a way through, but we owe it to the future to start reordering our priorities now.

Up until the end of the 19th century, all farms were local and organic, and everyone was a locavore. Before Atkins or South Beach or Sonoma, there was no philosophy of food—people just ate. Unless you lived in cities, you either grew your own or knew the farmer who did. Farming and growing food used to be everywhere, and everyone took part, without chemical fertilizers, genetic modification, irradiation, or food additives. For most people, the relationship between a meal and its source was immediate. In my part of the country, any hike through the second- and third-growth forests of the Hudson Highlands leads me over what was once cultivated land, cleared and farmed for generations until industrial agribusiness made the very rational small farm model untenable. Secondary forests reclaimed the fields as farms were abandoned and left to lie fallow. Now, toppled fieldstone walls and empty foundations are all that remain, and one can only imagine the lives that were lived there and what the land produced.

Agriculture, in its various permutations, has been around for at least 12,000 years, beginning in the mountains of Mesopotamia, now the Middle East, in an area often called the Fertile Crescent for its abundance of rich, arable land. Wild grains were first collected and cultivated there and irrigation was invented, but it was the ancient Sumerians who created what we now think of as agriculture. Around 5500 BC, on lands that are today part of southern Iraq, they began to develop brilliant systems of irrigation, enhancement of soil fertility, seed saving, and the use of granaries for food storage that changed civilization. The massive, stepped ziggurat at the center of the ancient Sumerian city of Ur (which still stands, although it was almost destroyed by coalition forces during the Gulf War) was a kind of temple to agriculture, where citizens of Ur would bring their vast food surpluses to the gods and receive their allotments. The Sumerians got so good at feeding their citizens through efficient agriculture, in fact, that their population exploded. At one point, Ur was feeding a population of 6,000 on about 3,000 cultivated acres of land. With barley and wheat as the primary crops, supplemented by flax, dates, apples, plums, grapes, and about 10,000 head of cattle and sheep, Ur was a kind of agritopia of the ancient world. Intensive overuse of land and water resources, lack of long-term soil

fertility, and population pressure ultimately did them in, however; a fate not too far removed from our own predicament if we don't have the foresight to act.

The development of agriculture steadily allowed settlement and population growth across the planet for thousands of years, with global crop yields peaking in the 13th century and staying steady until the late 18th century and the beginnings of the Industrial Revolution. Before then, most humans worked in agriculture, usually on subsistence plots to feed their own families or on cooperative farms. Just like the rest of creation, we spent our days securing food—planting, growing, harvesting, and saving seed. And thousands of years of seed saving is the reason we have any agriculture at all today. In fact, vast seed banks such as the Global Crop Diversity Trust and the Vavilov Institute of Plant Industry in St. Petersburg (the largest seed bank in the world) are preserving genetic diversity as a hedge against the collapse of any of the world's major crops and the mass starvation that would result. Of the quarter-million known plant species in the world, most of the human diet comes from only 20 cultivated crops, so a massive crop failure compounded by lack of diversity and a perilously narrow genetic window is a sobering possibility.

Historically, agricultural methods were consistent and remained relatively unchanged for thousands of years. (The ancient Romans had plows that were more efficient than those used in George Washington's day almost 2000 years later.) But the Industrial Revolution changed all that. Rapid innovations in agricultural machinery—where sickles and plows were replaced by mechanical reapers and massive combines—have meant labor-saving, yield-boosting advances in agriculture that served humanity well in the short term. But we're now hearing from nature's own "repo man," who's come around and let us know we've overstepped, and there will be consequences. It's Newton's third law, an absolute that every action creates an equal and opposite reaction. Today, we find ourselves so efficiently and mechanically removed from our own food that we've not only upset the equilibrium of our home planet but the balance of our own lives, as well.

GROW YOUR OWN

In an age of industrialized distance from real food, the local, sustainable farm is one of the few places to reconnect to the old way of eating, where you knew where your food came from, knew it was fresh, and knew it was sustainably produced. Of course, commodified, processed food is cheap, protected by crop insurance, Farm Bill subsidies, and well-paid lobbyists, so it sells, despite its toxic effects on human health and the environment. Yet imagine how different our landscape would be if the Farm Bill supported local, organic farming with economic incentives: Small farms would once again flourish because you could actually make a decent living from the land, national health would improve, and environmental degradation would slow.

If the price point for local, organic produce could be driven down by the same subsidies that keep industrial GMO soy, corn, and wheat—which is 75 percent of what's in supermarkets and

fast food, according to the Center for Food Safety—so cheap, then organics could compete on the shelf at the local Stop & Shop with their cheap, petrochemical cousins, as shoppers would be more likely to choose affordable organic. (Economics is almost always the tipping point for consumers.) The economic incentive could be ramped up further if the negative externalities of processed food came at a price; if tariffs, almost like a carbon tax, were levied against environmentally harmful production processes and high-risk foods, people might make better choices. It's been working for tobacco, so why not the daily meal?

If how we eat can change how the world is used (and, according to a 2009 Worldwatch Institute report, 51 percent of climate-changing greenhouse gases come from livestock production), then farming and eating an earth-friendly diet of mostly organic vegetables and fruit, and not supporting the industrial feedlot or the drive-thru, is not only about human health but also about healing the planet. The stronger argument against eating meat might not be whether or not you consider killing animals inhumane, or CAFO factories (confined animal feeding operations) obscene, but how you feel about destroying the only atmosphere we have.

Organic farming nourishes both the biosphere and the body, pushing back against the mainstream culture of fast and hyperprocessed food and exploitive agriculture. By deciding to grow your own, you are taking a stand against an almost-numbing list of perils that have made diet-related disease the number one killer in the United States. According to the Centers for Disease Control and Prevention, more than a third of American children are now overweight or obese, while 67 percent of adults are overweight, their obesity eating up 10 percent of the nation's health-care costs. Our food culture since the 1980s has become toxic and evolved into a very efficient killer of people, and perhaps—through land degradation, loss of biodiversity, air and water pollution, and climate change—a killer of the environment itself.

In the next few generations—by the 2080s, to be precise—the Milken Institute states that when we're close to 10 billion crowded, hungry souls on the planet, we'll need to be producing almost three times as much food. Thomas Robert Malthus, the 18th-century cleric and scholar of demography and political economy, wrote, rather disturbingly, that "the power of population is indefinitely greater than the power in the earth to produce subsistence for man." Unless checked by some kind of earth-altering event or Malthusian catastrophe, we're going to need to figure out how to grow a lot more food more efficiently without destabilizing the climate and continuing to rape the world of its resources. According to the UN Food and Agriculture Organization, 80 percent of the world's people already have no food safety net. "When disaster strikes—the economy gets blown, people lose a job, floods, war, conflict, bad governance, all of those things—there is nothing to fall back on," says Josette Sheeran, former head of the UN World Food Programme. "Forty-nine million Americans are hungry today, up almost 20 million from 1980. Every 10 seconds, we lose a child to hunger in the world. This is more than HIV/AIDS, malaria, and tuberculosis combined."

These are the startling facts, not some hysterical, alarmist rant. They make an urgent, pragmatic plea for change, moderation, and balance. It doesn't mean you have to turn your life

upside down or become a juice-fasting vegan zealot, but rather that you might become more mindful and proactive about how you eat and the resources you use. Ideally, you'll begin to grow some of your own food.

When my small farm began feeding others, I had a haunting dream one night that my neighbors were all walking down the middle of the road and staggering through the gates to my farm. The air was still. There was no sound from cars or trucks or distant hum of industry, just the slow shuffle of their feet down my drive. They looked haggard and hungry and were coming in droves to see if I could spare some eggs or a few vegetables so that they could eat. It seems the oil had run out, the supermarkets were empty, and my farm was one of the few local places that had any food. As unsettling as this dream was, it was also an affirmation that what I had built and cultivated mattered, that I was providing a small measure of food security for my community. Imagine if my efforts could be multiplied a millionfold, and if small farms were growing food everywhere as they used to, how different our outlook for the future could be. How different would our future look if our local suburban land were shaped by an appetite for organic food, not by the ubiquity of the chemical lawn or the strip mall, and we learned how to think of food as an ordering principle in our lives—one that defined our relationship with nature and with others?

Growing your own beautiful food is a way to restore some of what's been socially and physi-

cally depleted in our culture, a way to bind and mix deeply with a place. It's a personal, creative, courageous, political act; a way to effect multiple levels of change, one small farm or backyard plot at a time. But like anything worth doing, it begins with the idea, the dream of doing it, the seductive wish to reconnect with forces more important and larger than our own.

As the social scientist Edmund Bourne perceptively observed: "Despite all of its positive contributions to modern life, 300 years of scientific-technological development has left our civilization in an untenable position—at odds with its natural environment and ultimately its own deeper, collective soul. Only a global shift in fundamental perceptions, values, and corresponding actions will allow humankind to resume an evolutionary path in alignment with nature and the larger cosmos." If farming your own food makes sense to you, and you're interested in some realignment and value shifting in your life for any or all of the above reasons, then you've started to cultivate change and are ready to take the next step.

BREAKING GROUND

A farm must first begin with a place, a piece of decent land somewhere you and plants can put down healthy roots. The land you're considering should ideally be fallow, untouched by the potentially toxic habits of owners before you, and have all of its nutrient-rich microbial layers of topsoil and subsoil intact. A house in the middle ground of suburbia or on the urban outskirts will do just fine, as long as it's attached to a small patch of soil with decent sun exposure and reasonable drainage. It's important to think of yourself as a farmer from this point on, to redefine the very idea of farming for yourself: Micro you may be, but if you're feeding your family and others, that's who you are. "A farmer," according to Webster's, "is a person engaged in agriculture and the act of raising living organisms for food." That's you.

The ideal growing space should, in fact, and perhaps ironically, not already be a farm. Not only because—unless it's only been organically cultivated—the soil will have been depleted by harmful chemistry and the compaction of machinery, but because my central cultural argument here is the reintegration of food growing into the mainstream. As most of us live in cities or suburbs, a farm on the rural outskirts that's been left to founder there as populations have migrated to urban and suburban centers doesn't advance the idea of local integration as well as community-based farming. Decent farmland is, of course, a highly valued resource, but there's not enough of it in organic cultivation. Most farms in the last 100 years have been turned into housing developments or bought up and consolidated by agribusiness, which grows monocultures of corn and soy. The USDA's 2012 statistics show that in the last 80 years, the number of US farms has fallen dramatically from a peak of almost 7 million in 1935 (when population stood at 127 million) to less than 2 million today (with a population of 317 million). There are half a million farms with fewer than 50 acres. And it's those half-million small farms, which tend to be more accessible to population centers, that are consistently threatened by development but are the most necessary for food security and integration.

The most efficient way to begin growing food is to start small and build up over time as your skills and needs evolve. The biggest mistake people make when they begin to grow their own food is to let ambition get ahead of experience. Farming and gardening are empirical, learned by dirt-under-the-nails doing. If you overreach, you may get discouraged by how much you don't know or how much work it takes to maintain and nurture your small farm or garden. There's nothing sadder than an ambitious plot of once-productive land that's been abandoned to the elements, annexed by weeds, and beaten down by neglect. A garden of any size presumes care and keen interest, and starting small can keep it manageable and let you adjust your lifestyle to include the new rhythms and routine of growing food. It may be that a small salad garden, with a few essential herbs, leaf lettuce, and tomatoes, is ambitious enough for you; or you may want to grow enough for a few meals a week, enough to feed yourself and a few neighbors, or perhaps farm for an entire community. Whether this is a personal health and lifestyle change or a way to affect change for others or an added revenue stream, the basic principles are the same.

STONEGATE FARM

At Stonegate, we started with a small kitchen garden built within the stone foundation of an old barn that had been razed 30 years earlier. We grew herbs in one bed, rhubarb and asparagus in another; we mixed flowers with fruit trees and planted greens under indeterminate tomatoes. The small space, roughly 30 × 50 feet, was orderly and manageable. We even added a small chicken coop for a flock of eye-candy bantams in one corner, plus a compost bin. I used salvaged local brick to lay herringbone-patterned paths and repurposed the original 15-foot Gothic cupola from the old barn (which a neighbor was using as a toolshed) to serve as a rose-swathed ornament at the garden's center. This was my first garden, and it was high on romantic aspiration; very pretty and fussy and photo ready. For almost 10 years, that was all we needed. But as eating a healthy, nutrient-dense organic diet became more important, we began to outgrow our quaint, contained potager and dream of something more.

Land access was the first challenge, and in a high-priced residential neighborhood such as ours, so was economics. Most of the parcel that made up the original 37-acre estate had been lost—believe it or not—in a high-stakes poker game to a developer in the late 1950s, and he'd mysteriously let it lie fallow for almost 40 years (although he had surveyed plans to turn the property into ⅛-acre split-level suburban lots, tearing down the old farm buildings and destroying the future of Stonegate in the process). Another developer bought up the land just before the previous owner's death in the 1990s and had it subdivided into 1-acre parcels, the most desirable of which fronted the stone-walled and wooded ribbon of River Road, just north of the historic Balmville Tree, a massive 300-year-old cottonwood that marks the center point of the hamlet of Balmville.

Running north along the western highlands of the Hudson and 60 miles up from

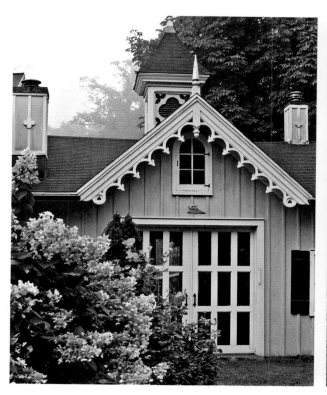

Manhattan, Balmville is a mix of 19th-century estates and newer development. Balmville retains some of the old grace and magic, but development pressure has compromised much of its historic feel; there's little understanding of context or place in the new sprawl, just a kind of sad *nowhereness*.

A century ago, before the franchising of American architecture led to collective, bland mediocrity, this really was somewhere. Stonegate, originally named Echo Lawn, was built in 1850 for George A. Elliot, a prominent paper manufacturer and a contemporary and friend of Andrew Jackson Downing. (Elliot was instrumental in moving Downing's ideas forward toward the creation of Central Park in New York City, whose layout owes much to Downing's articulation of the picturesque movement in America.) Echo Lawn, with its sweeping mansard roofs (one of the earliest such introductions in the country) and high-style interiors embellished with decoratively filigreed plaster and marble detailing, was an impressive expression of what Downing would call "social civilization and social culture."

When Stonegate was Echo Lawn, its neighboring estate to the east was Algonac, home to the Delanos and Roosevelts, and across the street was Morningside, a Frederick Clarke Withers masterpiece of Gothic Revival architecture. The Echo Lawn estate, with its ornate villa, picturesque grounds scattered with orchards, and Italianate gardens, was a property of its time, a place Downing would have known and approved of. Echo Lawn was the estate of the Knowlton

family in the late 1800s (whose early American furniture collection was one of the founding endowments of the American Wing at the Metropolitan Museum in New York) and the Beal family in the early 20th century. The Beals were an eccentric clan that included prominent landscape painters Gifford and Reynolds Beal, whose studio—with its 50-square-foot north-facing window—is the current kitchen of the carriage house at Stonegate. The property seems to inspire a kind of vigorous creative enthusiasm, something in the water that makes its owners, present company included, want to live expressively on the land.

And so in 2004, with lots running upwards of $100,000 an acre, we had to come up with some imaginative financing to keep the dream of expanding our farm from being undone by development. Lawyers in tow, we argued for architectural review in front of the local zoning board, lobbied the state's Historic Preservation Office to intervene, and campaigned hard to protect the integrity of Balmville's historic center. But as in most municipalities, money and private interests have eminent domain and tend to prevail. We won the battle but lost the war: A small footprint of the old estate has been preserved and put on the National Register of Historic Places, but its neighboring lands have been colonized by bland and incongruous vinyl boxes.

If you begin to grow food in the middle ground of suburbia, there will be zoning issues to

(continued on page 30)

consider, neighbors to placate, protections to secure. At Stonegate, it took us 2 years and some persistent lobbying of the county legislature and the local Cooperative Extension, including impassioned appeals to rooms full of skeptical bureaucrats, to get our agricultural district. The designation allows us significant protections under the bylaws of the New York State Department of Agriculture and Markets, including allowances for livestock, burn permits, secondary structures, and some property tax abatements. Checking with local zoning to see what you can and cannot do may just turn you into an accidental activist; you may have to plead and rally your case for community-integrated agriculture. The good news is that there's momentum moving in favor of the grow-local movement and against out-of-date zoning. These are winnable battles. Of course, nothing worth doing isn't also worth a good scuffle with authority.

DESIGNS FOR GROWING

The design of your garden or farm needs to reflect a larger set of priorities than the purely ornamental garden. This is a space where you will be growing food—beautiful, nutritious, flavorful food—and its design should have a kind of functional integrity that alludes to something bigger than beauty for its own sake. Good, strong bones; purposeful structures and buildings; practical layout; and a functional plan for support systems (watering, fertilizing, composting, harvesting, pest and disease management) are essential. Whether it's a large space or a small garden, getting the infrastructure right—the basic, coherent layout and flow of the place—will free you up to embellish it later. But the good bones have to be there first.

Your home itself has a distinct, articulated plan with regards to flow and light and livability, and your growing space should be an extension of those orderly ideas. At Stonegate, because of its strong and ornamental Gothic bones, the farm we built has equally defined lines and a decorative formality that fits the feel of the place. It's also on a small parcel, so attention to design and order is imperative. Stonegate came from a time when ornament still had value, before obsessions with industry and technology turned the home into a machine for living rather than an instrument for living, with a clear voice and character. There's been a perception over the last century or more that ornament is somehow dishonest and undemocratic. That sterile, monolithic urban structures and bland suburban boxes are more virtuous and sincere. That a "tough, mechanized citizenry . . . commercialized by machinery," as Frank Lloyd Wright observed, was the aspiration. Yet nature is always arguing against this idea, embellishing the planet with complex, incomparable beauty, pattern, and form.

There are wonderful agrarian places where purpose and beauty have been integrated, where agriculture seems to flow seamlessly to and from supporting structures. Colonial Williamsburg in Virginia, Shelburne Farms in Vermont, and Old Sturbridge Village in Massachusetts come to mind, with their idealized, premodern vision. There's a reason people are drawn to these places, not only for their value as historic artifacts but also because they are beautiful, coherent,

(continued on page 34)

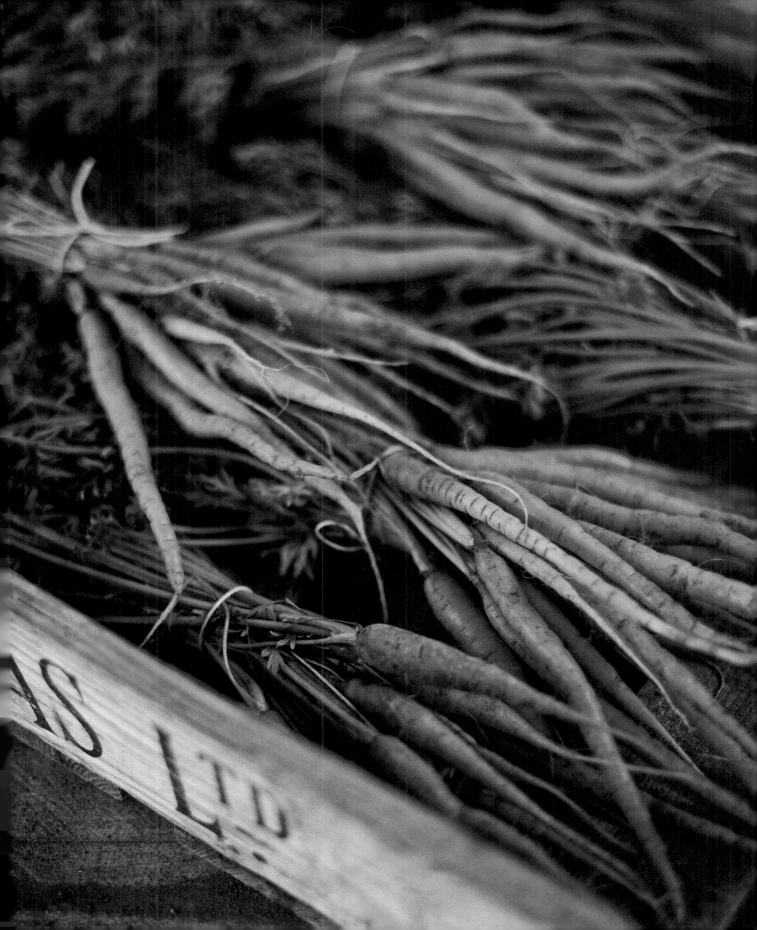

Work Is Love Made Visible

My wife's supercilious grandmother used to tell me I had peasant blood, which I took as a compliment. Better an honest, hardworking peasant than a soft-palmed scoundrel. Good, physical work, with something to show for it besides tight abdominals (a bountiful harvest, say), is an act of alignment and sometimes even exaltation. It ties us back to the order of the natural world. Work is what the wild things do—all day long—for food, shelter, survival, maybe even *joy*.

Growing food for others is a physical act. "Such hard work!" they say. Yes, but how fulfilling, how joyful. "The highest reward for a person's toil is not what they get for it, but what they become by it," said the social philosopher John Ruskin.

We have become more capable, more patient, more resourceful, more humble. Work on the land develops deep connective tissue with simple, empirical purpose—something we're in great need of in an age of texts and tweets.

I bought an old tractor for the farm this year. It's seen plenty of hard work, like me, so we're peers. Its throaty, cast-iron rumble is reassuring. No squeaky plastic or pot metal here. No imported parts. It was built somewhere in the Midwest, back when industry had some physical integrity and work wasn't just virtual bustle. It rambles across the property, making a clean cut in the orchard, indifferent to the rough carpet of twigs and small stumps.

A morning spent in the studio—editing film, answering e-mails from clients, or prepping for a shoot—is usually balanced by an afternoon of real physical work, of which there's always plenty. Without productive exertion of some kind, my time seems incomplete, unfulfilled. I need to feel used up at the end of the day.

"We don't move anything unless it weighs a thousand pounds," the *New York Times* quoted us saying in a House Proud feature on our efforts to restore Stonegate. Clearly, work has never been an obstacle. After an urban upbringing, among worlds others had created, I needed to build. I needed to move mountains. I needed to see what I could become by it.

So with a new chicken coop now completed in the orchard, my sweet Copernican universe, with the farm at the center of all things and us in perpetual orbit around it, seems momentarily balanced. I can stand back from the work on this small structure and feel its value to the farm, despite the long hours and considerable effort it took to build. "Work is love made visible," said Kahlil Gibran, and I'm holding him to it.

The laying hens have taken to their new digs without a lot of fuss and feather. Even the prodigal pullet rejoined the flock, although at the bottom of the pecking order. They're now ranging happily in the orchard, tilling and fertilizing the soil, devouring pests, making their most magical eggs. Working hard like the rest of us.

Setting a table in the orchard, where chickens wander underfoot, fruit is on the bough, and soft light filters through the trees. All is right with this world.

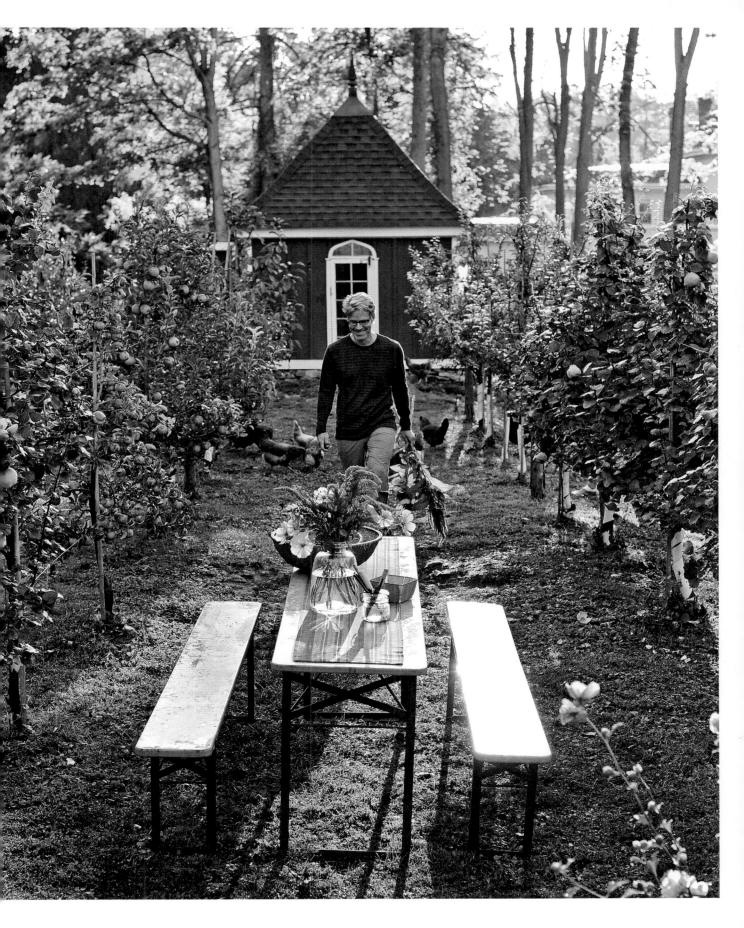

and orderly. The integration of agriculture and architecture (food and shelter, both basic human needs) and the idea of purposeful work and community resonate with us.

There's much to take away from these properties, much to be inspired by. As a result of visits to Colonial Williamsburg, for example, I'm a little obsessed with outbuildings. Almost every home there has them, in all shapes and sizes, each with its own distinct profile and purpose. These small working buildings create a visual conversation on the land, where all the practical ideas of the place are put forth: greenhouse, potting shed, icehouse, smokehouse, springhouse, granary, stable, coop. All of these structures imply a kind of industry, self-reliance, and freedom from want that's very appealing (as opposed to the prevailing consumer psychology of more and more want). Like a small boat or modest house, everything must have a place and purpose. I like that about farming on a small parcel; it forces you to stay organized within its limits and borders. Framed by fences and property lines that can be absorbed in one view, without a 3-hour tractor run, it discourages sprawl and waste. (Although Stonegate does have hidden transitional spaces where things can lie in forlorn piles and heaps, and almost every farm has a spot for materials waiting to be discarded or repurposed.)

These very efficient and beautiful historic small farms taught me to design spaces that aspire to harmony and grace, where structures are distinct but organically connected by design

and utility. These places have also heightened my respect for the integrity of materials, for wood and metal and machinery that is sound and durable. If you're going to build a coop for a small flock of chickens, for example, it's best to draw inspiration from the rooflines and architectural patterns of your home, or from the color palette. You're not looking to copy, only to imply a relationship. At Stonegate, our coop in the orchard not only punctuates the end of a central axis of quince and plum trees but its roofline, which is pyramidal and topped with a Gothic ball-and-point finial, also echoes the roofline and ornament of the 1850s cupola on the barn. Its color may be different, but the timber-frame construction and materials are similar, and its design is harmonious. (We use a mix of pale ocher yellow, deep historic barn red, and gray green for the 10 buildings on our property, all of which complement each other without the tedium of sameness.) The aim of visual harmony, as in music, is to create a complementary part that strengthens the experience of the whole. Often, the most successful design harmonies come from very subtle places, and their effect is almost subconscious: the segmented arch of a window repeated in the scroll of Gothic vergeboard; the post-and-rail pattern of fencing echoed in the battens and trim of outbuildings; the repeated, Euclidean symmetry of gables. Great design is the deep connective tissue that ties the small farm and its various constituent parts together.

BUILDING THE LOVELY BONES

Humans are pattern-seeking creatures. We're drawn by deep, ancient DNA to seek out pattern, symmetry, and repetition in our environment and find comfort and safety in it. It allows us some navigable protection from the unknowns of the natural world. Gardens and farms are highly unnatural, of course; they're nature reined in and domesticated. There are no Darwinian paradigms at work on this cultivated ground. If there were, we'd all be very successful weed farmers. We have to coddle and protect our fragile crops (yank out weeds, deter pests, foil critters), because we know that a farm without acts of intervention, order, and control would simply no longer *be*. There's no cease-fire or détente to be bartered between the farm and those who would undo it. It's strike or be stricken.

Permaculture, a form of sustainable, regenerative agriculture that aspires to mimic natural ecosystems, is our closest model of working with (and not protecting ourselves from) nature. Permaculture's ordering principles come from imitating the recurring patterns and symmetries of nature and incorporating them into design. Organic farming, at its best, works with nature as well but still imposes structure, design, and sustainable systems and protections that are essentially outside of the conventions of the natural world.

Before you grow anything, it's important to have a design plan for your property, to cultivate the farm of your imagination before you cultivate it for real. If you can, come up with a broad master plan that you'll complete in stages over a few seasons rather than get overwhelmed

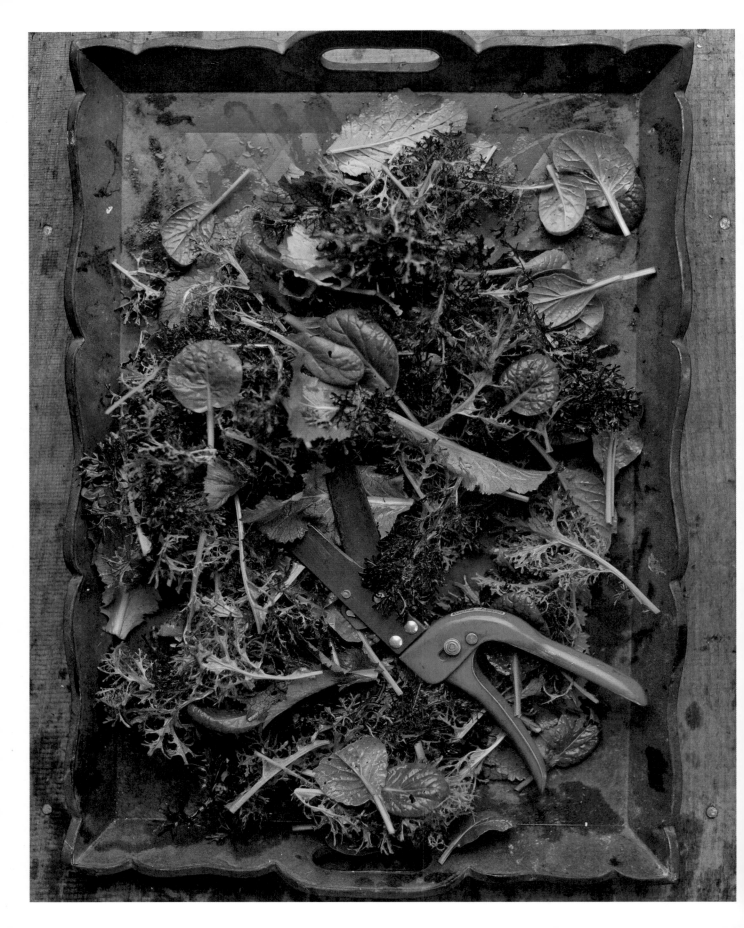

by rushing in and doing too much too fast. Farms and gardens presume attentive care, and you'll need to gauge how much time you can or wish to invest.

You'll want to grow on an exposed site, preferably with at least 6 hours of sunlight a day. Segue the garden so that it flows easily from your home, ideally from a kitchen or outdoor dining area. I like to grow in 5 × 20-foot (100 square feet) rows that stretch east to west, so that early and late light reaches through the farm, backlighting the beds and transforming them into beautiful, translucent ribbons of color. This does take planning, as you don't want to have taller plants and structures in more southerly beds shading out those to the north. I make sure to plant all my taller annual flowers on the northern edge of the farm so I can preserve this visual effect. Beds oriented on a north–south axis might get more even light, but the overall impression your farm makes when the light is low and evocative will be diminished. There's nothing like walking about your farm in the early morning with a good cup of coffee in hand, the farm waking up and glowing around you. Heaven.

Though planning and laying out your garden or growing space is a good off-season process, make sure you have an idea of how the sun moves across your property during the growing season, when trees are fully leafed out. Light in early spring and late fall is far different from the light during the majority of the season. There may be shadows that you can't control, like those cast by neighboring houses or buildings or trees, and you'll need to work around them. Laying out your growing beds in long rectangles that are narrow enough, at 5 feet, to reach into and cultivate from either side, with a lawn-mower-width strip of grass between them, will give the farm a pleasant and orderly symmetry. Because I farm biointensively, every inch of dirt in the beds is used and interplanted with successions of growth, so the green mowing strip around the beds is the only breathing space, and background color, between plantings.

SPATIAL RELATIONS

For your garden to be both productive and aesthetically alive, you'll have to allow time for the shape and flow of it to make sense. There's an important role for intuition in the process, and for the slow summoning up of ideas. Gardeners and farmers should always be scribbling, photographing, and sketching out. That's the virtual planting. The germination happens in the subconscious, as do the best photographs. I'm a much better designer in the landscape because I photograph for a living, having to make quick, intuitive sense of visual space. Goethe wrote that "it is good to think, better to look and think, and best to look without thinking." At its most ideal, the orchard of your imagination or the ideal vegetable and flower farm can't look like it just landed there, unbidden. It needs to seem as though somehow its presence always was, and you've just encouraged it into being.

Arranging your space with equal attention paid to both the aesthetic and practical is not a new idea. The ornamental farm, or *ferme ornée,* as English landscape designer Stephen Switzer introduced it in 1715, was an 18th-century conceit that emerged out of the romantic movement,

where cultivated food gardens and idealized farms were an expression of that period's pastoral aspirations. In *Ichnographica Rustica; or, The Nobleman, Gentleman, and Gardener's Recreation,* Switzer describes the practice of the *ferme ornée* as "mixing the useful and profitable parts of gardening with the pleasurable," noting that "my designs are vastly enlarged and both profit and pleasure may be agreeably mixed together." Thomas Jefferson's Monticello, James Madison's Montpelier, and George Washington's Mount Vernon all drew on Switzer's ideas. And my luminary 19th-century neighbor, Andrew Jackson Downing, wrote extensively on the subject in his *A Treatise on the Theory and Practice of Landscape Gardening:* "The embellished farm is a pretty mode of combining something of the beauty of the landscape garden with the utility of the farm . . . the owner of the small ornamental farm desires to unite with it something to gratify his taste, and to give a higher charm to his rural aspirations." Because Downing was a cultural force with an international reputation, and he wrote immensely popular books on the subjects of landscape design, rural architecture, horticulture, and pomology, his influence was particularly widespread. According to L. H. Bailey's *The Standard Encyclopedia of Horticulture,* Downing was "the single greatest figure in the history of American horticulture and one of the few persons who can be said to have had real genius."

The relationships you create on your farm need to be your own, of course, and not entirely borrowed. But thinking about what to grow and where, and how to transition between spaces,

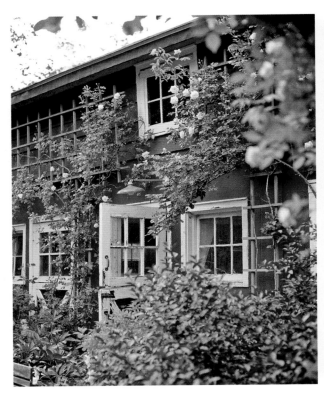 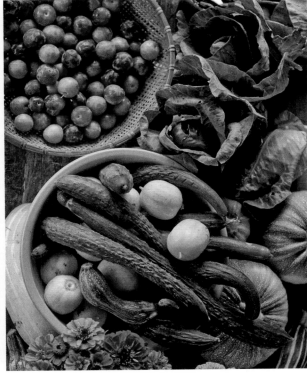

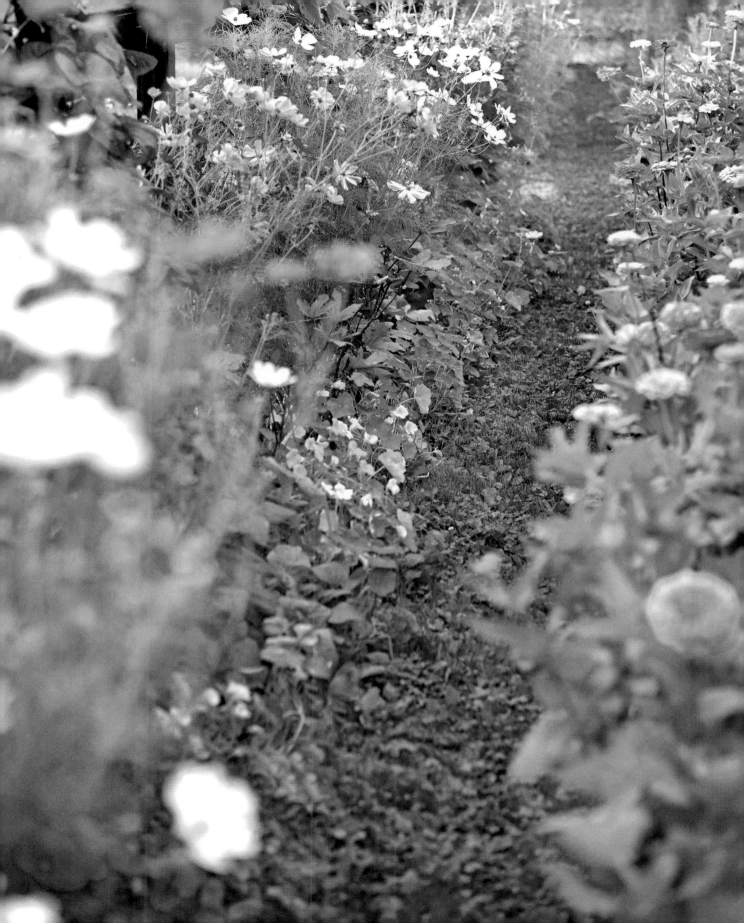

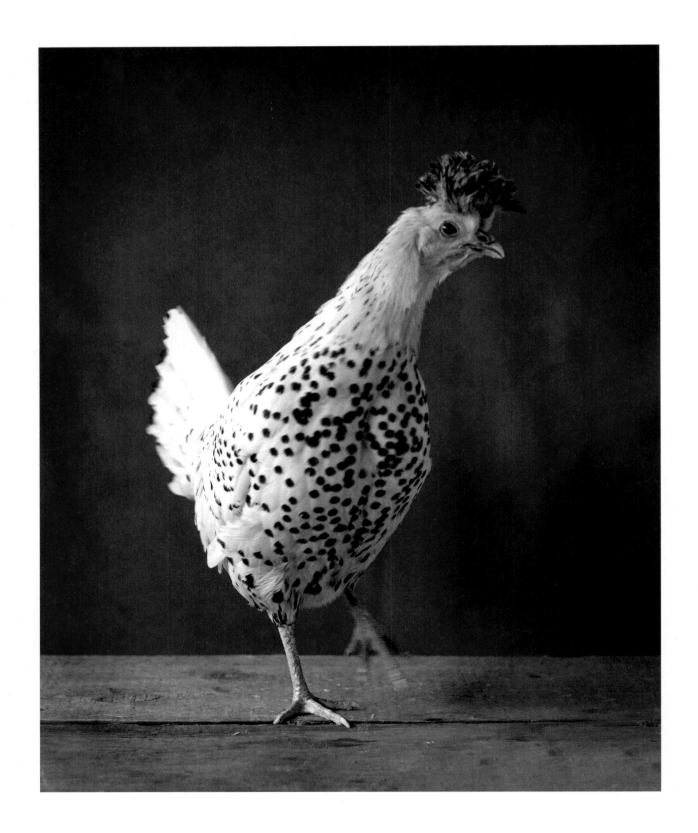

should be a balance of considering plant habit and needs as much as the beauty of the overall scheme. At Stonegate, I've designed it so you enter the farm either through an arched gateway cut into a large, sheared hornbeam hedge (*Carpinus betulus*), which marks the transition between horticulture and agriculture, or through the central nave of the cut flower farm, where the beauty of multicolored beds of zinnias, gomphrena, celosia, branching sunflowers, and waves of cosmos almost assails you. On the same central axis, but through a wide gate flanked by tall plumes of purple amaranth, is the orchard. Arranged in linear bands, the apple, pear, cherry, plum, and quince trees lead your eye through to the ornamental coop at the back of the orchard, which is a kind of Gothic coda at the end of the view. Chickens mill about beneath the fruit trees; bees wander in and out of hives along a southern edge of fencerow, legs heavy and pollen-dusted; and beyond them, tightly sown vegetables grow in thick, multicolored beds. When CSA members are picking up their shares at the farm on Saturday mornings, this view is backlit by low, eastern light. It's hard to imagine that the effort made to present the farm as an abundant, harmonic, magical place is lost on them.

FENCING

Once you've decided the best spot to grow and marked out your beds, you'll want to make sure you're fenced in. If your yard is already fenced, you may wish to further protect and define your growing area. Good fences make good farms, not only because they keep critters out but because they define space, creating order in the landscape. Fences clarify your intentions: chicken run, orchard, vegetables, flowers, or animal paddock. When nature conspires to undo all of your aspirations and careful planning, at least you can visually contain the chaos.

We've had seasons at Stonegate where the weather was so erratic and our growing so compromised that the only reminders that there was a farm were the fencerows.

We fence with wooden post-and-rail stained matte black and top the main flow-through areas with decorative ball finials. This fencing goes well with the red and yellow buildings and mimics a fine art photography frame. To make our fences even more functional, we attach 5-foot galvanized welded wire to the inside rails and skirt it out a foot under the sod surface to repel small critters, while the fencing itself deters deer. This welded wire keeps out all of the woodchucks and bunnies and fades discreetly into the background. Always try to choose fencing that beautifully knits and ties your property together, that frames and articulates your growing space. A fencerow made from recycled industrial pallets might have a kind of DIY beauty, but its appeal is tied more to the resourcefulness of the process than the object itself. The same holds true for trellises made from EMT pipe or chain link, bean towers made of lashed-together PVC, or raised beds framed with salvaged concrete block; there's beauty in the idea of repurposing, but ultimately, you have to look at it, and as the narrative of cleverly making it dims, you're left living with something industrial and unsightly. Remember that beauty affects behavior. The more come-hither your farm is, the more you will come hither to care for it.

STRUCTURES

After fields and pasture, the first impression the word *farm* is likely to suggest is buildings and structures: farmhouse, barns, coops, corncribs, haylofts, stables, granaries, silos. These structures, usually clustered in a sensible huddle somewhere near an access road, immediately conjure up the paradigm of a family farm. Images like these have faded from ubiquity as small farms continue to disappear (it's time to "get big or get out," as Nixon's dangerously misguided secretary of agriculture, Earl Butz, said in the 1970s), but we know what these places represented, and we have a nostalgic connection to their aesthetic and cultural value.

Just as places like Colonial Williamsburg and other living history museums have preserved the cultural practices of the past, part of the beauty of creating your own small farm, farmette, or garden will come from artfully alluding to that past. One of the most direct ways to do so is through structures, and you'll discover that there are so many graceful and historic design harmonies to be found in the aesthetics of the agrarian past. Use them as inspiration but not a plan; allow an intuitive sense of your own property and its character to guide you, and build around those ideas. Above all, make your structures dance and play—whether you remodel, repurpose, or start building from scratch. "You cannot make a building unless you are joyously engaged," said the architect Louis Kahn.

The buildings you design—or redesign—for your property need to embrace utility as much as they play with patterns, lines, and form. Structures too removed from honest purpose will seem like mere embellishment, a laugh rather than a smile. A farm at its core is purposeful, an organized space to grow food, but in our mechanized obsessions with efficiency and output, we've lost our allegiance to beauty, our ability to express it. Finding the right balance between beauty and function is a challenge. You need to allow yourself time to discover and make sense of your surroundings, to listen visually and understand deeply until you're fully aware of where you are.

One of the things I heard in the visuals right away at Stonegate was that the property evolved over time; it wasn't created all at once. It was built up as the demands and interests of the estate grew. You see it in the various rooflines (saltbox, shed, gable, cross-gable, pyramidal, mansard) and the siding (stucco, board-and-batten, clapboard). What the buildings have in common (besides a color palette and a zoning map) is the integrity of their materials, the rightness of their design, and a shared evolutionary context. This is not a museum. This is a real place, with a progressive history and pattern language of its own. The best communities are always a mix of the interesting but diverse sharing a common space. So, too, with architecture.

The buildings I constructed and added have played off the larger visual context of the property, drawing on existing ideas but elaborating on them, stressing and repeating certain features and underplaying or ignoring others. Bad design limits itself to pattern and formula, while good design imaginatively expands on it. The Gothic ornament I've added at Stonegate

wasn't originally there, but it broadens the period references of the board-and-batten style. The greenhouse, coop, and CSA shed all in some way reference the rest of the outbuildings, but each is distinct. When I stand back and take in the macroview of the place, it all comes together and connects. The buildings may speak the same language, but they're not all saying the same thing.

Among the other structures you'll likely build, besides fences and outbuildings, are a smaller, supporting cast of beehives, compost bins, trellises, coldframes, pole bean pyramids, tomato towers, and high and low tunnels. These structures, like diacritical marks stressing functions that are essential to growing, play an important part in the overall coherence and beauty. I make a conscious effort to use material and design ideas that fit the visual flow of the farm. I don't use many plastics, and I try to design and build most of my structures for growing vertically—like towers for pole beans or trellises for squash, cucumbers, or tomatoes—out of cedar, bamboo, or other rot-resistant natural materials. I prefer 14-gauge galvanized steel wire, rigid reinforcing panels, and natural jute twine over plastic netting and PVC for climbing plants. My beehives are painted a dark and light Provençal blue—not a major part of the palette at the farm, but the same color as the gates to the main gardens, places as essential to me as my bees.

The beauty in the small details adds up, and it's important to be as mindful of them as of the larger structures. I had two farmers one season who called me the farm's "creative director" (disparagingly, sometimes) because of my visual compulsions. I made them trade in their practical but ugly harvest buckets for nicely patinated, but heavier, wooden crates because they looked and photographed better. Can't help it.

My farm is a romantic place, to be sure, not lacking in attention to beauty and historical allusions, but it's not for everyone. It may feel too patrician for some (it is on an old estate), or too formal and fussed over, but it is a distinct expression of a certain point of view, a particular way of being in the world. And even though it's been built up, restored, salvaged, and reimagined in the most hands-on, DIY sense, it doesn't look that way. I'm one kind of farmer, coming into it with my own peculiar needs and vision, but there will be all kinds of new farms and farmers and new gardens and gardeners out there in the years ahead who will redefine agriculture for themselves. From the nonconformist protohippy types in the young farming community growing sprouts and microgreens to the urban and suburban demographic that has exhausted all the mainstream consumer myths, these gardeners are beginning to steward and farm small parcels of arable land for their own wellness and as a form of reconciliation with the natural world.

Whatever your reasons for wanting to create a nourishing farm or garden, the work waits for you and the future needs you. Growing beautiful food will give you a lifetime shot through with joy and purpose and will leave a better, more balanced world for others to inherit. As poet, farmer, and environmental activist Wendell Berry said, "A person who is growing a garden, if he is growing it organically, is improving a piece of the world."

PLANT

CUCUMBERS

ARUGULA

SCALLIONS

Civilizations that get too far from the land are bound to decay.

—J. I. RODALE

SOIL

Before the thrill of seed catalogs and plant sales, before the anticipated savor of heirloom tomatoes or tree-ripened fruit, there is soil, in all of its arcane and unknowable complexity.

Good soil is the foundation of successful growing, and without it, all of the energy and passion you've put into planning your farm or garden and nurturing seed into promising seedlings will be undone. Becoming a good soil farmer, though not as sexy or visual as cultivating plants, is critical; flourishing farms and gardens, like good houses, are always built on solid foundations.

Soil is the most complicated ecosystem on the planet, a dark cosmos of interdependent life that we tread on and don't give much thought to until we want to grow something in it. Understanding soil ecosystems—the mysterious bonds between microbial and fungal life, between organic and mineral nutrients, between organisms, insects, and plants—is a challenge to us all, and there's still so much intercellular noise and chatter going on that we have yet to understand.

Most of the problems and pathology of growing healthy plants can be traced back to soil conditioning, and when your plants struggle for life or fail to reach their seed-packet promise, it's usually your soil telling you something. It's best to learn how to feed and nurture the soil first, then let the soil feed your plants.

Soil and dirt are superficially the same thing, although soil is alive with decaying organic matter and microorganisms, whereas dirt is soil that has been displaced from its environment and is—essentially—dead. Most fallow ground found in yards, although it supports grass and a host of insects and organisms, is not near rich enough to meet the heavy demands of food crops. Once the sod is removed to create a growing space, the soil will need to be amended with organic matter in the form of compost, leaf mold, and green and animal manures to create a rich, healthy home not only for your plants but also for the countless life-forms that support soil health.

Organic growing builds up dynamic, living systems in the soil and consistently replenishes the earth's skin. This is how plants are fed in nature, without the intervention of agriculture, and any

look at uncultivated ground will tell you that nature seems to know what she's doing. By contrast, chemical farming—in the form of synthetic fertilizers and pesticides—adds nothing to the fertility of the soil and only exploits the immediate needs of plants while adding toxins and salts that destroy intricate living systems. The short-term gains in productivity using chemical farming have been great, but the price we're beginning to pay in depleted soil fertility is far greater.

Soil Types

Soil is made up of three basic particles: sand, silt, and clay. Sand is the largest, with irregular, quick-draining particles that tend not to bind. Silt's particles are smaller, though still irregular, while clay's structure is almost microscopic, with flat particles that lock into an impenetrable layer. Though clay is usually rich in nutrients, it is almost anaerobic and watertight. The ideal garden soil is a combination of these three, often called sandy loam, that is rich in nutrients, well-draining, and hospitable to plant roots.

You can determine your soil type and texture with a simple test. Take a handful of damp soil and squeeze it into a ribbon in your hand. If your ribbon breaks off at about an inch, you have sand or silt; if it makes it to 2 inches, you have loam; and beyond 2 inches, you're dealing with clay.

The ways in which soil particles bind (or don't bind) together determine the soil's structure. Most plants grow best in soil that binds together in small aggregates, clumps of particles that break apart easily. Aggregates create pore spaces in soil so air and water move well through the soil, but not too quickly.

Texture is just one of the things that determine a soil's structure. Climate, soil organisms, pH, nutrients, and minerals all contribute to the formation of structure. Compacting the soil with heavy equipment, or by walking on it repeatedly, and tilling the soil when it's too wet or dry can break apart aggregates and destroy soil structure. The best way to improve and support soil structure that is good for growing plants is to add organic matter.

Organic Matter

In addition to the mineral particles that make up nearly all of the solid part of the soil (air and water occupy about half of the space of healthy soil), a small but significant percentage of soil consists of organic matter. Including bacteria, fungi, living, and once-living plants and animals, organic matter rarely makes up more than 5 percent of the soil, but it is essential to plant life and health.

Included in the soil's organic matter is humus, a stable form of decomposed organic material that remains after once-living matter has been digested by soil-dwelling organisms. Among other benefits, humus is the glue that binds soil into aggregates.

"Feeding" the soil with plenty of organic matter, particularly in the form of compost, is at

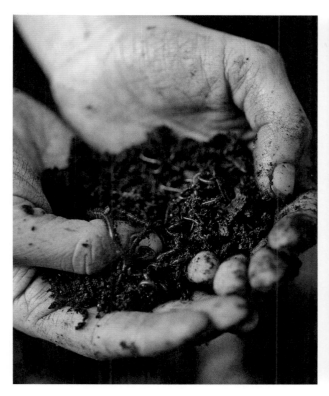 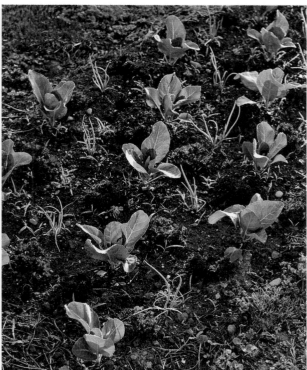

the heart of organic growing on any scale. By creating a healthy, diverse community of micro-organisms and larger soil-dwelling critters and by supplying that community with abundant material to eat and digest into humus, you are setting the stage for rich, healthy soil that will support productive, healthy plants.

Air and Water

Plants' roots need both air and water in the soil to grow and thrive, but too much of either one causes problems. Good drainage is essential for nearly all food crops. In soggy soil, roots suffocate and plants can't carry out their basic functions. Meanwhile, fungal organisms tend to thrive in wet conditions, and bacteria often travel in a film of water. Constantly wet soil sets plants up for disease problems and leaves them weak and vulnerable to infections.

At the other end of the drainage spectrum, however, is drought. Very sandy soil, with its big particles that don't fasten together well, lets water slip away too quickly. Plants need soil aggregates that hold a film of water on their surface where roots can reach it but that also create pore spaces for air in the soil. When the soil is too sandy, two things can happen: Roots dry out and die, or nutrients are unavailable to plants because there's no water to make them soluble so roots can absorb them.

Dreams under Our Feet

It's March, and most of the prevailing madness at Stonegate Farm these days is focused underground. Besides fretting over tender seedlings in the greenhouse, I'm preoccupied with soil: top-dressing, tilling, broad-forking, sampling. Managing the health and fertility of the land is a strange kind of rural hypochondria, particularly here at the OCD (obsessive compulsive dirt) farm.

We're obsessed with dirt because it is mysterious, with a deep and secret life of its own. It's the most complex and abundant ecosystem on earth; a dark universe of fungi, bacteria, and microorganisms all interacting with plant roots and rhizomes in a language that's still arcane to science. In a spoonful of dirt, there are more than a million species of microbes, mostly unknown: a cosmos of dreams beneath our feet.

"I have spread my dreams under your feet; / Tread softly because you tread on my dreams," said Yeats.

If I had any issues last season, they were largely subterranean, with soil lacking in certain trace elements or nutrients, with waterlogging leading to root rot on brambles in the orchard, and with not having rotated my crops and therefore depleting the soil's vitality.

Of course, there's always the usual flotsam the land heaves up in the thaw of spring: bricks, metal scrap, cistern caps, carriage linkages, not to mention the constant scree of glacial rock that lies reliably just 10 inches below my topsoil. There's nothing quite as bone shuddering as hitting a 20-pound chunk of stone with the business end of a shovel.

The roots of massive estate trees also have a way of weaving themselves into the soil, frustrating the tines of tillers and broadforks. Although none of our geriatric trees has tumbled out of the sky, some are looking precariously frail, just a puff away from oblivion. Our farm is loomed over by a collection of arboreal specimens that were born in the 19th century, majestic, beautiful, senile Victorians. They seem to wander about in the wind, their leafy green gowns flapped open, debris trailing from their brittle canopies. Ginkgo, tulip poplar, cucumber magnolia, Kentucky coffee bean, American linden, chestnut, sugar maple, black walnut. They're all here in hospice at Stonegate.

So I've been breaking new ground and my metaphorical back with my compulsion for agricultural order and fertility. And this season, in particular, after a winter spent abroad in the Bavarian countryside, where "*Ordnung muss sein*" (order must be), I'm more determined than ever to rein in the wild and scrappy. Bavaria, with its carefully cultivated farms and fields and charming villages, is postcard quaint; a place where the stewardship and care of agricultural lands are communal acts. If ever there was an argument to be made for agriculture beautifully integrated into community, you'll find it there. If here at Stonegate Farm I achieve a fraction of what the Bavarians have accomplished, I'll consider this whole OCD experiment a success.

Tons of composted horse manure top-dress the farm each spring, building up the soil's organic matter, tilth, and fertility.

Drainage

Because both air and water are so critical to the health of your garden, it pays to observe and get to know your land before you settle on a site for planting. Soil texture and structure both help determine soil drainage, as do climate and physical location. In general, drainage is difficult to alter. If at all possible, choose a garden spot that has well-drained soil rather than one that is either very wet or very dry.

If you're uncertain about your soil's drainage, try this simple test: Dig a hole that's roughly 1 foot deep and 1 foot in diameter. Fill the hole with water and let it drain away. Once the water has drained completely, fill the hole again with water and time how long it takes for the water to disperse. If water stays in the hole for longer than 8 hours, you will want to take steps, such as creating raised garden beds or installing a drainage system to divert water and improve the growing area for your plants. If the soil drains very rapidly, you may want to amend it with lots of organic matter to improve moisture retention and consider other measures to conserve moisture. Rapid drainage may seem easier to manage, but it means you'll spend a lot more time and resources supplying water to your garden over the course of the growing season.

Soil pH

The pH of the soil is a measure of its acidity or alkalinity and is determined by the native minerals that make up the soil as well as by climate. A pH of 7.0 is considered neutral. Below 7.0, the soil pH is acidic (or "sour"); above 7.0, soil is alkaline (or "sweet"). Plants are said to "prefer" certain pH levels because of the nutrients that are or are not available to them depending on the pH.

Soil pH is normally adjusted by adding ground limestone or gypsum (to raise pH) or ground sulfur (to lower pH). But modifying soil pH is a long-term process, best begun at least a growing season ahead of planting. If a test indicates that your soil's pH should be adjusted, your local Cooperative Extension office can recommend the right amount and timing of amendments for your soil type and growing conditions. Meanwhile, amending the soil with organic matter can help to mitigate the effects of pH by ensuring that nutrients are present in the soil in forms that plants can use.

Getting Tested

If you're uncertain about your soil's fertility before you start planting, or if you've been gardening in a spot where things just aren't growing as well as they should, a professional soil test can tell you what nutrients are missing. In most states, soil samples may be submitted to the land-grant agricultural university for analysis, usually by using a kit available through the county extension office. The kit will tell you how to collect and package a representative sample for testing. In exchange for your fee and a bit of soil, you'll receive a complete assessment of your

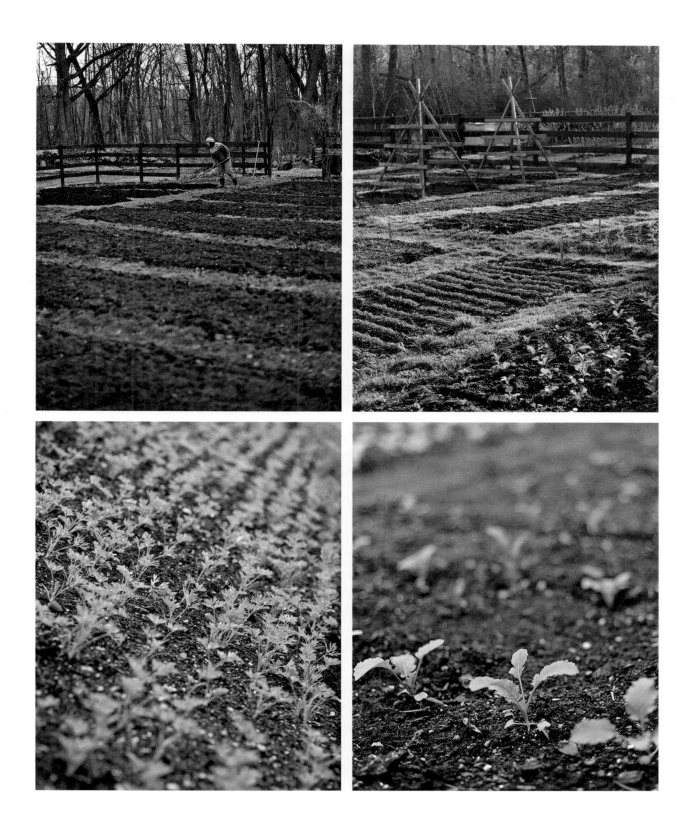

soil's nutrient content and pH, along with recommendations for amending it to suit your plants' needs. There are also a few private laboratories that perform soil tests for consumers; these may provide a more comprehensive evaluation but may also charge a higher fee. Wherever you choose to send your soil for testing, don't wait until the week before you plant a garden to send in a test. Collect your sample the summer before you hope to start gardening the following spring. If you're lucky, you'll get results in time to begin amending and improving the soil in fall, so that the soil is really ready to plant when spring rolls around. Finally, be sure to specify that you want *organic* recommendations and on a scale that's suited to the size of your garden— amounts per square foot, not per acre.

Fertilizers and Amendments

The garden soil you begin with will most likely need to be amended before you plant out your precious seedlings. Even if your future garden site supports a lawn, it may not have the nutritional strength necessary for fruiting plants and hungry vegetable crops. If you've had your soil tested, you know what to add and—hopefully—when to add it for the best results. But if you're flying without a net, as gardeners often do, you really can't go wrong by applying compost.

Incorporating ½ to 1 inch of compost into the soil each growing season is a reasonably

sound soil-care program that will add modest amounts of nutrients along with organic matter to support both good drainage and moisture retention. For a new garden bed, cover the surface with 1 to 2 inches of compost or composted manure and dig or till it into the top 4 to 6 inches of the soil. Incorporate compost in fall and then mulch the bed with straw or wood chips to protect the soil from weathering during winter. In spring, pull back the mulch to let the bed warm for early crops and plant into the compost-enriched soil. Or leave compost atop the garden as a protective winter mulch and incorporate it in spring as you prepare beds for planting.

For the most part, your garden will thrive as you build the soil and nourish the plants according to their specific needs. Your soil will need amendments, fertilization, and remineralization to restore the nutrients that hungry fruit and vegetable crops require. Remineralizing, in particular, is as essential as composting when it comes to soil health, fertility, and the nutrient density of what you grow; the healthier the soil, the more nutrient packed and healthful the food it produces.

At Stonegate, we tend to feed our heavy fruiting vegetables with extra phosphorus (in the form of a 0-45-0 triple superphosphate), for example, knowing that they make demands on the soil that normal phosphate levels may not be able to provide. We also fertilize the soil and foliar feed throughout the season with a high-octane fish emulsion and seaweed spray, which provides an almost complete and regular nutrient buzz for soil and plants.

Think of this as a patient, steady process—a way of providing a healthy, balanced diet for both soil and plants—rather than as some supersupplement pill that top loads plants with a megadose of nutrients while doing nothing to contribute to the long-term health and fertility of the soil that supports them.

Compost

I've been amending my beds and soil for years with composted horse manure from a friend's stables. He lets me load the previous year's piles into my pickup each spring, and it's become something of a ritual. His horses look on, seemingly amused by my compulsive shoveling of their waste. Once, his 10-year-old chestnut gelding stood curiously by as I shoveled composted manure into the truck, then slowly approached and brushed his long, warm muzzle against my shoulder as if to ask, "What are you doing with my poop?" I love this horse, with his sweet and massive tenderness. If I brought him a bushel of 'Purple Haze' carrots and heirloom apples, I wonder if he'd make the connection between what he gives and what we get?

My compost is a mix of last year's greens and carbons and manures left to cold compost in a large contained pile along the edge of the orchard. I think that not rushing compost, and allowing all of its richness to form into complex soils as nature does (over time), is the best for all the bacteria, fungi, and microorganisms—and human energy—involved. Quick and hot composting can kill a lot of the beneficial life you're trying to preserve. Besides the organic vegetable waste from the farm's harvests, we add fall leaves and straw and have a small electric

(continued on page 58)

Or•gan•ic (*adj*) \or-gan-ik\

We've been setting out young greenhouse seedlings for the last week—loose-leaf lettuce, broccoli rabe, rainbow chard—and organizing them into perfect matrices on the farm; it's the kind of hopeful symmetry that prevails in spring, before the sprawl of summer growth turns order into succulent mayhem.

When you're not spread out over acres of land but are farming on limited ground, your season is defined by meticulous planning and biointensive forethought. Small farms need to make particularly efficient use of space. Deciding what to plant where and with whom is a kind of delicate agricultural choreography, one where missteps can seriously lower productivity or, worse, lead to crop failure.

Each season begins with the same questions: What can I plant here and harvest early before the space is succeeded by a later-season variety? What could I squeeze into the soft, usable dirt between taller stems, or companion plant so that there's balance and harmony, not competition?

Of course, balance and harmony are fundamental to organic farming. Organic asks that you take as much as you give, that you're attentive to inherent cycles and rhythms, that you consider the farm as a macro-organism where all the living parts function in service of the whole.

But organic isn't just a method and philosophy of growing food. The *Oxford English Dictionary* defines organic as "denoting a relation between elements of something such that they fit together harmoniously as necessary parts of the whole."

And aren't we all looking for lives that "fit together harmoniously," for a sense of order and meaning, for some magical coherence at the end of the day?

Working with the land gives you some of that. It ties you in and proposes that you ask the right questions. When I began to restore this property 15 years ago and stood looking at a cluster of worn-out buildings buried beneath veils of bittersweet and at the menacing loom of wild and unruly trees, I started to ask those questions: What if we restored this, or added that, or moved this building here and built one there, or *started a farm*?

The answers have broadened the meaning of organic at Stonegate. Very little that happens here is out of context or harmony. My work as a photographer and writer is shaped by my relationship with this place and vice versa. Working in magazines and books helps add broader purpose and meaning to the farm and is an engine of its sustainability. (I've even grown my own props for food shoots!)

In order to be fulfilled, life needs some organizing principles. The center for me is held by the farm, the pulsing heart of things that helps to make beautiful sense of it all.

Spring-planted carrots are a sweet, crisp harvest come midseason.

chipper to shred plant stalks and stems into biodegradable, manageable pieces. I'll also add richly soiled straw bedding from the chicken coop in fall and early spring, along with aged horse manure, and turn it into the pile. The mound gets worked and turned only occasionally and produces a healthy, friable soil every season.

There's a lot of blather about the do's and don'ts of composting, and some folks seem to get so caught up in the conversation that they lose track of why they're composting in the first place. Some composting methods can seem daunting, full of arcane references to organic chemistry that will remind you of why you dropped out of premed. Composting does feel like a kind of alchemy, turning waste into something rich and viable, and it appeals to our resourceful, enterprising spirit as growers, but it's not the end-all. Make it a part of what you do, not the whole point.

The compost you make should resemble the one nature makes on her own: deep brown, crumbly, full of organic matter. With the right mix of carbon and nitrogen-rich materials, water, and air, plant material will decompose, worked on by millions of tireless microorganisms, and regenerate itself as soil.

What to Compost

While you may need to forage locally for ingredients for compost making, there should be little need to buy materials to put in the pile or bin. Our gardens, lawns and landscapes, and kitchens typically provide plenty of raw materials for the composting process, with the exception of animal manures, which you may need to seek out if you don't have a few critters of your own.

The more diverse the materials that go into the compost pile, the more nutritionally varied the outcome. With the exception of meat scraps, dairy products, and greasy foods and quantities of oil (they'll put up a stink and attract pests), put *all* the organic wastes from the kitchen and garden into the compost pile: eggshells, coffee grounds, tea leaves, fruit peels, vegetable trimmings, cooked pasta, crumbs from the bottom of the cereal or cracker bag, bread scraps, and more. Almost everything you eat can be converted to compost.

From the garden and landscape, collect weeds, fading plants and plant parts, grass clippings, fall leaves, twigs and branches, stems of perennials cut back for winter, cornstalks, and ornamental grasses. We use a small electric mulcher, or shredder, to break down thicker plant stalks, and you can also use a mulching mower to break down small twigs and leaves. Don't despair if you lack a lawn or trees to yield clippings and leaves. Often these can be picked up from local curbsides during municipal yard waste collections. Or your local government agency may have a central collection point where they produce "compost" or wood chips that are free to residents. Not surprisingly, municipal products can be highly variable—not everyone is scrupulous about what they toss into the leaf pile or drop off at the collection facility. To be safe, you can get your yard waste from a friend or neighbor who you know is tending their landscape without the chemical soup of weed killers or toxic pesticides.

Green grass clippings are known as the "manure of suburbia" and can boost microbial

activity in a compost pile with their high-octane shot of nitrogen. A combination of chopped dry leaves and fresh grass clippings makes a fine compost mix without anything else added.

To the rich mix of plant wastes from home and garden, add manure if it is available. Skip the wastes of carnivores—no dog or cat droppings in the compost—because they can carry disease organisms that can affect humans. The bedding from a chicken coop, the material from beneath a rabbit hutch, and straw and manure from stables or barns that house horses, cows, sheep, goats, and llamas are all nutritionally potent additions to the compost.

How Compost Happens

While it may seem like you are doing most of the work of transforming all this organic waste into compost, your contribution actually pales in comparison to the labors of countless micro-organisms (and there are billions of them in a gram of compost, including bacteria, fungi, and protozoa) that munch their way through the heap.

Launching a successful compost project is quite simple, but what happens to the assembled materials is remarkably complex. Compost ingredients can be generally classified as either "browns" (carbon) or "greens" (nitrogen), and they represent the two main nutrients required. While each material contains its own ratio of these nutrients, and complex algorithms can be devised to perfectly balance the amounts of each that go into a compost pile, there's really little need for that level of scrutiny. As a general rule, a compost pile should be constructed of two or three parts of carbon/brown materials to one part of nitrogen/green materials by volume, typically expressed as a 3:1 ratio. Think of two or three bags of dry leaves mixed with one bag of fresh, moist grass clippings or a similar amount of manure.

Working the Soil

At Stonegate, our growing beds are divided by grass paths that are 18 inches wide (lawn mower width), and the beds themselves are 5 feet wide. This means we're never walking on and compacting our growing soil, and we're always planting, weeding, tilling, and amending from the edges. A green grid between beds is easily maintained by mowing, not time-consuming weeding, and helps to visually define the growing areas. Distinct and abundant beds of vegetables framed by neatly mown borders are perennial-garden pretty and make it clear that you're answering to a higher aesthetic authority than if you were just working a big patch of dirt.

We do most of our soil work in spring and fall, after it's sufficiently dry, and throughout the growing season as needed, and we use a number of sturdy and reliable tools. If farming is a long-term investment, then the tools you use should be, as well. In general, older tools and machines that have proven themselves over time—and are not mass-produced, riveted together, and made of disposable pot metal—are best.

My two go-to tools for soil work are the broad fork and a 40-year-old Troy-Bilt Pony tiller

that I bought on Craigslist. Because my soil has a fair amount of clay and is slow to drain, using a broad fork each spring opens up the deep layers of soil to nutrients from above and improves drainage. A broad fork is a manual beast, one of the few tools you have to stand on to work, and it consists of a series of long, sturdy tines attached to a flat bar that bridges two long, upright handles. The fork is driven into the soil and then stood on and worked back and forth to loosen soil layers to a depth of about 14 inches.

Once all of my beds have been pierced and loosened by the broad fork, a thick layer of compost and composted manure is spread across them, along with any needed nutrients based on an annual soil test. Once these composts are spread across the farm, they're tilled in with a walk-behind tiller that works these amendments into the top 6 inches of the soil, then raked with a sturdy bow rake into a smooth, loamy bed ready for planting.

During the growing season, the tiller and bow rakes are used to prep beds for succession plantings, and different hoes—such as circle, scuffle, and stirrup—are used for weeding between rows. You will make thorough and demanding use of these tools and will come to rely on them as much as you do your own passion and stamina for growing, and they should be treated fairly.

After designing your growing space, putting in the necessary infrastructures of fencing, trellising, water supply, and tool storage; and after tilling, amending, and prepping your soil, it's time for the fun part: ordering seeds.

SEED STARTING

One of the most compelling and magical things about growing, whether gardening or farming, is the adventure of turning a tiny dusting of seeds—with all their stored genetic promise—into fully formed plants. Buying plants that someone else has started and grown will never have the same transformative power. So much potential lies in a small and improbable seed packet: to feed yourself and others, to create beauty, to take an active part in cycles outside your own. We are bonded as a species, like the rest of the natural world, by regeneration, by the process of creating new life; beyond all the bustle and distractions of being human, it's really why we're here.

There are many arguments for starting your own plants from seed, but the most persuasive reasons are access to thousands of varieties that you'll never see at the nursery and being able to grow many more plants at a fraction of the cost. There are nurseries that sell only heirloom seeds, those that specialize in rare and exotic varieties, and those that focus on annual flowers. There are those that concentrate on organics, or just tomatoes, or herbs, and some that sell it all. Whatever the farm or garden of your imagination can conjure, there are seed catalogs out there to tempt you.

One of your first considerations before you order seeds will be determining your USDA Zone. These are growing areas defined essentially by your first and last frost dates, and zone maps are ubiquitous online. Knowing your zone will tell you what plants you can safely grow: Any number higher than yours will be iffy for you. (For example, growing a Zone 8 kumquat in Zone 6 is asking for trouble.) All perennial seed packets will indicate what zone that plant is suited for. Your zone for annuals tells you how soon you can plant out in spring without risk of injury from frost and how late you can plant short-season annuals into fall. Because the climate has been so unstable lately, zones are also shifting, and you may find yourself being bumped up a zone or two at some point. (So, kumquats? Maybe.)

For organic growing, you'll want to find seeds from companies that carry organic, non-GMO seeds. Many mail-order catalogs have both organic and conventional seeds, while some specialize in organic only. Heirloom seeds are something to consider as well; they're open-pollinated, meaning they are true to type and you'll be able to save some seeds from your vegetables at the end of the season and plant them the following year. (If you order only heirlooms, you could theoretically never have to buy seeds again!) Ordering organic seeds means you're supporting organic growers who—unlike conventional producers that use earth-damaging chemical fertilizers, pesticides, and GMOs—are invested in restoring the balance of natural ecosystems.

Make a list of what you want to grow and what you love to eat, then compare it to the amount of space you have. Be ruthless about paring down the list, based on the space each crop requires and how much care it will need. It's better to start small and get more ambitious next season. Many enthusiastic growers get discouraged their first time out when they overplant without realizing the amount of work and maintenance involved. Once your skills, needs, and desires are more defined, you can go all out.

Soil Blocking

Soil blocking is my preferred method of starting seed, not only because no pots or seed trays are involved but because the blocks can be transferred directly into the soil once the seedlings are ready. A soil blocker is a one-, four-, or eight-celled metal soil mold that is used to make firm squares of potting mix that are then seeded. (We primarily use a blocker with four 2-inch-square cells.) The mold is pressed firmly into moist potting soil and compressed into a square with a small dimple in the top of the square for the seed. Seeds grown in soil blocks will not suffer from root binding as can often happen with pots; their roots will go only to the edge of the block and stop (they're smart that way). The outer soil in the block will form a harder crust as it dries, which will keep the block intact.

We start our soil-blocked seedlings in the greenhouse and lay out the blocks in tight rows on repurposed metal restaurant trays (the 18 × 26-inch galvanized baking sheets you see in racks in professional kitchens). We may have ample light for seed starting in our greenhouse in March, but with late winter still lingering outside, our unheated greenhouse barely gets to 50°F, and the soil blocks are even cooler, so the soil must be warmed from below to trick seeds into thinking it's time. There are commercial seed heating mats available, some with thermostats, but they're prohibitively expensive for the square footage of heat you get. Needing more bottom

heat on a budget to aid germination, I've improvised a DIY system that works quite well: The trays are put over runs of gutter heating cable, which brings the soil temperature of the blocks up to around 70°F—ideal for starting most seeds.

If the soil-blocked seedlings begin to get too large for their 2 × 2-inch block, they can be potted up into a larger soil block (made with a bigger blocker), transplanted into a larger 4-inch pot until planting out, or (ideally) planted out directly into the garden after your last frost.

Seed Starting Indoors

Starting seeds indoors is where most home growers begin. Before you invest in the expense of a greenhouse or hoop house, it's important to see if any of this really is for you. Indoor seed starting can happen in all types of containers on a bright windowsill or in an area of the house where you can create favorable growing conditions. To get seeds off to a healthy start, use a soilless seed-starting mix that will retain moisture but drain quickly. You can buy a commercial mix or make your own by combining equal parts of vermiculite, milled sphagnum moss (or good-quality, screened compost), and perlite. Avoid products that contain fertilizers—seeds come prepackaged by nature with their own startup food supply.

Any container that has drainage holes may be used for starting seeds, but professional growers have good reasons for using the familiar 10 × 20-inch plastic flats that fill garden center shelves each spring. The shallow depth of a standard-size flat holds enough growing medium for seedlings to spread their roots while allowing for watering from the bottom. A flat may be filled with seed-starting medium or used to hold cell packs or other individual containers. Seedlings such as squash or melons that may suffer if their roots are disturbed during transplanting may be started in biodegradable pots of peat, coir, or newspaper supported in a flat until it's time for planting out. If you're recycling flats or cell-packs that held previous plant purchases, wash them with warm, soapy water and rinse thoroughly before adding seed-starting mix.

Sow seeds in the moistened mix according to their size and the instructions on the seed packet. Fine-textured seeds may be sprinkled over the surface of a container, while larger ones should be spaced evenly in rows and planted at the recommended depth. Pay attention to light needs: Some seeds require light to germinate and should not be covered, while others germinate only in darkness. Cover small seeds with a sprinkling of dry seed-starting mix (moisten afterward with a spray bottle mister) or with fine sand.

Once seedlings are up, light is essential. A windowsill may seem bright but often is not light enough in the short days of late winter. Fluorescent shop lights are inexpensive and can ensure seedlings get enough light. Hang (or support) lights just a couple inches above seedlings and set a timer to turn them on and off so young plants get a reliable 8 to 10 hours of light per day and a rest at night that ties them in to nature's circadian rhythms of light and dark.

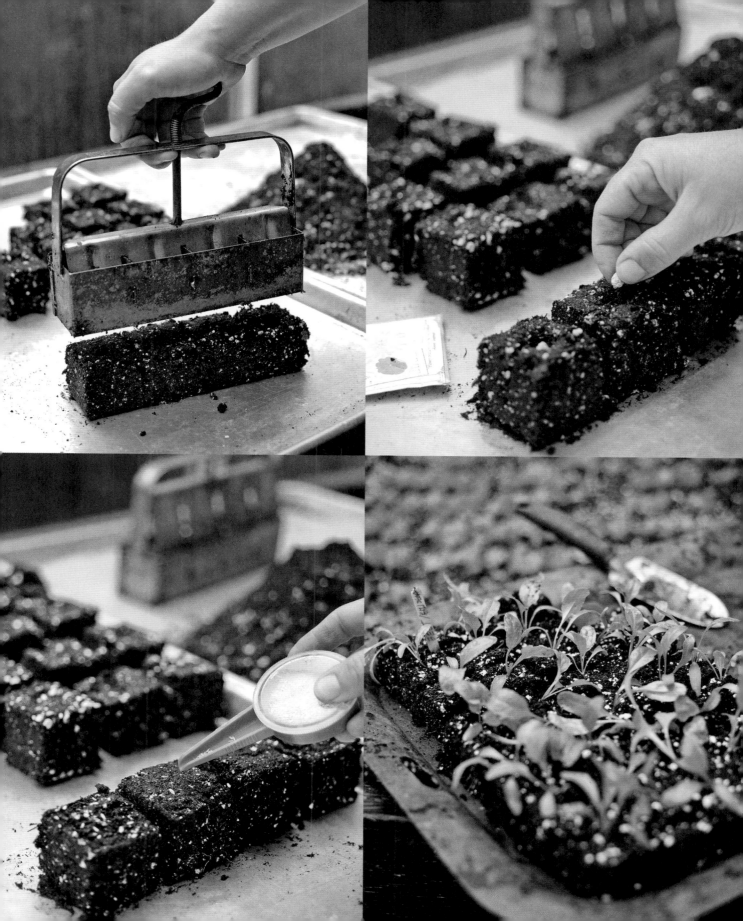

Potential Problems

Seed starting most often fails when the conditions are not right. If flats of newly sown seeds fail to germinate or germinate poorly after a reasonable amount of time, chances are that the seeds' germination requirements were not satisfied or you possibly have some old, expired seed. If you started with fresh seeds from a reliable source, consider if the growing mix was too warm or too cold, if the seeds were covered too deeply, or if the medium dried out. Check the normal germination rate of the crops you're starting—some seeds are naturally finicky (perennials in particular) about sprouting and may come up sparsely even if you do everything just right. Adjust the conditions and try again.

If young seedlings become pale and yellowish or develop any other abnormal color, a lack of nutrients is probably to blame. Add organic liquid fertilizer, diluted to half the recommended strength, to the watering routine no more than once every 1 to 2 weeks. Seedlings will also benefit from a foliar (sprayed) application of half-strength liquid seaweed or fish emulsion, but

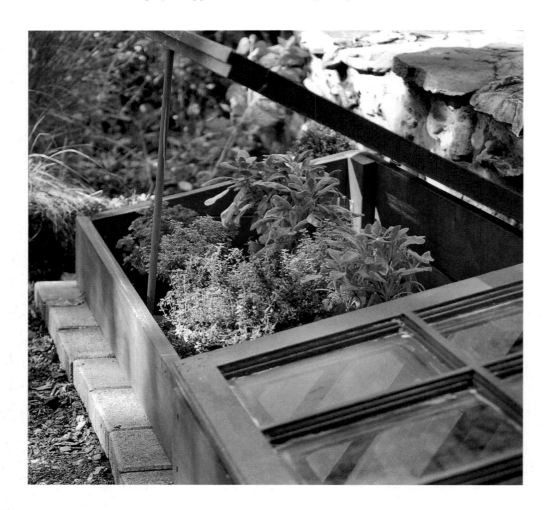

be aware that they'll smell of low tide, so consider whether the location of your seedling flats is a place where this is tolerable or not.

Seedlings that suddenly collapse have fallen prey to damping-off disease, a fungus that occurs in soil and fells apparently healthy seedlings, typically causing them to bend over right at the soil line. Damping-off is soilborne, which is why starting in clean containers with soil-less mix is so important. The disease also thrives in damp, cool conditions where there's little air movement; increasing ventilation with a small fan can help prevent problems, too, as can filling seed-starting containers to the rim so their sides don't block airflow around young stems and leaves.

Seeds want to grow—that's why they're here. They all have the hope of viability in their DNA, wanting that delicious, life-giving cocktail of dirt, water, and light to set them loose upon the world. Your job is only to steward them—they'll take care of the rest.

Coldframes

Coldframes are great season extenders, allowing you to harden off your seedlings earlier in the season and grow plants later in the season as frosts come and go. Hardening off is the process of slowly acclimating seedlings to outdoor conditions. A coldframe is basically a mini greenhouse, often made from rot-resistant lumber, topped with a repurposed window to let light in and with a means of propping the window open during warm days. It's a pretty simple DIY project.

Plants want light, good soil, moisture, and protection from frost, and coldframes will give you all of that, with the added benefit of creating a transitional space for your seedlings when the greenhouse becomes too crowded (and it always does) in late spring.

A coldframe, as its name implies, should be cooler than the greenhouse and allow plants to start acclimating to the outdoors. They are usually built with the front, south-facing edge lower than the back, to minimize shade from the frame itself and to allow water to shed. The glass should be propped up and vented during the warmest days in spring, as direct spring light—unobstructed by a canopy of leaves—can warm up the coldframe interior quickly. Adding hinges to the window frame will allow you to vent the frame during the day and close it at night to reduce convection.

Greenhouses and Hoop Houses

Every gardener dreams of having a greenhouse to grow in. There's nothing like creating your own biosphere of warmth and light that pulses with life during the off-season, when the rest of the growing world lies dormant.

Not only does it extend your season by a few months on either end, giving you a place to start seeds in early spring and continue growing cold-hardy crops into fall and winter, but it also protects higher maintenance plants (like fussy, heat-loving tomatoes) during the season

and allows you to more carefully control and monitor the growing environment. A greenhouse creates a perfect microclimate for you and your seedlings, and while a coldframe is a small step, a greenhouse or hoop house is a giant leap toward becoming a serious grower.

Hoop houses, which come in many sizes and are made from galvanized pipe and translucent polyethylene sheeting, are an economical answer to the expense of a traditional greenhouse. They're relatively easy to construct and take down, require no permanent foundation to be built (usually meaning no permits necessary), and provide most of the benefits of a traditional greenhouse, except for the higher solar heat transfer of glass. Hoop houses are usually constructed using a double layer of UV-resistant, 0.6-millimeter poly film, while commercial greenhouses use a double-walled rigid polycarbonate or double-glazed glass, but they all have a relatively high thermal performance that keeps the warmed air inside the structure from cooling due to convection.

The most economical option, after a hoop house, is a high tunnel, which is a single-walled hooped structure. High tunnels will do a reasonable job of season extension, as will low tunnels, which are a scaled-down version usually made with ¾-inch EMT pipe. There are pipe benders on the market for forming your own hoops, making it simple to create protective row covers for your crops.

The only downsides of hoop houses are that they are vulnerable in high winds or heavy

 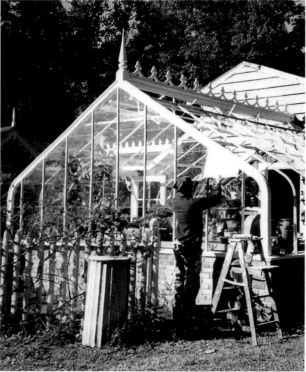

snow loads (they don't have the structural integrity of more permanent structures) and that the polyethylene film degrades over time. They also aren't the most beautiful things, looking a bit like oversize and half-buried plastic barrels, but they have plenty of utility and economy.

If you are resourceful and want a more permanent, eye-pleasing structure for your property (but still don't want to blow your kid's college fund), you can look for a used glass greenhouse on the Internet. These structures are often in disrepair, missing glass, and overrun by neglect, but with enough time and energy, they can be taken apart, salvaged, and restored.

Shortly after I moved in at Stonegate, I uncovered an abandoned greenhouse foundation in the woods that used to be part of the old estate before trees and time ate it up. Its ornate lion's face fountainhead was the only sign of its former grandeur, poking out indignantly beneath a scrap heap of twisted metal and glass. The most salvageable piece was the fountainhead, which I moved (somehow) to a spot on the eastern side of the potting shed, where it sat glaring at me for a few years until someone told me about an old commercial greenhouse nearby that was about to be torn down. I got in touch with the property owner and came to check it out, and there was this forsaken 52-foot Gothic structure from the 1920s, with most of its glass gone and trees and vines growing through the open rafters, but with all the beautiful, original bones intact: scrolled ironwork brackets above the doors, terra-cotta staging tiles, functioning worm gears and venting wheels. I was ecstatic. It took about 3 weeks to salvage enough material for the 18 × 18-foot greenhouse I wanted to build, and another few weeks to rebuild it on-site, but because the old galvanized materials had such integrity and had somehow shrugged off the effects of time, the greenhouse went up like a kit from another time. It's now where the farm gets started—and finishes up—each year.

Before you go through the expense and effort of putting in a greenhouse or hoop house, be sure that your site is appropriate: Water and drainage are essential, as is access to electricity. A greenhouse also wants as much early- and late-season light as possible, so siting it with its gable ends to the east and west means its longest side will be south facing and have the most solar exposure. The only downside here is getting too much heat gain in summer, making venting and shading necessary. We solved that problem at Stonegate by planting two vigorous seedless Concord grape vines outside the foundation wall and then training them under the wall and up into the greenhouse rafters where they shade in summer and—with their roots outdoors—drop their leaves in winter, letting in all the wanted light. Oh, and there's the small delight of those glinting clusters of grapes hanging from the rafters in August: Practical and beautiful meet again.

PLANTING OUT

After allowing your soil-blocked seedlings to harden off for a few days, it's time to transplant them into your beds. Do this on a cloudy day, as the UV light under the open sky is much stronger than anything your plants have experienced under glass, and they'll struggle and go into shock if it's too bright out. Be sure to know the last frost date for your zone and your particular

(continued on page 72)

Heart of Glass

The greenhouse at Stonegate Farm has been transformed this month from a cool, empty glass box to a biosphere of warm green life taken over by the bustle of seed starting.

It's Hope Central for the farm, a strange and wonderful refuge of genetic desire. The greenhouse is where you lay out your floral and vegetal longing in orderly blocks of soil, pinch in an improbable speck of seed, and say your prayers. *Ora pro nobis.*

Ideas incubate as well here: what to interplant this season, how much of this variety to grow, when to start that, how many successions you'll need. You test-plant in coconut coir or start seeds under the cosmic pull of a full moon. You glaze young greens with an emulsion of fish and seaweed and imagine low tide. It's all very seductive, to be inside this small ship of hope, when the gray and cold of late March are still clawing at the glass.

You have time to meditate on what you're doing or what others before you have done. I've been researching biodynamics, for example. Developed by scientist and philosopher Rudolf Steiner in the 1920s, biodynamic farming looks for harmony between earth and sky, among soil, plant, and planet, and tries to score those forces into one resonant voice. This is no easy task, with all the dissonant pressure from pest and fungi acting against organic growing. But these ideas feel right here, and we're doing our lyrical best to sound them out.

Sometimes you just do, without much thought. You pump iTunes through your brain to give rhythm and meter to the monotony of seed starting or hum a sacred dirge when thinning fragile and crowded cotyledons. Then you catch yourself reflecting on the meaning of growing food for yourself and others and why it matters.

This season, with the first expansion of the farm in 5 years, it's a wonderfully crowded house. The cut flowers alone, preening beauties that they are, have laid claim to half the space, while the dozens of new vegetable varieties pack the aisles. Maybe we should crank some Green Day into this glassy mosh pit?

While I was away from the farm this winter, these plans were all virtual, scrawled out in journals and circled in dog-eared seed catalogs. My absence always seems to make the farm grow fonder. Even while winter storms gave us a climatic battering and kept me cursing the gods from far away, I couldn't wait to pick up the farm and start all over again.

But that's just part of why we do this. As gardeners, growers, and microfarmers, we always see things as *we are*, and if we're joyful, hopeful souls, we'll come back, happy to press our wills against the odds. For now, we're in the greenhouse—the glassy, pulsing heart of the farm—and, despite the swirling snow and wind, we're seeing things as we are.

The greenhouse begins to bustle in March, when soil blocks and flats of wheat grass mark the beginning of the season.

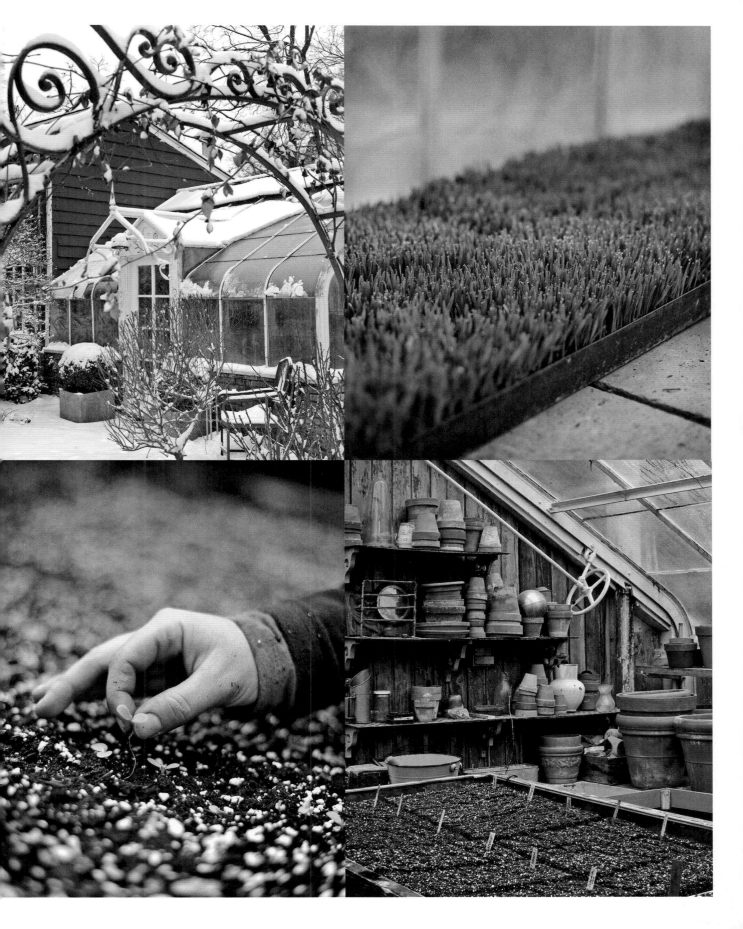

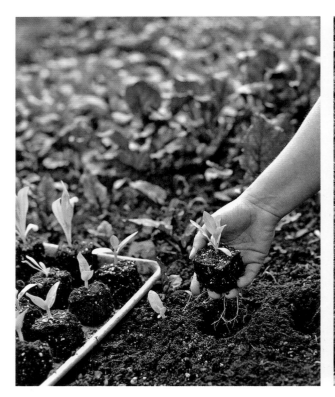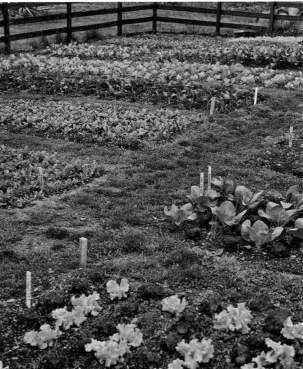

area, so you don't risk losing all of your seedlings in one fatal drop of the mercury. If you've planted out and a late frost is forecast, protect your seedlings with row cover—a double layer if necessary—to keep them insulated, or even a few bedsheets or newspaper, if that's what's available.

To begin planting, mark where each seedling will go. (We use a 5-foot bamboo pole to draw lines in the soil and then punch a hole to mark each planting spot.) It's important to mark out your seedbeds carefully before you plant, reading all of the cultural information on the seed packet about spacing and light. At Stonegate, we tend to plant closer than is suggested and triangulate our plantings so that we maximize space.

If we're planting out kale seedlings, for example, and the suggested distance between plants is 18 inches, we'll draw 5-foot rows in the bed that are perpendicular to its 25-foot length, spacing the rows 1 foot apart and leaving about ½ foot of space at each end. We'll then mark out each of the 24 rows in an alternating 4:3 pattern, so that each plant in a row is occupying the space in between those in the next row. Depending on the plant and its needs, the pattern and spacing changes, but the triangular 1:2 relationship remains constant.

The number of plants needed for each bed can be calculated before you start your seedlings in early spring, but my advice is to always grow more than you think you'll need. (We use our kitchen garden as a kind of dugout for relief seedlings that can be sent in to the farm should they be needed.) In the case of the kale bed, we would need 86 plants on a 4:3 scheme to fill the bed,

but we might seed 100. Seeds are cheap, but the time it takes to start new ones comes with a price.

If your seedlings have been soil blocked, they can now be directly planted in the soil. Because potting mix is a different consistency than garden soil, I always throw a little of it into the planting hole to help the seedling acclimate. I'll use a narrow trowel and make a hole slightly larger than the size of the soil block, add some mix, then water the hole before planting—this will help seedlings coming from the controlled conditions of a greenhouse or grow lights to get comfortable. Once the seedlings are planted, the entire bed is watered.

For the first few days, keep a close eye on your transplants. Water them regularly, and if it gets too sunny and hot and they're looking faint (this can easily happen with lettuce seedlings in spring, as their leaves are thin and transpire quickly), cover them with row cover to reduce the effects of direct light and mitigate transpiration. If they flop at first, don't panic: It's just a bit of transplant shock. They'll usually rally in a few days.

It's not just light and moisture that are different once you move outside, but soil temperature, as well. Early spring greens and brassicas will not complain too much about the cooler ground, but heat lovers like tomatoes, eggplant, and peppers will throw a fit if planted in soil that's too cool. These plants in the Solanaceae, or nightshade, family want soil that's at least 60 degrees, and though ambient temperatures in late spring may reach that point, the soil will be much cooler. We cover our Solanaceae beds with a durable black landscape fabric in early spring that not only absorbs UV light and warms the soil beneath but also suppresses weeds in those beds while still allowing water to permeate. This fabric is kept on during the growing season; you cut slits in the fabric when it's time for seedlings to be planted.

Seed starting—whether in a greenhouse or basement or in soil blocks or seeding trays—will get your growing season off to a great and early start, giving you a reliable sense of what you'll be growing and a kind of anticipatory joy about the season ahead.

Direct Seeding

Though I try to start almost everything I grow in my greenhouse, because it's a predictable, controllable environment, there are some plants that are best planted directly into living soil.

Snap peas are one of the first seeds to go in the garden and tend to be planted in the thawing muck of middle March, followed by cold-hardy brassicas and greens. The usual caveat on a seed packet will be to plant *"as soon as the soil can be worked in early spring,"* which translates to that time when you're no longer crunching through snow in your mukluks or forking over chunks of half-frozen ground.

There are two techniques I use for direct seeding. One is to use a small hand seeder and plant in rows, carefully tapping out the seeds and covering them lightly with soil. The other technique is broadcasting, where an entire 5 × 25-foot bed will be seeded by sowing seed directly from the packet and casting them evenly across a finely raked bed. Once I have an even amount of coverage, I use the back of the rake to very lightly cover the seeds and then water them in.

I have two or three beds each spring that I broadcast with a custom mix of loose-leaf lettuce, mustards, Asian greens, mizuna, and baby brassicas to grow a thick shag carpet of colorful cutting greens. These are harvested with a hand trimmer, which is like a large pair of scissors with a ratcheting handle that rotates 90 degrees. The bed of greens is harvested in sections, moving down its length as needed. Usually, by the time I've reach the last bit, the section from the first harvest has regrown and can be cut again.

I will also direct-seed in between longer-season annuals, particularly with quick, early growers like radishes, baby turnips, loose-leaf lettuce, spinach, and arugula. These will come and go throughout the season as the stalwarts stay put.

Thinning Seedlings

Once your seeds germinate, either under the shelter of a greenhouse or grow lights or outside, they will need to be thinned. You are usually planting more than one seed per cell or soil block as a hedge against spotty germination and planting more seeds per row in the garden than you can possible grow for the same reason. Though every seed is programmed to germinate and grow, not all seeds will develop, and some will just sit there and inexplicably do nothing. So you overplant, and thin, as a form of crop insurance.

In the wild, nature settles the score, and competition is fierce: Plants thrive or falter as conditions allow. On the farm, however, an environment is created to maximize the odds of survival. And as seedlings push their hopeful new leaves up from the dirt, most are quickly dispatched as we thin the beds.

It's one of the most Machiavellian chores on the farm. No matter how careful you are when planting seed, particularly tiny dust-in-the-wind lettuce seed, overseeding is routine. Seedlings that will be allowed to grow to maturity are spared, and competing siblings that have sprouted around them are yanked out with a quick flick of thumb and index finger.

As seeds germinate in soil blocks or trays, they will also need to be reduced to one strong seedling per block or cell. Those that are direct-seeded should be thinned to their proper spacing. The weaker ones can be cut with small scissors just above soil level or carefully removed by hand. Remember that young seedlings have a very slight hold on the soil and that by carelessly removing the culls, you can pull out your chosen ones, as well. This is necessary but time-consuming work, particularly when you're bent forward over densely germinated growing beds or seed trays for hours, delicately plucking out hair-thin growth.

Interplanting

One of the fundamental organizing principles of small-scale farming is to make full use of your growing space. Because you don't have a lot of land, every scratch of dirt is a potential root zone for something edible.

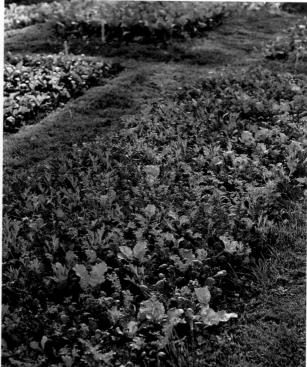

We don't allow a lot of uncultivated dirt at Stonegate. We plant, interplant, succession plant, companion plant. Dirt—exposed and unused—is inefficient. If the natural world were to prevail over the imposition of agriculture, there would be no dirt visible. Every bit of soil would be colonized by something green, seeking a determined chance at life. A walk in the forest will bear witness to that.

The way we interplant diverse vegetables, herbs, and flowers at Stonegate in close, careful proximity means we also moderate soil temperatures, reduce weed pressure, and create relationships and dialogue between species that are mutually beneficial. When tall and leafy eggplants are shading Asian greens and cucumber trellises are sheltering tender arugula, or peppers are keeping a carpet of mesclun happy, I feel as though a true, democratic system is in place, where every plant has a voice. This is the kind of balance and harmony you're after.

When we plant out cabbage in spring, for example, it takes about 2 months to mature, so in the row space parallel to the young seedlings, we'll plant out a deep red 'Lollo Rossa' lettuce as well as purple bunching onions between each plant. This interplanted bed not only makes full and efficient use of growing space, but it is also a beautiful sight: the cool blue green cabbages accented by frilled purple lettuce and sharp spears of onion. The bed becomes a kind of rich, edible tapestry of color and form.

We interplant as often and as diversely as we can, and successions of greens are repeatedly

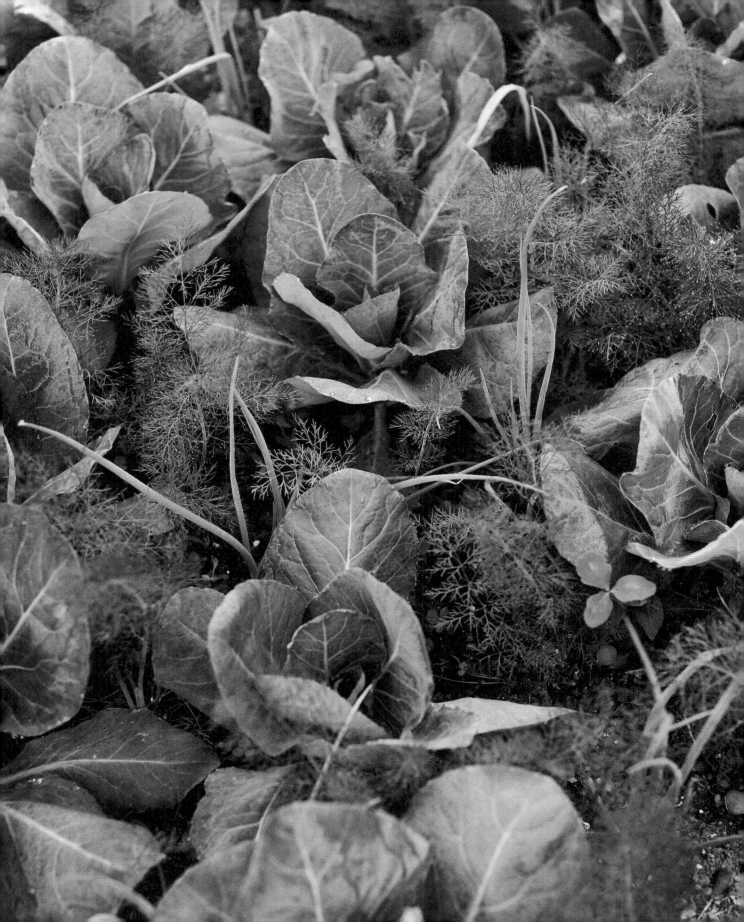

planted or seeded beneath the shading leaves of larger plants throughout the season. Spinach and lettuce are grown under tall umbrellas of kale, for example, where they do well—even midseason—protected from the glare of the sun. Or radishes and Asian greens are tucked under the shade of rainbow-hued chard.

Mixed varieties of a single cultivar can also create stunning combinations when planted together. For example, planting the loose-leaf lettuce 'Red Sails', with its deeply lobed crimson leaves, next to the exuberant lime green frill of 'Black Seeded Simpson' creates an exciting bed of banded, alternating color.

Interplanting asks that you think like plants and figure out what they need culturally in terms of habit of growth, hours of light, soil, and water, and then grow them in the right spot, with the right crowd. But it also allows you to think like an artist and to imagine combinations of plants that are not only beneficial and sensible but beautiful.

It's important to consider not only color, of course, but also form when combining plants. Plain leaf shapes look better next to those that are lobed or serrated; tall, frilly forms ally well with those that are stout; lanky, clambering plants are more defined when growing above an edging of something sprawling and low. In the cut flower farm at Stonegate, these combinations are more obvious, as flower cultivation—and arranging—is all about the right mix, but adding that same sensibility to the rest of your farm and garden will take it to a whole other level. When we started throwing color-saturated edible flowers into our salad mixes—on top of an already vibrant textural mix of greens—they became works of art.

Some of our favorite color combinations using both mixed and single cultivars on the farm include planting frothy bronze fennel in a bed with dusty gray cabbage and purple scallions (left); combining a pole bean like 'Purple Pod' twining on the same trellis with a bright yellow variety like 'Anellino Giallo'; mixing together cherry tomatoes like 'Sun Gold' and 'Black Cherry'; or fronting a trellis of bicolor tomatoes such as 'Striped German' with a purple basil like 'Amethyst'. We have even chosen breeds of chickens for the colors of the eggs they lay, from the deep speckled brown spheres of Cuckoo Marans to the blue green jewels of Ameraucanas; a carton of eggs never looked or tasted so good. Combinations such as these—like perfectly mixed perennial borders in a lovely garden—are what growing beautiful food is all about.

It's a joy to walk through your garden or farm and feel as though you're walking through a thoughtfully curated space—a gallery of vegetables, fruit, and flowers with new exhibitions being put on every few weeks. Your landscape will become a living, nourishing, highly aesthetic environment that will change how you experience and appreciate food.

Succession Planting and Crop Rotation

As with interplanting, succession planting aims to make the most of the space available for growing, while rotation guides the arrangement of crops from one season to the next. Succession planting means that the garden you're tending as frost arrives in the fall looks different

from the one you planted in early spring and possibly even from the one you cared for in mid-summer. Crop rotation means that this year's garden has a different configuration and possibly different crops than last year's.

How much succession planting you're able to do depends on the length of the growing season and the time your plants need to reach maturity. Crops grown in succession tend to be quick-growing plants that reach productive size, are harvested, and then are done. Vegetables that favor cool weather often lead the succession: leaf lettuce, mesclun greens, radishes, scallions, and peas don't mind starting out early in spring, but they sulk in the heat of summer. We succeed cool-season leafy greens with more heat-tolerant Asian greens like bok choy, pak choy, mustards, and mizuna so there's always a salad mix to enjoy—even in the swelter of August.

Rotation to manage fertility is a bit easier, since it deals with shorter time frames. The goal of this type of rotation is to precede nutrient-hungry (typically fruiting) crops like tomatoes, eggplant, and squash with soil-building nitrogen fixers such as peas and beans, and to follow those fruit-bearing plants with leafy crops and light-feeding root crops like carrots and onions. At Stonegate, we grow spring snap peas in beds that will be followed by tomatoes, for example, in order to give the soil a nitrogen fix.

If rotation is truly not possible, and you only have a few beds in your tight growing space that will work for heat- and sun-loving plants, there are a few other things you can do to reduce pressure from pests and disease. Mulching well is a start, as well as watering at ground level to reduce splashing, because bacterial spores and fungi can be easily spread through moisture. Keeping your beds as clean as possible throughout the season is also important, and particularly in fall: removing fallen leaves, stalks, and spent fruit is critical to reducing pressure from overwintering pests and disease.

Because we're not able to rotate as much as we'd like to at Stonegate, we're careful about our cultural practices and not only replenish exhausted soil regularly with compost, minerals, and nutrients but also foliar feed throughout the season with a fish-and-seaweed emulsion that builds strong, healthy plants. Like humans, the healthier the plant, the more resistant it will be.

PROTECTING

Once your seedlings are finally in the ground, settled in for a long season of growth, they're susceptible to attack from all sides and will need reasonable care and protection.

An edible garden or a small farm is an open invitation for critters, pests, and vegetal thugs to crash your delicious, colorful party, and the best bouncers you'll find will be good fences, solid structures, effective traps and barriers, and your own awareness and understanding of the wild and scheming world outside your garden gates. Remember: You build it, and they will come.

Critters

Good fences, of course, make good farms; fences at least 4 feet high, reinforced with welded wire that's either buried a foot below grade or angled like an apron beneath the soil at 90 degrees to the fence line, are very effective. That said, if there's a breach somewhere where a bunny or woodchuck can slither through or dig under, or a raccoon can climb over, they will. Deer can jump most fences under 7 feet, so the best deterrent on a 4- to 5-foot fence is to run a perimeter of 14-gauge wire 2 feet above the fenceline supported with angle iron. Also, if you plant your tomatoes and pole beans on the perimeter, this will help fend them off as well, because deer do not like enclosed spaces or those with an obstructed landing area.

Your fruit and vegetables will need protection besides good fencing from critters like birds, bunnies, woodchucks, squirrels, possums, and raccoons: a wild kingdom of plunderers out to undo all of your small-scale agriculture efforts. Woodchucks (also known as groundhogs) and bunnies, in particular, will raid your greens any chance they get, and a patrol of the fence perimeter every few days to look for breaches is a good idea. Any sign of digging means you've been found out, and once a woodchuck gets a bead on your kale (they love all things brassica), they can wipe it out in one demented binge.

A Havahart trap seems to work best for us, and when we find an ingress through the fence and into our foodshed (and there's usually more than one), that's where the trap goes, unbaited, as a kind of "foyer of regret." (They get as far as the hat rack and the doors slam shut.) A trap set out with bait like greens and peanut butter might work occasionally, but why walk into a wire tunnel when there's a whole garden to ravage? (Thinking like a groundhog is a stretch, but worth the effort.) When they tunnel under your fence with cries of "Once more unto the breach!" you've got it—and them—covered. Bunnies might need a smaller, more sensitive trap, and they tend to slip through fencing, not underneath it; they also nibble and browse, which I can tolerate, versus the seek-and-destroy habits of woodchucks. If the bunnies begin to plague you, you can run a tighter mesh of chicken wire along the lower perimeter of the welded wire.

When I first moved out of the city, where anything four legged and furry that's not on a leash is a plague, the site of scurrying woodchucks was startling. I was told they had to be dealt with swiftly and without mercy, otherwise vast, despotic colonies would form beneath the house, turning foundation walls into grottos and electrical wiring into dental floss. So, wanting to prove my ready-for-rural mettle, I baited and trapped and disposed.

Where you draw the line when deciding what to do with the small, unwelcome souls among us is a personal decision. Is a mouse, rat, or vole (warm-blooded mammals all) any less deserving of a full life of scurrying than its exponentially larger cousins? The line drawn is at best arbitrary—a scratch in sand. It seems moral ambiguity is the only certainty. If you're at your wit's (and cucurbit's) end, you can just go after them in a fury, wielding a hoe like Mr. McGregor on a rage of futility against Peter Rabbit.

In the orchard, where the chickens do roam, we need to protect low-hanging fruit from

their insatiable appetites with black plastic netting. This 14-foot-wide netting is run across the tops of rows of dwarf fruit trees and is cinched at the bottom with 4-inch strands of 14-gauge wire. Not only does this keep the chickens out, but it also hinders other birds and the orchard's nimble archenemy: the squirrel. At Stonegate, the number of large, geriatric trees means plenty of soft wood to nest in and heights to scamper safely to. I've had gangs of acrobatic squirrels pluck every young pear and apple off my trees and bury them for a frozen dessert come January, and the only defense against them has been netting. This hold true for birds, too, who will dispatch with your cherries and plums in short order if they're not protected. Like a good cop, your job as a farmer is to serve and protect your vulnerable plantings.

Insects

Insects will be your most pernicious enemy when growing organically. Their sheer ravenous numbers are enough to demoralize you, and when you've been set upon by a destructive swarm of something or other, you'll understand why there are entire aisles at the box stores dedicated to their demise. Of course, the presence of insects is a balancing act: Too many bad ones and not enough beneficials will skew things.

When you start out, insects will be a minor annoyance, but as you continue to grow in the same spot, they'll soon catch on. We knew we'd been found out in our third year of growing, when we finally met The Beetles. The little beasties began to make a loose veil of my seedling eggplant and potato leaves, rendering tender shoots a skeletal gauze of their former selves. This vegetal crusade against all plants in the Solanaceae family (including potato, eggplant, and tomato) is a fright. The spring-loaded horrors have no organic pest control, except for row cover or kaolin clay early in the season, so you stoop and squish, firmly between forefinger and thumb, until the offending speck is no more. When you're in the process of losing all of your painstakingly grown seedlings to an enemy the size of a pinhead, there's a kind of macabre, control-freaking pleasure in pinching these lacquer-backed bugs to death between your fingers. (This is what farming can do to you.)

There are effective organic strategies for keeping the most destructive insects in check (see Grow beginning on page 86 for plant-specific pest control), but most organic pest management—unlike the toxic soup used in chemical farming—is about physical barriers like row cover, pheromone traps, sticky traps, beneficial insects, and insecticidal soaps and oil sprays. At Stonegate, we use row cover religiously, particularly in spring on new plantings, and we also use a kaolin clay product that we spray on fruits and vegetables as an irritant to insects. My apple, pear, and quince get a ghostlike dusting of this microfine clay, and it gunks up the tiny inter-locking membranes of bugs (think of sand between your joints) and, clogged and bothered, they move on. But as with most organic growing, there's a fair amount of basic, hands-on manage-ment. (There's nothing like a Ball jar full of soapy water and some quick reflexes.)

Occasionally, you'll have a season where the pests seem as though they're all reading from

the Book of Revelations and come at you in obscene numbers. I've been on my property long enough to have witnessed two cycles of 17-year cicadas. These strange creatures, armored and bloody eyed, with a blunt head and cellophane wings, fly about in apocalyptic numbers and wreak havoc on the orchard with their egg-laying wounds. (I have heard my orchard screaming.) The season following a cicada brood always shows some compromise, with berry shrubs and fruit trees having lost productive limbs, but the chickens love the slow-flying protein and scurry about the orchard plucking the cicadas out of midair. There are always winners and losers. The hordes of Japanese beetles that have turned my grapevines to lace, the sawfly larvae that reduced my gooseberries to leafless twigs, and the cucumber and flea beetles that destroy growth without mercy are a loss, but maybe a bit of martyrdom and resignation that—as an organic grower—you can't control it all is good for something?

Weather

Once your tender seedlings have been planted out, freed from the sheltered supervision of grow lights, greenhouses, and coldframes, they'll be under the open sky, where heavy rains, late frosts, or foot-blistering heat can undo most of your patient care.

With the climate swinging so unpredictably back and forth these days, where extreme weather is becoming the new normal, growing food crops—never mind beautiful ones—is a persistent challenge. When I lived in cities, weather meant little more than deciding which umbrella or scarf to grab. But organic farming demands a far less facile relationship; it prescribes that your view is long, that your measure of success is shaped by allowing forces beyond your control to play out, and that you do what you can to protect your plants. You are constantly considering, and talking about, the wiles of weather, with all of its exasperating uncertainty.

We've had weeks at Stonegate, for example, where endless rains and gale-force winds have ripped through the farm with such blustery, sodden force that beds were quickly turned into a slurry of unworkable muck. Newly transplanted seedlings of arugula, bok choy, and mesclun greens have been washed out of their neatly planted rows and sent in a hapless swill toward the Hudson. After rains like these, most often coming just after you've planted your spring or fall greens, the garden will lie as saturated as a sponge mop, the soil giving way like pudding underfoot. Seedlings will whimper and drown as their roots can't breathe, and seeds will just sit there, floating in their hard seed coats, waiting it out.

Farming needs water, of course, but not that much, and not so relentlessly. Sitting on a pretty high aquifer here at Stonegate means that heavy rains tend to percolate up and glaze across the open ground like a tide.

The opposite of too wet is not as bad because you can usually irrigate and water when it gets too hot, but it's pretty challenging to dehydrate once you're in the soup. Our farm has sometimes found itself simmering under such unrelenting, record-breaking heat that lawns, which are never watered, go from supple green to scorched earth in a matter of days, and brittle blades

of grass pierce the tender soles of children as they scamper across it to find relief in the pool.

These sweltering waves send everything on a bender; hens pant in the heat, their beaks slung open like secateurs; bees splash themselves across hives in cooling desperation; greens secretly conspire to bolt. Even the open blossoms of fruiting vegetables, and the promise they represent, can wither like parchment and drop if the heat is too intense for too long. Then, just when you're about to surrender and concede to a season of loss, the rain comes; its cool, wet relief seeming almost surreal. At first, it drums on the bone-dry ground, running and pooling on the surface like mercury before the soil opens up to drink in life-giving gasps.

At the other end of the mercury, a hard winter can be a serious threat to chickens and bees, as well as perennials and fruit in the orchard. Chickens can suffer from frostbite and frozen combs. Fruit trees can incur winter damage that will kill buds and inhibit flowering and fruit, or they may flower early only to have their blossoms dispatched by a late frost. They could also bloom and languish on the branch because the bees they depend on for pollination have perished in the deep cold.

One year, my bees rallied valiantly against a brutal, permafrost winter, but it proved too much for them, and they succumbed. Their stores of honey exhausted and their thousandfold wing beats unable to keep the hive at a survival temperature of 94°F (34°C), they died of exposure and starvation. In December, the hive seemed to be humming along. Bees that were terminally exhausted had flown out and curled up in the snow to die, which they're predisposed to do (I found them scattered like small apostrophes around the hive), and I watched winged undertakers occasionally bringing out their dead near the hive entrance.

All seemed well until mid-January, after a week in the single digits, when the humming and cleaning stopped. When I opened the hive, the honey combs were empty, and I found a tight cluster of lifeless bodies huddled in a sphere around their queen, who seemed to have died on the throne. The bees had needed more protection from the elements, more routine care, and I felt as though I had failed them. Any success in farming is always guarded and qualified, tempered by the humbling reality of caring for living things.

Farming does long for some level of predictability, wanting to be scripted, thought out, and measured. Planning is at its core, and maintenance is the drumbeat. But weather is the big variable. (The USDA Plant Hardiness Zone Map was redrawn in 2012 to adjust for climate change. Should I be ordering seed for kumquats and Ponderosa lemons?) Partnering with weather, as fickle and unpredictable as it is, is always healthier, for plant and person, than railing against it. Planning for the worst season will always ensure you a better one.

Finally, before you dig too deep and plant too much, step back and make sure you're not overreaching early on. The anticipation and thrill of growing is sometimes dulled by the burden of maintenance. To plant successfully, a reasonable plan needs to be put in place: What shall I grow? What do I love to eat? What will taste best ripened in my own backyard? What makes economic sense? How much time do I have? Growing food takes commitment and care, so plant what you love and make that love happen in a few beautiful, manageable beds first.

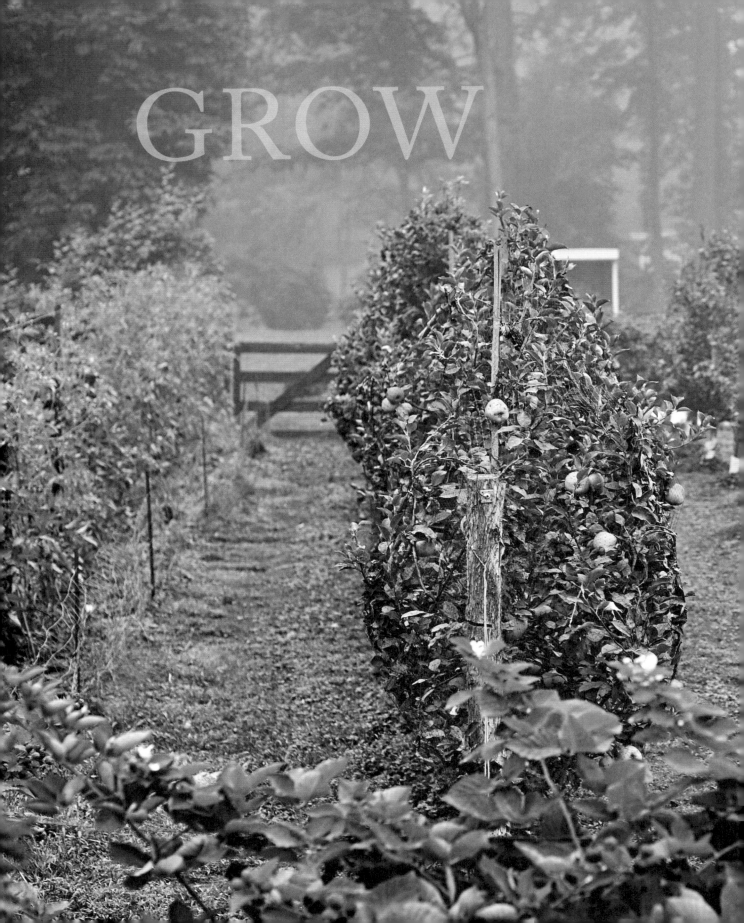

GROW

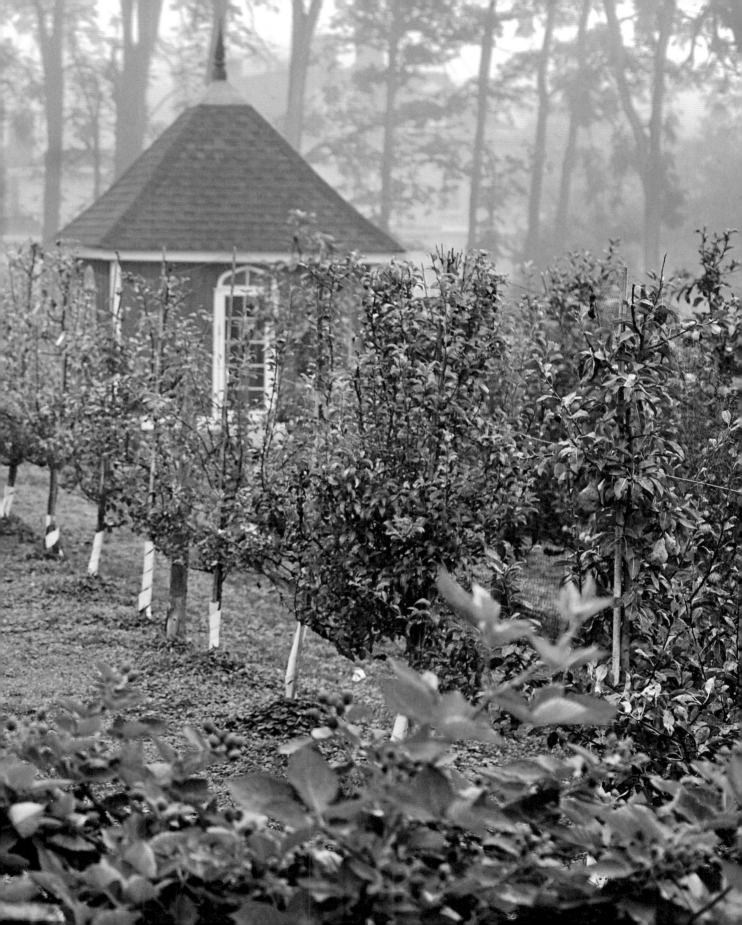

Lettuce, Leaves & Greens

THE CLEAN, CRISP SAVOR OF greens, cut fresh moments before eating, is one of the deep, seasonal delights of the farm and garden. Before I began to grow my own, salads were often a disappointing bother, more about the flavor of the dressing than the delicate texture and taste of the leaves. Brassicas were commonly braised to oblivion, rendering them over-cooked and bitter, while other greens such as chard and bok choy were mere curiosities on a side plate. But once the prodigious world of greens, from the serrated and aromatic to the deeply frizzled and savory, made its presence felt on the farm at Stonegate, there was no turning back. Fresh organic lettuces and greens are what I delight in the most: mixed in complex, beautiful salads, stirred into soups and sautés, or eaten exquisitely fresh and raw out of hand. If I could only grow one thing, this would be it.

Salad greens are some of the easiest vegetables to grow and, with repeat plantings, have the longest harvest season. With their delicious daubs and whorls of burgundy and green, they're also a great opportunity for aesthetic play. When sown in pleated bands or creatively interplanted among neighboring vegetables, they cover a lot of space, hide a lot of dirt, and colorfully weave together the fabric of the farm.

From delicate and tender to fibrous and hearty, greens are packed with vitamins, minerals, fiber, antioxidants, and phytonutrients. Calorie for calorie, dark leafy greens are the most concentrated source of nutrition of any food we eat. And eating them ties you in to your inner herbivore, your grazing primordial past. It wasn't too long ago that greens were our staple diet, and our primate ancestors ate up to 6 pounds of them a day as they browsed the tree canopy. We've sadly fallen off the branch a bit since then, with few of us getting our recommended daily quota, so setting aside enough growing space to celebrate and savor them is vital.

Arugula

Eruca vesicaria subsp. *sativa*

Ah, arugula: Pungent, peppery, and irregularly lobed, this once-misunderstood green is now a garden and market mainstay. Arugula used to be considered a male aphrodisiac, so much so that the Catholic church banned its cultivation in monastic gardens. Now it just turns everyone on. Its spicy tang is a singular flavor unlike anything else in the garden, and it's always great in fresh salads and sautés or chopped into an heirloom tomato salsa.

Site and Soil

Arugula tolerates a wide range of soil conditions but is at its best in a fertile, moist, well-drained situation in full sun to partial shade.

Planting

Sow seeds in early spring or in mid- to late summer for fall-into-winter harvests. Broadcast the tiny seeds over moistened soil and press them in lightly, covering with ¼ inch of fine

soil. Plant more seeds every 2 to 3 weeks throughout the growing season to enjoy a steady supply of fresh leaves. As the weather warms up, sow seeds in the shade of taller garden crops. Arugula is quite cold tolerant and may be grown through winter in a cold-frame or under heavy-duty row covers in many regions.

Growing

Also called rocket, arugula grows rapidly in cool weather and evenly moist soil. Keep the crop well watered to delay bolting. Thin overcrowded seedlings to 4- to 6-inch spacing, snipping off the extras rather than pulling to avoid disturbing the shallow roots of neighboring plants.

Harvesting

Quick growing in favorable conditions, young leaves will be ready to harvest starting about 3 weeks after planting. Gather individual leaves or cut off entire plants just above soil level. Arugula's flavors become sharper when the plants begin to bolt, and its cross-shaped white flowers have a similar, but milder, zest than the leaves, only with a floral finish, and make a pretty addition to salads.

Pests and Diseases

Floating row cover will keep arugula's leaves from being scatter shot with holes by flea beetles but may encourage slugs to seek shelter in the cool, moist conditions beneath the plants. Put ground-level traps filled with beer in place to catch the slimy pests, or lay boards atop moist soil next to the arugula row and police them each morning for slugs clustering on the undersides.

Extraordinary Varieties

'Astro', 'Dragon's Tongue', 'Sylvetta', 'Wasabi'

Asian Greens

Brassica rapa varieties

Asian greens are a go-to staple at the farm for summer salad mixes, when the cool-loving lettuces are sulking in the heat. Their crisp and complex flavors, colors, and textures add diversity to your beds and will keep you in delicious greens through the hottest part of the season. Bunching but not quite heading types include bok choy (also called pac choi, Brassica rapa var. chinensis) and komatsuna (B. rapa var. perviridis). Somewhat looser and leafier are tatsoi (aka spinach or spoon mustard, B. rapa var. narinosa), which produces rosettes of spinachlike rounded leaves on short, crisp stems, and mizuna (B. rapa var. japonica), which produces loose clusters of tender, deeply frilled leaves. These four variations of the same species as turnips and broccoli rabe have mild, mustardy flavors with a hint of deep mineral earthiness and are at home in salads, braised, or added to flavorful dishes.

Site and Soil

Fertile, moist, but well-drained soil serves these greens well, in sunny locations or lightly shaded during the heat of summer.

Planting

Although they're happy in cool weather like other leafy greens, these crops fare far better through the swelter of summer, when lettuce and spinach typically send up their pale flowerstalks as though waving the white flag. Plant from early spring through midsummer, sowing about 1 seed per inch in well-prepared, compost-amended soil and covering with ¼ inch of fine soil. Thin tatsoi and komatsuna to 4 to 6 inches apart; thin bok choy to 8- to 10-inch spacing. Sow in late summer for a cool-weather fall crop. For baby Asian greens, you can blend your own mix and broadcast it across an entire well-prepared bed, raking it in lightly and watering thoroughly. These can be cut young and repeat harvested for salads or braising. Try alternating rows of red and green komatsuna or frilled and lobed bok choy for a decorative effect.

Growing

Maintain even soil moisture to keep these mildly spicy greens from developing fiery flavors. Water with liquid seaweed or fish emulsion every couple weeks to keep them growing rapidly. Bolting signals the end of the line for the leafy yield of these greens, but their flowerstalks and buds may be eaten like broccoli and the bright yellow blossoms tossed into salads and stir-fries.

Harvesting

Gather small leaves for salads when they reach about 3 inches high. Thin these crops by harvesting, removing small leaves and entire plants for fresh use from between others that will grow to full size. For a broadcast planting, shear what's needed, starting from one end of the bed, then return to it a few weeks later when it's regrown.

Pests and Diseases

In general, these crops suffer less from pests such as the loopers and cabbageworms that put the bite on brassicas, but they are not entirely immune. Put row covers in place over young plants and seal the edges to protect them from egg-laying moths, adult root maggot flies, and flea beetles. Pinholes in the leaves mean flea beetles are already active. Be on the lookout for slugs and use traps to catch them before they rasp holes in the greens.

Extraordinary Varieties

Chrysanthemum coronarium greens, 'Dark Purple Mizuna', 'Red Choi' (magenta spreen), 'Red Komatsuna', 'Red Rain', 'Vitamin Green'

Broccoli Rabe

Brassica rapa (Ruvo Group)

For a delicious green that can be sautéed and added to an early or late-season pasta, there's nothing better than broccoli rabe. Also called rapini, it's more closely related to turnips than to the familiar broad green flower heads of its better known, and often unloved, vegetable cousin. Like broccoli, it's grown for its tender stems, leaves, and clusters of buds. Dark green and slightly bitter, broccoli rabe is an Italian staple, and we often sauté it with garlic in olive oil and serve it as a side dish, throw it on pizza or pasta, or let it go to flower and toss the tender yellow blooms into salad.

Site and Soil

Grow broccoli rabe in a sunny spot in compost-amended garden soil that is evenly moist but well drained.

Planting

Cool weather favors broccoli rabe's rather speedy production cycle. Sow seeds in early spring when soil temperatures reach 50°F (10°C). Thin plants to 2 to 3 inches apart. For an extra-early harvest, start seeds indoors along with other brassicas, 10 to 12 weeks before the last spring frost date. Plant seeds for a late harvest in mid- to late summer.

Growing

Steady soil moisture keeps broccoli rabe growing rapidly and keeps leaves and stems tender. Late-season crops will benefit from light shade during hot weather.

Harvesting

You can clip entire plants when buds begin to appear or only trim off what you need and new buds will form. If you let them go to flower, toss the flower heads into salad or decoratively in pasta. Most varieties reach harvest size in about 40 days.

Pests and Diseases

Broccoli rabe's relatively speedy trip from seed to harvest helps it avoid some of the common pests of brassicas, but it may still be bothered by the usual cabbage family pests. Protect transplants from cutworms with collars; use row covers over the young plants to keep root maggot flies and moths from laying eggs that would become root- and leaf-eating pests.

Extraordinary Varieties

'Sessantina Grossa' (early), 'Spring Raab'

Cabbage
Brassica oleracea

Forget everything you know or fear about cabbage, because it's usually fermented to death in sauerkraut or kimchi. When it's grown as locally fresh as your own dirt, this crisp, delicious brassica is not only a bold standout in beds of mixed greens but amazing on the plate, as well. We love it chopped raw into salads, cut into coleslaw, or cooked in savory soups.

Site and Soil

Rich, evenly moist, well-drained soil suits cabbage best, although plants can grow well in sandy or clay soils as long as the ground remains moist without being soggy. Choose a sunny spot for early spring cabbage crops, but consider light or partially shaded locations when planting in midsummer for fall and winter harvests.

Planting

Start cabbage seeds indoors up to 3 months before the last spring frost date. Set out transplants 12 inches apart or direct-sow seeds in the garden 3 to 4 weeks before the last frost date. Thin seedlings to 12-inch spacing. Sow seeds for fall crops in midsummer where they will be shaded by taller crops to keep them cool.

Growing

Amend the soil with compost before planting cabbage and apply additional compost around the bases of plants 3 weeks after planting. Cabbages are heavy feeders and will benefit from foliar applications of liquid seaweed or fish emulsion midway through the growing season. Water regularly to maintain even soil moisture and use mulch to keep the soil moist and to prevent weeds from popping up around cabbage's shallow roots. Uneven watering, particularly abundant moisture following a dry spell, can cause cabbage heads to crack or split; early varieties

tend to be more prone to splitting as they near maturity.

Harvesting

Harvest by cutting just below the bottom leaves when heads are fully formed and feel solid. Smaller heads typically are sweeter and more tender.

Pests and Diseases

It's no coincidence that several pests are known for their affiliation with cabbages: cabbage loopers, imported cabbageworms, and cabbage maggots are just some of the beasties that feast on cabbage. Cultivate garden beds once or twice before planting time to expose cutworms lurking in the soil to hungry birds. Put floating row covers in place over transplants to protect them from moths laying eggs that become very hungry cabbage-eating caterpillars. Secure the edges of the covers by weighting them down with boards or stones or burying them in the soil to keep moths from slipping underneath. Row covers also block access by cabbage root maggots and flea beetles.

Steer clear of disease problems by choosing resistant varieties and moving cabbage family crops to different spots from year to year. Good growing conditions are the best way to avoid the diseases common to cabbage family crops.

Extraordinary Varieties

Choose varieties that are suited to the season to minimize problems resulting from exposure to high temperatures. Even so, in places where temperatures rise quickly in early summer, varieties sown in midsummer for harvesting in fall perform better than early spring cabbage crops. Mini cabbage varieties like 'Caraflex' produce solid 4- to 6-inch-diameter heads that reach maturity earlier than full-size types. Other excellent varieties include 'Deadon' (beautiful red and green savoy type), 'Farao' (early), and 'Red Express' (early red).

Raw

The growing season has begun its slow and certain ebb from the farm, and in an almost absurd panic to inhale as much green as possible before a winter of chlorophyll privation, I find myself grazing in the beds like a ruminant. Not on all fours, mind you. More like a vegan biped with opposable thumbs.

I'm in among the greens in the late afternoon, and after picking out the last stubborn weeds of the season and straightening out rows where soil had spilled onto sod, I begin to forage.

I eat the tender inner blades of 'Toscano' kale right off their ungainly, palm tree–like stalks. Their leathery, astringent flavor is full of life, albeit challenging. I feel like I'm chewing tobacco. If a spittoon were within sight, or a dugout, I might take aim. Instead, I opt for a stalk of rainbow chard. It's crisp and nutty and mild and puts me back in neutral.

I pull the last of the pole beans from their top-heavy tangle of vines. The sweet snap of flavor is delicious and fun, almost unseemly. Soon I've turned the trellis inside out to get at every tender pod. Only an encounter with raw mustard greens sobers me up. Mustards are heat all the way through, from tongue tip to epiglottis. They are the swaggering habaneros of the leaf world.

I grab some of the last 'Sun Gold' cherry tomatoes to put out the blaze. Their boundless growth has been checked by the cold, so the heat-sweetened flavor is only a suggestion now. I end the forage with arugula and nasturtium, both with their own take on savory: Arugula has a warm, peppery intensity, while nasturtium's heat is more complex and perfumed, like the foreign language version of a savory, where you need subtitles to understand why on earth you're eating a flower.

Eating raw is as intimate as you can get between plant and palate. And it's the healthiest diet out there. Cooking destroys most of a plant's vital phytonutrients and enzymes, all necessary to maintain health, fight chronic disease, and reduce cancer risk. There's also nothing quite as magical as eating straight off the vine, stem, or stalk.

This close affinity with the food you eat is one of the true pleasures of farming. Only by taking it all off and farming in the altogether could I get any closer to my foodshed. In fact, my wife and I were advised to do just that when we started growing here, as a way to determine microclimates of warmth and cold with our own thermally sensitive parts. For those of you eating our food, you'll be pleased to know we never did take on the Book of Genesis approach to horticulture.

This kind of raw grazing is a fleeting grace in fall. Soon, only the stalwart brassicas and those greens given protection from frost with a row cover will be left standing.

When winter starts to seem like a bleak eternity, this moment of heightened intimacy on the farm, when you're eating as fresh and local as possible, will be safe in your memory bank, ready for an off-season withdrawal.

Towering stalks of sweet fall snap peas are a hand-to-mouth favorite when grazing on the farm.

Chard

Beta vulgaris (Cicla Group)

With its glossy, creased leaves that are as colorful and translucent as stained glass, chard is a standout in the vegetable bed for its beauty alone. A cousin of the beet, chard is nearly as nutrient dense as its more famous relative, spinach, but is much sexier. Leaf blades rise up on crisp stalks in white, pink, golden yellow, purple, or ruby red, forming vase-shaped plants that may reach 2 feet tall. They can be interplanted with other greens for even more color.

Site and Soil

Moist, fertile, well-drained soil in a sunny spot will provide chard with the conditions it needs for healthy, vigorous growth. Amend the bed with compost prior to planting.

Planting

Plant chard seeds ½ inch deep and 1 to 2 inches apart in the garden around the time of the last spring frost date. Although it grows well in cool conditions, chard is more heat tolerant than many greens. Thin young plants to 8 inches apart to give them room to reach their prime. You can also sow succession plantings throughout the summer and early fall. The tender young blades add color and crunch to salads.

Growing

Keep chard evenly moist and water it with liquid seaweed or fish emulsion when the plants reach about 6 inches high. Apply mulch to conserve soil moisture and keep things cool, or grow a companionable living mulch of leaf lettuce, arugula, or Asian greens in the shadows of chard's tall leaves.

Harvesting

Pick outer leaves as they reach usable size, once plants are 6 to 8 inches tall. Young, tender leaves are best for salads. Cook larger leaves and leaf stalks much as you would spinach, in soups and sautés. Separated from the leaves, chard's colorful stems may be cooked and eaten like asparagus.

Pests and Diseases

Leaf miners, the larvae of various fly species, may tunnel into the leaves of spring-sown chard, creating winding or blotchy pale patches of damaged tissue. Injury tends to be most noticeable on early plantings because the pests become active when plants are still young. In northern gardens, leaf miners are most troublesome in spring and early summer; in the South, populations increase and cause more damage as summer progresses. Cultivate the soil before planting in spring to bury overwintering leaf miner pupae. Put row covers in place over early spring crops to block egg-laying adult flies. Row covers will also keep shiny black flea beetles from biting holes in chard leaves.

Extraordinary Varieties

'Bright Lights', 'Golden Sunrise', 'Peppermint', 'Rhubarb'

Kale

Brassica oleracea
(Acephala Group)

Pound for pound (and by season's end, it can feel that way!), kale is one of the most nutrient-rich greens on the planet, loaded with antioxidants, anti-inflammatory nutrients, and cancer-fighting glucosinolates. If I were limited on space, this would be the one green besides lettuces that would be planted and savored. It's delicious in stir-fries and frittatas, over pasta, as baby greens in a salad mix, or as a base for green smoothies. We grow several varieties at Stonegate, including lacinato (or dinosaur), a frilled 'Scarlet', and a purple/lacinato cross. Its long harvest season means you'll be gathering leaves even after snowfall, when its starches delicately sweeten.

Site and Soil

Kale grows quickly in a sunny spot where the soil has been well amended with compost. Cool conditions suit it best, along with moist but well-drained soil. As the temperature climbs, kale benefits from light or partial shade, and evenly moist soil is key to keeping the leaves from becoming tough and bitter.

Planting

For an early crop, start seeds indoors along with other brassicas, up to 3 months before the last spring frost. Kale and other brassicas tolerate cool growing conditions, but seed germination is best when the soil temperature is around 75°F (24°C). Set transplants or direct-sow seeds in the garden 3 to 4 weeks before the last frost. Plant seeds in midsummer, 10 to 12 weeks before frost is expected in fall, for a crop that will produce into early winter. For full-size plants, thin to about 1 foot apart, or triangulate them in alternating rows of three and four plants per row.

Growing

Nutrient-rich leafy greens start with nutrient-rich soil and a steady supply of moisture. Side-dress kale with compost and foliar feed with liquid seaweed or fish emulsion throughout the season. Mulch with straw to keep the soil moist, and interplant with short-season greens to keep down weeds and make use of the available soil. These are tall plants and won't struggle with greens around their ankles.

Harvesting

Begin gathering young leaves about a month after planting, snipping them from the outside of the plant near the bottom. Smaller, younger leaves can be added to salad, while the older leaves are best cooked. We eat them, stems and all, chopping them finely or throwing them in a high-performance blender. It's best to harvest only the leaves, as opposed to the whole plant, as it will keep producing for many months. By season's end, you'll have a bed of lanky, palm tree–like plants that will carry on after frost.

Pests and Diseases

Kale is less bothered by the usual pests—cabbage loopers and other "worms"—than other brassicas, but it still benefits from protection to keep its leaves from being riddled with holes. Cover spring transplants with floating row cover and seal the edges—don't just tack them down—with bricks or by laying a board over them to keep egg-laying moths from getting to the plants. If other cabbage family crops are in your garden, many of the wormy pests will go for those instead of the kale, but keep an eye out for equal-opportunity aphids and slugs.

Kale is not particularly prone to diseases but should be rotated—like all brassicas—with other plant families to prevent problems from gaining a foothold. Extended cool, wet weather can favor downy mildew. Infected leaves turn yellow and develop whitish or grayish coatings. Remove and discard infected leaves and avoid working amid plants while they're wet. Take out whole plants that are severely affected.

Extraordinary Varieties

'Lacinato Rainbow', 'Scarlet', 'Red Russian' (*B. napus*), 'Toscano'

Lettuce

Lactuca sativa

Lettuce from the farm is what I miss most during the dark, chlorophyll-deprived days of winter, so it's one of the first things I seed in early spring. The variety of cultivars available for the home farm and garden is staggering. From flat or frilled to mesclun mixes, loose leaf, or butterhead, they have a place at every meal. And the lettuces themselves are just the beginning: Add the beauty of edible flowers and orchard fruit, and a salad becomes more of a celebration.

Site and Soil

Lettuce and other greens will grow in a wide range of conditions, including poor, sandy soils, and are among the most shade-tolerant crops. Even moisture supports healthy growth, but drainage is critical to prevent soggy soil that promotes disease problems. Most lettuces perform best in the cool weather of spring and fall, but some have been developed to withstand summer heat and others are hardy enough to grow all winter long in a sheltered spot or cold frame. We swap out Asian greens for many of our salad mixes when it begins to swelter, as they're more heat tolerant.

Planting

We plant loose-leaf lettuces in short rows perpendicular to the length of the bed, about 6 to 8 inches apart, using a small hand seeder. The tightness of the rows means that we get more lettuce out of each planting, and as they grow, they shade out the weed-conspiring soil between them. Because the outer leaves are repeatedly harvested, they stay compact and neighborly. Lettuces are happier in the shade during the blaze of midsummer, so we interplant many of our midseason lettuce crops between long-season annuals such as peppers, eggplant, or kale and chard and let the larger-leaved plants shade the lettuce when they need it most.

Because lettuce is so decorative, we often plant in bands of neon green and deep burgundy, and we make distinct aesthetic decisions about the color and form of a leaf and its complement in the bed. (A deeply frilled, purple 'Lollo Rossa' lettuce planted among gray green 'Caraflex' cabbage is truly gorgeous.)

The mesclun planting mixes we make, which include loose-leaf lettuces, Asian greens, mustards, arugula, and baby chard, are broadcast across an entire 100-square-foot bed, lightly raked in (not too deeply, as lettuce seeds need light for germination), and watered regularly and evenly. The dense, almost psychedelic shag carpet of delicious greens that emerges can be repeat-harvested over several weeks.

For head lettuces, start them indoors 4 to 6 weeks before your last frost date, making three small plantings at weekly intervals. At the same time, direct-sow leaf lettuce outdoors at 2-week intervals. Seeds will germinate in soil temperatures as low as 40°F (4°C), but be sure to choose cold-tolerant cultivars for early spring planting. As the weather warms up, switch to heat-resistant cultivars to replace the spring crops that have been harvested. In midsummer, make successive plantings of head or romaine lettuces, sowing the seeds in shady spots for harvesting into fall.

Growing

Lettuce is 90 to 95 percent water and has shallow roots, so keep the soil surface moist but not soggy. Plants need at least 1 inch of water per week from either rain or irrigation. Water on sunny mornings to minimize disease problems that can happen when the leaves stay wet overnight. Add compost around the bases of the plants and foliar feed with an organic fish emulsion or seaweed fertilizer.

Harvesting

Harvest the outer leaves of loose-leaf lettuce in the morning, when the plants are moist and crisp, or just before making a salad mix for the table. Beds of mesclun greens can be harvested with a horizontal shear, starting on one end and continuing along to the other, allowing the first cut to regrow over a few weeks before the next cut. Head lettuces should be harvested soon after the heads form. Cut heads off just below the bottom leaves or pull them out by the roots. Because lettuces lose almost half of their nutrient value a few days after harvest, try to eat them as fresh as possible (this is why you're growing your own, after all).

Pests and Diseases

Healthy, well-grown lettuce is reasonably trouble free, but a few beasties, such as cutworms and aphids, may turn up among the leaves. Aphids may cluster on the undersides of leaves or in the centers of head lettuces. Watch for curled, stunted plants that indicate their presence. Wash the aphids off plants with a strong spray of water.

Extraordinary Varieties

Once you've considered their cultural requirements, days to germination, and type, choose the most beautiful varieties possible and plan ahead for how you will artfully combine them in your planting scheme. A gorgeous lettuce is just as easy to grow as a humdrum one.

Loose Leaf: 'Black Seeded Simpson', 'Dark Lollo Rossa', 'Flashy Trout Back', 'Red Sails', 'Red Salad Bowl', 'Salad Bowl'

Head Lettuce: 'Skyhooks' (butterhead/Boston), 'Cherokee' and 'Mottistone' (French or summer crisp/Batavian), 'Breen' and 'Flashy Trout Back' (romaine/cos)

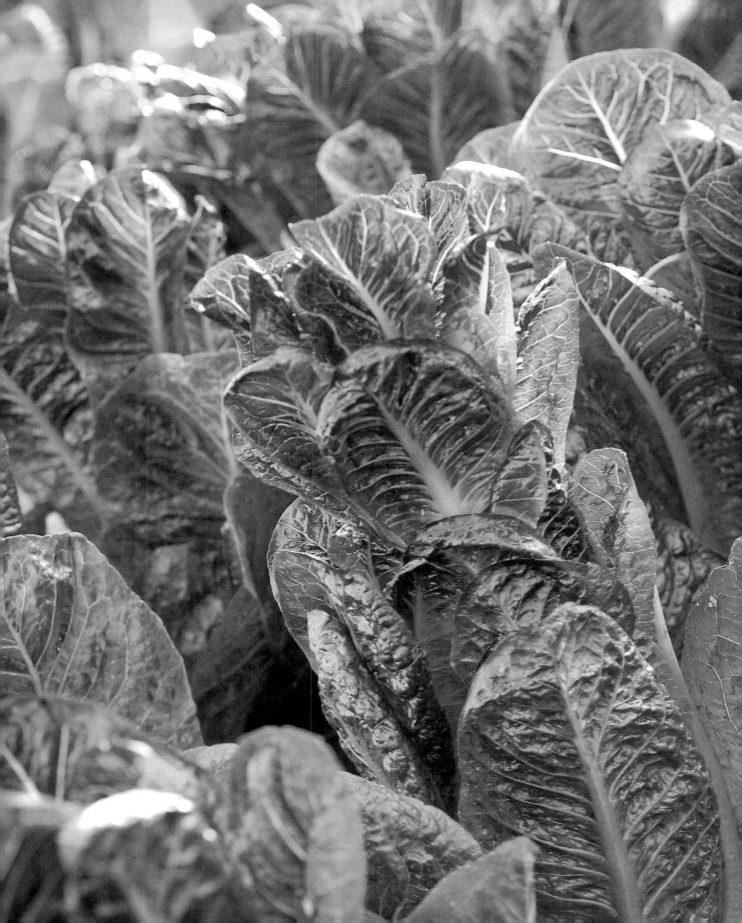

Mustard

Brassica juncea

Mustard is the four-alarm king of greens, adding deep and intense heat to salads, mesclun mixes, and stir-fries. Available in shades of dark burgundy and frilled or flat leaved, it's also beautiful planted in with other leafy greens. Flavors intensify as the plants age, so young leaves are best for salad, but older plants can be left to flower into delicious neon yellow blooms.

Site and Soil

Full sun and rich, moist, well-drained soil are what mustard needs to produce a healthy crop of flavorful leaves. Amend the site with compost before planting.

Planting

Sow mustard seeds about 4 weeks before the last spring frost date. In late summer, plant seeds of cold-tolerant varieties for a fall harvest. In mild winter areas or in a coldframe or unheated greenhouse, plant seeds in fall for production during the winter months. Broadcast seeds over wide rows for harvesting young leaves; thin plants to 12 to 24 inches apart if they will grow to full size.

Growing

Seeds sown in summer will benefit from light shade during hot weather. Maintain even soil moisture to keep leaves tender and not too peppery and to forestall bolting. Water every 2 weeks with dilute liquid seaweed or fish emulsion.

Harvesting

Harvest young leaves when they are about 3 inches long, picking from the outside of the plant or shearing off the entire row or bed. Cut full-size plants from spring crops before hot weather prompts bolting; harvest late-season mustards after cool weather—even a light frost or two—has mellowed their flavor. Once plants send up flowerstalks, the leaves become bitter tasting, but you can snip off the flowers to add color and flavor to salads.

Pests and Diseases

The pests that trouble other cabbage family crops will also feast on mustard. Put row covers in place over transplants and seedbeds to block access by root maggot flies, flea beetles, and the adult moths looking to deliver eggs that will hatch into leaf-eating caterpillars. Rotating brassicas to avoid overwintering pests and good garden cleanup in fall both help to keep mustard leaves pest free.

Extraordinary Varieties

'Golden Frills', 'Red Giant', 'Ruby Streaks', 'Scarlet Frills'

Spinach
Spinacia oleracea

Almost as nutritionally rich as kale, spinach brings a host of health benefits to the table, including vitamin A for eye and skin health and plenty of iron, fiber, and folate. It can be easily interplanted among longer-season annuals in spring and fall.

Site and Soil

Cool, moist conditions suit spinach well. It grows best in full sun but benefits from light shade when temperatures climb. Spinach grows well in a wide range of soil conditions from sandy—where it grows quickly—to heavy loam, which produces the greatest yields. Even moisture and good drainage are important, as is near-neutral soil pH; spinach grows poorly in very acidic soil. Amend the soil with compost and a nitrogen source such as bloodmeal or alfalfa meal to meet spinach's feeding needs.

Planting

Plant spinach as soon as the soil can be worked in spring, up to 6 weeks before the last frost date, sowing seeds 2 inches apart and ½ inch deep. Make successive plantings every 2 to 3 weeks until daytime temperatures remain above 75°F (24°C). Spinach sown in late spring and early summer will benefit from growing in the shade cast by taller crops in the garden. Start planting again in fall 1 to 2 weeks before the expected first frost date. With the protection of a coldframe or heavyweight row covers, spinach may be kept growing all winter in many areas.

Growing

Once plants have at least two true leaves, thin them to 4 to 6 inches apart. Crowded plants are less productive and more prone to bolting. Maintain even soil moisture and water or foliar feed with liquid seaweed or fish emulsion when the plants have four true leaves.

Cultivating or pulling weeds around spinach can damage the roots; use mulch to keep the soil moist and suppress weeds.

Harvesting

Cut baby spinach at 3 to 5 weeks or pick leaves from the outsides of plants as they reach useful size. Harvest entire plants by cutting off at ground level at the first sign of bolting.

Pests and Diseases

In wet weather, downy mildew may affect spinach. Remove infected leaves and stay out of the spinach patch when it's wet to avoid spreading disease spores. Choose varieties with resistance to this common spinach disease. Leaf miners like spinach as much as they do chard and beet greens but are less likely to trouble the crop in cool early spring. Put row covers in place to block leaf miners and flea beetles on spinach sown as things warm up. Use traps to put a stop to slimy slugs that munch on spinach, and encourage toads and other slug foes to frequent the garden.

Extraordinary Varieties

'Flamingo', 'Red Kitten', 'Space', 'Tyee'

Some Assembly Required

Late spring harvests at Stonegate Farm begin early in the morning, when the tender salad greens are cool and moist and the edible blossoms are barely open.

It's a rude awakening for them, still lost in their chlorophyll dreams, to be abruptly sheared from sleep, but this is the moment for spring greens at the farm, before summer heat sends them into a feverish bolt.

When the season winds down months from now, it's these salad days I'll miss most.

Creating a great salad is usually a symphonic act, with texture, color, form, and taste all playing their parts. But at Stonegate, we play it more like jazz, where the rules are thrown out and the notes and harmonies are improvised. A salad should be a delight in the mouth, with plenty of seductive leaf feel and flavor variation. That means enough range, complexity, heat, and texture to reach that fabulous and elusive "I'll have what she's having" climax in the mouth.

One favorite lettuce mix, for example, is a combination of smooth, neon green 'Simpson', the loose and mottled leaves of 'Red Sails', and the firm, crimped frill of purple 'Lollo Rossa'. Throw in sprays of golden broccoli rabe blossoms and the tangy blue florets of garlic chives and the music really begins.

I used to have a somewhat ambivalent relationship with salad until I started growing my own. It all seemed pretty bland unless it was dolled up with a strong vinaigrette or a good and goaty chèvre. But now I could happily live on the farm's mixed greens alone, with their subtle and complex flavors and forms. And the edible flowers take the whole leafy harvest to eleven. Flowers from mustard and arugula are hot and floral, while chive and broccoli blossoms subtly allude to the parent plant. Plus, they're so damn pretty!

Taste alone is argument enough to eat local and organic greens, but when you factor in the short half-life of lettuce—that once harvested, they lose 50 percent of their nutritional value, or half of their vitamins, minerals and enzymes, in the first 24 hours—it makes a week-old lettuce harvest from Salinas, California, seem like a cruel proxy for the real deal.

Like tomatoes, until you've had just-cut organic salad greens, you haven't had salad at all.

Each week in season, the blends are different depending on what's harvestable. Mesclun and mustards added to the mix will bring on the heat, bok choy will fill the midsummer gap when lettuce sulks, and edible flowers such as nasturtium, calendula, and borage will bring some bling to both the eye and mouth.

The organic greens at Stonegate are decadently flavorful, colorful, nutritious, and downright seductive, which—all sustainability arguments aside—is why we're here.

A spring salad of mixed loose-leaf lettuces and mustard greens tossed with broccoli rabe and chive blossoms.

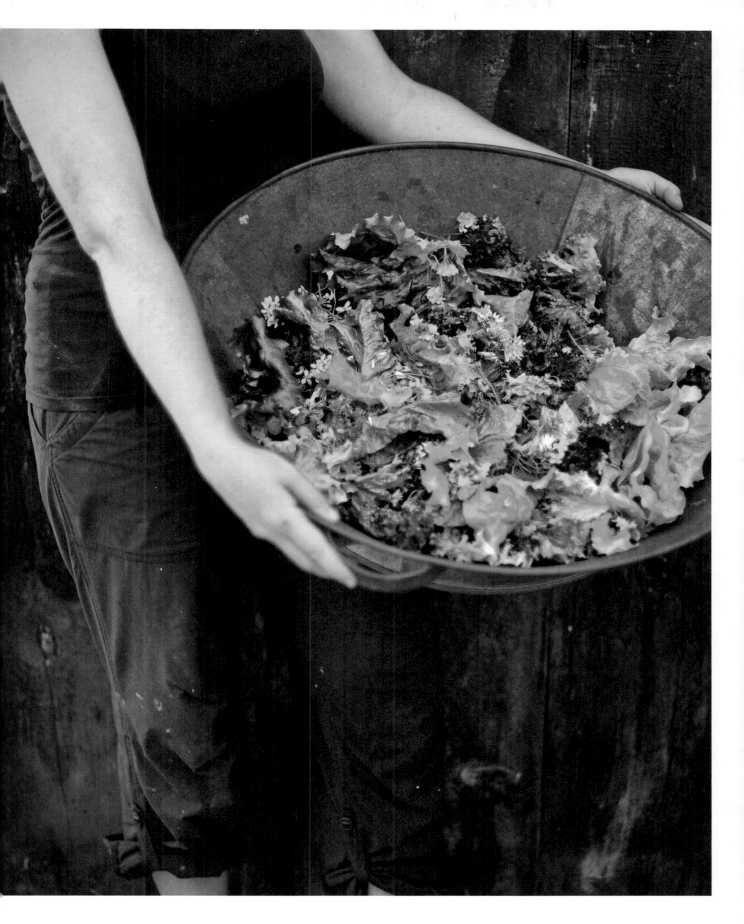

Pods, Vines & Fruiting Vegetables

FOR MANY, THESE ARE THE celebrities of the vegetable world, and we wait for them like stalking paparazzi, harvest shears at the ready. They have such star power, in fact, that they are the number one reason people get into growing their own food. When they ripen into glimmering moons and spheres on sprawling, orbital vines, we pounce.

Peppers, eggplant, and tomatoes, all members of a plant family (Solonacea) that includes more than 2,700 species, seduce us hopelessly with their flavor and form, while the skyward reach of pole beans and the lustrous tangle of snap peas, crisp cucumbers, and summer squash add to the exuberant show.

By growing your own fruiting vegetables, you not only get to delight in all the sun-ripened flavor, but your varietal choices and nutritional values are also sizably boosted. In fact, most tomatoes that are harvested green, gassed with ethylene, and shipped thousands of miles not only have the texture and flavor of wet cardboard, but this premature harvest limits the fruit's full nutrient potential, as well. Studies have shown that vine-ripened tomatoes and peppers have 30 percent more vitamin C and contain far more antioxidant beta-carotene and lycopene.

Never mind all the arguments for nutrient value and lack of petrochemical meddling: Organic, farm-grown fruiting vegetables are a mouthwatering joy.

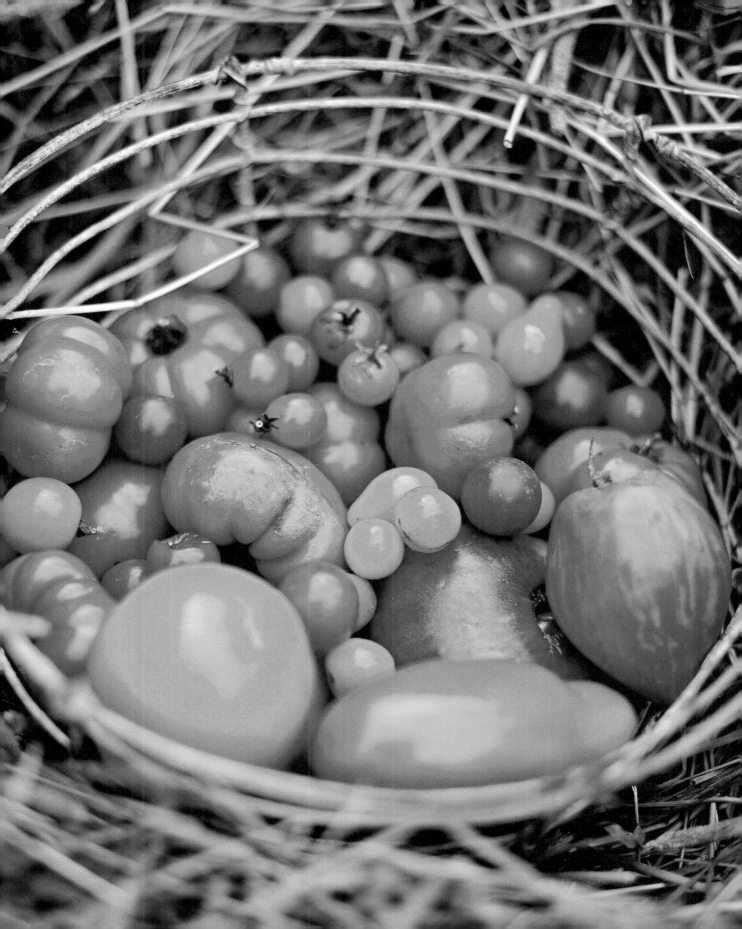

Cucumber

Cucumis sativus

Once you start growing your own cukes, with all the delightful shapes and colors available from seed, the supermarket standard just won't do. With the long twists of 'Striped Armenian', globes of yellow 'Lemon', miniature alien-looking whites, spiky Asian, and smooth seedless varieties, cucumbers have come into their own, rivaling summer squash for their varied forms, flavors, and—most important—garden space.

Site and Soil

Cucumbers need lots of sunshine and rich, moist, but well-drained soil.

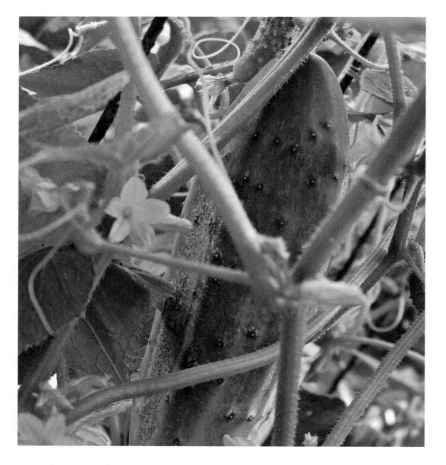

Planting

Warm soil (70°F/21°C) is essential for starting cucumber seeds; seeds will not germinate in soil temperatures below 50°F (10°C). Cucumbers are very frost sensitive and will struggle in prolonged cool conditions. Plant seeds in warm soil at least 1 week after the last frost date, sowing 1 to 2 inches deep in hills of soil mounded a few inches high. Space hills of standard cukes 2 feet apart; 3 feet for bush varieties. Start seeds indoors 2 to 3 weeks before the last frost date for an earlier start, but use biodegradable pots to avoid disturbing roots at transplanting.

Growing

To keep cucumber vines from gobbling up garden space, put trellises in place at planting time. Use fabric strips or other soft ties to train tender vines to supports. Trellising makes harvesting easier, keeps fruits cleaner, and reduces disease problems. Hand-weed around cucumbers to avoid root disturbance, and mulch well after plants are up to keep the soil moist. Water when needed to keep the soil from drying out; even moisture is critical during fruit development.

Harvesting

Keep up with picking once cukes begin to reach full size. Mature fruits that remain on the vines will prevent others from developing. Harvest daily, snipping or twisting gently to avoid damaging the vines.

Pests and Diseases

Be on the lookout for cucumber beetles, troublesome pests of cukes and other vine crops. Yellow green and either striped or spotted with black, these ¼-inch-long beetles munch on leaves, vines, and blossoms and spread diseases. Put row covers over young plants to block beetles' access; remove covers when plants begin blooming to let pollinators work. Patrol plants daily and handpick and destroy beetles.

Rotate cucumbers and other vine crops to minimize disease problems. Clean up residues at the end of the growing season to get rid of overwintering pests and pathogens. Choose varieties with resistance to the most common diseases in your area.

Recommended Varieties

'Lemon', 'Miniature White', 'Northern Pickling', 'Poona Kheera', 'Striped Armenian'

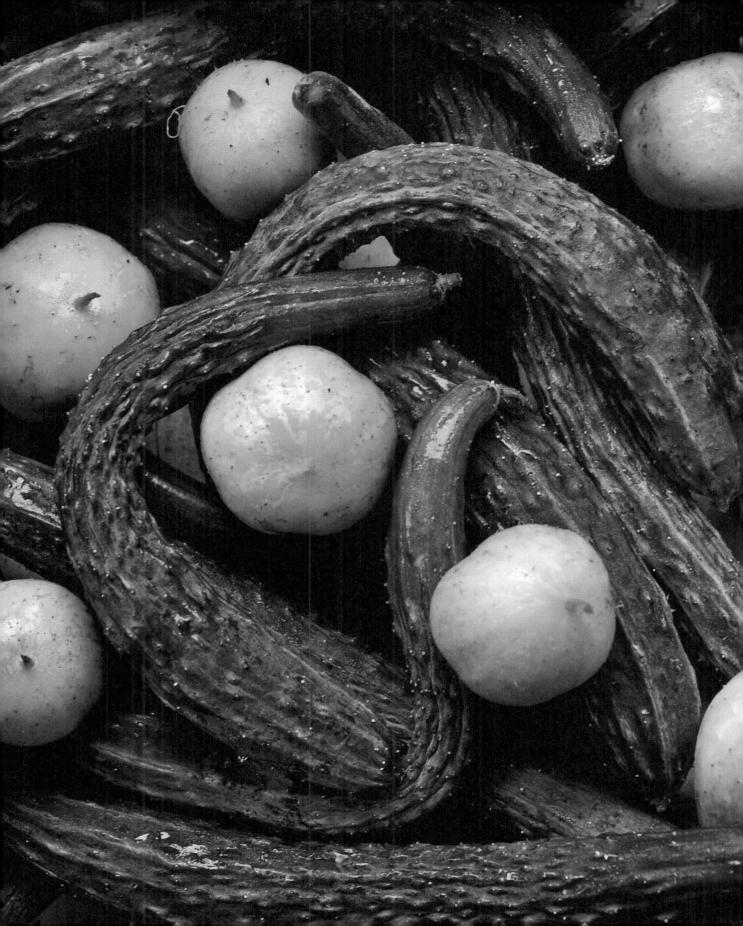

Eggplant

Solanum melongena

When eggplant's delicate, five-pointed flowers finally transform themselves into spheres of glossy-skinned fruit, it's a moment to savor, both for the eyes and palate. These tropical plants were named after mostly white 19th-century cultivars that resembled goose eggs. Today's varieties range far wider in form, from long mauve-colored Asian cultivars to festively striped purples, greens, and deeply warm blacks. They need plenty of heat to ripen to perfection but will reward you with delicious, tender white flesh that will add volume and flavor to countless dishes.

Site and Soil

Choose a sunny site for warmth-loving eggplants where the soil is loose, reasonably fertile, and well drained. Eggplant tolerates a range of conditions but will fare poorly in soggy, dense soil. Dig in compost before planting to improve texture and add nutrients.

Planting

Start eggplant seeds indoors 6 to 9 weeks before the last spring frost date. Soak the seeds overnight in room-temperature water to encourage germination, and use bottom heat to warm the growing medium to 80° to 90°F (27° to 32°C). In warm, moist conditions, seeds sprout in 8 to 10 days. Harden off seedlings by gradually exposing them to outdoor conditions when nighttime temperatures reliably remain above 50°F (10°C). Transplant seedlings to the garden after all danger of frost is past and air and soil temperatures are at least 70°F (21°C), spacing plants at least 2 feet apart. At Stonegate, we plant them in our larger 5 × 25-foot beds, in alternating rows of three and two plants per row, and interplant greens between the rows.

Growing

Apply mulch around eggplants after transplanting to conserve soil moisture and prevent competition from weeds. Water with liquid seaweed at bloom and every 3 to 4 weeks thereafter, and add a little superphosphate around the bases of the plants when they're starting to fruit. If the weather turns cool, consider covering plants to protect them from low temperatures; plants may languish and stop producing during extended periods of temperatures below 60°F (16°C).

Harvesting

Harvest young fruits as they reach edible size, while their seeds are small and tender and their skins are glossy. Dull-looking fruits are past their prime. Use a sharp knife or shears to cut off fruits, leaving about an inch of stem on each one. Harvest regularly to encourage remaining fruits on the plants to develop.

Pests and Diseases

Practice good rotation habits with eggplant to avoid problems with the soil-borne disease verticillium wilt. Put cutworm collars in place when transplanting into the garden to protect seedlings from these nocturnal stem munchers. Cover young plants with floating row cover to shield them from flea beetles that will riddle the leaves with small holes, or spray plants with kaolin clay solution to discourage leaf-eating pests. Patrol plants for black-and-yellow-striped Colorado potato beetles and handpick and destroy them and their yellow egg masses that appear on the undersides of leaves.

Recommended Varieties

'Casper', 'Hansel', 'Pingtung Long', 'Rosa Bianca'

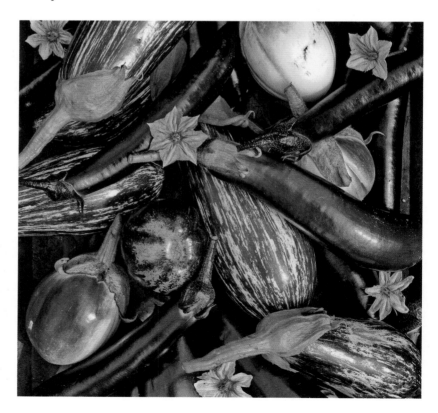

Pepper
Capsicum annuum

I can't imagine a summer salad, stir-fry, or pasta without fresh, organic peppers. Either sliced fresh or grilled to a smoky sweetness, peppers brighten up the farm—and your food—with their warm, sweet fire. They're usually rated in seed catalogs by their heat index, or Scoville scale, and we usually grow in the sweet or mildly spicy range, but if you like to get torched, plant a few hot pepper cultivars for excitement.

Site and Soil

Sweet or spicy, peppers like a spot in the sun and warm, loose, well-drained soil to sink their roots into. Even moisture is important for healthy fruit development, but dense, soggy soil will cause plants to grow poorly.

Planting

Start pepper seeds indoors 8 weeks before the last spring frost date, sowing them in moist seed-starting medium in individual pots or soil blocks. Peppers are sensitive to having their roots disturbed, so it's best to start them in pots roomy enough to hold them until it's time to transplant them into the garden.

When the soil temperature is at least 60°F (16°C), 2 to 3 weeks after the last spring frost date, set out sturdy 4- to 6-inch transplants that have been hardened off by gradual exposure to outdoor conditions.

Space plants about 18 inches apart. Large-fruited varieties benefit from staking or caging; put supports in place before planting to avoid injuring roots.

Growing

Apply straw mulch after planting to keep the soil moist and block weed growth. Peppers require even moisture throughout the growing season. Water or foliar feed with liquid seaweed or fish emulsion every 2 weeks until plants begin to bloom.

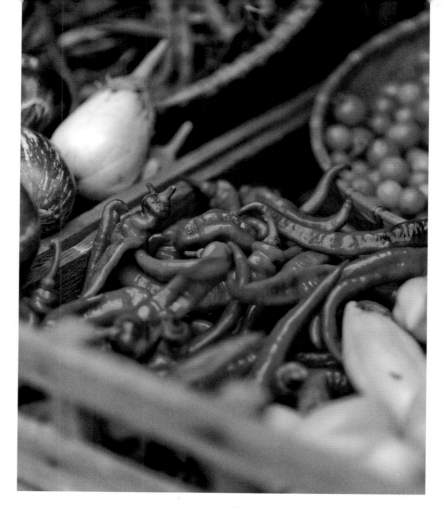

While peppers can't tolerate frost, they also may suffer if temperatures soar in midsummer, when the plants are blooming. When the mercury climbs above 90°F (32°C), plants may wilt and drop their blossoms. Growing peppers where they receive afternoon shade from taller crops can help prevent problems if the weather heats up.

Harvesting

Gather sweet peppers whenever they reach usable size and hot peppers when they develop their mature color. Pick the first fruits that form a little on the early side to encourage plants to keep producing. Mature fruits that remain on a plant can slow or stop further production. Use a sharp knife or shears to clip off peppers to avoid breaking plants while harvesting. When frost threatens, pick all fruits and bring them indoors to ripen in a cool, dry spot.

Pests and Diseases

Put cutworm collars around peppers at transplanting to shield their stems from nibbling caterpillars. Few pests bother peppers that are healthy and well grown. Keep watch for the same pests that may show up on tomatoes and eggplants and deal with them as needed.

Sidestep common pepper problems by rotating them along with their relatives, tomatoes and eggplants. Ideally, avoid planting any of these crops in the same spot within 4 to 5 years. If space limits lengthy rotation plans, grow peppers in 12- to 18-inch pots for a season or two. As further insurance, choose varieties that are resistant to the most common disease problems in your area.

Recommended Varieties

'Aurora', 'Jimmy Nardello', 'Marconi Red', 'Tequila Sunrise'

Tomato-Palooza

The slow fruition of all the heat-longing Solonacea, who sulked through June's cool nights, has finally begun to show promise, as clusters of 'Sun Gold', 'Lemon Drop', and 'Black Cherry' tomatoes have emerged jewellike on sprawling indeterminate vines, and peppers and eggplant are standing tall like fat hat pins above interplanted lettuce.

It's been quite a star turn for tomatoes in particular on the farm this season. No blight, no gummy end rot, just loose, far-reaching tangles of sweet fruit splattered across the fencerow in the orchard. Their sprawl and vigor has been almost unseemly, shaming the rest of the farm with an insatiable appetite for sun and sweetness.

Tomatoes can make or break a farm season. When you're left without, like we were a few years ago when late blight was early and pernicious, you almost want to strike the set and start a mushroom farm. Your CSA members, faced with a bleak, tomatoless summer, solemnly line up to collect their brassica shares, like martyrs.

And you end up like an account executive for kale, a huckster of bitter, leafy greens. "Kale salad, kale chips, kale frittata, kale quiche. How many ways can you prepare kale? So many!" you preach to a crowd of circumspect locavores. There's no doubt kale is the most nutrient-dense leaf out there, with healthy doses of micronutrients, antioxidants, and proteins, but its taste and texture are challenges to some, and no substitute for a ½-pound Brandywine.

Of course, much of the Tuscan kale had to be replanted after being nibbled down to ungainly stumps by a wily and determined woodchuck; powdery mildew did away with my French cucumbers with one sad, moldering puff; and a flock of ravenous starlings ate an entire hedgerow of *Aronia melanocarpa* berries that were just about to be harvested. Sisyphus, you had it easy!

After last season's exasperating battle with flea beetles, we shrouded the eggplant and Asian greens with row cover this year: a light, spun fabric made of recycled materials. It foils the beasties by physically blocking their voracious appetites. It seems to have worked. Just when I thought things on Fusspot Farm couldn't get tidier, I resorted to actually tucking in my beds, minus the hospital corners.

If I were half the farmer I'd like to be, I would be keeping an eye on the heirlooms that are thriving and would be saving their seeds to be planted next year. In theory, Darwinian adaptation can be accelerated a few generations by a little attentive intervention. If I were to put theory into practice, the plants that do well on my parcel would be unnaturally selected, carefully saved, and replanted. Next year.

Small organic farming will continue its metronomic give and take. And given one season of magical tomatoes, like this one, the memory of all the blighted, forsaken fruit that came and went before disappears.

The emergence of sweet, indeterminate cherry tomatoes along the fencerow in the orchard and juice-heavy heirlooms elsewhere makes all the weeks of waiting worthwhile.

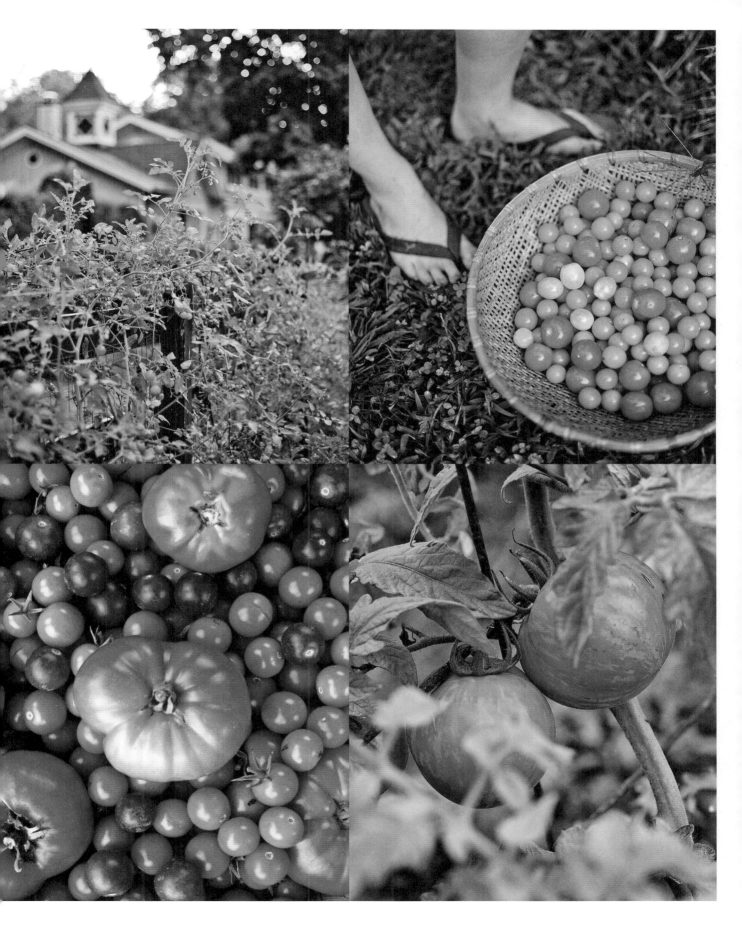

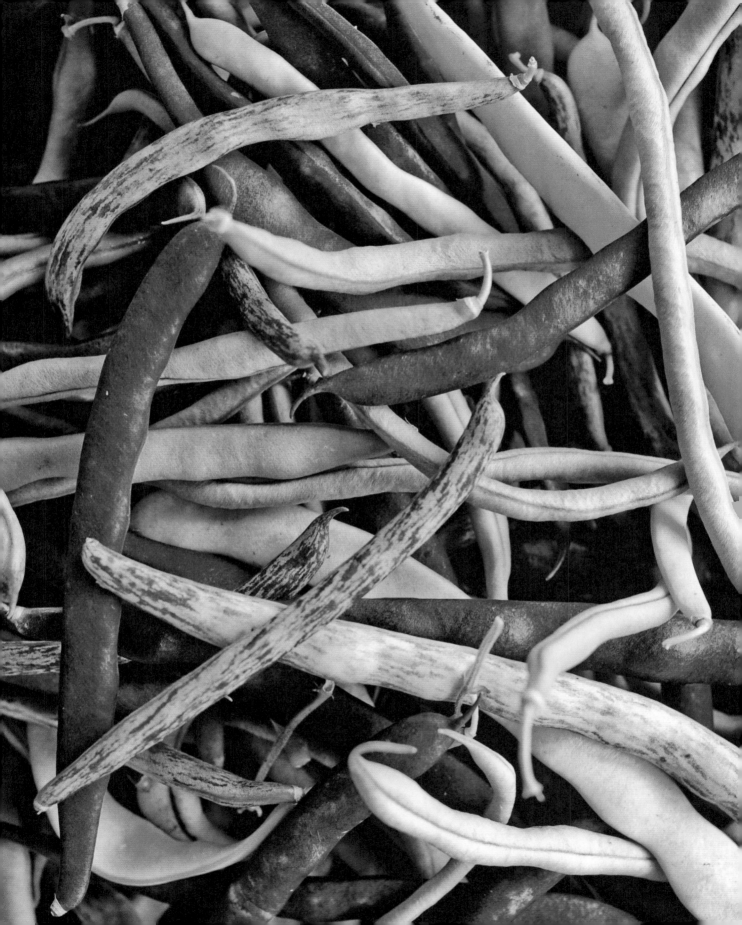

Pole Bean
Phaseolus vulgaris

The great thing about pole beans, besides their incredibly fresh snap and crunch when grown as locally as your own land, is that they bring the farm and garden upward, filling that middle ground between earth and sky. Many varieties can climb beyond 12 feet, so tall structures can be swathed all season in their delicious clambering. There's nothing quite like the taste of tender, just-picked pole beans right off the trellis, and sometimes you're lucky if they even make it to the kitchen.

Site and Soil

Prepare a sunny bed for beans in soil that is loose, fertile, and well drained. Beans don't grow well in heavy, soggy soil conditions. Amend the soil with compost and phosphate before planting.

Planting

Sow beans after danger of frost is past, 1 to 2 weeks after the last spring frost date, when the soil temperature is at least 60°F (16°C). Beans are sensitive to frost and germinate poorly in cold soil, so don't rush to plant them too early. Plant seeds 2 inches deep and 10 inches apart, firming the soil over them to ensure good contact. Put supporting trellises in place at planting time. Pole beans may take up to 14 days to germinate.

Growing

Water as needed to keep the soil moist but not sodden. Even moisture is especially important during germination and when plants are blooming. Mulch around the bases of plants after they're up to keep the soil moist and cool and to block weeds.

Harvesting

Begin harvesting green, or snap, beans when the pods are pencil size and before the seeds inside are evident as visible bumps. Keep up with harvesting

once production begins; mature pods that remain on plants will suppress the development of more flowers and beans. Pole beans will continue producing until frost brings their season to an end. While most varieties are grown either for snap beans or for dry shell beans, some types can meet both needs. Gather young pods for fresh use for a few weeks, then switch to leaving pods to mature on the plants until they are dry and brown and the seeds are hard. Shell dried beans and store them in airtight containers.

Pests and Diseases

A few insect pests need to be discouraged from munching on bean plants. Cover newly emerged bean seedlings with row cover for a few weeks to block leafhoppers, flea beetles, and bean leaf beetles from nibbling on young plants that can't afford to lose their foliage. Pole beans will quickly outgrow covers; patrol unprotected plants for Mexican bean beetles (yellowish round beetles with black spots) and their fat yellow grublike larvae. Handpick and toss into soapy water to destroy them.

Avoid problems with diseases by growing resistant varieties and rotating beans to different garden beds. Space beans in the garden to allow air movement around the plants, and don't pick beans when the leaves are wet. Remove plants that show signs of infection to keep diseases from spreading.

Recommended Varieties

'Cherokee Trail of Tears', 'Chinese Red Noodle', 'Kentucky Wonder', 'Rattlesnake'

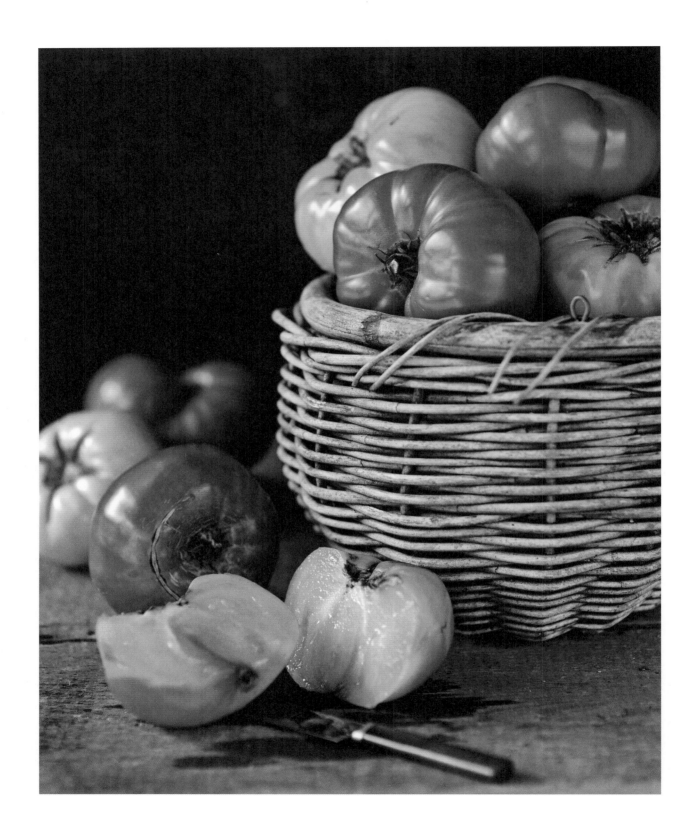

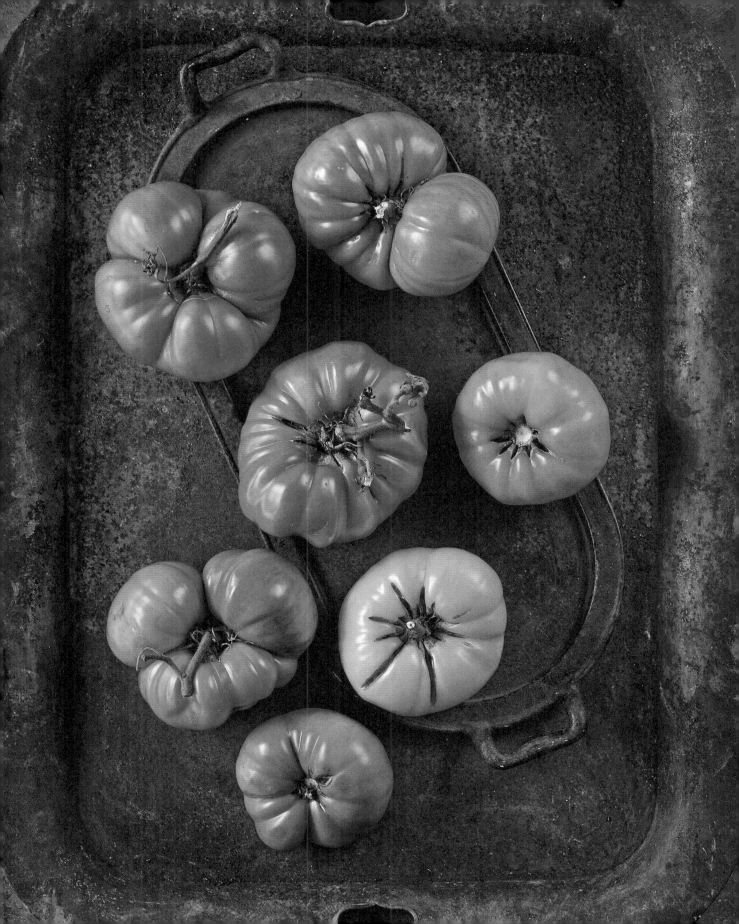

Snap Pea

Pisum sativum

Besides spring greens, snap peas are the first taste of the sweet onset of summer and are some of the earliest seeds to be planted out, usually in the muck and drizzle of mid-March. This initial foray into the muddy garden is full of hope and promise, and in early June snap peas reward with tall and lanky vines dripping with pods, edible leaves, and shoots. I can't imagine a season without them.

Site and Soil

Going early into the garden, peas need a sunny location and loose, well-drained soil that is mildly acidic and amended with compost.

Planting

Plant peas in cool early spring, 4 to 6 weeks before the last frost date, as soon as the soil can be worked. Stretch the harvest by making successive plantings at 2-week intervals until early May, bearing in mind that peas will grow poorly when temperatures climb above 75°F (24°C). Treat pea seeds with bacterial inoculant before planting to increase their ability to fix nitrogen; apply according to label directions. We wet the seeds first, put them in a mason jar, add the gray inoculant powder, and shake, coating each seed. Plant 1 to 2 inches deep and 4 to 6 inches apart.

Growing

Even snap pea varieties that produce relatively short 2- to 3-foot vines will benefit from a bit of support. Put simple string or wire trellises in place at planting time to give pea vines something to climb. Peas growing on supports are easier to harvest, cleaner, and less prone to disease problems caused by crowded vines and plants in contact with the soil. Mulch peas after they're up to keep the soil cool and moist. Peas have modest water needs—about ½ inch per week—but avoid letting them dry out during germination, when plants are blooming, and when pods are forming. Healthy peas don't need any additional fertilizer during the growing season, and excess nitrogen can hinder productivity.

Harvesting

Pick succulent snap peas when the fleshy pods are plump and bright green. Harvest daily to stimulate remaining blossoms and young pods to continue developing. Use scissors to snip pods from the vines to avoid accidentally pulling them out of the soil as you pick.

Pests and Diseases

Peas miss a lot of pest problems by growing in cool, moist, early spring weather. Aphids may appear when things start to warm up, clustering on stems and leaf undersides. Wash them from plants with a strong spray of water.

Diseases are a different story. There are a few common problems that trouble peas and are best avoided by choosing resistant varieties when available and rotating peas to different garden beds.

Recommended Varieties

'Amish Snap', 'Sugar Ann', 'Sugar Snap'

Summer Squash

Cucurbita pepo

Don't stop 'til you get enough is a mantra lost on summer squash, which—once they kick into high gear in midseason—can pump out more prolific fruit than there are ways to cook them. The good news is that with their diverse shapes and sizes and edible blooms, there are so many ways to put them to use in the kitchen. And if they really don't stop and you've truly had enough, there's always zucchini philanthropy. Your neighbors will thank you.

Site and Soil

Good, well-drained garden soil and a sunny exposure suit summer squash plants just fine.

Planting

Plant seeds of favorite summer squash varieties in warm (at least 60°F/16°C) soil about 2 weeks after the last spring frost date and up to 8 weeks before the first frost date in fall. Sow seeds 1 inch deep in premoistened hills spaced 2 to 4 feet apart, planting about 6 seeds per hill. Some varieties, such as the Italian 'Tromba d'Albenga', can be grown as climbers on a sturdy trellis. Because summer squash are so prolific, resist the temptation to plant too many of any one kind.

Growing

Once seedlings have at least one true leaf, thin to the two strongest plants per hill, snipping off the extras to avoid disturbing the roots of the remaining plants. Put row cover over young seedlings to protect them from squash bugs and cucumber beetles; remove covers when the plants begin to bloom. Squash needs ½ to 1 inch of water weekly. Avoid wetting leaves when watering to reduce the risk of mildew problems.

Harvesting

Pick summer squash when they are young, small, and tender by cutting or

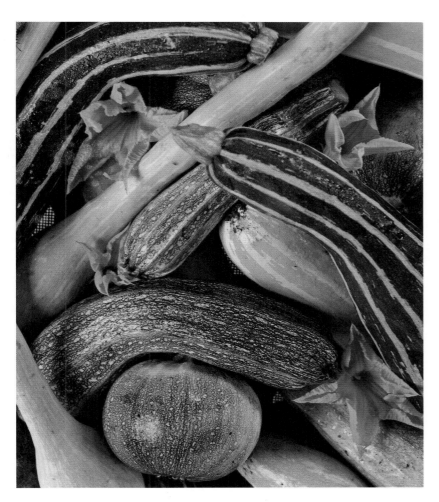

gently twisting them from the plants. Harvest blossoms for salads, frying, or stuffing when they are fully open. Focus mainly on male flowers—look for thin stems and no swelling at the base—if you want to enjoy a crop of squash as well as the blossoms; leave a few male blooms to provide pollen for the females.

Pests and Diseases

Elongated shield–shaped, gray brown squash bugs feed on squash foliage, causing the leaves to wilt and turn black. Handpick the ¾-inch-long adults and the smaller, wingless nymphs and drop them into soapy water to destroy them; check the undersides of leaves for clusters of red brown eggs and destroy these as well. Summer squash attracts attention from other pests common to vine crops, including cucumber beetles and squash vine borers, as well as aphids and spider mites.

Sidestep common disease problems by choosing resistant varieties and rotating vine crops to new locations from year to year. Plant at a distance from cucumbers to avoid cross-infestations. Avoid wetting foliage when watering and working amid plants in wet conditions to keep from spreading disease from plant to plant.

Recommended Varieties

'Costata Romanesco', 'Eight Ball', 'Geode', 'Safari', 'Tromba D'Albenga' (*C. moschata*)

Tomato

Solanum lycopersicum

There's something so amazing about tomatoes, about the succulent, heat-swollen tangle of color and flavor that they spill out in summer, that it defines everything we love about growing our own.

Tomatoes range in size from petite, pop-in-the mouth grape and cherry types to massive, lobed heirlooms that weigh in at a pound or more, and their colors are equally diverse: streaked in orange and yellow or gleaming in deep red, purple, and pink. While there is some nuance involved in successfully producing these delectable fruits, the hardest part may be deciding which of these beauties to grow.

Determinate types grow to mature size and then bloom and set all their fruits at the tips of the main and side stems at around the same time, which is useful when a lot of tomatoes are wanted in a fairly narrow window. Varieties that keep stretching their lanky stems throughout the growing season are called indeterminate, or vining. Indeterminate tomatoes produce clusters of blooms at intervals, and production continues as long as conditions are right for the plants to keep growing. Because they have more leaves relative to their fruits, indeterminate varieties tend to be more flavorful. But they also need more care—sturdy supports for vines that may reach 20 feet long over the course of the season and regular pruning to keep leafy growth from affecting fruit set. Heirloom varieties have seeds that have been passed down for generations, meaning they're some of the best, and you can save seeds yourself for next season.

Site and Soil

Give these heat lovers a sunny location where the soil is rich in organic matter and well drained. Amend the bed with compost before planting; warm the soil with black landscape fabric a few weeks before transplanting, then tuck in transplants with a shovelful of composted manure. Sandy loam is ideal, but tomatoes will grow in most well-drained soils. Soggy soil conditions promote problems with diseases.

Planting

For access to the most variety, start tomatoes from seeds planted indoors 6 to 8 weeks before the last spring frost date. Prepare the bed and transplant seedlings to the garden when all danger of frost is past, about 2 weeks after the last spring frost date. At Stonegate, we often plant tomatoes in a bed that previously held early spring snap peas, which have fixed nitrogen in the soil for hungry tomatoes. Tomato plants can form roots along the length of their stems, so plant them deeply, with the lowest set of leaves at soil level, adding a cup of kelp meal and a cup of bonemeal to the planting hole. Leggy seedlings may be planted horizontally in a shallow trench. Strip off the leaves from the part of the stem that will be covered and lay the transplant on its side, leaving at least two sets of leaves above the soil. Firm the soil gently around the roots and water thoroughly after planting. Put stakes or cages in place at planting time.

Growing

Cultivate gently around young plants as needed to prevent weeds from cropping up. Once the soil is warm, put a thick layer of straw mulch around the bases of plants to keep the soil moist and block weed growth. Water weekly with liquid seaweed and apply and work in a phosphate fertilizer (0-30-0) around the stems to encourage fruit formation. As stems grow, tie them gently to supports with twine. Prune out suckers—small leafy shoots that sprout at the intersections of main stems and leaf stems—by pinching them off while you are training the plants to their supports.

Harvesting

Begin picking tomatoes when the first fruits change color. Let tomatoes ripen on the plants to enjoy the best flavors. If frost threatens at the end of the growing season, gather any unripe fruit and ripen them indoors at room temperature. Do not refrigerate tomatoes, as cold temperatures adversely affect both flavor and texture.

Pests and Diseases

Pests and fungi love tomatoes as much as we do, but healthy, vigorous plants growing in suitable conditions are rarely bothered. Choose varieties that are resistant to common tomato diseases and practice good tomato culture—keep the soil evenly moist to prevent fluctuations that can cause fruits to crack. Avoid wetting the foliage when watering and don't work amid wet plants to keep from spreading leaf spot diseases. The healthier and more robust the plant, the more it will be able to fend off disease, so a foliar feeding with liquid seaweed will supply vital nutrients necessary for healthy growth. Patrol plants for hideous tomato hornworms, 2- to 3-inch-long green-striped caterpillars with a prominent horn, which gorge on tomato leaves and stems; handpick and destroy these horrible beasties. Plant dill around tomatoes to support tiny wasps that parasitize hornworms. If you find a caterpillar with white, ricelike cocoons on its back, leave it in the garden—it is host to garden good guys that will control pest caterpillars for you.

Recommended Varieties

Cherry: 'Black Cherry', 'Matt's Wild Cherry', 'Sun Gold', 'Supersweet 100'
Heirloom: 'Brandywine', 'Black Krim', 'Costoluto Genovese', 'Green Zebra', 'Moskvich', 'Striped German'

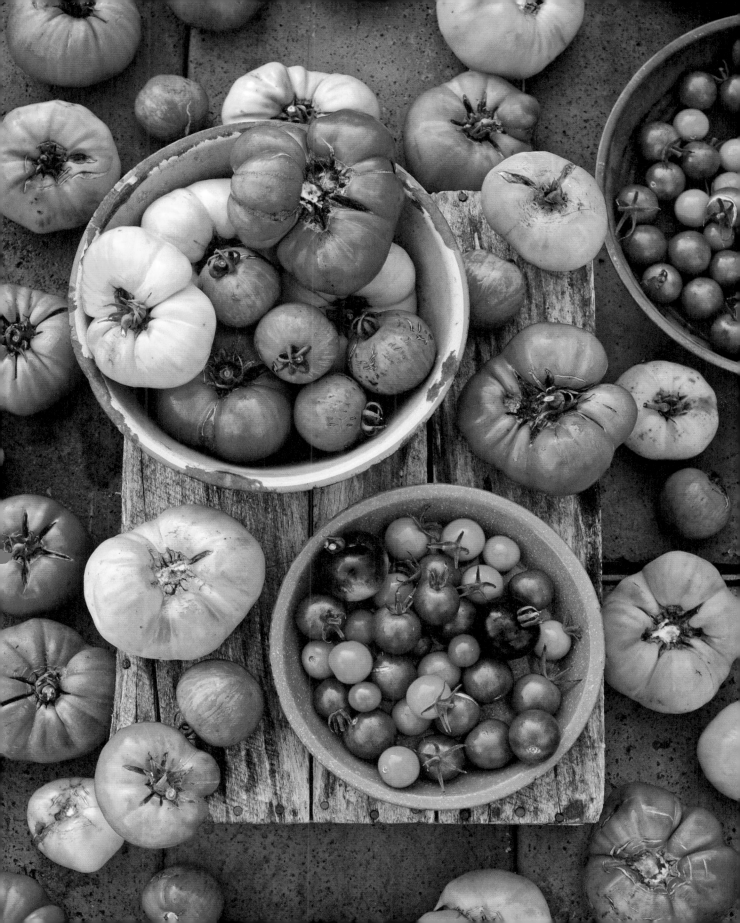

Wabi-Sabi

Judging by our lobed and fissured tomatoes and mottled fruit, we grow beautifully imperfect food at Stonegate Farm. Imperfect in the idealized, Apollonian sense, that is, but oh-so-perfect in the fabulous flavor, nutrient-density department.

There is something remarkable about a warm, unruly ravel of locally grown, organic tomatoes, the kind of sensual squalor you don't get from the neatly marshaled packages found at the supermarket. These are what the French called love apples. (They thought the *pomme d'amour* was an aphrodisiac.) The Germans also have their *Liebesapfel*, and the Italians their *pomi d'amore*. It seems this little fruit gets around.

But grow them organically and their seduction lies deep beneath the skin. Organic is really a euphemism for misshapen beauty, or the Eastern aesthetic philosophy of *wabi-sabi*, where imperfection, transience, and asymmetry have more value and are "more perfect" than perfection.

In Japan, for example, where the modern CSA movement, called *Teikei*, began, *wabi-sabi* is central to their aesthetic philosophy. The more crazed and cracked the teapot, the wonkier the pear, the greater its integrity, beauty, and value.

There is something beautiful in transience, in the faltering impermanence of living things, be it an overripe 'Shiro' plum or even *us*.

Our closest approximation is Virgil's lacrimae rerum, or "tears of things," but try and use that (or worse, quote Virgil) when selling anything in the new and improved West. So much of Eastern philosophy is simply lost in a land where the newer, shinier, and more Botoxed, the better.

Organic beauty has always been more than skin deep; in fact, its skin is often deeply flawed. With no toxic petroleum armor to protect it, organic produce must fend for itself, relying on the skilled coddling of its growers.

Much of what we grow wouldn't pass visual muster at the local Price Chopper, where aisles of pesticide-infused sameness prevail. But our *wabi-sabi* veggies, greens, and orchard-grown fruit—even the weathered siding of our century-old barns—have a deep and resonant beauty that you can't get from mass production.

It's no wonder the Japanese, with their non-Western paradigms, created a partnering system between consumers and organic farmers where they cooperated not only with each other but also with the lovely imperfection of the natural world. They say that when you learn a new language, you acquire a new soul, and the language of organics is about working symbiotically with nature's quirks and variations, not against them.

Maybe growing local and organic creates not only better food, but also better philosophy.

Organic heirloom tomatoes in all shapes and sizes burst onto the scene in early August, raising the flavor bar at the farm for the rest of the season.

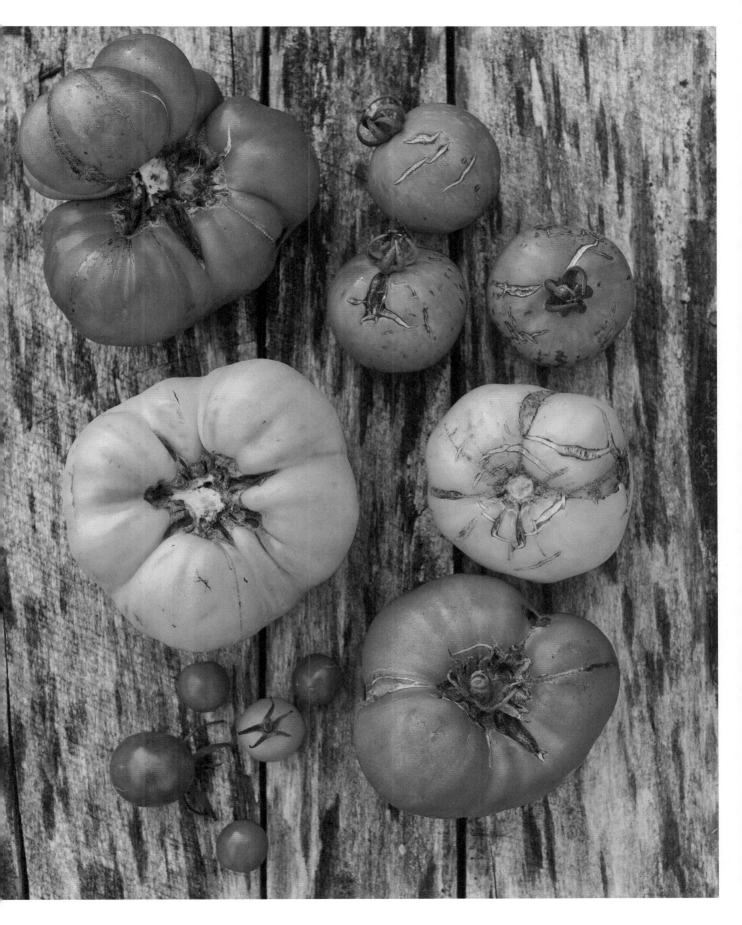

Tubers, Roots & Bulbs

ROOTS AND BULBS MAY NOT have the come-hither sexiness of their cousins aboveground, but what they lack in allure they more than make up for in longevity and flavor. Just beneath the rough skin of the earth, they incubate in mysterious mineral darkness, forming their complex carbohydrates, fiber, and phytonutrients—all essential to our health. They can even be left in the ground after frost, where their starches will sweeten, and they store so well that they're a staple of a healthy winter diet.

Often underappreciated (maybe because they're usually cooked into an unimaginative mush), root veggies and bulbs are wonderful eaten raw (save for potatoes), and nothing beats them in salads or as a base for nutrient-dense smoothies. They're also remarkably beautiful: Pencil-thin baby carrots, if closely planted, will twine in a sweet, delicate embrace beneath the soil, while multicolored spring radishes, like crisp jewels of color, can be repeatedly planted for a constant supply in the cool months of spring and fall. Radishes are also one of the fastest and easiest vegetable to grow, with many varieties maturing in as little as 3 weeks. If you want to get your kids interested in food growing, easy radishes are a great place to start.

Root crops allow you to maximize the calorie and nutrient output of your farm by as much as 20 times the calories per square foot of other crops, but the trick with most roots and bulbs is the tilth, or texture of the soil: It needs to be light, rich, and well-draining. After that, they'll work their magic for you.

Beet

Beta vulgaris

Beets never used to be my favorite. Maybe because they came in a can, floating in a purple haze of liquid, and tasted cloyingly sweet for a vegetable. That was before I learned about the smoky caramelizing that happens when roasting and grilling them or the fresh colorful ribbons of flavor they add to salads. Now I can't get enough of them, and the beautiful varieties available to the home gardener make them even more alluring. They also make efficient use of space in the garden, giving you both the greens and the bulbs to harvest.

Site and Soil

A sunny spot with light, loamy soil that is evenly moist and well drained is best for both tops and bottoms of sweet, juicy beets.

Planting

Plant seeds in prepared soil up to a month before the last spring frost date, spacing them 2 to 4 inches apart and covering with ½ inch of fine soil. Sow more seeds at 2-week intervals through spring to enjoy a steady harvest of roots and greens. Plant again in late summer, 1 to 2 months before the first frost date; soak seeds in water overnight before planting to improve germination.

Growing

Each beet seed in a packet is really a small fruit that may hold as many as eight actual seeds. This means thinning is important to give roots room to expand. Thin the clusters of tiny plants shortly after they come up to leave one seedling from each group. When the beets reach 2 to 3 inches tall, thin them to 4 to 6 inches apart. (Eat the tender young thinnings.) Keep the soil evenly moist to prevent flowerstalks from forming, which brings an end to leaf production and makes the roots tough and stringy. Water every 2 weeks with liquid seaweed or fish emulsion, and mulch to conserve soil moisture and keep out weeds.

Harvesting

Begin harvesting roots when they reach 1½ to 3 inches in diameter. Pull roots carefully by hand to minimize bruising and breaking. You can harvest up to a third of a beet's leaves without impeding root development, but it's sensible to make separate plantings for roots and greens to get a full harvest of each. Roots of most varieties reach maturity about 55 days after planting.

Pests and Diseases

Leaf miners (fly larvae that tunnel beneath the surfaces of leaves) may target beet foliage, spoiling its looks with brown blotches or serpentine trails. Handpick affected leaves; consider covering young plants with row cover to keep leaf miners and flea beetles from ruining the greens.

Stunted roots with internal hard black spots are evidence of boron deficiency. Growing beets in compost-enriched soil and regularly applying liquid seaweed or fish emulsion during the growing season will ensure that they get enough of this nutrient.

Extraordinary Varieties

'Bull's Blood', 'Chioggia', 'Cylindra', 'Touchstone Gold'

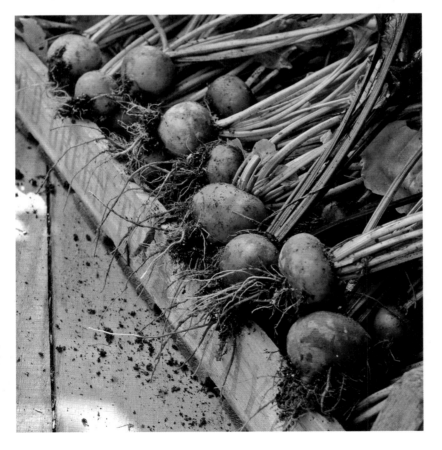

Carrot

Daucus carota var. *sativus*

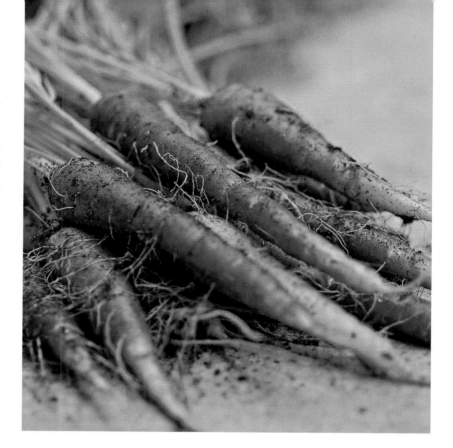

Carrots hide their magic for months beneath the soil, coming out of the dark in colors and shapes beyond imagining, from classic orange to yellows, creamy whites, reds, and deep purples. Harvested young, they have a delicious, earthy crunch, and when grown in winter coldframes, carrots will take on a sweetness beyond belief. They are packed, not surprisingly, with beta-carotene as well as other healthful phytonutrients.

Site and Soil

Long, straight carrots that taper to a point need deep, loose, sandy to loamy soil that drains well but remains evenly moist and a sunny to lightly shady spot in the garden. Prepare the soil thoroughly before planting carrots, digging deeply or building a raised bed of rock-free soil amended with plenty of compost. Dig in rock phosphate and kelp meal before planting to supply phosphorus and potassium, but avoid excessive nitrogen, which can stimulate lots of slender side roots, giving carrots a hairy appearance.

Planting

Start sowing carrot seed in prepared soil 2 to 3 weeks before the last spring frost date. Sprinkle the fine seed over a premoistened seedbed and cover with ¼ to ½ inch of fine-textured soil or sand. Because carrot seeds may take up to 3 weeks to germinate, gardeners often mix quick-sprouting radish seeds in with the carrots to mark the rows. Water gently after planting to avoid washing away the seeds. Covering newly planted seedbeds with row cover can protect them from heavy rainfall and also helps prevent some pest problems. To keep a steady harvest of carrots coming, plant more seeds every 2 to 3 weeks, watching the calendar to allow the roots to reach maturity by the first fall frost date.

Growing

Keep the soil evenly moist but not soggy while waiting for the seeds to sprout. Thinning tiny carrot seedlings can be tedious, but it is essential to alleviate crowding so the remaining roots have room to grow. When the tops reach 2 inches tall, snip off or pull excess seedlings to create 1-inch spacing; thin again in 2 to 3 weeks to space remaining carrots 3 to 4 inches apart.

Be prompt about removing any weeds that crop up, and hand-pull carefully to avoid disturbing carrots' roots. Maintain even soil moisture. Soil that dries out and then is suddenly soaked by makeup watering can cause carrot roots to split.

Harvesting

Begin enjoying carrots as soon as the roots are large enough to eat. Flavor improves as they grow, so the roots can remain in the ground until needed, as long as they're shielded from hot, dry conditions and freezing temperatures. Moisten the soil to soften it before harvesting, then hand-pull mature roots. Use a spading fork or trowel to loosen the soil if necessary, taking care to avoid bruising or cutting the carrots.

Pests and Diseases

Carrot rust flies and carrot weevils both lay eggs on carrot seedbeds, and their larvae tunnel into roots. Both are especially troublesome in early spring crops; rust flies may be avoided by delaying carrot planting until early summer. Rotate carrots to elude these pests and others, and cover newly sown seedbeds with row cover to block egg-laying adults.

Rotating carrots and planting in soil well-amended with compost also helps prevent problems with pest nematodes that can cause carrots to form stunted, knotty roots. Choose resistant varieties if leaf blight diseases are a known problem in your area.

Extraordinary Varieties

'Atlas', 'Atomic Red', 'Mokum', 'Nelson', 'Purple Haze', 'White Satin'

Kohlrabi

Brassica oleracea
(Gongylodes Group)

Another weirdly alien-looking bulb that sits on the soil surface like a probe from another planet, kohlrabi is a must-have for both flavor and novelty. Kohlrabi is a cabbage relative that forms a bulbous "root"—actually a swollen stem—just above the soil surface. Beneath its rather lumpy green or purple skin, the flesh of kohlrabi is crisp, white, and sweet, with a mild flavor similar to a turnip's.

Site and Soil

Give kohlrabi a sunny spot in good garden soil that's been amended with compost to improve drainage and moisture retention.

Planting

Plant seeds directly in the garden 4 to 6 weeks before the last spring frost date, sowing them ¼ inch deep and about an inch apart. Make successive small plantings every 2 weeks up to the last frost date rather than one large one. Kohlrabi likes cool growing conditions and its bulbs are sweetest when they grow rapidly to harvest size. Six to 8 weeks before the first fall frost date, start seeds indoors for a fall crop. Transplant seedlings to the garden when they are about 4 inches tall.

Growing

Thin seedlings to 4 to 6 inches apart when they reach 4 inches tall. Keep up with watering and apply about an inch of organic mulch around the plants to maintain soil moisture and block out weeds. Dry soil followed by a soaking rain can cause kohlrabi to split. Water with liquid seaweed or fish emulsion when plants are about 6 inches tall.

Harvesting

Mark the calendar to begin harvesting kohlrabi when it reaches the date indicated by the variety's estimated "days to

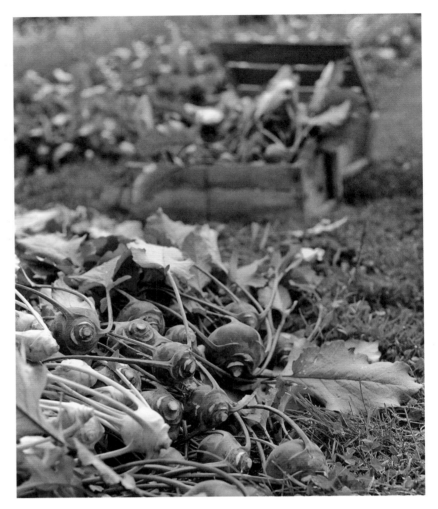

maturity." Younger and smaller bulbs typically have the best flavor and texture. Start by picking 2-inch-diameter kohlrabi, cutting off the roots about 1 inch below the swollen bulb. The young leaves may be eaten like collards or kale. Monitor varieties that produce larger bulbs and harvest at the appropriate time. Kohlrabi that remains in the garden too long, particularly in hot, dry weather, tends to become tough and woody.

Pests and Diseases

The same pests that riddle other cabbage family crops with holes will put the bite on kohlrabi, although it typically is less troubled than its kin. Use collars around spring transplants to protect them from cutworms; install ground-level beer traps if slugs and snails are sliming around young plants. Put row cover over young kohlrabi and seal the edges to block flea beetles and egg-laying adults of leaf-eating caterpillars.

Rotate kohlrabi and clean up plant debris after harvest to avoid disease problems common to the family. Promptly remove and destroy plants showing signs of disease.

Extraordinary Varieties

'Azur Star', 'Kolibri', 'Kossak', 'Winner'

Parsnip
Pastinaca sativa

Long and tender with a mild, herbal sweetness, pale-skinned parsnips are carrot's Goth cousins and are grown much the same way. They're delicious oven roasted with rosemary, tossed into soups and pot roasts with other root vegetables, or served as a starchy stand-in for potatoes. When harvested as baby bulbs, they can be enjoyed raw in salads; peel and shred if they're more mature.

Site and Soil

Give parsnips a sunny site with deep, loose, fertile soil that is moist but well drained and free of rocks and clods. Amend the bed generously with compost before planting but forgo applications of fresh manure or other nitrogen sources that can make parsnip roots grow forked and hairy.

Planting

Time parsnip planting in spring by counting back 3 to 4 months from the first frost date in fall. Parsnips may be planted in early spring as soon as the soil can be worked, but the goal is to have the roots mature around the time of the first fall frost and not in the heat of summer. Start with fresh seeds and soak them overnight before planting to encourage germination.

Sow seeds 1 inch apart and ½ inch deep in rows 12 to 18 inches apart, covering them with sand, sifted compost, or vermiculite. Parsnip seeds may take up to a month to germinate; mix in a few radish seeds to mark the rows until the parsnips appear.

Growing

Cover the seedbed with row cover to retain moisture and keep out pests. Maintain even soil moisture while seeds are germinating and seedlings are getting started. Watch for weeds and remove them while they're small. When parsnips reach about 6 inches tall, thin them to 4 to 6 inches apart and mulch lightly. Avoid walking on the soil around parsnips to keep from damaging the long, slender roots.

Harvesting

Wait until after a frost or two has fallen to begin harvesting mature roots. Use a digging fork to carefully loosen the soil around the roots before pulling them up. To harvest parsnips through winter, cover the row with a 1-foot layer of straw and pull it back as needed to dig more roots. Finish harvesting by early spring, before new leaves begin to sprout. Dig the entire crop in fall if winter rains are likely to keep the soil cold and soggy for extended periods.

Pests and Diseases

Carrot pests may also bother parsnips but usually to a lesser extent. Spots on leaves may indicate a fungal disease that also causes sunken red brown cankers on the tops of parsnip roots. Remove plants showing symptoms of canker disease and thoroughly clean up debris after harvest. To minimize problems, choose resistant varieties and cover exposed parsnips' shoulders with soil.

Extraordinary Varieties

'Hollow Crown', 'Javelin', 'Lancer', 'White Spear'

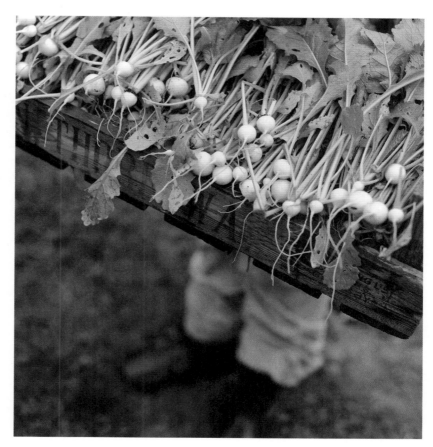

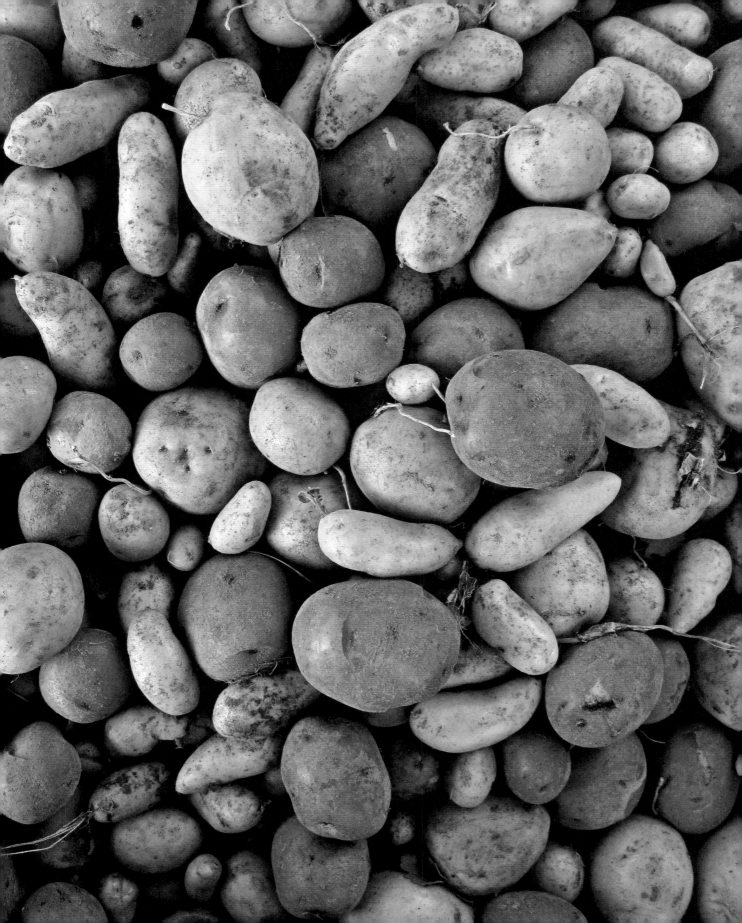

Potato

Solanum tuberosum

There is so much more to potatoes than the stolid, ho-hum spuds sold in supermarkets, and few pleasures are more immediate than reaching into loose soil to pull out fresh fingerlings for the next meal or turning over abundant forkfuls of colorful tubers late in the season to stockpile for the winter months ahead.

Grown from "seed" potatoes—tubers selected from the previous season's harvest—instead of from seed, potatoes are an easy crop to add to the garden. Growing your own vastly expands the available options in color, texture, and flavor far beyond the slim choices offered in most stores.

Site and Soil

Potatoes grow best in light, loose, well-drained soil in a sunny spot. Dig in compost before planting to meet their modest fertility needs and to improve moisture retention and drainage. Acid soil conditions (pH 5.0 to 6.8) favor healthy growth and help prevent infection by scab disease.

Planting

Unlike their heat-loving cousins in the Solanaceae family, potatoes prefer cool growing conditions. Plant certified disease-free seed potatoes in spring, about 2 weeks before the last frost date or when the soil is at least 40°F (4°C). A day or two before planting, use a sharp knife to cut seed potatoes into pieces no smaller than 1 ounce and with two or three eyes each. Spread the cut pieces out to dry in an airy, well-ventilated place for 24 hours or more to give the cut surfaces time to harden a bit.

Plant the pieces, cut side down, 6 inches apart in a trench 4 inches deep in prepared soil. Cover with 2 to 3 inches of soil and mulch lightly.

Where the soil is heavy or poorly drained, seed potatoes may be planted on the surface of a prepared bed and covered with a deep layer of mulch. Space prepared seed potato pieces 6 inches apart in rows and cover with 4 inches of straw mulch.

Growing

As plants grow, hill up soil around the stems or add more straw mulch to keep developing tubers completely covered. Keep adding mulch until the straw is 8 to 12 inches deep; stop hilling soil or mulching when blossoms appear. In addition to keeping the soil moist and blocking weeds, mulching around potatoes prevents tubers that form close to the soil surface from turning green from exposure to light and can reduce damage caused by troublesome Colorado potato beetles.

Water regularly to keep the soil or mulch evenly moist. Foliar feed potatoes growing in mulch with liquid seaweed or fish emulsion when the plants emerge and again when they bloom to help make up for nutrients they aren't getting from the soil.

Harvesting

When flowers appear, search in the soil or mulch around the bases of plants to find small "new" potatoes to harvest. Replace the mulch to shield remaining tubers from exposure to light.

Potato plants may begin to turn brown and wither as their tubers reach maturity. You can encourage this process by knocking over or cutting off the plants when they reach the number of days to maturity for the variety. If the weather is not too wet or warm, leave the tubers in the ground for a week or two to harden before harvesting.

Harvest in late afternoon or on a cloudy day. Pull plants out of loose soil or mulch and gather the tubers that come up on the roots. Then explore the hole for more potatoes. Use a spading fork to turn the soil to expose tubers deeper in the ground. Put the harvested potatoes into a bag or bucket to keep them out of the light.

Rinse or gently wipe off excess soil, then spread potatoes in a single layer in a cool, dark place to dry for 2 weeks before storing in a dark place at about 40°F (4°C). Set aside any tubers that were cut or damaged during digging and use them right away.

Pests and Diseases

Wireworms are shiny, segmented brown or yellow beetle larvae that burrow into the roots of many vegetables, including carrots and potatoes. Wireworms are most prevalent in areas where grass has been growing; avoid planting potatoes and other root crops in gardens that have recently been converted from turf.

Colorado potato beetles are chunky, ½-inch-long yellowish insects with lengthwise black stripes on their backs. They emerge from the soil around the same time as early potato crops, climbing the stems to feed on leaves and lay clusters of bright orange eggs. Their voracious larvae are reddish grubs that also gobble potato foliage. Handpick these pests and crush any eggs you find. Straw mulch seems to confuse emerging beetles and may impede their progress from soil to stems and leaves.

Preventing diseases in potatoes is much easier than curing them. Rotate potatoes and related crops—tomatoes, peppers, and eggplants. Remove weedy family members like nightshade from the garden area. Buy certified disease-free seed potatoes and choose varieties that are resistant to diseases common in your area. Clean up crop debris at the end of the growing season and destroy any plants that show signs of disease.

Extraordinary Varieties

'French Fingerling', 'Gold Rush', 'Magic Molly', 'Peter Wilcox', 'Russian Banana'

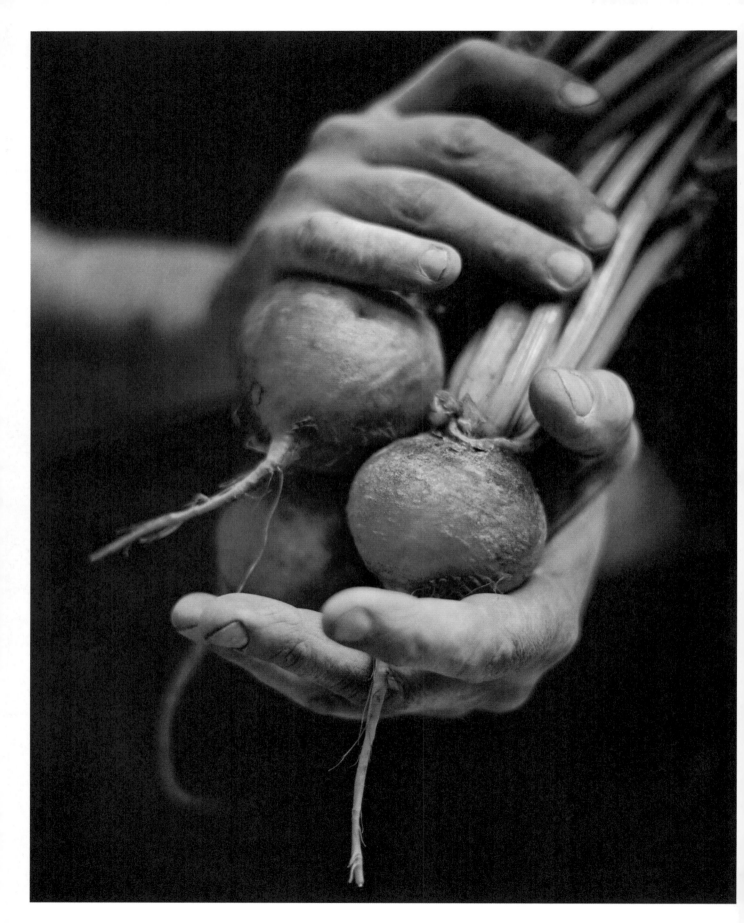

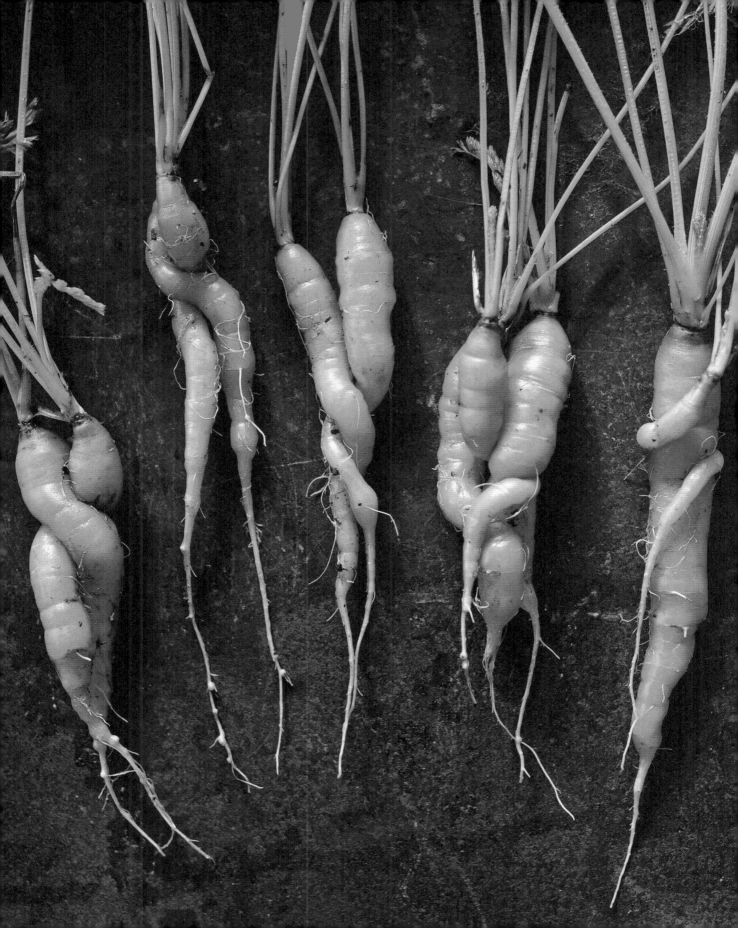

Radish

Raphanus sativus

Radish savvy has come a long way in recent years. Once only sliced into salads or carved into florets and mildly creepy dioramas, radishes are now available in a rainbow of colors, shapes, and sizes—from gumball-like globes of pink, purple, and white to long French varieties (such as 'D'Avignon'), pale Asian daikon, and black-skinned Spanish types. Easy to grow and quick to reach edible size, radishes can help satisfy the urge to garden in earliest spring, when conditions are far too unpredictable for all but the hardiest of crops.

Site and Soil

Like most root crops, radishes do best in loose, evenly moist and well-drained soil that is free of rocks and clods. Dig in compost to prepare a sunny to lightly shady site for radishes, but avoid manures and other potent nitrogen sources that can promote abundant leafy growth at the expense of the roots. As temperatures rise, plant radishes in the shade cast by taller crops to keep things cool.

Planting

Start planting radish seeds in the garden as soon as the soil can be worked in early spring. Sow them ½ inch deep and 1 to 2 inches apart. Rather than planting a lot of radishes at one time, make successive, smaller plantings every 10 days throughout spring, until daytime temperatures regularly exceed 75°F (24°C). Resume planting as things begin to cool down in fall. Sow seeds of daikon and other winter radishes in midsummer for harvesting in fall and early winter.

Growing

Keep radishes evenly moist to allow them to grow quickly to harvest size—in as little as 21 days for some varieties. Thin crowded rows or beds to leave 2 inches between small spring varieties

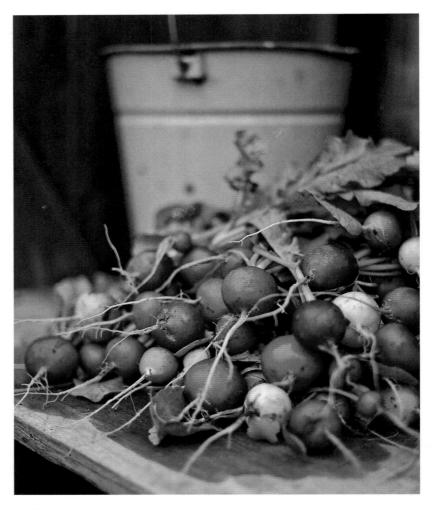

and 3 inches between larger winter radishes. Enjoy the thinnings in salads. Dry soil and high temperatures make the roots tough and fiery tasting. Mulch around summer-planted radishes to keep the soil cool and moist and to suppress competition from weeds. Radish roots may split if they receive abundant water in the wake of dry soil conditions.

Harvesting

Begin pulling radishes as soon as they reach mature size—in 3 to 5 weeks for most spring-sown varieties and within 7 to 8 weeks for winter radishes. Radishes do not improve the longer they remain in the soil, especially when the

weather turns warm. Lingering roots lose their crisp, dense texture and become "pithy"—woody and tough—and strong tasting. Eventually, radishes left in the garden will bolt.

Pests and Diseases

Radishes growing quickly and in favorable conditions rarely are bothered by problems. Cabbage maggots may tunnel into a few roots but rarely damage an entire planting. Shiny black flea beetles can be troublesome if they feed heavily on the leaves of young seedlings.

Extraordinary Varieties

'D'Avignon', 'Easter Egg', 'Miyashige', 'Nero Tondo', 'Red Meat'

Scallion

Allium fistulosum **and others**

At Stonegate, we often tuck scallions between other spring greens, letting them shoot up like slender fountains between broader leaves. The purple varieties are particularly showy, and all scallions (members of the Allium family, which includes garlic, onions, leeks, ramps, chives, and shallots) will add zest and punch to the plate, whether served fresh, sautéed, or grilled.

Site and Soil

Shallow-rooted scallions need loose, fertile soil that remains moist but not soggy in a sunny to partly shady site. Dig in compost before planting. In wet or heavy soil, plant scallions in a raised bed well amended with organic matter.

Planting

Plant seeds of scallions in early spring, as soon as the soil can be prepared, 4 to 6 weeks before the last spring frost date. Start with fresh seed and sow thickly, ½ inch deep. Mix a few radish seeds in with the onion seeds to mark the rows and to serve as a trap crop for root maggots, which prefer burrowing into radishes but will go after onions. Make successive plantings every few weeks throughout the growing season for a steady supply of scallions into fall.

You can also sow seeds of bunching onions in fall, about 4 weeks before the first fall frost date, for plants that will overwinter for harvest in spring. Mulch young scallions with 4 inches of straw in fall; remove it in early spring.

Scallions also may be grown from onion sets—small bulbs sold in spring for planting. Plant sets in early spring, 2 inches deep and about 4 inches apart. Some can be used for green onions and others left to produce mature bulbs. Onion sets usually are offered by color—white, red, or yellow—while seeds allow for a selection of superior varieties of bunching onions.

Growing

Thin young seedlings to 1 inch apart and pull out and harvest radishes once they've fulfilled their purpose as row markers and root maggot traps. Keep onions evenly moist to prevent splitting that can occur in dry conditions. Apply mulch after the soil has warmed up to maintain soil moisture and prevent competition from weeds. Onions are poor competitors with weeds and dislike having their roots disturbed.

Harvesting

Begin pulling scallions for use as soon as they reach a suitable size. Most bunching varieties mature within 55 to 65 days.

Pests and Diseases

A few pests may bother onions being grown for large bulbs, but comparatively quick-growing scallions that are planted in favorable conditions and well-prepared soil usually are trouble free. Rotate onions of all types and any relatives—garlic and leeks—to avoid buildup of diseases or pests specific to the family.

Extraordinary Varieties

'Deep Purple Bunching', 'Nabechan', 'Parade'

Out of This World

With a CSA share this past week of neon purple kohlrabi, snap peas with their tender twining shoots thrown in, and a constellation of edible flowers, we're reaching into the beyond for taste and texture. Throw in the drumming and flooding rain and the freakish 17-year cicadas whirring about, and it feels like science fiction out there.

Kohlrabi is the Sputnik of brassicas. With its gangly, outrigged antennae and swollen, spherical center, you can almost imagine it floating silently in the cosmos. And snap peas, with their clambering tendrils and pods of remarkable sweetness, are also, metaphorically at least, out of this world.

Having descended from their skyward vines on delicate white parachutes of bloom, the 'Sugar Snap' pods have emerged to conquer our tastebuds. And (*sorry for this*) they've come in peas.

The ongoing space race at the farm is so 1960s. Where the peas are beginning to tower, indeterminate cherry tomatoes below are competing for light and nutrients, waiting for their turn in the sky. The peas have been fixing nitrogen in the soil (something legumes do) and will make it available for hungry tomatoes.

Lettuces, too, have been carrying on well into early summer, shaded as they are by the broad leaves of kale and chard; and nasturtium, squash, and pole beans are all in a delicious tangle for limited space. At Stonegate, the universe may be expanding, but it's not infinite.

At the moment, the war of the worlds is mostly being fought in the orchard, where the dreaded cicada mating and egg laying has begun in the fruit trees and brambles. Although I went about mercifully at first, unable to dash the hopes of so many unrequited 17-year-old virgins, I've had a change of heart. All it took was one look at a young quince tree, with its velveteen fruit full of promise but its outer branches collapsed and dying from the bark-piercing spawn of females cicadas, to turn me. They had me at *hell, no*.

So the cicada pogrom was on. Mating pairs were plucked in flagrante delicto from branch tips and crushed. Spent and feckless males were fed to excited chickens. Larvae-ridden bark has been thrown on the burn pile. It's a winless battle, I know, but maybe it will put a dent in the next brood, or my own exasperation.

The cicadas will fly to the treetops, mate, and die. The indeterminate tomatoes and pole beans and sunflowers will defy gravity and touch the sky, the surreal climbing squash and cucumbers will curl themselves upward, and we'll be down below, buzzed about it all. To paraphrase Oscar Wilde, "We're all in the gutter, but some of us are looking at the stars."

Harvesting sweet and crisp 'Sugar Snap' peas against a lush backdrop of 'New Dawn' roses.

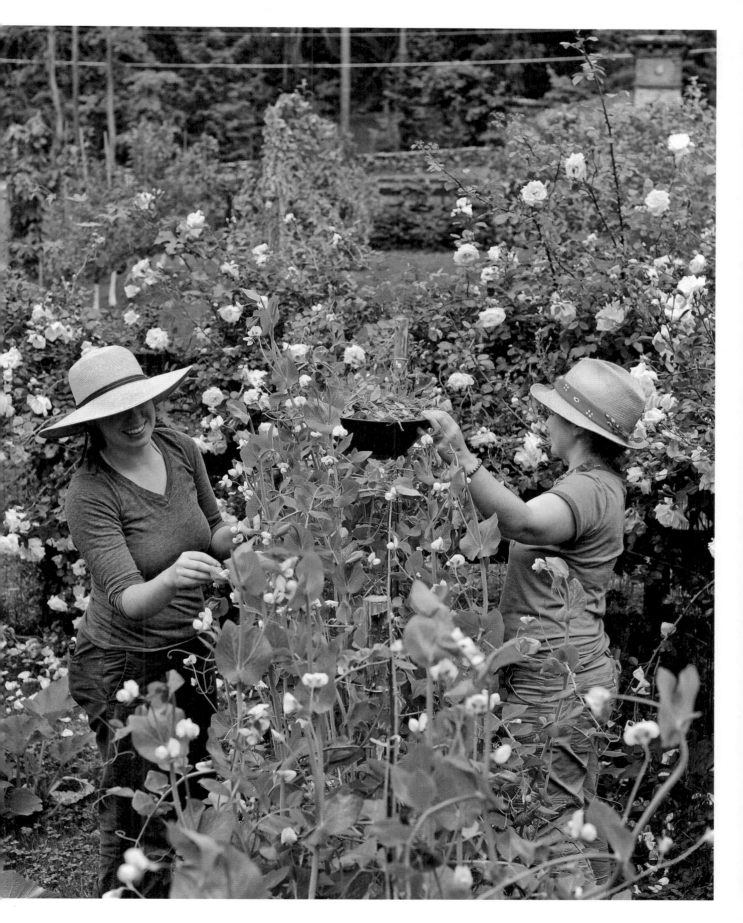

Cut Flowers, Herbs
& Edible Blooms

FLOWERS, WITH THEIR LOVELY, CHROMATIC whorls of color, are the divas of the growing season. Glamorous, fragrant, many petaled, they define our aspirations for cultivating beauty. But on the farm, these top models have to work a little harder; they need to be both beautiful and useful—as cut flowers that will hold up in a bouquet, as delicious edible additions to salads, or as indispensable aromatic herbs. *"Il buono e il bella"* (beautiful and practical), as the Italians say.

Organic flowers and herbs will add season-long beauty and ornament to the farm and are wonderful interplanted among beds as companion plants or just for a splash of color. Some will self-seed, and you'll have them enthusiastically popping up everywhere the following season, while others will need to be started again in spring. Many can be dried for long-lasting arrangements or mixed into herbal teas and tinctures, but their real virtue is simply to adorn the farm with beauty.

Flowers are harvested early in the morning, after the dew dries but before the heat of the day sets in, and repeat harvests throughout the season encourage more branching, buds, and flowers. Some of the best long-season annuals include zinnias, gomphrena, celosia, statice, snapdragons, sunflower, amaranth, and cosmos—all food for the eyes. Delicate and delicious pansies, nasturtium, calendula, and borage are food for the table, as well.

When I do my walkabout in the early morning at Stonegate—propped up by kitchen clogs and a strong espresso—it's the flower farm I head to first, not only because it catches the first splinters of light moving through the trees, but also because starting the morning on such beautiful, cultivated ground is a buffer against anything that could possibly come next. This is my wake-up call, and it's always the most perfect moment of the day.

CUT FLOWERS

Cut flowers are the heart and soul of the flower farm, and most of our floral space at Stonegate is dedicated to their cultivation. Because this is where you enter the farm when you visit, it needs to be a kind of *field of dreams,* planted abundantly with all the imaginable, exuberant color and form of annual blooms. Though these are working flowers, meant to be cut and sold for bouquets, they're also working to make a great first impression.

Amaranth

Amaranthus species

Amaranth's tall, torchlike spires light up the back of the cutting garden with their dramatic flames of deep purple and red. Besides adding height and boldness to cut flower bouquets, the young, handsome leaves of this vigorous annual are edible, and the seeds are used as a grain in Asia and South America. The deeply hued flowers are also a source of red dye in some cultures. Though the most common variety is known as love-lies-bleeding and has deeply pendulous blooms, we prefer the upright cultivars at Stonegate Farm for their bright, tiki-torch exuberance.

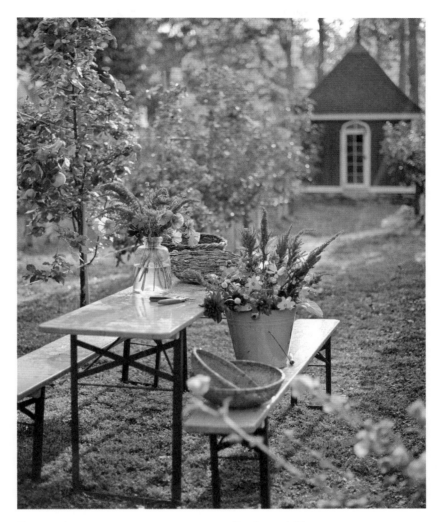

Site and Soil

Amaranths grow well in a sunny location in average soil that's evenly moist but well drained.

Planting

Start seeds indoors 4 to 6 weeks before the last spring frost date. Barely cover seeds sown in soil blocks or peat pots to minimize disturbance at transplanting. Where there is a long growing season, direct-sow amaranth seeds in prepared garden soil after the last frost date. Seeds germinate within a week at temperatures of 70° to 75°F (21° to 24°C). Transplant seedlings while they are small, but after danger of frost is past, spacing them 12 to 15 inches apart.

Growing

As long as the soil is well drained, amaranths grow easily into dramatic garden specimens 3 to 5 feet tall and 1½ to 2½ feet wide. Flowering amaranths such as love-lies-bleeding may require staking to help the tall stems support their heavy, drooping flower heads. Pinch shoots back to a leaf axil to promote branching. Seed-grown amaranths bloom within 2 to 3 months after sowing.

Harvesting

Cut fresh flowers when approximately three-quarters of the tiny blossoms of the flower head have opened. To harvest for drying, wait until seeds are setting and the flower heads feel firm. Hang in a warm, airy location to finish drying. Young leaves of amaranths are edible and may be pinched off as needed and cooked like spinach. The substantial inflorescences produce abundant edible seeds that can be threshed when dry and eaten as a grain. Birds may visit ripening seed heads to feast in late summer.

Pests and Diseases

Watch for clusters of aphids where leaves meet stems and for tiny spider mites on leaf undersides. Wash either pest from plants with a strong spray of water.

Amaranths growing in soggy conditions are prone to root rot; otherwise, plants are reasonably trouble-free.

Extraordinary Varieties

'Autumn's Touch', 'Burgundy', 'Four Star Explorer Mix', 'Opopeo', 'Polish'

Celosia

Celosia species

The upright, cone-shaped bristles of celosia, in shades of lavender, pink, and purple, add a lot of flair to the cut flower bouquet. Some varieties are shaped like small heads of coral or roosters' combs, but we prefer the narrow, quilled cultivars at the farm. They're easy to grow and will form a dense and vibrant planting that persists into fall.

Site and Soil

Plant celosia in full sun to partial shade in average to good, evenly moist and well-drained soil.

Planting

Start seeds indoors 6 to 8 weeks before the last spring frost date. Sow in peat pots or soil blocks to minimize root disturbance at transplanting. Where the growing season is long enough, seeds can be sown directly in the garden after the danger of frost is past. Barely cover the seed, which will germinate in 1 to 2 weeks in warm (70° to 80°F/21° to 27°C) soil. Move transplants to the garden 1 to 2 weeks after the last spring frost date, spacing them 6 to 12 inches apart.

Growing

Water regularly and feed plants with liquid seaweed or fish emulsion to help them produce the largest flower heads. Dry or cold soil and disturbances to their roots can slow celosias' growth and reduce flowering. Apply mulch around them after the soil is warmed, to keep it moist and to block weed growth. Tall crested varieties may need staking to help support their substantial flower heads. Deadhead faded flowers to keep plants blooming.

Harvesting

Cut the flower heads when they are fully opened. Hang in a dark, airy location to dry. Celosias keep their colors fairly well when dried.

Pests and Diseases

Soggy soil invites problems with root rots. Celosia is otherwise easy growing and relatively trouble free.

Extraordinary Varieties

'Cramer's Amazon', 'Flamingo Feather', 'Ruby Parfait'

Cosmos

Cosmos species

Despite their delicate, asterlike blossoms and lacy foliage, cosmos are tougher than they look and will stand tall in the back of the border all season long, swaying gently, waving their pretty pastel blooms. They come in a variety of colors and in single and double forms, but our favorites are the pale purple, pink, and white varieties. All cosmos are easy to grow.

Site and Soil

Give cosmos a spot in full sun in well-drained soil of just average fertility. Plants grow poorly in soggy conditions. In rich soil, cosmos tends to produce more leaves than flowers and becomes too tall and floppy.

Planting

Sow seeds directly in moistened, prepared soil in the garden after the danger of frost has passed. Keep the soil evenly moist until seeds germinate in about a week's time. Thin seedlings to about 1 foot apart.

Growing

Cosmos begins blooming about 10 weeks after seeds are sown. They can be started earlier indoors to give them a jump. To keep the flowers coming, deadhead regularly, removing faded flowers and stems down to the next set of leaves. Tall varieties may need staking to keep from flopping over, particularly in humid conditions. Late in the season, let some flowers remain to produce seeds. Birds will enjoy them, and some will likely fall to the ground to become next season's colorful bed of blooms.

Harvesting

Cut the flowers as the petals are opening but are not fully flattened into their classic daisy display.

Pests and Diseases

Cosmos rarely are bothered by pests or diseases, but can get powdery mildew later in the season. Large stalks should be staked.

Extraordinary Varieties

'Seashells', 'Sensation', 'Sonata', 'Candy Stripe', 'Collarette' (semi-double), 'Rose Bonbon' (double)

Gomphrena
Gomphrena globosa

Gomphrena grows on upright stems topped with lollipop-like blossoms in a profusion of colors that are pretty enough to give you a sweet tooth. Sometimes called globe amaranth, gomphrena is a different plant from its cousins in the amaranth family, delightful in its own right and wonderful for both fresh arrangements and for drying at the end of the season.

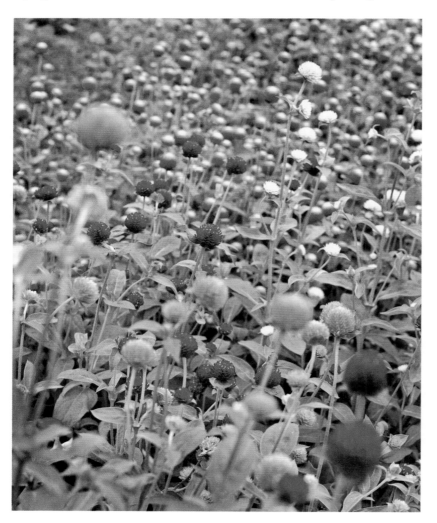

Site and Soil

Grow gomphrena in average, well-drained to dry soil in a sunny site.

Planting

Start gomphrena indoors 6 to 8 weeks before the last spring frost date or sow seed outdoors after the danger of frost has passed. Soak seeds overnight in warm water before planting and sow thickly to make up for gomphrena's typically low germination rate. Use a well-drained soilless mix for indoor seed starting and press the seeds into the surface. Cover the seed flat or put it in a dark location at 70° to 78°F (21° to 26°C) until seeds germinate in 1 to 2 weeks. Transplant seedlings to the garden when the soil is warm and the danger of frost has passed, spacing them 6 to 8 inches apart.

Growing

Pinch young plants to encourage branching and bushy growth. Gomphrena tolerates heat and dry conditions but grows best with regular moisture throughout the season. Tall varieties may need staking.

Harvesting

Cut flowers for fresh use when they display full color but are not completely opened. For drying, gather fully open flowers and hang them in an airy location. Gomphrena's bright flower heads hold their color well when dried.

Pests and Diseases

In their preferred growing conditions, gomphrenas rarely are bothered by pests or diseases. Humid weather and soggy soil can promote leaf spot diseases and molds. Prune or thin plants to improve air circulation, if necessary. Drought stress can make gomphrena susceptible to powdery mildew; avoid this by keeping the soil evenly moist.

Extraordinary Varieties

'Bicolor Rose', 'QIS Carmine', 'QIS Formula Mix'

Nigella

Nigella damascena

The blossom of nigella, or love-in-a-mist, emerges from a froth of soft, lacy foliage and bracts and forms a delicate sphere with a raised, tangled crown of stamens at the center. This exotic display would be beautiful enough, but the seedpods are what I love most. Like small, pleated lanterns, these pods add plenty of drama and flair to a late-summer bouquet. The pods also dry well and can be used in colorful, long-lasting arrangements.

Site and Soil

Nigella grows easily in average to good, well-drained soil in a sunny location.

Planting

Sow seeds in the garden in early spring as soon as the soil can be worked. Scatter them over the surface of prepared soil and cover them lightly. Germination takes place within 2 weeks as the soil warms up. Plant more seeds at 2- to 3-week intervals until midsummer for ongoing flowers and seedpods. Nigella forms a taproot that makes it difficult to transplant successfully, so starting early in flats can be difficult.

Growing

Water as needed throughout the growing season. Nigella grows best in cool temperatures and may fade in hot summer conditions.

Harvesting

Nigella begins blooming about 2 months after seeds are planted. Cut for fresh use when pods begin to form and most of the flowers on a stem are open. Harvest firm pods for use in dry arrangements.

Pests and Diseases

Easy-to-grow nigella has no noteworthy problems with pests or diseases.

Extraordinary Varieties

'Cambridge Blue', 'Miss Jekyll', 'Persian Jewels'

Thank You, You're Beautiful

"I must have flowers, always, and always," said Claude Monet, and, like him, Stonegate Farm is under the spell of a kind of wild floral alchemy this season, with organic cut flowers having their magical way with us.

With radiant blooms busting out all over, I think—even in his near blindness—Monet would have fumbled for a fistful of hog bristle brushes and gone at it, particularly the luminous, raveled clumps of nasturtium we have growing along our fencerows. These are the same flowers that still grow so beautifully underneath Monet's famous allée at Giverny.

There would be more for him to take in, of course: dark-plumed amaranth and velveteen sunflowers towering above it all with watchful Cyclopean eyes; the blue, upright bristle of anise hyssop or the radiant chromatic whorls of long-stemmed zinnias.

All of this color and form goes to my head (have you noticed?), but why not farm for beauty? If you're looking for earthly transcendence, you'll find it in flowers.

I'm up early and usually make a beeline (along with the bees) to the flower farm where, even in the half-light before the sun stretches through the trees, the blossoms are filling the air with fragrance. Besides the smell of dark espresso, that's all I want my nose to know.

The beds of anise hyssop, with their licorice-scented leaves and blue bottlebrush flower heads, are a heady experience, especially for the bees, who make a sweet, fragrant honey from the nectar. Planting for bee forage is important to the health of the farm. The orchard provides ample nectar flow in spring, while summer- and fall-blooming annuals from the flower farm round out the season.

Some of the best forage for bees are common weeds, such as dandelion, clover, and milkweed, and they're the very ones that we've banished from our gardens. With bees in trouble across the globe, it may be time to rethink the humble weed. It's just a flower in the wrong place, after all.

Flowers in the right place can make all the difference. Harvests from the flower farm always happen in the early morning, before the blossoms fully unfold, so that they're as fresh as possible for the CSA shares. With shears and buckets, they're carefully cut just above a new leaf node, with a quiet *thank you, you're beautiful* snip, and arranged into the week's bouquets.

It's hard to go wrong with any of these, and they all cast a spell, but the neon buttons of pink gomphrena paired with the molten, lava-lamp purples of celosia is one of my favorite combinations.

There is one flower above all that has my heart, however, and that's my daughter, Daisy. Lovely and sweet, she is all flowers to me.

My daughter, Daisy Marlena, with an early morning bouquet of Celosia 'Ruby Parfait'; upright plantings of celosia; newly picked 'Benary's' zinnias in warm pastel hues; and a scramble of tall and luminous cosmos.

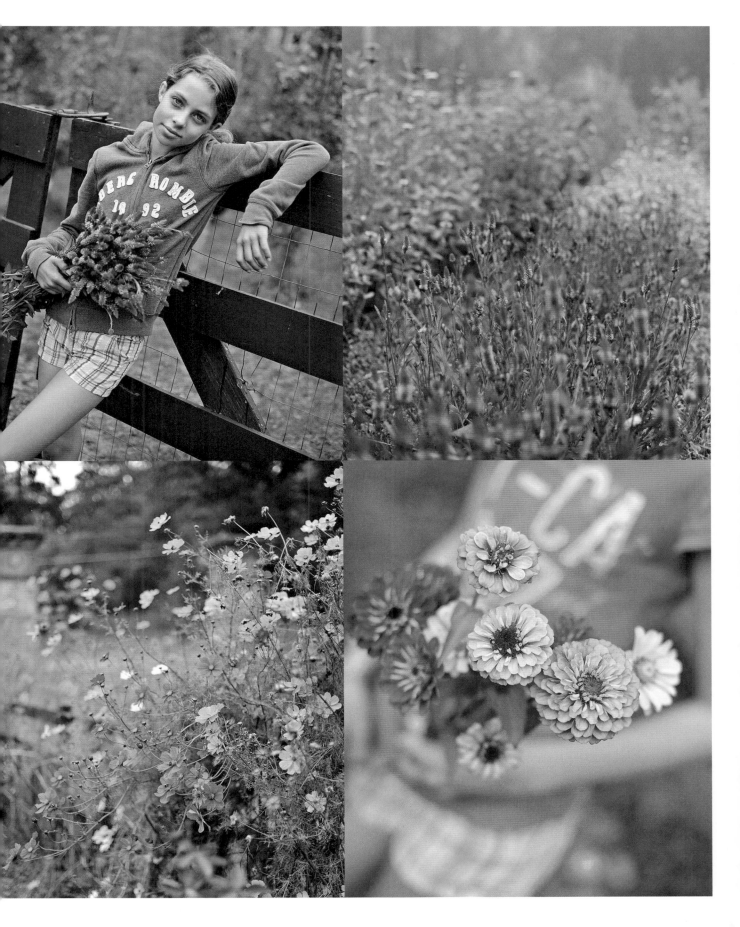

Snapdragon
Antirrhinum majus

The brightly colored multibloomed stalks of snapdragons add a beautiful cottage charm to the cut flower bed and are a favorite in cut flower arrangements. Emerging from the bottom up, the blooms of snapdragons clamber in a skyward whorl on long, elegant stems in almost every color except true blue. Children love snaps because they can pinch the individual blooms and watch the flower—like a dragon's mouth—snap open and closed.

Site and Soil

Plant snapdragons in a sunny to partially shaded location in light, humus-rich soil that is evenly moist but well drained.

Planting

Start snapdragons indoors 8 to 12 weeks before the last spring frost date. Sprinkle the seeds over the surface of moistened growing medium and press them in gently without covering—snapdragon

seeds need light to germinate. Put the container under lights and keep the medium evenly moist until seeds begin sprouting in 2 to 3 weeks. Water seedling trays from below to minimize the risk of rot.

Growing

Pinch the tips of seedlings when they have six leaves to stimulate bushy growth. Snapdragons prefer cool temperatures and can tolerate light frosts. Harden seedlings and transplant them to the garden 2 to 3 weeks before the last frost date, spacing them 8 to 12 inches apart to allow good air circulation around the plants. Water to keep the soil evenly moist and feed with liquid seaweed or fish emulsion every few weeks. Remove faded flower spikes to promote reblooming.

Harvesting

Snapdragons bloom 3 to 4 months after seeds are planted. Harvest spikes of flowers for fresh use when the blossoms on the lower third to half of the stems are open.

Pests and Diseases

Rust disease may show up on snapdragons in wet weather and humid conditions, starting as brown spots on foliage and flowers and eventually killing affected plants. Choose resistant cultivars and maintain good spacing in the garden. Water carefully to keep from wetting the foliage and remove plants showing signs of infection immediately. Plant snapdragons in a different spot in the garden if rust has been a problem in previous seasons.

Extraordinary Varieties

'Chantilly Bronze', 'Costa Mix', 'Rocket Mix', 'Twinny Appleblossom'

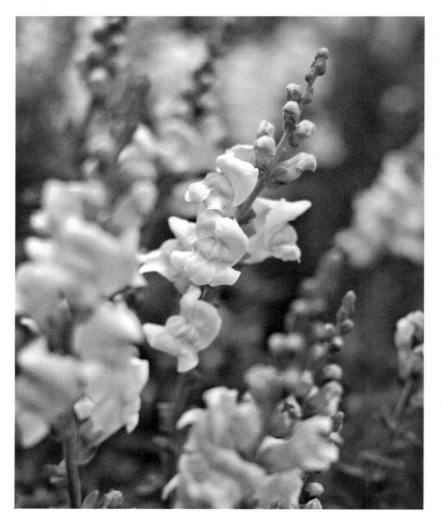

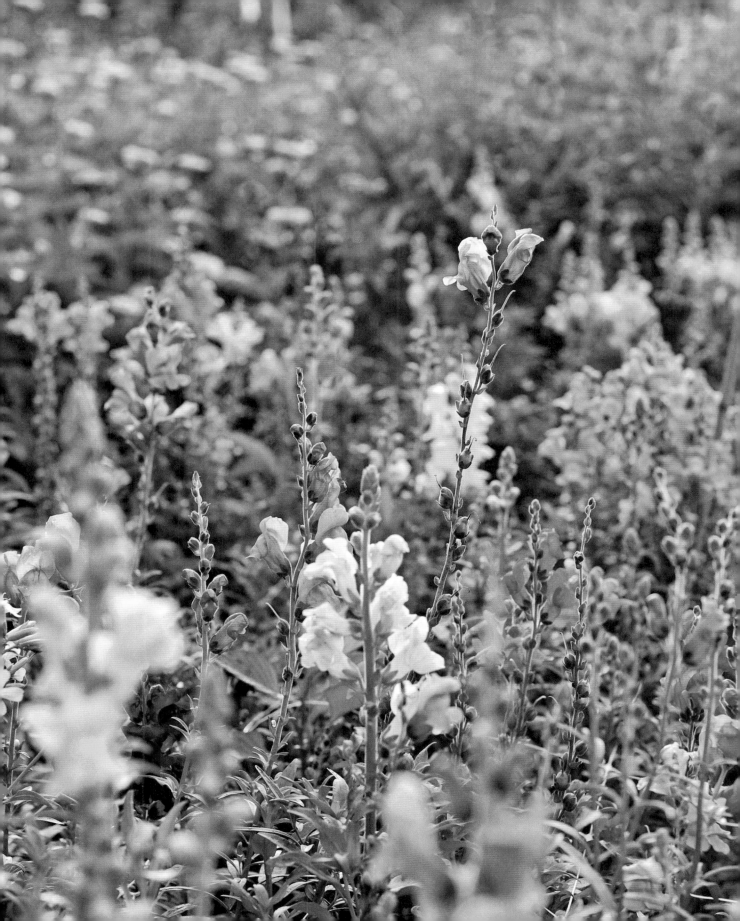

Sunflower

Helianthus annuus

For sheer height and summer drama, not much can top sunflowers. We tend to plant the multibranching, medium-height varieties (4 to 6 feet) at the back of the border, where their warm yellows complement the frothy purple sway of companion-planted amaranth and cosmos. Larger-headed varieties can be grown for their abundant seeds, as bee forage, or for their impressive scale alone. Nothing says summer quite like sunflowers.

Site and Soil

It's no surprise that sunflowers like a place in the sun in average to rich soil that is evenly moist but well drained. Choose a spot on the north side of the garden to keep towering sunflowers from shading other plants.

Planting

Sow sunflower seeds in prepared, warm soil, after the danger of frost is past. Seeds may be started indoors 2 to 4 weeks before the last frost date, but sunflowers grow quickly and dislike having their roots disturbed, so direct seeding is usually preferable. Plant seeds about ½ inch deep and keep evenly moist while waiting for them to sprout, usually within 1 to 2 weeks. Thin or space seedlings 1 to 2 feet apart, depending on the variety.

Growing

Established sunflowers are reasonably drought tolerant but benefit from supplemental watering in very dry conditions. Feed lightly, if at all, to keep plants from producing abundant foliage at the expense of the flowers. Mulch around sunflowers to limit weeds and root disturbance caused by weeding. Remove fading flowers from multi-stemmed varieties to encourage more flower production.

Harvesting

Gather flowers for fresh use when they are just starting to open and the ray flowers are not yet flattened around the central disk. Harvest flowers for seeds when the seeds begin to turn brown and the back of the seed head turns yellow. Cut flowers with a length of stem to allow for hanging them upside down in a dry, airy place to dry fully.

Pests and Diseases

Sunflowers rarely are troubled by pests or diseases. Watch for aphids clustering at the bases of flower buds and beneath leaves; wash them from plants with a strong spray of water. Cover flowers with cheesecloth or mesh bags to save seeds from hungry birds. Remove lower leaves if they become infected by leaf spot or mildew diseases. Avoid wetting leaves when watering to limit problems with disease.

Extraordinary Varieties

'Autumn Beauty', 'Buttercream', 'Moulin Rouge', 'Peach Passion', 'Starburst Lemon Aura'

Zinnias

Zinnia species

Zinnias are my favorite cut flower at the farm, and I plant more varieties of this flower than any other. There are giant, dahlia-like singles in bright polychromatic shades that yield over a long season and brighten up any bouquet. There are doubles, bicolors, and dwarf groundcover varieties, all heat tolerant and free flowering. For extraordinary, easy beauty over a long season, zinnias are a go-to favorite.

Site and Soil

Give zinnias a place in the sun in average to good, well-drained soil.

Planting

Zinnias are easy to grow from seed sown directly in the garden after the danger of frost is past. To enjoy their cheery blooms a bit earlier in the growing season, start seeds indoors 2 to 3 weeks before the last spring frost date. Sow seeds over prepared, moistened soil or growing medium and cover lightly; germination occurs within 3 to 5 days at 65° to 80°F (18° to 27°C). Use soil blocks, peat pots, or other biodegradable containers for indoor seed starting to minimize root disturbance at transplanting. Move transplants to the garden after the last frost date, when air and soil temperatures are reliably warm.

Growing

Thin zinnia seedlings or space transplants about 12 inches apart to promote good air circulation around the plants. Water only when the soil is dry, taking care to avoid wetting the leaves. Remove spent flowers to keep zinnias blooming until frost.

Harvesting

Cut stems for fresh use before the flowers are completely opened.

Pests and Diseases

Japanese beetles like zinnias and will munch on flowers and foliage when they get the chance. Handpick the metallic bronze pests into soapy water to put a stop to their feasting.

In humid weather, zinnias are prone to powdery mildew, a patchy, white fungus that coats leaves and stems. Resistant varieties are available and are a good idea where summers tend to be warm and sticky. Space zinnias to allow air movement, and water carefully and only when needed to further reduce the risk of powdery mildew. Soggy soil can cause problems with root rot; avoid planting zinnias in poorly drained sites.

Extraordinary Varieties

'Benary's Giant Mix', 'Giant Dahlia Flowered Mix', 'Persian Carpet', 'Profusion White', 'Queen Red Lime'

HERBS

All of the flavor and food we grow and eat on the farm would be diminished without herbs. They are almost as essential to preparing a home-harvested meal as the vegetables themselves. We tend to grow more than we'll need in a season, as they can be dried and stored, and we try novel varieties each year to keep things interesting. There's nothing like a Thai or lemon basil, variegated thyme, or a pineapple ginger to liven things up.

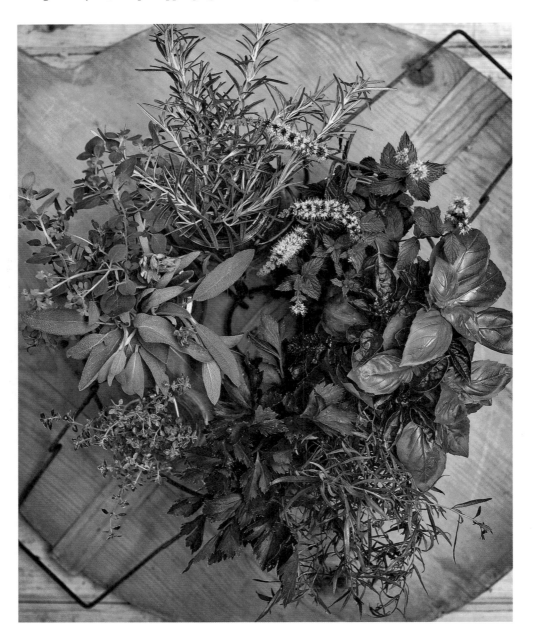

Basil

Ocimum basilicum

With its aromatic leaves and bristly, plumed flowers, basil is a must for the herb garden. Plucked fresh and tossed into pasta or a seasonal caprese salad with tomatoes, mozzarella, and olive oil, basil screams joyfully of summer. This annual herb comes in dozens of varieties, with flavors ranging from traditional peppery Italian to lemon, cinnamon—even licorice.

Site and Soil

Prepare a sunny spot for basil by digging in compost or composted manure to create rich, moist, well-drained conditions.

Planting

Basil grows easily from seed but requires toasty warm soil for germination (75° to 85°F/24° to 29°C) and reliably warm air temperatures throughout its productive life. Plant seeds a week or two after the last spring frost date, covering them lightly with sand or fine-textured soil about ⅛ inch deep. Or start seeds indoors 4 to 6 weeks before the last frost date and move transplants to the garden once the weather has settled. Thin or space plants 12 to 18 inches apart. Sow more seeds every 2 to 3 weeks until midsummer to keep a steady supply of this versatile herb on hand.

Growing

Basil may suffer cold injury if temperatures dip below 50°F (10°C). Be ready to cover plants if chilly nights are in the forecast. Water regularly and apply mulch to warm soil to conserve soil moisture. Weekly, pinch or snip off stem tips to above a pair of leaves to encourage branching, bushy growth and to forestall flowering. Pinch off flower heads to keep leaves coming.

Harvesting

Begin picking the outermost foliage from basil when plants have formed several pairs of leaves. Handle gently to avoid bruising and wait to wash until just before use. Basil is best when fresh and doesn't store particularly well—at temperatures below 40°F (4°C), the leaves blacken—so harvest as needed. When a large quantity is needed, gather whole stems or pull entire plants and strip them of their leaves.

Pests and Diseases

Downy mildew and fusarium wilt are fungal diseases that may affect basil. Buy seed from reputable sources and choose resistant varieties when available. Carefully inspect nursery plants before buying. Space plants for good air circulation in the garden and avoid wetting the foliage when watering. Don't harvest when plants are wet. Remove and destroy entire plants that show disease symptoms. These diseases can persist in the soil for years; do not plant basil in sites where infected plants grew in previous seasons. Clean up and discard all plant debris at the end of the growing season.

Extraordinary Varieties

'Amethyst Improved', 'Ararat', 'Genovese', 'Thai Magic'

Chives

Allium schoenoprasum

Chives are the first herb to emerge in spring, sending up tall, slender spears topped with purple blue, globe-shaped flowers. In exchange for very little care, perennial chives will return year after year, their onion-infused scapes flavoring almost anything they touch, while their moon-shaped blossoms do their part for edible beauty.

Site and Soil

Dig in compost in a sunny site to prepare it for chives. Like other onions, chives grow best in light soil that is moist but well drained, but they'll get along fine in any average garden soil.

Planting

Start chives from seed sown indoors in late winter and plant the seedlings in the garden in early spring when they're about 2 inches high. Or find a gardening friend who is willing to divide his or her chives to supply a few bulbs to get you started in either spring or fall.

Growing

Once they're settled, chives grow easily with little fuss or attention. The clumps of small bulbs increase gradually over the years. Divide as needed to create smaller clumps to share with friends or to plant in other places in your garden.

Harvesting

Pick rounded pink flower heads in spring to add color and flavor to meals. Remove flowerstalks after blooming; unlike the leaves, they are solid. Snip off a few inches of the slender hollow leaves as needed.

Pests and Diseases

Pests that trouble onions may also go after chives, but they are usually undisturbed by problems of any sort.

Extraordinary Varieties

'Fine Leaf', garlic chives (*A. tuberosum*), 'Purly', 'Staro'

Cilantro

Coriandrum sativum

A versatile plant that—along with its seed (coriander)—is the most widely consumed herb on the planet. But sow it, and you will also sow dissent, as cilantro polarizes people's tastebuds: Some taste delicious citruslike freshness, other taste metallic soap. Cilantro gives flavor to cuisines from Asia, the Middle East, South America, and Mexico and is easy to grow.

Site and Soil

Plant cilantro in average garden soil that is moist but well drained in sun to partial shade.

Planting

Sow cilantro seeds—which you may recognize as coriander—in warm soil after all danger of frost is past. Space the seeds 2 inches apart and cover with ½ inch of fine soil or sifted compost to provide the darkness necessary for germination. Plant more seeds every 2 weeks through summer for a ready supply of this versatile herb.

Growing

Cilantro seeds are really small fruits that hold two or more seeds. Once plants are 2 inches tall, thin to 4-inch spacing. Weed and water as needed; otherwise, cilantro is relatively carefree.

Harvesting

Plants reach harvestable size about 50 days after planting. Pinch or shear off leaves as they are needed. Young leaves have the best flavor. Leaf quality declines once plants begin blooming, but the flowers are favorites of many beneficial insects and, if left to finish their life cycle, will supply coriander for your kitchen. Cut off whole plants when the leaves and stems turn brown and hang them upside down in paper bags to catch the seeds that fall off as they dry.

Pests and Diseases

Few problems bother cilantro, but it is susceptible to a bacterial leaf spot disease that can disfigure the foliage. Buy seeds from reputable sources and avoid wetting foliage when watering to minimize the risk of disease problems.

Extraordinary Varieties

'Calypso', 'Marino', 'Santo'

Dill

Anethum graveolens

Dill's wispy, fernlike leaves and edible seeds add zest to pickles, soups, and sauces, and its Fourth-of-July bursts of bright yellow flowers on lanky stems are a pleasure for the eye. It's easy to grow and attractive to beneficial insects.

Site and Soil

Dill grows well in average to good, well-drained garden soil in a sunny location.

Planting

Plant dill seeds in early spring and every few weeks throughout summer. Dill needs light to germinate. Prepare the soil and then moisten it before scattering the seeds evenly over the surface. Gently press the seeds into the soil but don't cover them. Mark the spot where you plant it—dill may take as long as 3 weeks to sprout.

Growing

Keep the seedbed evenly moist while waiting for seeds to germinate. Thin seedlings to 6 to 12 inches apart, depending on the mature size of the variety being grown. Water regularly to keep the soil from drying out, which can prompt bolting. Dill may be prone to bolting in hot summer weather, but it tolerates light frosts and can be kept growing into fall in a coldframe or other protection from freezing temperatures.

Harvesting

Dill leaves will be ready to harvest starting about 40 days after planting. Snip off what is needed for fresh use; the leaves do not store well in refrigeration. Once dill begins blooming, the quality of the foliage declines. Let seeds mature on the plants until they are light brown, then cut off long flowering stems and hang them upside down in small bunches in an airy location to dry fully. Put the bundles in paper bags or hang them over sheets of newspaper to catch seeds that fall as it dries.

Pests and Diseases

Dill is fairly trouble-free. If you are inclined to share dill with 2- to 3-inch green caterpillars marked with yellow-dotted black bands, you may have the pleasure of watching the caterpillars become elegant black swallowtail butterflies. Usually, it's worth giving up a bit of dill in exchange for the miracle of metamorphosis, but if the dill is in danger of being overwhelmed, handpick and transfer them to alternate hosts, such as parsley or Queen Anne's lace.

Extraordinary Varieties

'Bouquet', 'Fernleaf', 'Veirling'

Fennel
Foeniculum vulgare

We grow two kinds of fennel at Stonegate—the bulb-forming type (also called Florence fennel or *finocchio*) and its leafy, nonbulbous sibling. Both plants produce handsome, feathery foliage in shades of lime green and copper and bring sweet, anise or licorice flavor to the table in all their edible parts.

Site and Soil

Grow fennel in rich, moist, well-drained soil in full sun. Dig in compost or rotted manure ahead of planting. In the garden, choose a spot for fennel away from bush beans, kohlrabi, and tomatoes, all of which can be negatively affected by nearby fennel.

Planting

Sow seeds of common (leafy) fennel early in spring, as soon as the soil can be worked. Florence fennel also may be sown early but is less likely to bolt if planted in midspring to early summer so it reaches maturity in the shorter, cooler days of early fall. Cover seeds lightly and keep the soil evenly moist during germination. Sow more seeds every 2 to 3 weeks to enjoy an abundant harvest of flavorful fennel.

Growing

Thin seedlings to 6 to 12 inches apart. Maintain even moisture throughout the growing season to keep fennel from bolting, which reduces the quality of foliage and bulbs. Weed carefully to avoid disturbing the roots. Mulch around fennel once the soil is warm to conserve moisture and block competition from weeds, but avoid putting organic mulch right up against developing fennel bulbs. Fennel will tolerate light frost. Be prepared to cover plants in fall if heavy frosts are predicted, allowing them to continue producing for a few more weeks.

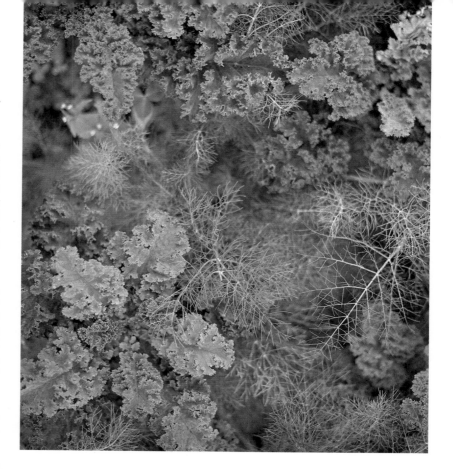

Harvesting

Begin harvesting feathery leaves about 50 days after planting, starting with the oldest foliage. If leaf fennel plants begin to bolt, let the seed heads mature on the plants until they start to turn brown, then snip off the flowerstalks and hang them upside down in a dry, airy location to finish drying. Put a paper bag over the seed heads while they dry to catch any seeds that fall.

Harvest fennel bulbs, actually swollen leaf stems, when the base of the plant begins to thicken. Use a sharp knife or pruners to cut at soil level, just below the bulb, and snip off the leaves about an inch above the bulb.

Pests and Diseases

Aphids sometimes find fennel foliage tasty. If you notice clusters of these tiny pests on the leaves and stems, wash them from plants with a strong stream of water.

While watering is important, fennel can succumb to root rot in soggy soil conditions. Good drainage is important to keep the deep roots healthy. Some of the same diseases that affect carrots can also afflict fennel, reducing the quality of the foliage. Healthy plants in good growing conditions are the best defense against most disease problems, along with rotation (rotate fennel with related carrots, celery, parsnips, and parsley) and good garden sanitation.

Extraordinary Varieties

'Giant Bronze', 'Grosfruchtiger', 'Orion', 'Zefa Fino'

Parsley
Petroselinum crispum

Parsley is so much more than a limp sprig of green on the side of the plate. This mildly bitter, biennial herb makes savory dishes even more savory and is packed with vitamins A and C as well as a host of other nutrients. Parsley is either flat leaved or curly and will lend color and vibrant flavor to salads, pesto, and soups. The flat-leaved varieties are generally better for cooking.

Site and Soil

A sunny to partially shaded bed with good garden soil that is moist but well drained will do just fine for parsley. Dig in compost before planting to prepare the site.

Planting

Start parsley seeds indoors 6 to 8 weeks before the last spring frost date. Parsley is a biennial, and its seeds can be balky about getting going. Soak seeds in warm water overnight before planting them ¼ inch deep in soil blocks or biodegradable pots. Make sure the seeds are covered by moist medium; they need darkness to germinate. Like its deep-rooted relatives, carrots and parsnips, parsley forms a taproot that makes transplanting tricky. The seeds may take up to a month to germinate. Keep the growing medium moist while you wait for plants to appear. When parsley seedlings are a few inches tall, transplant them to prepared, moistened soil in the garden. Space seedlings 8 inches apart.

Growing

Be quick to remove any weeds that encroach on parsley's space, and maintain even soil moisture. Water at the bases of plants rather than overhead to reduce the risk of disease problems. Mulch around parsley to block weeds and conserve moisture, but pull the mulch a few inches back from the plants' crowns. Mulching also prevents soil from splashing onto parsley's

leaves. In fall, use heavy-duty row covers to keep parsley growing until freezing temperatures arrive.

If left in the garden over winter, parsley may produce more foliage in spring. Side-dress awakening plants with compost, and snip off flower stalks as they appear. Plants will die once they have bloomed, but they may self-sow and produce small plants that can be potted up and moved indoors to produce tasty leaves during winter.

Harvesting

Use scissors to snip off outer leaves as they are needed. Whole sprigs or chopped leaves can be frozen or dried at the end of the season.

Pests and Diseases

The stripey green, black, and yellow-dotted larvae of black swallowtail but-terflies are often called "parsley worms," and these dramatic caterpillars may show up amid the foliage, munching away at stalks and stems. If you don't mind sharing, you can expect to enjoy beautiful butterflies in the garden in exchange for a portion of the parsley harvest. If caterpillars seem to be taking more parsley than you can spare, relocate them to nearby Queen Anne's lace or dill.

Parsley plants are susceptible to crown rot disease. Avoid overhead watering and keep organic mulch away from the bases of plants to minimize problems.

Extraordinary Varieties

'Giant of Italy', 'Moss Curled', 'Titan'

EDIBLE BLOOMS

It was E. E. Cummings who implored us to eat flowers and not be afraid, and we took him at his poetic word. The edible flowers we grow at Stonegate not only beautify any dish they accompany but also add flavors of their own, from the perfumed heat of nasturtium to the celery-like coolness of borage and viola. We add them to all of our salad mixes, desserts, stir-fries, and cooling summer cocktails—wherever beauty and flavor meet.

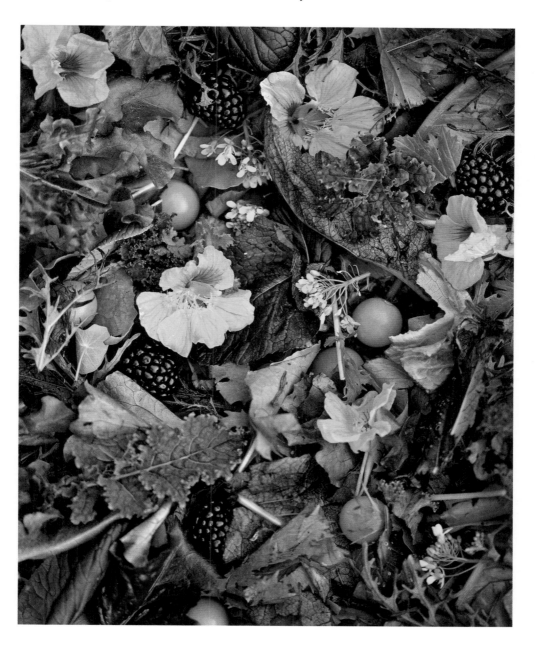

Anise Hyssop

Agastache foeniculum

Anise hyssop's delicate spires of brushy lavender are as beautiful in the back of the border (where the bees will surely be savoring them) as they are on the plate, sprinkled onto fruit salads or dessert, where their licorice-mint flavor is a delightful complement. The flowers and leaves can also be dried and made into teas.

Site and Soil

Good drainage is critical for the long-term success of perennial anise hyssop.

Prepare a site for it in sun to partial shade in neutral to slightly alkaline soil of average fertility.

Planting

Start seeds of anise hyssop indoors in late winter, sowing them on top of moistened growing medium and pressing them gently into the surface. Or sprinkle the seed over a prepared seedbed in the garden in spring or fall, covering lightly with fine soil or vermiculite. Fall-sown seeds will germinate the following spring. Keep things moist while waiting for seeds to germinate, which may take 1 to 2 weeks. Transplant seedlings to the garden when the danger of frost is past, spacing them about 2 feet apart.

Growing

Keep young plants evenly watered during dry weather. Established plants are relatively tolerant of dry conditions. Mulch lightly in late spring to conserve soil moisture and block weeds. In late summer, cut anise hyssop back by no more than a quarter of its height to remove faded flowers and encourage bushy growth. This can also stimulate a second round of blossoms. Anise hyssop will self-sow prolifically if flowers are left to mature on the plant. Although it is perennial in USDA Zones 6 to 9, anise hyssop may live for only a year or two. Take advantage of volunteer seedlings that pop up to replenish your garden.

Harvesting

Pinch or snip off flowers and young leaves as needed for fresh use. Gather leafy flower stems in summer to dry for use in teas.

Pests and Diseases

In a well-drained site, anise hyssop is largely trouble free, but plants growing in soggy conditions are prone to crown and root rots. In humid weather, powdery mildew, rust, and leaf spot diseases may disfigure the foliage. Good cultural conditions—even soil moisture and good drainage, good air circulation, and vigorous plants—help to minimize the risk of these problems.

Extraordinary Varieties

'Blue Fortune', 'Desert Sunrise' (*A.* hybrid), 'Golden Jubilee'

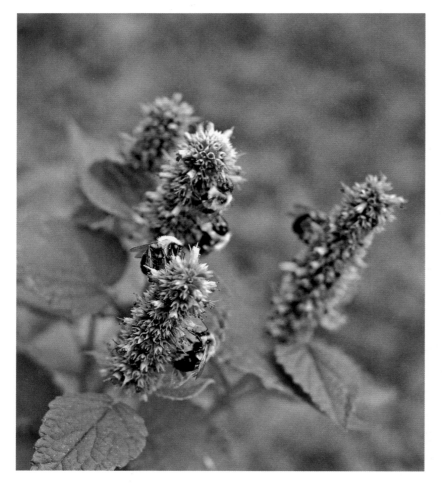

Borage
Borago officinalis

Borage is a large, bushy annual with clusters of delicate, star-shaped blossoms in shades of blue or pink. The flowers and leaves have a mild cucumber-like flavor that goes well with salads and cold soups. Bees love borage flowers, too.

Site and Soil

Plant borage in rich, moist soil in a sunny garden spot.

Planting

Sow seeds in prepared soil in spring when the danger of frost is past. Cover the seeds lightly and keep them moist during germination, which may take 1 to 2 weeks. You can also plant seeds in fall to sprout the following spring.

Growing

Thin seedlings 1 to 2 feet apart. Borage is a sprawling, gangly plant that needs room to grow. Although it's an annual, borage self-sows prolifically, so it will seem to come back each year. Transplant volunteer seedlings when they are small if they come up in unwanted locations. As borage grows, it becomes less tolerant of transplanting and other root disturbances. Keep young plants well watered but not soggy. Mulch around borage to conserve soil moisture and block weed growth. Established plants are reasonably tolerant of occasional dry spells. Pinching off a few inches of borage's stem tips—easily done while harvesting flowers—encourages branching and helps keep plants more compact.

Harvesting

Borage begins blooming about 50 days after planting. Pick off clusters of flowers and edible young leaves as needed. Borage plants are covered in fine hairs, and these can be quite stiff on older leaves, making them unpalatable.

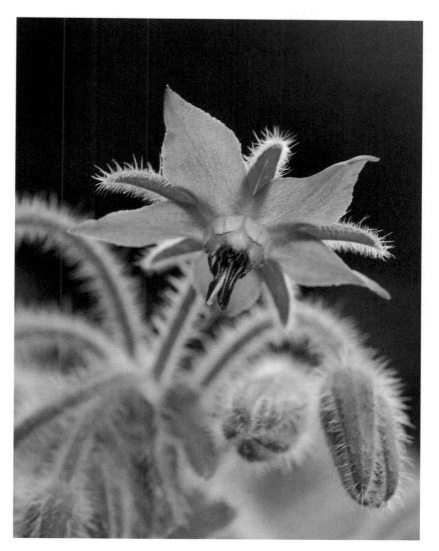

Borage flowers and leaves are best used fresh from the garden because their cucumbery flavor does not survive freezing or drying.

Pests and Diseases

Borage's furry foliage deters most pest problems, and it is largely untroubled by diseases, too.

Extraordinary Varieties

'Alba', 'Bianca', 'Bill Archer'

Calendula
Calendula officinalis

Edible calendula blossoms will add a bright and cheerful splash of yellow and orange to your salads, but they go beyond beauty by acting as an insect repellant and a benefit to soil fungi through their roots. Calendula's other talents (and its curriculum vitae is impressive) include its use in infused oils and lotions to treat rashes, as a substitute for saffron in rice dishes, or even as feed for chickens to darken their egg yolks.

Site and Soil

Any good garden soil in full sun to partial shade will suit calendula's needs, as long as it is well drained.

Planting

Plant fresh calendula seeds in prepared soil around the time of the last spring frost, or sow seeds indoors 4 weeks before that date. Cover seeds with fine soil or compost to exclude light, which interferes with germination. Keep indoor seed flats in cool conditions to produce sturdy seedlings. Germination takes 1 to 2 weeks. Transplant to the garden after the danger of frost is past, spacing them 6 to 12 inches apart.

Make two or three successive sowings in the garden in spring, separated by 2 to 3 weeks, to have continuous blooms from summer into fall.

Growing

Thin direct-sown seedlings to 6- to 12-inch spacing and remove competing weeds. Otherwise, calendula is a care-free annual that will begin blooming about 55 days after planting. Water or foliar feed with liquid seaweed or fish emulsion when seedlings are about 6 inches tall to encourage flower production. Remove spent flowers and pinch back stems to stimulate ongoing blooming and bushy growth. Flowers that remain on the plants will self-sow freely.

Harvesting

Gather fully open flowers as needed for fresh use in salads and soups and as garnishes. Calendula petals may be dried and used as a substitute for saffron.

Pests and Diseases

Aphids, caterpillars, and slugs and snails may pester calendula. Watch for clusters of tiny aphids on leaf undersides and at the bases of blossoms and wash these pests from plants with a strong stream of water. Handpick caterpillars into soapy water. Use ground-level traps baited with beer to lure slugs and snails to their doom.

Leaf spot diseases, powdery mildew, and other fungal woes can infect calendula, disfiguring the foliage and reducing plants' overall vigor and productivity. Good drainage goes a long way toward preventing disease problems, along with even soil moisture and careful watering to avoid wetting foliage unnecessarily.

Extraordinary Varieties

'Antares Flashback', 'Flashback', 'Neon', 'Rainbow', 'Zeolights'

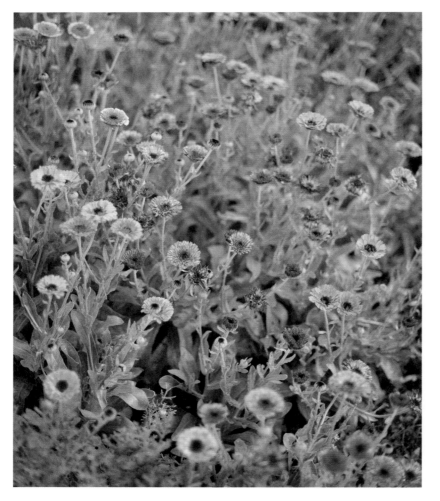

Nasturtium

Tropaeolum majus

One of our favorite flowers at the farm, nasturtium turns salads into edible art. With their glimmering, jewellike inflorescences in shades of deep red velvet, pale yellow, and hot orange, these flowers—and their disk-shaped leaves—add a delicious, peppery heat to salads, and the buds can be pickled like capers. They can be tucked into borders as a colorful base, and some varieties will even climb with support. There's a whole lot to love.

Site and Soil

Nasturtiums do fine in average, well-drained soil in a sunny location. In rich soil, nasturtiums tend to produce abundant, lush foliage at the expense of flowers. Where summers are very hot, nasturtiums benefit from partial shade in the middle of the day.

Planting

Two weeks before the last spring frost date, direct-sow nasturtium seeds where they will grow. Cover the seeds with ¼ to ½ inch of soil. Nasturtiums respond poorly to transplanting. To start indoors, sow seeds in soil blocks or peat pots 2 to 4 weeks before the last frost date. Germination takes 1 to 2 weeks when soil temperatures are 60° to 65°F (16° to 18°C).

Growing

Pay nasturtiums little attention and they will repay neglect with colorful, spicy flowers. Provide support for trailing types, which will need to be tied up if they are to "climb" a trellis, and water as needed. Keep nasturtiums a bit on the dry side and skip fertilizer applications altogether.

Harvesting

Pinch or snip off flowers, young leaves, flower buds, and green seed capsules as needed for the table. Apart from the buds and seed capsules, which may be

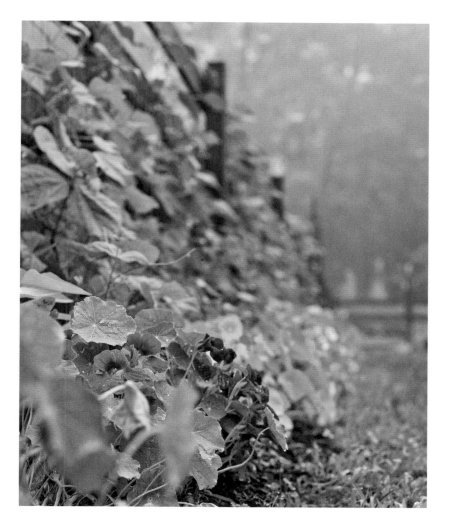

pickled, nasturtiums are best enjoyed fresh.

Pests and Diseases

Aphids are overly fond of nasturtiums, especially when the plants are lush from watering and rich soil. In fact, nasturtiums may be used as a trap crop to lure aphids away from other plants in the garden, which is not good news when nasturtiums *are* the desired crop. Patrol plants regularly for clusters of aphids on the undersides of leaves and below flowers; wash them off plants with a strong spray of water. Be on the lookout, too, for caterpillars, flea beetles, and slugs, and take action as needed to keep pests from disfiguring or damaging flowers and foliage.

Extraordinary Varieties

'Empress of India', 'Lady Bird', 'Moonlight', 'Vesuvius'

Incredible, Edible

Flowers are the narcissists of the garden, shouting from far above their lanky stems, or twining on high to get our attention: *Look at me, aren't I beautiful!* And they are! We take in their self-loving beauty easily with the eyes. But why not experience that splendor in the mouth by feeling a blossom's strange, pleated silk on the tongue? Birds do it, bees do it, why on earth shouldn't we do it?

At Stonegate, we've been tossing edible flowers into the salad mixes all season long, not only for their loveliness (although here at Fusspot Farm, aesthetics are reason enough to do anything), but also for taste and texture. The taste of most flowers subtly alludes to the flavor of the leaf, so the fragile inflorescence of arugula has a peppery bite, while the golden sprays of mustard flower are a three-alarm blaze of heat. Cucumber and squash blossoms are cool and mild and sweetly vegetal, and the blossoms of Asian greens have a deep mineral warmth.

When greens go to flower and seed, they usually give up their harvestable selves and get bitter, while fruiting vegetables move from flower to flesh. So blossoms are either a beginning or a postmortem in the vegetable garden; a wedding or a funeral.

Flowers have been enjoyed in foods for thousands of years. Romans used to toss mallow, roses, and violets into their pots; daylilies and chrysanthemums have been feasted on by the Chinese and Greeks for centuries. And capers, broccoli, and artichoke are all just unopened flower buds.

There are even flowers from the herbaceous border outside the walls of the vegetable garden that are fine to eat, including bee balm (*Monarda didyma*), garland chrysanthemum (*Chrysanthemum coronarium*), cowslips (*Primula veris*), daylilies (*Hemerocallis* spp.), English daisy (*Bellis perennis*), evening primrose (*Oenothera biennis*), fuchsia (*Fuchsia arborescens*), gardenia (*Gardenia jasminoides*), and hibiscus (*Hibiscus rosa-sinensis*). Forget the vase and get out the platter!

If you are a hapless sensualist, as I am, the more dimensional your experience of the natural world, the better. Why take something in with only one or two senses when they can all be indulged? More is more.

There is something vaguely salacious and decadent about eating flowers, of course. But that has more to do with culture and metaphor than fact. A flower in the mouth is unfamiliar; without the usual crunch of leaf or vegetable, it takes a moment for the tongue's rough, exploratory curiosity to figure it out. But once you've binged on a bouquet or two over the course of a season, as we do, the exotic mouthfeel is a gift.

Edible flowers take routine salads to another level of texture, flavor, and beauty. This harvest of nasturtium, calendula, arugula, broccoli rabe, and folded squash blossom will bring visual delight to the table.

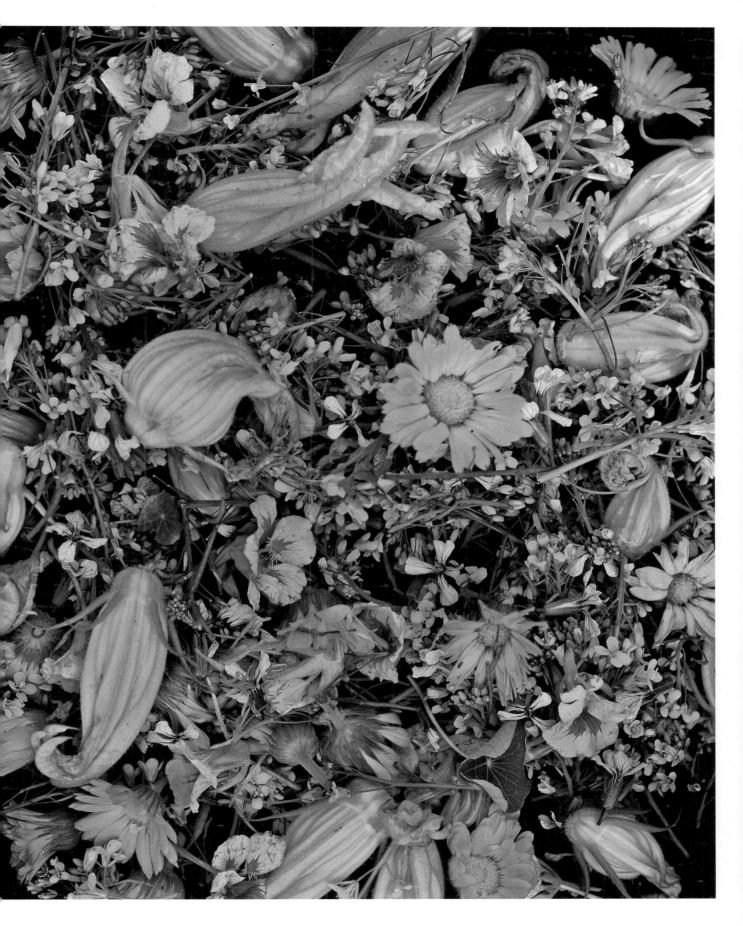

Berries, Brambles & Tree Fruit

WHEN THE ORCHARD FIRST CLOUDS ITSELF in puffs of fragrant bloom, stirring the nectar lust of thousands of bees, you know that spring has arrived. By midsummer, when the branches of fruit trees and the deeply nodding canes of brambles are burdened with sweetness and pearls of red and white currants dangle in delicate strands, all of the labor and love that go into raising fruit is rewarded.

If a small, organic farm has a provocation worth taking on, it's growing fruit. Loved by us, but also by countless insects, critters, and fungi, the organic orchard makes considerable demands on the grower. But properly managed, organic heirloom apples and pears, plums, sweet and sour cherries, gooseberries, black and red currants, blackberries, raspberries, and blueberries are worth the trouble; one delicious pie or crumble, or a fresh berry smoothie or fruit-scattered salad, will attest to that.

Planting dwarf fruit trees means they will bear sooner, yield abundantly, and take up a fraction of the space of standard varieties. And the small orchard can indulge in rare or unusual fruit that's often not available in the market. Historic apples, for example, with names like 'Keswick Codlin', 'Kerry Pippin', and 'Devonshire Quarrenden', seem to come from another time and place, with complex flavors and forms that evoke a time a century ago when more than 700 known varieties of apples were cultivated in the United States. Beauty alone is reason enough to cultivate orchard fruit, but throw in exquisite flavor, health, and history, and growing them is worth every fussy, coddling minute.

BERRIES

If pome and stone fruit are the showy tree ornaments in the orchard, then berries are the smaller, seductive swags of color and melt-in-your-mouth flavor that fill the lower canopy. Berries come in a range of forms, flavors, and colors, and at Stonegate, we've dedicated our orchard rows to a few tart favorites: black and red currant, gooseberry, and aronia berry. One reason is that these are hard to find in the market, and the other is that the sharp, dark flavors these berries have is an antidote to the ubiquity of oversweetened everything.

Aronia

Aronia melanocarpa

We grow a 75-foot row of aronia berry at Stonegate as a kind of hedge against mortality. It's so full of free-radical-fighting antioxidants and phytonutrients that we put up with its lip-puckering sourness and chalky finish just for the incredible health benefits. By freezing it and adding it to smoothies, or making preserves with a sweet complementary fruit, aronia will last well beyond the growing season.

Pretty enough to be used as a land-scape plant, it's hardy in USDA Zones 3 to 8 and demands little care once established. A few named varieties are available; these have generally been selected for improved fruit flavor and size. The fruits of the unimproved spe-cies can be quite tart, earning the chokeberry name, but don't confuse aronia with *chokecherry*, a wild species of *Prunus*.

Site and Soil

Plant aronia in understory conditions: full sun to partial shade, with rich, moist, well-drained, acidic soil. Aronia tolerates wet soil but dislikes droughty sites.

Planting

Plant in fall or early spring in soil amended with compost. Mulch after planting to protect developing roots and to keep the root zone moist.

Growing

Water during dry periods to maintain evenly moist soil conditions. Use a 2-inch layer of organic mulch to keep things cool and moist around the roots. Aronia forms a large multistemmed shrub, 6 to 8 feet tall, and can be grown as a fruit-bearing hedgerow that needs little tending other than occasional thin-ning to remove old or crowded stems.

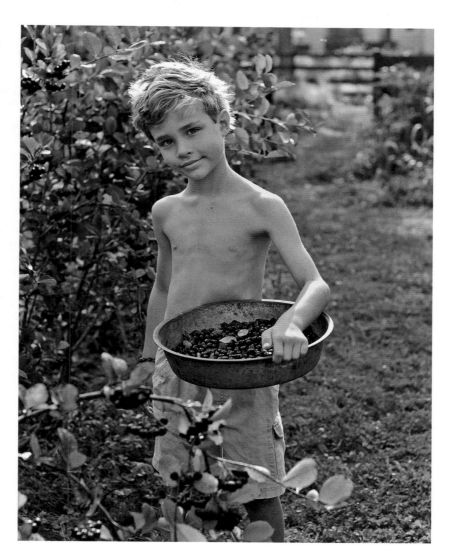

Harvesting

Pick clusters of fully colored berries in late August to September. Like the tart varieties of currants, aronia berries are used primarily for juice that is turned into jelly or syrup, made into wine, or blended with other juices for drinking.

Pests and Diseases

Pests and diseases seem to leave this hardy native alone.

Extraordinary Varieties

'Autumn Magic', 'Nero', 'Viking'

Black Currant

Ribes nigrum,
R. americanum, and
R. odoratum varieties

One of my favorite berries to grow (and we grow a lot of them at Stonegate), black currants grow on upright, multi-stemmed shrubs and bear profuse amounts of purple black fruit in dense, dangling clusters. The fruit has a complex, dark sweetness, reminiscent of an aged port—in fact, it's mixed with wine to make cassis. Black currants are also fairly easy to grow and will bear abundantly.

Both currants and gooseberries and—all members of the genus *Ribes*—have had to run from the law in the past. Because *Ribes* is a necessary host in the life cycle of white pine blister rust, a federal ban on planting currants and gooseberries was in place for a good part of the 20th century. Of little consequence to currants and gooseberries, the rust is devastating to white pines, and the ban on *Ribes* was meant to protect what was then an important source of timber. While federal prohibition on growing *Ribes* was lifted in the 1960s, restrictions still exist in some states. (New York, our home state, only lifted its ban in 2003.) Check with the Cooperative Extension office in your county before planting currants or gooseberries.

Site and Soil

Grow currants in full sun to partial shade (particularly in the southern part of their range) in evenly moist, well-drained soil amended with plenty of compost. They will grow well in most soil types except soggy situations. Currants bloom early; avoid low-lying frost pockets where their flowers may be damaged by cold. Choose a site with good air movement to reduce problems with powdery mildew.

Planting

Dig a broad, deep planting hole in prepared soil for black currants. Plant bareroot bushes in late fall or early spring, setting them in the soil 3 to 4 inches deeper than they grew in the nursery. Water thoroughly after planting to finish settling the soil in the hole, then apply a thick mulch to protect the developing roots.

Growing

Maintain 2 to 3 inches of organic mulch beneath currants to keep the soil moist and block weed growth. Promptly hand-pull any weeds that pop up to avoid the need to cultivate around currants' shallow roots.

Feed currants with a high-nitrogen organic fertilizer such as composted manure or alfalfa meal, spreading it over the root zone in fall before refreshing the mulch beneath the branches.

Black currants bear most of their crop on 1- and 2-year-old wood. During dormancy, prune out up to five of the oldest stems, cutting them back to the ground, and prune old lateral branches back to young side shoots. Remove crowded or crossing branches and any that are lying on the ground.

Harvesting

Harvest entire clusters of currants when the fruits are ripe and still firm and use them soon after picking. Convert black currants to juice or freeze them for longer storage.

Pests and Diseases

Currant borers are the larvae of a clear-winged moth. The caterpillars hatch from eggs laid in June on stems of currants and gooseberries. The first sign of borers' presence may be wilting stem tips in summer. Look for entrance holes and prune off infested stems below the point of entry; destroy the prunings to get rid of the pests.

Extraordinary Varieties

'Ben Sarek', 'Consort', 'Crusader', 'Titania'

Gooseberry

Ribes hirtellum **and** *R. uva-crispa* **varieties and hybrids**

Gooseberries are a lovely fruit: pale, translucent skin, pleated with ribs, with flavors that are alive and sharp with sun-formed complexity. The flesh is moist but firm and reminiscent of currants, only mellower.

This fruit is borne on large, spiny, vase-shaped shrubs that are hardy in USDA Zones 3 to 6 and grow best in areas with cool summers. A few gooseberries have been developed with enough heat tolerance to grow well in Zones 7 and 8, but southern climes may not satisfy their significant chilling requirements. Gooseberries are self-fruitful, so you only need one bush to enjoy an abundance of tart, succulent fruit.

Site and Soil

Gooseberries are less particular about their situation than many fruits, as long as their roots are moist and cool during the growing season. Full sun to partial shade suits them, in soil that is evenly moist (but not soggy) and slightly acidic. Keep gooseberries out of low spots where frosts may settle and cause damage to their early-opening blossoms.

Planting

Plant bareroot gooseberries in fall or early spring in soil amended with compost. Dig a broad hole that's deep enough to accommodate the roots and leave a cone of undisturbed soil in the middle. Arrange the roots over the cone of soil so that the uppermost root is about an inch below the soil surface and the bush sits slightly lower than it was in the nursery. Replace the soil removed from the hole, filling in around the roots and compacting it gently to eliminate air pockets. Water thoroughly after planting to finish settling the soil in the hole, then apply a thick mulch to protect the developing roots.

Growing

Maintain 2 to 3 inches of organic mulch beneath gooseberries to keep the soil moist and block weed growth. Promptly hand-pull any weeds that pop up to avoid the need to cultivate around gooseberry's shallow roots.

Fertilize gooseberries in late fall to late winter by spreading balanced organic fertilizer over the root zone before replenishing the mulch. Gooseberries are most in need of supplemental potassium and magnesium, while their nitrogen needs are modest.

Prune during dormancy, removing wood older than 3 years and thinning new growth to leave 6 to 12 new shoots. Remove crossing or crowded lateral branches. In July, prune the current season's lateral branches back to retain three to five leaves.

Harvesting

Pick gooseberries destined for pies and other cooked dishes before they are fully ripe. Let varieties meant for fresh eating ripen completely on the bush. Store the harvest in cold, humid conditions for 2 to 4 weeks.

Pests and Diseases

Early in spring, adult female black sawflies lay eggs on the undersides of gooseberry leaves, setting the stage for the appearance of imported currantworms, hungry sawfly larvae that typically begin feeding on a bush's lower leaves. Be on the lookout for spotted green worms munching on gooseberry foliage and wash them off plants with a strong spray of water or clip out heavily infested branches. Spray with insecticidal soap, if necessary, to put a stop to currantworms before they completely strip a bush of its leaves.

Powdery mildew appears on gooseberries as powdery white patches on foliage and progresses to infect fruits.

European gooseberry varieties tend to be more susceptible to mildew, but breeding programs have produced many resistant varieties. Sidestep mildew problems by choosing resistant varieties, avoiding excessive nitrogen fertilization that increases susceptibility, and pruning appropriately to improve air circulation around plants' leaves.

Because all members of the genus *Ribes* have been linked to white pine blister rust, some states may have planting restrictions. Check with the Cooperative Extension office in your county before planting gooseberries.

Extraordinary Varieties

'Invicta', 'Pixwell', 'Poorman', 'Tixia'

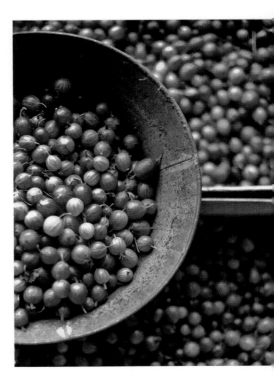

Red Currant

Ribes rubrum, R. sativum, and *R. petraeum* varieties

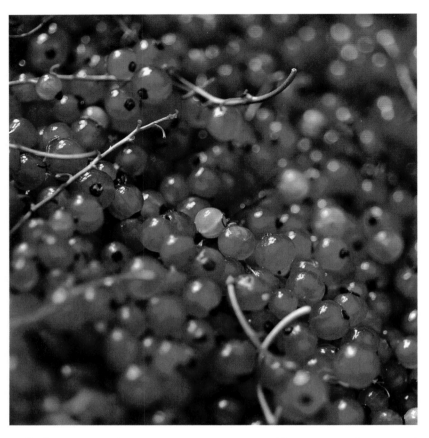

Red currants, hanging in loose, glossy strands from upright branches, are as delicious to the eyes as they are to the mouth, and when seen against the sun, the pearl-like berries are almost translucent. These vigorous, prolific, and easy-growing shrubs are hardy in USDA Zones 3 to 5. Most varieties are self-fertile, but some will be more productive in the company of another variety for cross-pollination.

Site and Soil

Red currants prefer cool, moist growing conditions and appreciate a bit of shade at the southern boundaries of their range. A sunny location on a north-facing slope will suit them, too. Soil of average fertility is fine for currants, as long as it is cool and evenly moist but well drained. Keep currants out of low-lying sites where settling frosts might damage their early blossoms.

Planting

Dig a broad, deep planting hole in prepared soil for red currants. Plant bare-root bushes in late fall or early spring, setting them in the soil so the uppermost root is about 1 inch below the soil surface. Water thoroughly after planting to finish settling the soil in the hole, then apply a thick mulch to protect the developing roots.

Growing

Maintain 2 to 3 inches of organic mulch beneath currants to keep the soil moist and block weed growth. Promptly hand-pull any weeds that pop up to avoid the need to cultivate around currants' shallow roots. Water as needed to maintain evenly moist conditions; currants fare poorly in hot, dry situations.

Feed currants with a high-nitrogen organic fertilizer such as composted manure or alfalfa meal, spreading it over the root zone in fall before refreshing the mulch beneath the branches.

Red currants may be grown as cup-shaped, multistemmed bushes with open centers or trained to stakes or against a wall as cordons, allowing for more currants in limited space. Prune in winter to remove crowded or crossing branches and stems that are more than 3 years old; 2- and 3-year-old wood is most productive.

Harvesting

Pick entire clusters—known as strigs—of currants for cooking as soon as they are fully colored. Red currants meant for fresh eating may be left on the bush to ripen for several days after they've turned red. Once they're harvested, be quick to convert currants to pies, jellies, sauces, and other tangy delights; the fresh berries do not keep for long after picking.

Pests and Diseases

Red currants are susceptible to the same problems as gooseberries and black currants, but they—and all *Ribes*—are reasonably trouble free. Lush, soft summer growth prompted by excess nitrogen fertilization can increase currants' odds of developing a couple problems. Aphids may cluster on the undersides of leaves and cause curling and reddening of affected foliage, but their damage is rarely consequential. If their numbers seem unusually large or if the damage appears to be more than cosmetic, wash the pests from plants with a strong stream of water. Otherwise, healthy plants in a diverse garden with lots of beneficial insects often will withstand a few aphids without intervention.

Extraordinary Varieties

'Cascade', 'Red Lake', 'Rovada', 'Wilder'

BRAMBLES

Clawing, thorny canes aside, brambles are among the easiest fruits to grow. Prohibitively expensive at the market, fragile, flavorful raspberries and plump, succulent blackberries can be yours to pick at their sun-ripened best in exchange for a truly modest amount of care. Everbearing varieties are the easiest, allowing you to cut them to the ground in late winter for a bang-up crop in season.

Although we call them berries, the bramble fruits are aggregates, clusters of drupelets that form around a central receptacle. When ripe, raspberries come free from their central core, while blackberries cling to the core, which comes free from the plant at harvest.

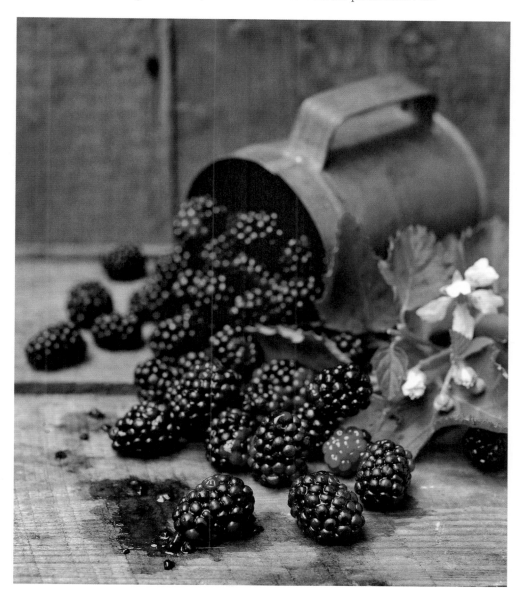

Blackberry

Rubus varieties

Lustrous blackberries the size of your thumb and blistered with juice are a late-season treat. We grow ever-bearing varieties at Stonegate, which fruit twice a year, in summer and fall, but we prune them back for one big bang of a harvest in fall.

Typically bigger and more vigorous than their raspberry relatives, blackberries thrive where summers are hot and humid and winters are mild (or where they are protected from intense cold). Most varieties are hardy in USDA Zones 5 to 9; thornless and trailing types tend to be less cold-hardy than thorny, upright varieties.

Site and Soil

Plant blackberries in full sun to partial shade in rich, loose, moist but well-drained, acidic soil. Good air movement around brambles helps keep them healthy. Avoid low-lying sites where cold air may settle.

Planting

Plant certified disease-free, bareroot plants in early spring, setting them 1 to 2 inches lower in the soil than they grew in the nursery. Keep the roots moist while planting and dig holes large enough to let the roots spread out naturally. Cut topgrowth back to about 6 inches after planting, and mulch to maintain soil moisture while the plants are getting established. Space blackberries 5 to 6 feet apart, leaving 7 feet between rows.

Growing

Care for blackberries in much the same way as raspberries, keeping them well watered during the growing season and feeding with compost in early spring, after dormant pruning is completed.

In early spring, prune out all but six to nine sturdy canes per plant and shorten the remaining canes to 6 to 7 feet. Cut off weak side shoots and shorten remaining side branches to about 1 foot long. Blackberries produce fruit on 2-year-old canes. Cut fruiting canes back to the ground after they are finished bearing in summer.

Harvesting

Pick blackberries when they are fully ripe, preferably early in the day but after the morning dew has dried. Ripe berries will come off the stems fairly easily. Place berries gently in shallow containers no more than a few layers deep. Store, if necessary, in refrigeration, for no more than a couple days. Wash or rinse right before use.

Pests and Diseases

Although blackberries are susceptible to most of the same problems as raspberries, they generally are trouble free and suffer few pests or diseases. Starting with healthy, virus-free plants, pruning appropriately, and maintaining good vigor usually keep problems from cropping up in the blackberry patch.

Extraordinary Varieties

'Darrow', 'Prime-Jan', 'Prime-Jim'

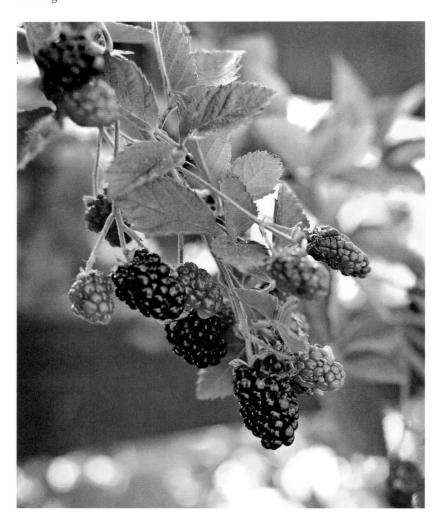

Raspberry
Rubus varieties and hybrids

Fresh raspberries are one of those seasonal delights people look forward to all year.

Bearing luscious fruit in shades of red, gold, and purple, arching raspberry canes range from fiercely thorny to barely prickly. Red varieties are the most cold-hardy and prefer cooler summer conditions. Black raspberries give up a bit in cold-hardiness but are more tolerant of summer heat.

Site and Soil

Grow raspberries in full sun in rich, loose, moist but well-drained, slightly acidic soil. In partial shade, raspberries will still be reasonably productive, but the plants tend to be more prone to problems. Good air movement around brambles helps keep them healthy.

Planting

Plant certified disease-free, bareroot plants in early spring, setting them 1 to 2 inches lower in the soil than they grew in the nursery. Keep the roots moist while planting and dig holes large enough to let the roots spread out naturally. Cut topgrowth back to about 6 inches after planting and mulch to maintain soil moisture while the plants are getting established. Space red and yellow varieties 1 to 2 feet apart and black raspberries 2½ to 3 feet apart, leaving 5 feet between rows.

Growing

Keep raspberries well watered throughout the growing season, particularly as fruits are developing. Drip irrigation makes this easy and reduces the risk of problems resulting from wetting the foliage while watering.

Use organic mulch around raspberries to reduce competition from weeds. Hand-pull weeds if necessary; avoid cultivating around brambles' shallow roots.

Fertilize by spreading compost over the root zone in late winter to early spring, around the same time as dormant pruning for summer-bearing red raspberries and black raspberries. Cut fall-bearing red raspberries to the ground after leaf drop in fall and spread compost over the top of the bed.

In very early spring, cut out any remaining fruiting canes of summer-bearing red raspberries and thin remaining canes to two to four strong canes per foot of row. Cut these canes back to 4 to 5 feet long.

Dormant-prune black raspberries by thinning canes to leave six to nine strong canes per plant and pruning side strong side branches back to 8 to 12 inches. In summer, prune off the tips of black raspberry canes when they reach 2½ to 4 feet tall to stimulate growth of sturdy side shoots for fruit production.

While raspberries are generally upright and self-supporting, training them to a simple wire trellis makes all aspects of care much easier.

Harvesting

Pick raspberries when they are fully ripe, preferably early in the day but after the morning dew has dried. Ripe berries will slip easily from their central receptacles. Place berries gently in shallow containers no more than a few layers deep. Store, if necessary, in refrigeration, for no more than a couple days. Wash or rinse right before use. If an abundant harvest leaves you with more raspberries than you can use immediately, spread clean berries on cookie sheets and freeze, then put the frozen berries into freezer bags.

Pests and Diseases

Good cultural practices—pruning and removing the clippings, for example, and keeping plants thinned and trellised—go a long way toward avoiding many problems that can affect raspberries.

Japanese beetles are highly visible pests of raspberries and can skeletonize leaves and damage ripe berries with

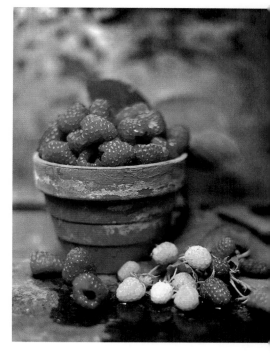

their feeding. Handpick beetles into soapy water or put traps at a distance from raspberries to lure them away.

Less visible but potentially more harmful are aphids and leafhoppers that feed on stems and foliage and spread viral diseases. Wash aphids from plants with a strong stream of water.

Viral diseases are the bane of brambles, infecting entire plantings and causing a gradual but inevitable decline. Start with virus-free plants, control aphid infestations, and remove wild brambles growing near your raspberry patch to limit the spread of virus woes. Remove and destroy wilted canes; those with distorted, discolored, or stunted foliage; canes with sunken purple spots or swollen galls; and any that display blackening upward from the soil.

Extraordinary Varieties

'Anne', 'Autumn Bliss', 'Double Delight', 'Fall Gold', 'Heritage', 'Redwing'

Nirvana

"Out of such chaos comes the dancing star," said my favorite dystopian curmudgeon Nietzsche, who may have come from farming blood for all I know. His obsessions with hardship and trial as paths to enlightenment, just like Homeric and Eastern mythology, are very much in the spirit of agriculture.

And if agriculture has a Grail—an odyssey of tribulation and effort—it's organic fruit.

Fruit is the most difficult thing we grow. When cultivating organic fruit, from pome (apple, pear, quince) and stone (plum, cherry) to thorny brambles, it's us against insects, fungi, birds, squirrels, chipmunks, and the rest of ravenous creation. Even the chickens went on a bender this week when a few cherries dropped to the orchard floor while we were harvesting.

Fruit is desire; it's forbidden biblical temptation. (We might still be living in sinless oblivion had Eve handed Adam a fistful of kale.) And while most fruit is sweet, tempting our evolutionary lust for sugar, I'm in love with sour: the sharp, lip-puckering sour of ripe currants or gooseberries, or the tang of tart cherries, bloodred and swollen, with stone-hard pits that must be spat. Maybe they just seem edgier, and a less obvious choice, given the physiology of taste.

Humans can sense five tastes: sour, salty, bitter, sweet, and umami (soy sauce–like fermentedness). Sweet has been something we've done way too well for too long and are paying the price in an epidemic of obesity and diabetes. We've been sugar bombed and beaten into a neophobic lull by agribusiness for decades. It's time for sour to have its moment.

Look at the growing popularity of the sour and bitter taste spectrum, from kombucha and hoppy beer to pickling just about everything, and it seems sour is making strides. Our bodies will thank us: Acids from sour fruit are crucial, since humans must get ascorbic acid from their diet (unlike most mammals, who can make their own), and if we don't eat it, we'll die of scurvy.

So what is it about tartness? Is it just that it's an antivenom to the corn-sweetened everything of our culture? "Sour foods are growing because of what they aren't: sweet," says Mark Garrison in the online magazine *Slate*. "With public health officials in open warfare with soda and corn syrup, the opposite of their flavor profile sounds an awful lot safer to many consumers."

Stonegate has been going sour since its inception, with black and red currants, sour cherries, goose-berries, and chokeberries (as in "choking on insane bitterness"). Cultivating fruit is what drew me to farming in the first place, plus an affinity for the work of 19th-century cultural stylist Andrew Jackson Downing and his ideas on both fruit cultivation and rural architecture. An orchard heavy with organic fruit seemed as close to the vault of agricultural nirvana as I could get.

I think Downing would have liked it here, even the way I first found it. The wonderful Gothicness of the place—clambered over by bindweed, wild grape, and lilac, with the lovely bones barely poking through a skin of neglect: Stonegate in the raw, abandoned to time and indifference.

Downing would have seen the potential, particularly now, with the orchard in its fullness, radiant and heavy with the sweet and sour glimmer of fruit, like Nietzsche's dancing stars, lighting up the farm.

Hothouse grapes, currants, gooseberries, and plums add their decadent gleam to the growing season. Pearls of luminous red currants and lip-puckering gooseberries are harvested in late June.

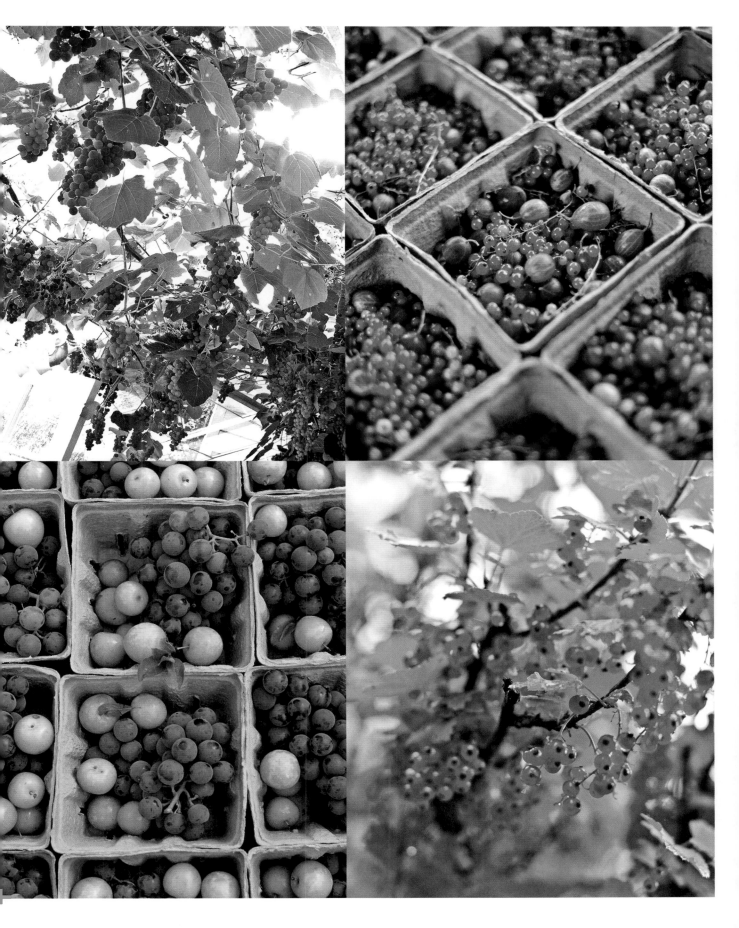

POME FRUIT

An organic orchard, branch-heavy with beautiful, rare, and historic varieties of fruit, was one of the images swirling in my head long before I began to farm. I'd painstakingly espaliered a few pears and apples in my first kitchen garden and got a taste for the delights of homegrown fruit. There were gooseberries, too, and figs, and a few scraggly currants that the birds always got to before me. But as soon as I'd put a fence around a thousand square feet of open land on my property, I knew what was to come: fruit, and lots of it.

Of course, with 19th-century pomologist Andrew Jackson Downing's long and deep shadow looming over my every move at Stonegate (he was born in Newburgh and is buried just up the road from me), I felt I needed to get this right. With Downing's 1845 *The Fruits and Fruit Trees of America* in hand, I spent a few weeks researching 19th-century varieties of apple and pear that Downing wrote about and admired. Then—miraculously—I found a rare fruit nursery in Michigan that had a few dozen varieties of these historic fruit in its nursery stock. The Downing orchard was beginning to take shape.

To connect more deeply with the history of my property, and to cultivate an edible landscape that had as strong a narrative with the past as my architecture, I was determined to plant fruit varieties from the period and earlier without hybridized resistance to common pests and only organic cultivation. I ordered 1-year-old branched apple trees with evocative names and an interesting life story, like 'Esopus Spitzenburg' (Thomas Jefferson's favorite apple), 'Ashmead's Kernel' (an early 18th-century English variety known for its "honeyed nuttiness"), 'Swaar' (grown by early Dutch settlers to New York who gave it its name, which means "heavy" in Dutch, and one of Downing's favorites), 'Celestia' (an apple Downing described as "crisp, tender, juicy"), 'Newton Pippin' (which George Washington grew at Mount Vernon), 'Hidden Rose', 'Roxbury Russet' (one of the oldest American apples), 'Maiden Blush', 'Surprise' (an early 19th-century hybrid with pink flesh), and 'Caville Blanc d'Hiver' (served at the table of King Louis the XIII of France in the mid-17th century). These apples have come into their own now in the orchard, bearing remarkable, complex fruit that would impress Downing.

Antique pears, like 'Vicar of Winkfield', 'Abbé Fétel', 'Beurré Gris', 'Fondante d'Automne', 'Sucrée de Montluçon', 'Seckel', and 'Winter Nelis', with a cataloged history dating back to the medieval gardens of France and England, form another row in the orchard, as do quinces. These long bands of antique fruit trees, particularly when they're in full and fragrant blossom or fruit, are something to savor and fix me more deeply to the history of this place.

Downing wrote—thoroughly and eloquently—about all of these, and my planting them not only promised an orchard sweetly burdened with rare fruit but also an interesting dialogue with Downing, a man who had been here and done this.

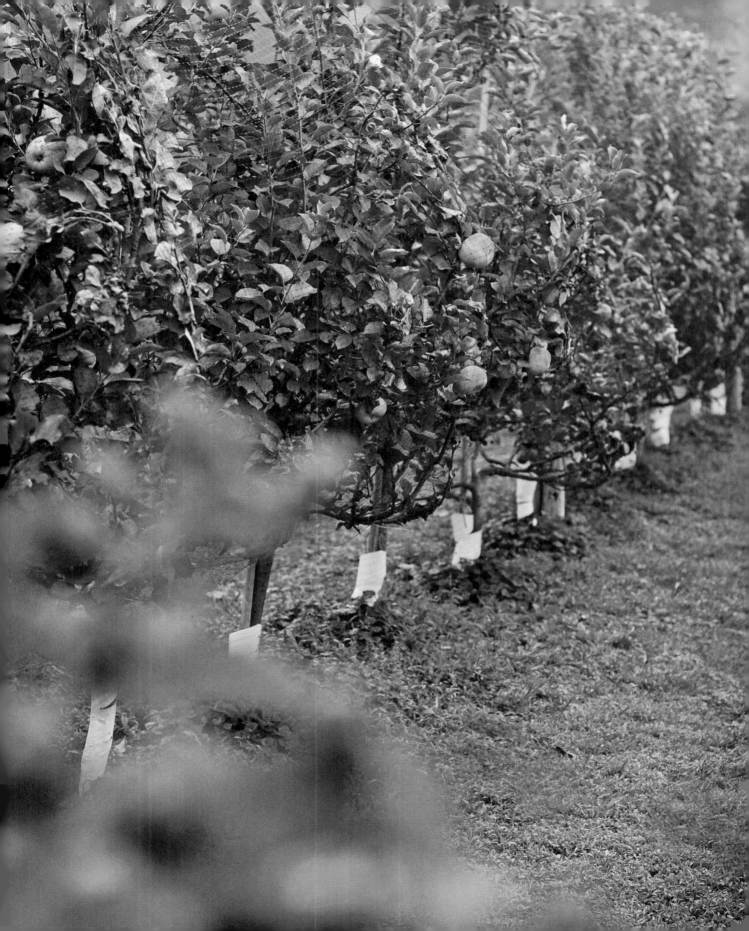

Apple

Malus varieties

The legend of John Chapman, or Johnny Appleseed, makes apple growing sound so easy: Just wander about strewing seeds far and wide, and apple trees are sure to follow. The truth is, successfully harvesting a crop of apples from your own trees takes more work, but they'll doubtless be the best apples you've ever tasted.

Do your homework before deciding which apple varieties to grow. Sample fruits at local orchards and farm markets to find your favorites. We grow historic fruit because that's part of our profile and mission at Stonegate, but choosing modern, disease-resistant varieties can reduce seasonal maintenance tasks. Most apples require cross-pollination by another variety to produce fruit, and some varieties don't make much pollen. Depending on which varieties you select, you may need two or three trees to provide adequate cross-pollination. Focus on varieties—both scion and rootstock—that are suited to your climate and growing conditions to avoid trees that struggle and grow poorly. Dwarf and semidwarf apples that are grafted onto a hearty quince rootstock have done well for us, producing bountifully. Their smaller size will mean you can plant more trees and have more varietal choice, and all the pruning, spraying, netting, and harvesting tasks are more accessible with trees their size.

Site and Soil

Because apple trees are a long-term investment, site selection is particularly important. Plant in full sun in well-drained, fertile, neutral to slightly acidic soil well amended with organic matter. Try to avoid low spots where the soil may be soggy and where frosts may settle. If you're worried about too much moisture, you can hill up and plant higher than grade to help with drainage.

Planting

Plant dormant 1-year grafted trees in early spring as soon as the soil can be worked. Dig a broad hole at least twice the width of the tree's root mass, leaving a raised cone of undisturbed soil a few inches high in the middle. Use a digging fork to loosen the bottom and sides of the hole. Spread the roots over the central cone of soil, checking to see that the graft union will be 2 inches above the soil level when the hole is filled. Make sure the trunk is vertical, then fill in around the roots with unamended soil removed from the hole.

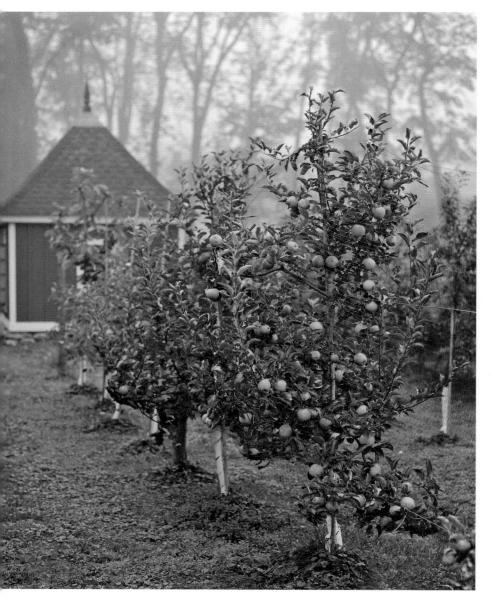

Gently press the soil down around the roots to ensure there are no air pockets that can let roots dry out. A firm press with the heel usually does the job. Water thoroughly and mulch over the top of the soil, keeping soil and mulch away from the graft union. We ran drip irrigation through our orchard to help the young trees establish themselves with consistent moisture.

Growing

Pay close attention to watering during the months after planting. Evenly moist soil—neither soggy nor dry—helps trees develop strong, healthy roots that will serve them well for years to come. Established trees benefit from supplemental watering in dry conditions during the growing season, particularly while they are blooming and as fruits begin to ripen.

Apply mulch around the base of each apple tree to conserve soil moisture and to prevent weeds and grass from competing for water and nutrients. In early spring, mulching each tree with compost, spread beneath the tree from 1 foot away from the trunk out to the branch tips, provides a gentle nutrient boost as well.

Sprays of liquid seaweed or fish emulsion in spring around the time of petal drop and fruit formation are also beneficial. Apply any fertilizers primarily in spring; feeding at other times of the year can stimulate soft growth that is inviting to pests and diseases and susceptible to injury from cold temperatures.

Dwarf apple trees require regular pruning and training to keep them productive and to maintain their desired size. Most apples are trained in a "central leader" configuration—a single upright central stem surrounded by four or five "scaffold" branches spaced evenly around the central leader. In subsequent years, additional scaffold branches are chosen above the original set, so the branches spiral around the main stem, allowing light to penetrate. Branches will compete for apical domi-

nance, so be sure to always choose a leader and stick with it.

At Stonegate, we've planted our orchard of dwarf trees in rows of 15 varieties 6 feet apart. These rows are supported by a two-strand trellis of 12-gauge galvanized wire strung between cedar posts. Young trees often need support, and the post-and-wire setup handles that, but more important, it allows you to train your young trees with more precision, tying branches to wire where needed and creating a more open form. This is close planting and trellising and will require careful training, but the reward is more fruit.

In addition to pruning to shape the tree, cut off any shoots that arise low on the trunk or at its base. Prune out crossing or rubbing branches and those that cast shade on lower ones, as well as dead or diseased branches.

Be prepared to take action if you notice pest activity or disease symptoms that seem likely to threaten fruit production or the tree's overall health. Ideally, a regular program of preventive care will keep problems from reaching levels that require additional management.

In late fall, refresh the mulch around trees, adding a 6-inch layer to protect the roots over winter but

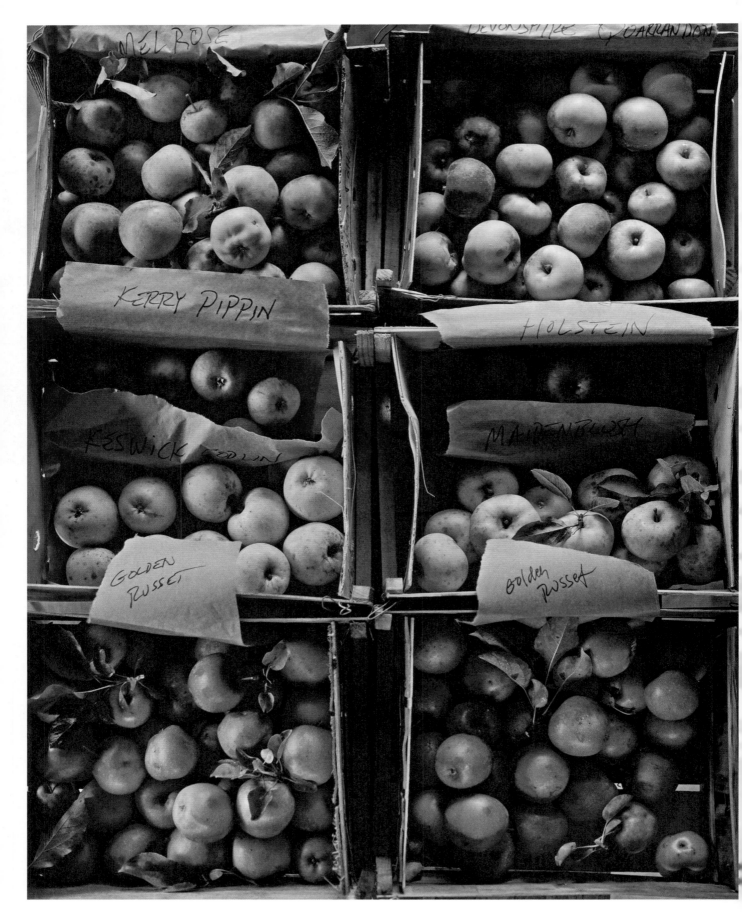

keeping it well away from the trunk to prevent rodents from nesting and feeding on the bark. In our orchard, we've used white plastic sleeves around the trunks that expand as the tree grows. Alternately, you can paint the trunk from the lowest branches to ground level with diluted white latex paint to prevent sunscald, as well as encase the base of the trunk with a 2-foot cylinder of wire mesh to further block rodent activity.

Harvesting

Apples ripen from late summer to late fall, depending on the variety. Know the approximate harvest window for the varieties in your home orchard and monitor fruit daily as that time approaches. Watch for changes in the fruits' underlying skin color—typically from bright green to yellowish—and for fruit that separates easily from the twig when gently twisted. Sample the first apples harvested to determine if they're fully ripe. Starchy, sour flavor indicates fruit that's not ripe.

Gather apples when they meet the variety's (and your) standards for ripeness, handling them carefully to avoid bruising. Store unblemished fruits in a refrigerator. Early-ripening varieties tend to have shorter lives in storage than those that mature later in fall. Use fruits that are bruised or otherwise damaged as soon as possible, since they won't keep well.

Pests and Diseases

The list of chewing, nibbling, scratching, tunneling, and generally infuriating pests and of troublesome infectious fungal organisms that may afflict apples is long. That's not to say that reasonably unblemished and worm-free apples are impossible using organic methods, only that producing a healthy, unbitten crop requires monitoring trees, good cultural practices, and following a regimen of organic controls. Your organic, imperfect apples will have all the flavor and character lost on most store-bought varieties.

In general, plan to apply a dormant oil spray in late winter to thwart overwintering pests. In spring and into summer, traps may be useful to monitor and control pests such as codling moth, tarnished plant bug, plum curculio, and apple maggot. Depending on variety, preventive sprays for other diseases or pests may be necessary. At Stonegate, besides dormant oil, we also spray with wettable sulfur for fungal diseases during the bloom cycle (at green tip and after petal drop). We also apply a very fine particulate clay (known as kaolin clay and marketed as Surround), which we dilute in water and spray on fruit immediately after petal drop and throughout the season. This organic clay coating, applied with a 5-gallon backpack sprayer, covers the emerging fruit with a fine, white film that discourages egg-laying insects from damaging the fruit; the clay is an irritant (imagine having sand in your joints) and will keep damage under control. It will need to be monitored and reapplied regularly throughout the season, as a heavy rain will wash it off.

We let our chickens roam the orchard, pecking at any fallen fruit and adding to their diverse diet. (It all ends up in the health and flavor of the eggs.) But chickens will also scratch and dig with their three-toed dinosaur feet, so we've run chicken wire over the roots of our trees to protect them. We also net our dwarf trees with 14-foot wide, 1-inch plastic netting to keep birds, squirrels, and chipmunks from stealing our precious fruit. We roll out the netting over the trees with a custom-built jig, then drape it around each side of the trees, tying it at the bottom with 14-gauge wire. It can be difficult to work with but will protect your fruit all season long. We remove it in the late fall for pruning. It's either prevention or be pillaged at Stonegate.

If deer are active in your area, be prepared to protect apple trees from their browsing during winter. Experiment with repellents such as bags of

human or pet hair and bars of deodorant soap to see what is most effective. Success often varies depending on how hungry deer are and what other foods are available to them.

Throughout the season, remove sprouts that arise at the base of the tree and both dead and diseased branches. Pick up fallen fruits to disrupt the life cycles of pests that occupy them. Clean up leaves in fall to keep diseases from overwintering in them and infecting next year's foliage. In winter, remove any lingering fruits and prune out diseased or damaged branches.

Extraordinary Varieties

Antique: 'Ashmead's Kernel', 'Caville Blanc d'Hiver', 'Celestia', 'Cox's Orange Pippin', 'Esopus Spitzenburg', 'Hidden Rose', 'Keswick Codlin', 'Maiden Blush', 'Swaar', 'Winter Nelis', 'Surprise', 'Duchess of Oldenburg'
Modern: 'Empire', 'Holstein', 'Honeycrisp', 'Liberty', 'Macoun', 'Melrose'

Pear

Pyrus varieties

Biting into the forgiving flesh of a perfectly ripe pear, as its thick, delectable syrup drips down the chin, is truly one of life's enduring pleasures, and growing your own pears will free you from the dearth of options in the supermarket—rock-hard proxy pears picked so early they will never ripen, no matter how long they sit among bananas on the counter, or mushy or mealy fruit that has been stored too long. Pears from the home orchard can be picked at just the right time, and there's no comparison.

Like apples, pears need cross-pollination to produce fruit. Plan to grow at least two varieties and make sure they are capable of cross-pollinating one another; not all pears have viable pollen. Pears are often grafted onto rootstocks that control their size or impart other desired characteristics, such as resistance to fire blight, a disease that can devastate pear trees.

Site and Soil

Plant pears in rich, moist, well-drained soil in full sun. Pears are more tolerant of damp, heavy soil conditions than many tree fruits but shouldn't be planted in a very soggy site. Pears bloom early, often putting their blossoms at risk from spring frosts; avoid low-lying sites where cold air may settle in spring.

Planting

Plant dormant bareroot pear trees in early spring as soon as the soil can be worked. Dig a broad hole at least twice the width of the tree's root mass, leaving a raised cone of undisturbed soil a few inches high in the middle. Use a digging fork to loosen the bottom and sides of the hole. Spread the roots over the central cone of soil, checking to see that the graft union will be 2 inches above the soil level when the hole is filled. Make sure the trunk is vertical, then fill in around the roots with unamended soil removed from the hole. Gently press the soil down around the roots to ensure there are no air pockets that can let roots dry out. Water thoroughly and mulch over the top of the soil, keeping soil and mulch away from the graft union.

Growing

Care for pear trees is much the same as described for apples, including training to a central leader. However, in warm, humid spring and summer areas where fire blight is a particular problem, keep pear pruning to a minimum to avoid creating wounds where the disease can enter trees. Do any pruning that's needed to shape and train in early spring, before trees break dormancy.

To increase their yields of fruit and to create stronger trees that are less prone to breaking, it's helpful to train pear trees' branches to overcome their strongly upright habit. By using spreaders between scaffold branches and the central leader or by hanging weights from the scaffold branches, the narrow angles of the branches can be opened to develop a less-crowded crown with sturdier branch angles. As we do with our apples, we train our branches onto orchard wire strung between posts, which is the simplest way to create an open habit. Pears are even more likely than apples to produce more fruits than a tree can support. Thin fruits to one or two per cluster about a month after trees finish blooming.

Harvesting

Pick pears before they are fully ripe, when their color changes from deep to light green and the fruits separate easily from the twigs with a slight twist. Cut a pear in half to be sure—ripe fruits have dark seeds. Sugary-sweet 'Seckel' pears are an exception; let them ripen on the tree before harvesting. Store pears in the refrigerator; ripen them at room temperature for a day or two before eating.

Pests and Diseases

Pear psyllas are tiny insects that are barely visible, but they can do substantial damage to pear trees by sucking juices from leaves and stems and by introducing viruses as they feed. Infested trees may turn black from the sticky honeydew the insects exude and the sooty mold that grows on it. If uncontrolled, feeding by psyllas can cause trees to gradually decline and die. Prevent these pests by spraying pear trees with kaolin clay in spring after the trees have finished blooming; repeat sprays as needed to protect the trees all season.

Blackened shoots that often are bent into a crook shape at the tips are signs of fire blight, a bacterial disease that affects pears, apples, and quinces. Resistant varieties and good cultural practices are the best defenses against fire blight. Keep pruning to a minimum to avoid creating wounds where bacteria can enter, and prune only during dormancy. Fertilize pears minimally and only in spring to limit lush, soft growth that also is a target for fire blight and pests.

Extraordinary Varieties

Antique: 'Abbé Fétel', 'Beurré Bosc', 'Beurré Gris', 'Fondante d'Automne', 'Seckel', 'Sucrée de Montluçon', 'Vicar of Winkfield', 'Winter Nelis'
Modern: 'Ayers', 'Blake's Pride', 'Maxine', 'Pineapple', 'Potomac', 'Warren'

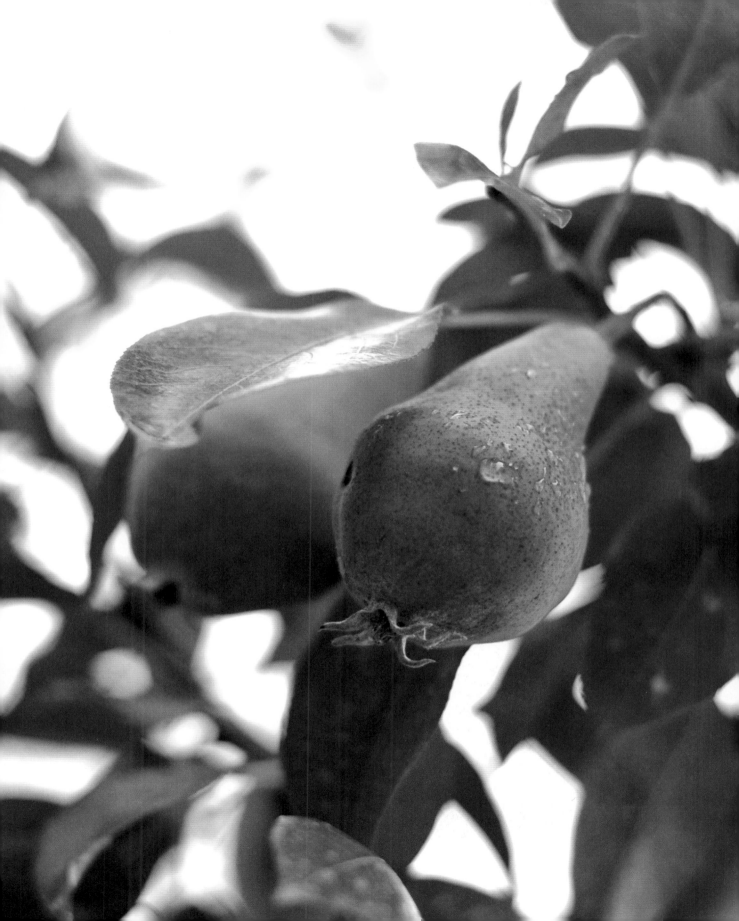

Quince

Cydonia varieties

Quince is often hard to find in the market, making it all the more valuable to the home orchard. Like a cross between a pear and an apple, quince's oblong, golden, aromatic flesh is delicious when turned into jams, pastes, or preserves or even poached for dessert. And a quince tree in bloom is a beautiful sight: Its blossoms unfold like pale pink roses. Unlike its more popular pome cousins, quince is a fruit used almost exclusively for cooking or preserving. The dense, astringent flesh of all but a couple varieties makes them nearly impossible to eat fresh. And don't confuse true quince—a small, sometimes multistemmed tree—with flowering quince (*Chaenomeles japonica*), an ornamental shrub, even though the latter also produces edible fruit.

Site and Soil

Give quince a sunny site in fertile, well-drained soil.

Planting

You can plant two or more varieties of quince to increase fruit production, but quinces are self-fertile and do not require cross-pollination to produce a crop.

Quince varieties usually are grafted onto dwarfing rootstocks that provide moderate size control. Plant in early spring while dormant as described for apples and pears, preparing a broad hole with a cone of soil in the middle and spreading the quince's roots over the soil cone.

Growing

After planting, water and care for quince as you would any newly planted tree or shrub. Quinces tend to grow broader and stockier than apples or pears and may be trained in an open-center arrangement—lacking the central leader described for apples—or as multistemmed shrubs. Prune young plants during dormancy in late winter to early spring to control size, if necessary, to remove dead or diseased branches, and to alleviate crowding in the crown of the plant. Quinces begin bearing 3 to 5 years after planting, producing flowers and fruits on the tips of the previous season's growth.

Harvesting

Quinces turn from green to yellow, shedding their fuzzy coating as they ripen. Leave fruits on the tree as long as possible, without exposing them to frost, to let them develop the best flavor. Cut fruits from the branches rather than twisting to avoid damage at the stem end that will reduce storage life. Handle carefully to avoid bruising; store in a cool, dry location away from other fruits, most of which will readily absorb the flavor and fragrance of the quinces.

Pests and Diseases

Quinces are prone to many of the same pests and diseases that trouble apples and pears. In fact, a quince tree may be useful as a trap for drawing pests away from other fruit trees, as long as you don't mind losing a few quinces.

Sprays to control codling moths, Oriental fruit moths, and scale insects should be factored into quince care plans, starting with a dormant oil application in late winter to early spring. Kaolin clay applications will also discourage egg-laying pests.

Fire blight is as threatening to quinces as it is to pears. Limit pruning to winter dormancy and avoid making any cuts or wounds during the growing season to avoid giving the bacteria an opening.

Extraordinary Varieties

'Champion', 'Fuller's', 'Missouri Mammoth', 'Smyrna', 'Vranja'

STONE FRUIT

Nothing speaks more evocatively of summer in the orchard than stone fruit: Plums, cherries, peaches, and Pluots all ripen around the same time in midseason and are the first tree fruits to bear. Given the right conditions (and members of the genus *Prunus* are demanding about their growing conditions), these soft fruits will relinquish impossible amounts of sweetness and in such profusion that all of the challenges of growing them will be quickly forgotten.

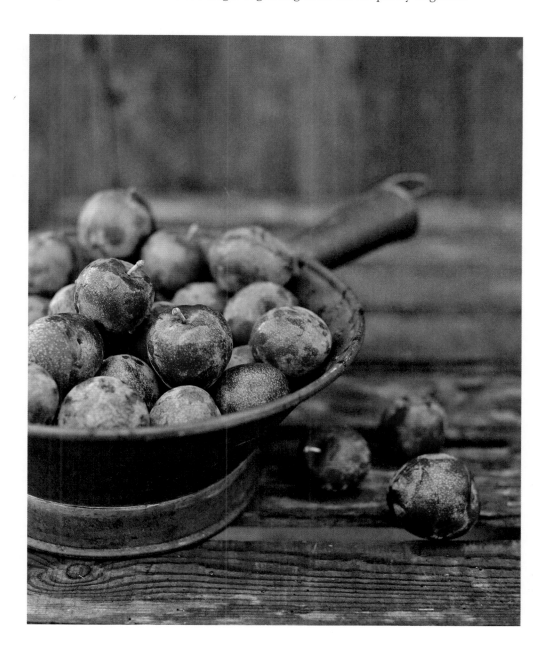

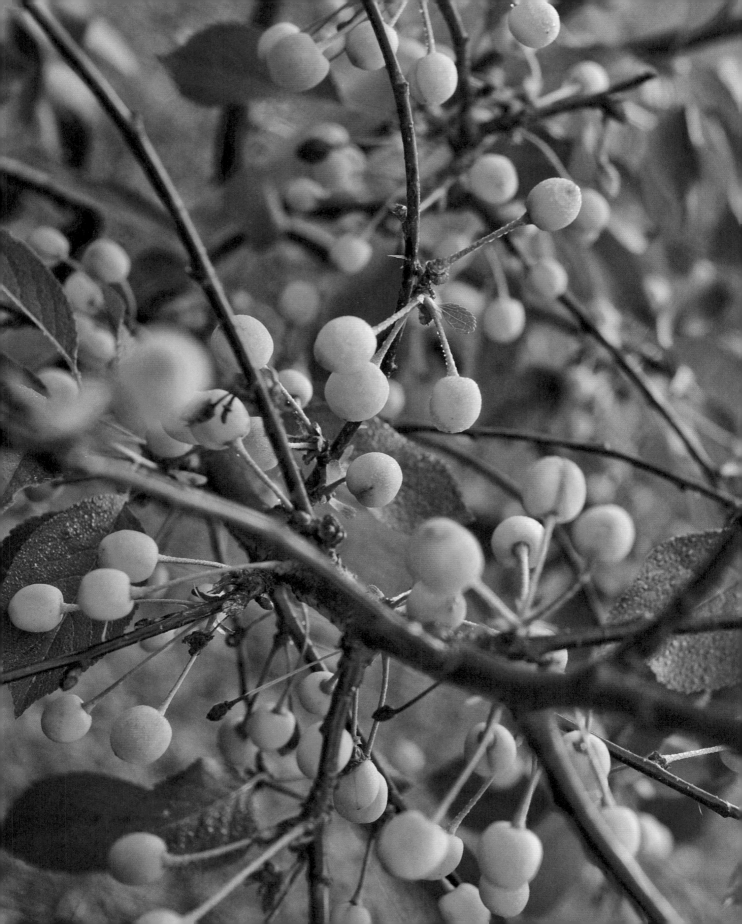

Cherry

Prunus avium and *P. cerasus* varieties

Cherries are the first trees to flower in my orchard, and they flower so abundantly that they seem almost covered in snow. Those flowers transform themselves into dense sprays of sweet and sour flavor by early summer.

The two types of cherries—sour (or tart) and sweet—have different growth habits and require different growing conditions. Sweet cherries can grow to be large trees that are hardy in USDA Zones 6 to 8, while sour cherries are small and spreading trees that favor cooler conditions in Zones 4 to 6.

Although a few are self-fertile, most sweet cherries need cross-pollination from a different variety that blooms in the same time frame. Sour cherry varieties are self-fertile; you can enjoy a harvest with just one tree.

Site and Soil

Choose a place in the sun with fertile, moist, well-drained soil and good air movement. Avoid low-lying sites where cold air may settle, particularly for sweet cherries whose earlier blossoms are at risk from late-spring frosts. Sour cherries are moderately tolerant of heavy soils but will grow better where the drainage is good.

Planting

Plant 1- or 2-year-old grafted trees in spring, preparing a broad planting hole that's twice the diameter of the rootball and deep enough to accommodate the roots while ensuring the tree's graft union will be at least 2 inches above the soil surface. Leave a cone of undisturbed soil in the middle of the hole and position the roots over it. Make sure the trunk is vertical and gradually replace the soil from the hole around the roots. In moist or heavy soil, cherries may be planted in raised beds or mounds to prevent problems related to poor drainage. Gently compact the soil over the roots to ensure good contact between roots and earth and to eliminate air pockets that can let roots dry out. Water thoroughly to further settle the soil in the planting hole.

Growing

Mulch after planting to maintain soil moisture and prevent weeds from competing with young trees. Water as needed throughout the growing season to keep the soil moist but not soggy.

Train young dwarf sweet cherries in a "central leader" arrangement—a single upright central stem surrounded by four or five scaffold branches spaced evenly around the central leader. Sour cherries more naturally assume an open-center shape. Use spreaders and/or weights on side branches to direct them outward rather than upward, controlling height and stimulating earlier fruit production. Once trees begin bearing, prune to let light and air into the center of the crown. Prune sour cherries annually in late winter; sweet cherries need pruning every few years.

Be prepared to follow a regular schedule of pruning, monitoring, and spraying to prevent and control disease and pest problems, starting with winter removal of diseased branches and late-winter sprays of dormant oil to control overwintering pests. Visit and monitor cherry trees regularly to ensure their ongoing health and to spot any developing problems before they get out of hand.

Harvesting

Cherries don't ripen after they're picked, so wait to harvest until the fruits signal ripeness by starting to drop. Sample a few to be sure, then pick carefully, pulling off clusters of cherries with the stems intact for better keeping. Don't pull off the twigs (spurs) that hold the stems—these will produce next year's cherries. Sour cherries will mellow and sweeten a bit if left on the tree to ripen for an extra day or two. But harvest promptly in warm, humid weather when the fruits can go quickly from ripe to rotten. Rainfall while cherries are ripening can cause fruits to crack.

Pests and Diseases

Cherries are both easy to grow and prone to a long list of pest and disease problems that can make them seem endlessly in need of care. Providing good growing conditions that keep young trees healthy and vigorous goes a long way toward preventing many problems. And maintaining a diverse garden around those trees invites the helpful presence of beneficial insects and microorganisms.

While there are many smaller pests that may want to take a bite of cherries as they grow, birds are often the biggest threat to ripening fruits. In short order, birds can strip a tree of its entire crop, leaving nothing for the gardener who has lovingly tended the tree for years to bring it to fruition. Birds are perhaps the best argument for dwarf cherry trees, since completely covering a dwarf tree with netting is easier—although still challenging—than getting a net over larger trees. Where netting is not possible, try a diverse and changing array of deterrents such as fake snakes and owls and shiny objects hanging from branches. Move these scare devices around frequently to keep birds from becoming accustomed to their presence. A mulberry tree, planted nearby but not too near, may draw birds away from cherries with its preferred fruits.

Extraordinary Varieties

Sweet: 'Bing', 'Black Tartarian', 'Emperor Francis', 'Lapins', 'Stella'
Sour: 'Balaton', 'Montmorency', 'North Star'

Plum

Prunus varieties

Compared to their fuzzy and opaque peach cousins, plums are smooth and glossy with jewel-toned, translucent flesh. There's nothing like a sun-warmed plum in the hand, just freed from the branch and about to explode with flavor in the mouth.

Plums represent species and hybrids of oblong European plums (*Prunus domestica*), damsons (*P. insititia*), round heart-shaped Asian plums (*P. salicina*), and bite-size native American plums (*P. americana, P. maritime,* and others). Fruit colors range from deep purple to rosy pink to gold, and flavors vary from sugary sweet to tart and tangy.

The various plum species and hybrids have somewhat differing needs. European plums and damsons are hardy in USDA Zones 4 to 9 and are at least partly self-fertile. Asian plums require compatible varieties for cross-pollination and are less hardy than

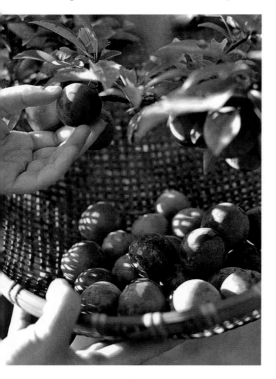

European plums but more heat tolerant (Zones 6 to 10). Native American species tend to be quite hardy but also require another plum for pollination.

Site and Soil

Site plum trees in a sunny location where their early blossoms are unlikely to be injured by late-spring frosts—avoid low-lying areas and southern exposures that may tempt them to bloom even earlier. Like other *Prunus,* they'll do best in loose, rich, well-drained soil, but plums—especially European varieties—are generally more tolerant of heavy soils than cherries.

Planting

Except in mild-winter areas, plant dormant bareroot 1- or 2-year-old plums in early spring. Prepare a broad planting hole that's twice the diameter of the rootball and deep enough to accommodate the roots while ensuring that the tree's graft union will be at least 2 inches above the soil surface. Leave a cone of undisturbed soil in the middle of the hole and position the roots over it. Make sure the trunk is vertical, then gradually replace the soil from the hole around the roots, gently tamping it down to ensure good contact between roots and earth. Water thoroughly.

Growing

Water regularly during the first growing season to help plums establish. Mulch the area around new trees to keep the soil moist and to eliminate competition from weeds, but keep the mulch at least 6 inches from trunks.

In early spring, spread an inch of compost over the soil beneath plums 6 inches from the trunk out to the branch tips. Foliar feed with liquid seaweed or fish emulsion after petal drop and throughout the growing season to enhance plant health.

Upright European plum varieties

usually are trained to a central leader configuration, as described for sweet cherries. Asian plums tend to have a spreading form that lends itself to open-center training, like for peaches. American plums may grow more like large bushes than small trees, depending on their parentage and any rootstock in use. Few native species are available commercially.

Prune to shape and train in late winter. Remove unwanted sprouts and crowded branches around the time the buds begin to open in spring. When plums begin bearing, take time to thin out overcrowded fruits.

Harvesting

Typical of stone fruits, plums do not ripen after harvest. Pick fully colored fruits that are slightly soft to the touch. Keep stems intact for longer storage; store plums in moist, cold conditions. Not surprisingly, prune plums (certain European varieties) are particularly good for drying.

Pests and Diseases

In various degrees, the problems of cherries may also afflict plums. Follow the guidance of your county Cooperative Extension office and the reputable fruit nursery you buy plums from regarding potential pest and disease problems in your area and strategies for prevention and control.

Black knot is a fungal disease that affects plums and, to a lesser extent, cherries, peaches, and apricots. Infected branches develop knobby, black, swollen galls. Infection occurs in spring when windblown spores land on fresh, new growth. Monitor plums for signs of black knot galls, and prune out diseased branches in late winter.

Extraordinary Varieties

Beach plum, damson, 'Methley', 'Redheart', 'Shiro'

Pluot

Prunus hybrids

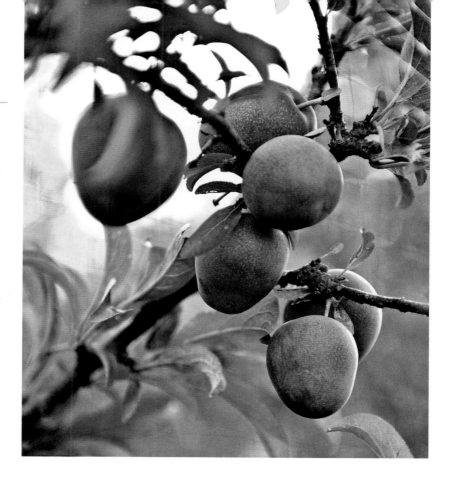

Pluots seem an invention of convenience: If you want all the flavor of a plum, without the drippy, plummy mess, look no further than Pluots. Plum flavors dominate (Pluots are about 60 percent plum), but the mouthfeel is that of an apricot, so drier and firmer. Pluots are also much sweeter than their plum and apricot parents.

Pluots are hybrids of plums (*Prunus salicina* and *P. cerasifera*) and apricots (*P. armeniaca*). On the spectrum of crosses between these species, the trees called Pluots (a trademarked name) are genetically closer to plums than hybrids named plumcots (originally a 50-50 cross), Apriums, or apriplums. Typically hardy in USDA Zones 6 to 9, the nature of these fruits tends to vary depending upon their parentage, as do their pollination requirements. Most Pluot trees need another Pluot or a Japanese plum for pollination, although some varieties are self-fruitful.

Site and Soil

Prepare a sunny site for Pluots in rich, evenly moist but well-drained soil that's been well amended with compost prior to planting. Pluots are somewhat tolerant of dry growing conditions but are unlikely to grow well in heavy, wet soil. Like their parent species, Pluots tend to bloom early, putting their blossoms in harm's way of late-spring frosts. Avoid planting in low spots where cold air settles.

Planting

Except in mild-winter areas, plant dormant bareroot trees in early spring. Prepare a broad planting hole that's twice the diameter of the rootball and deep enough to accommodate the roots while ensuring the tree's graft union will be at least 2 inches above the soil surface. Leave a cone of undisturbed soil in the middle of the hole and position the roots over it. Make sure the trunk is

vertical, then gradually replace the soil from the hole around the roots, gently tamping it down to ensure good contact between roots and earth. Water thoroughly to further settle the soil in the planting hole.

Growing

In general, grow Pluots like you would Asian plums. Follow any specific care and training instructions provided by the nursery.

Harvesting

Pick Pluots when they are fully colored and slightly soft to the touch. Sample a fruit or two to be sure they are completely ripe. Store ripe fruit in humid, cold conditions.

Pests and Diseases

Pluots are prone to the usual array of pests and diseases of *Prunus* varieties. Be aware of the potential problems that are common in your area and when to

take preventive actions against them. Plant in a favorable location, space trees appropriately for their mature size, prune to improve air circulation, and water and fertilize as needed to maintain healthy trees that will be less susceptible to problems of all sorts.

Bacterial leaf spot is a common disease of plums, apricots, and peaches in the eastern United States. Note that both of Pluots' parents are affected by this disease. Small dark spots appear on leaves; the centers of these spots dry and fall out, creating a characteristic shot-hole appearance. Fruits on infected trees develop small, sunken dark spots or cracks. Some Pluot varieties have resistance to leaf spot; otherwise, vigorous growth and appropriate pruning are the best defenses against infection.

Extraordinary Varieties

'Dapple Dandy', 'Dinosaur Egg', 'Flavor King', 'Flavor Supreme'

iPick

My own apple genius bar was set pretty high when I presumed that cultivating an organic orchard at Stonegate was even remotely doable.

The Cooperative Extension folks shook their Carhartt-capped heads at my callow ambitions; nurseries tried to sell me the same old dreary disease-resistant cultivars; and local farmers insisted that the Hudson Valley, with its centuries of apple production, had created its own Darwinian microcosm of ever-adaptive pestilence that would do me in.

It seemed without the regular puffing out of vast clouds of synthetic pesticides, I was doomed to harvesting bushels of rotting, inedible muck. Organic apples were truly forbidden fruit; a tired old trope for original sin.

So, of course—always one to succumb to a little biblical temptation—I planted them: historic apples with seductive, suggestive names like 'Hidden Rose', 'Maiden Blush', and 'Pink Sparkle'; those that sounded decent and honorable like 'Ashmead's Kernel' and 'Esopus Spitzenburg'; and a few that reeked of high-born patrician plant naming, like 'Duchess of Oldenburg', 'Devonshire Quarrenden', and 'Calville Blanc d'Hiver'.

The choosing of varieties (and there are 16 dwarf, spindle-trained apple trees in my orchard) was not entirely up to me. I have the ghost of Andrew Jackson Downing and his 19th-century tome *The Fruits and Fruit Trees of America* to thank for much of the fussy decision making.

Downing, who was the foremost pomologist of his time and had his nursery in Newburgh, just a few miles from my farm, is something of a legend in these parts. More than just a plant nerd, he was a prominent horticulturalist, landscape designer, and architect who cast a long and dazzling spell during his short life. (He died at 37, drowned rescuing others during a steamship fire on the Hudson.) When it came down to planting an orchard at Stonegate, I wanted Downing's help.

I spent weeks online, obsessed, looking for rare and historic apple and pear varieties that Downing knew and grew more than 150 years ago, and I stumbled across a quirky, cranky rare-fruit nursery on the southwestern tip of Michigan called Southmeadow Fruit Gardens—they even quoted Downing on the cover of their catalog! After cross-referencing varieties they were growing with ones Downing had written about and praised, I put in my order.

With minimally invasive organic pest management, the orchard at Stonegate has matured over the past 5 years, and the apples this season are the payout: Flecked and pocked and full of a kind of organic indignation for what passes for fruit these days, these are apples to be reckoned with.

We've just tasted some of the first remarkable fruit of that planting, with a bushel or more of 'Golden Russet', with its fine-grained flesh and bronze cheeks; 'Maiden Blush', flaring red over tender, yellow skin; 'Kerry Pippin', with its spicy, aromatic tang; and 'Hidden Rose', its flesh faintly streaked with pink—the apple of my i.

They may not be the prettiest *pommes* out there, but they've got plenty of organic personality. And unlike the dull, synthetic supermodels at the box stores, these apples have so much to say.

The ghost of 19th-century pomologist Andrew Jackson Downing haunts much of the apple growing at Stonegate Farm, influencing not only which historic varieties are cultivated but how they're grown.

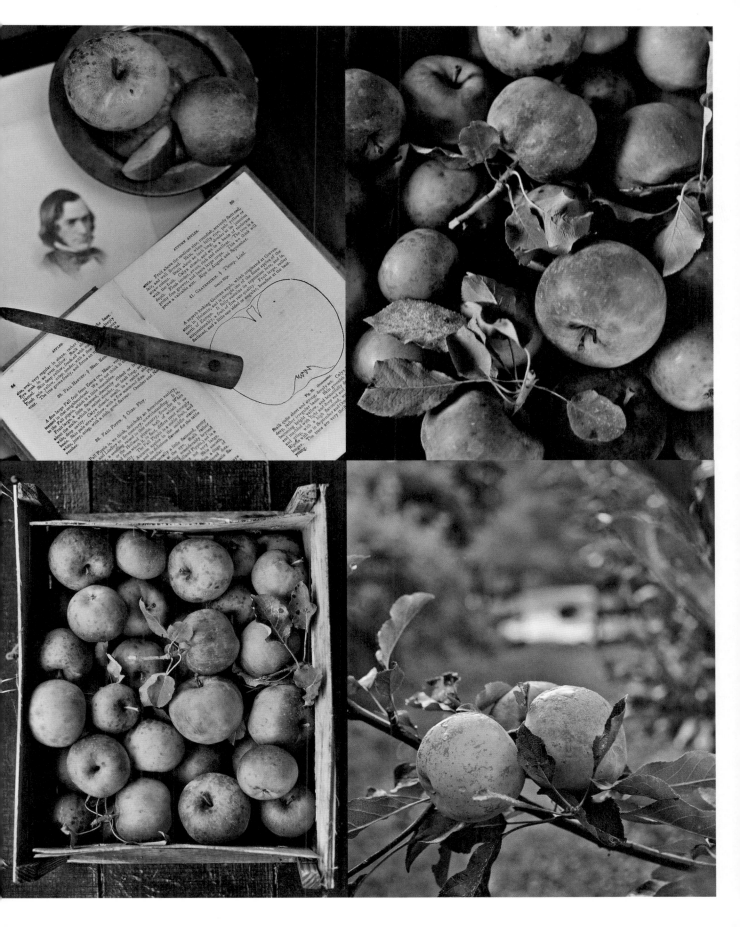

Chickens, Eggs & Coops

THERE'S NOTHING LIKE A FEW CHICKENS strutting and fretting around the farm to bring the place to life. For all their magic, walking about is something earthbound plants don't do. Chickens, on the other hand, cluck and peck and flutter like feathered perennials on legs. Brightly plumed and insatiably curious, chickens spend the day foraging for insects, seeds, and scraps; taking long, languorous dust baths; and murmuring praise to themselves for producing one of nature's truly elegant wonders: the egg.

Freshly laid eggs are a daily blessing at the farm, and a hen in her prime will average one a day. In muted tones of linen white, beach glass blue and green, and deep speckled brown, eggs from your own flock will be the best eggs you've ever tasted. Instead of industrial feed, antibiotics, and growth hormones, your flock will be pumped full of all the dynamic life and flavor of free ranging.

They're also great at keeping pests under control, and their droppings, if left to mellow, will add some serious high-octane nitrogen to your growing beds. Chicken care is pretty basic. Given decent shelter from predators and weather, clean water, and a healthy diet, they'll take care of the rest, the one caveat being that they might also take care of a few of your precious baby greens or dig a big dust bath in the middle of your bok choy. Chickens may not know a weed from arugula, but a little loss of green seems a small price to pay for the delicious, nutrient-dense eggs you'll be getting.

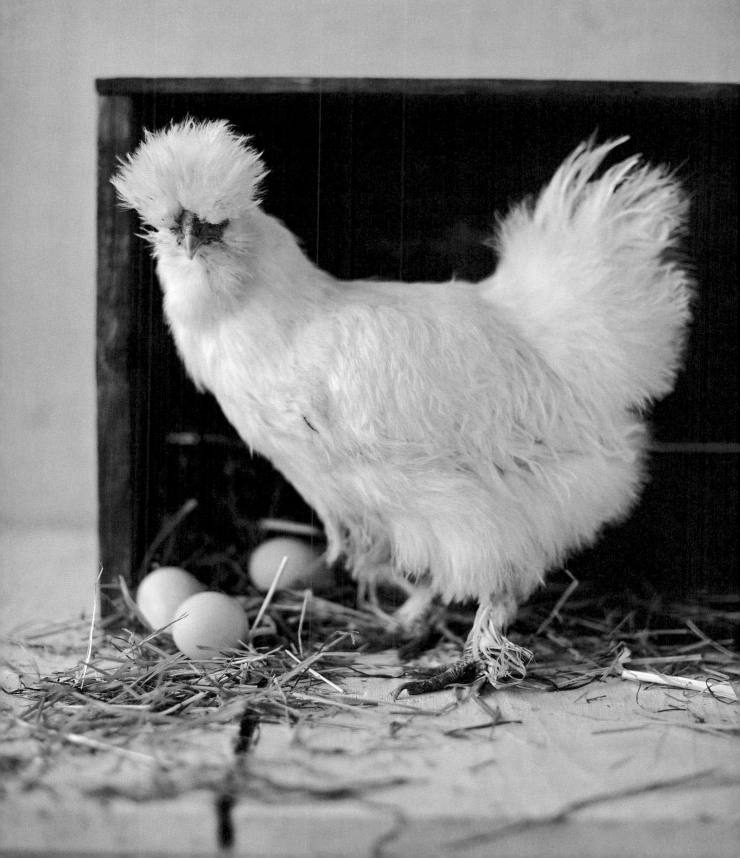

Why Chickens?

If ever there were a path to instant farm cred, a fallback to hopping up on your straw bale and shouting "Hey, I'm farming here!" chickens might be it. They clearly send the message that you're a serious and self-sufficient foodie. And knowing what we know about the wing-on-wing crowding and misery of most poultry farms, keeping a few contented chickens makes a lot of karmic sense. We eat with our eyes and minds as much as we do our tongues, and the sight of a small flock of freely ranging hens clucking about the property, happily creating delicious eggs, is an ongoing delight.

Supermarket birds, even those labeled "free range" and "organic," are usually fed an unnatural compromised diet, meaning a less varied forage and inferior eggs. Once you've tasted poached or soft-boiled perfection from your own flock, with their firm whites and rich orange yolks, it's hard to settle for less.

We let our chickens range freely in the enclosed orchard, pecking at fallen fruit, digging for seeds and bugs, and dust bathing. This keeps them content and well fed, and—if you believe in karmic gratitude—they thank us with their remarkable eggs.

Chickens have been around for thousands of years, and there are hundreds of recognized breeds. Some are prodigious egg layers, others are bred for their meat, while many are simply ornamental. Bantam breeds are popular for their showy, patterned plumage and small size, a plus when your property is modest. All breeds are egg layers, although bantam eggs are smaller. Breeds come in a dazzling blend of colors and patterns, some with feathered feet, others with fleecy plumes or mop tops. A flock of mixed, multicolored hens is a beautiful garden unto itself.

Whether you allow them to free range or keep them in a coop and run, caring for backyard chickens is relatively easy. As long as they have access to clean water, food, shade, and shelter, they'll go about their business without much fuss. The rewards of caring for your own feathered flock are many, and you may find yourself bonding with your birds like with any other pet. Their insatiable curiosity and amusing social habits are always entertaining around the home. Besides all their bug-eating and egg-laying benefits, chickens are just plain fun to have around.

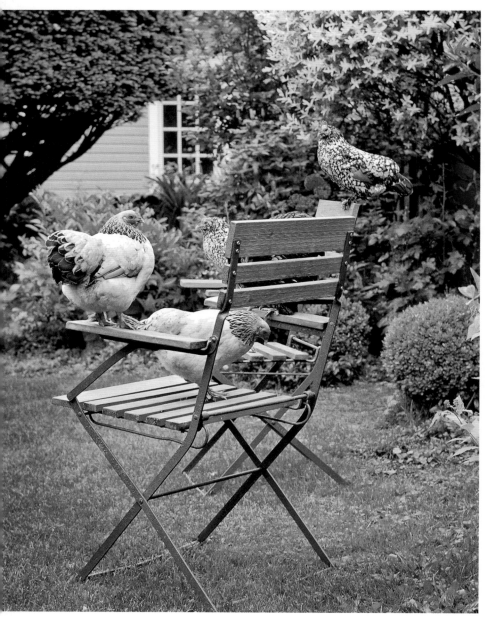

Where to Begin?

Be sure to check local ordinances before you decide to raise a backyard flock. Some towns and municipalities don't allow chickens, while others restrict the size of the flock and whether roosters are permitted. You may also want to let your neighbors know, appeasing any concerns with the promise of fresh, organic eggs.

Chicks should be ordered in early spring. They can be bought either at the local farm supply store or from catalogs and online suppliers. Ordering online has the advantage of variety, although most hatcheries require you to order a minimum of 25 chicks, as they come cheeping in the US mail, huddled together for warmth. The least expensive orders are straight runs, which are usually half roosters, half hens. Since a flock needs only one rooster to produce fertile eggs, a "sexed" run of all females and one male is best. If you just want a laying flock and don't plan on breeding chicks (or if roosters would unnerve the neighbors), order a sexed run of only females.

Chick Care

Your baby chicks will need close attention and care for the first few weeks, so be sure your schedule fits theirs. It's important to have your brooder box set up before you order. This is an enclosed space for day-old chicks with a water fountain, feeder, and heat lamp. It can be as simple as a large cardboard box with wood shavings or paper towels as bedding, but be sure to change the bedding regularly. The brooder box needs to be draft free and placed somewhere in the house or garage where it can be checked on easily at least a half-dozen times a day (although chicks are so adorably fuzzy and cute you may find that they monopolize your time!).

Baby chicks need a steady heat source for the first few weeks of their lives—95°F (35°C) for the first week, 90°F (32°C) for the second, and so on, reducing the temperature by 5 degrees each week. Keep a thermometer in the brooder to monitor the heat: Extremes in either direction could be fatal. An infrared lamp (250 watts) is a good heat source, and its red spectrum is less disruptive than white light.

Baby chicks can be chaotic and messy when it comes to drinking and eating, so invest in a waterer and feeder designed specifically for them. The waterer should be filled a few times each day, as 95°F and no shade brings on thirst. The feed you'll need, usually called starter feed, is a finely ground mash, or crumble, that's medicated to prevent certain diseases in young chicks. You can even feed them the odd bug or two, which they'll love!

By the second week, your chicks will be strong and curious enough to flap out of their brooder box unless the top is covered with netting or chicken wire. If you find a chick poking around in your sock drawer, you know it's time to put the roof on.

Once your chicks are a few weeks old, and if it's warm enough outside, you can bring them out for a little romp in the garden. Be sure they have access to water and shade and protection from drafts and predators. Until fully grown (and their sharp beaks are at eye level with the family cat), they're on everyone's meal plan.

Housing

Before you consider keeping chickens, determine where your chicks will live after they leave the brooder, because you'll need to have your housing ready for shelter and egg laying. Ideally, it's in partial shade in summer and has access to electricity for a winter heat lamp and water warmer. The closer to your home the better in order to keep an eye out and to make egg harvesting more convenient.

Standard breeds will need at least 1½ cubic feet per bird, while bantams will need 1 cubic foot. Coops can be

stationary structures with access to a run so the birds can get outside, or you can let them out each day to free range on your property. Just remember that foraging birds are unprotected from predators (everything from hawks, raccoons, and coyotes to the family dog), so there's risk in letting them range. We've lost a few hens to hawks, taken out by a swift set of talons in broad daylight. Chickens are easy to spot from above—a fluff of life against a monotony of grass, and not much of a match for a hawk's silent wings and its keen, focused hunger. Aside from keeping chickens enclosed in a run or pen, however (which would counter our free-range philosophy), there's really no protecting against a determined predator from above. If you are small and yummy and out under the open sky, they will have you.

Another option is a movable coop,

(continued on page 194)

Don Juan Draper

We ordered a sexed run of baby chicks in February, meaning all female (you don't need a rooster to have eggs), and one of the Ameraucanas had always seemed a bit mannish—less chat and gossip, more heavy lifting—so I had my suspicions.

Then suddenly, a strident, piercing yodel, and all the aloof and indomitable maleness that follows. I've had to assert my alpha to his beta, of course, but the fluttering harem is his. Now the crow is all day long, a sexual marathon of carping because he just can't get *enough*. (Meanwhile, we can easily get *an oeuf* from our teenage harpies without him, thank you very much.)

We've called the newly outed rooster Don Draper, after the oversexed drunk on *Mad Men*, and to stay on theme, our little covey of Peking ducks are Joan and Peggy. The rest of the hens are just flirty, egg-laying extras, hoping Don will offer them a drink and a shag.

I'm of two minds about roosters. They're more imperious and beautiful than the hens, so points there for my meddlesome camera and me, but the noise and the rough sex are alarming—like a neighbor with multiple clients in cuffs and leather. There's also not a lot of sweet feathered courtship or foreplay. It's all frenetic, sexual hop-scotch (or would that be Kentucky bourbon for Don?).

Having a rooster around is an encounter with maleness at its most primal: all the territorial machismo, the rampant, brutish polygamy, the female subjugation. But it's best not to project onto nature. She has her reasons. It's only when we intervene and skew the balance that the trouble begins.

Mornings are the busiest for Mr. Draper. He wakes with a few good crows, then romps through the orchard, downing dead cicadas for protein and a few stray berries for breath, before going on the prowl, coming on to whatever bit of fluff will have him.

Because he's still such a callow lover, he hasn't yet learned the slow, copulatory waltz of chicken wooing: one wing down and extended, a rhythmic rattle and sway around the hen. His efforts are graceless and awkward, like any teenager.

For the hens, who are still learning to master the submissive come-hither crouch, this is just the laying before the laying. Let Don Juan Draper have his moment, then it's on to the important business of making eggs or domestic squabbling over roosts and worm scraps.

Don is a future king. Though still too slight of crown and feather, he will enter his prime in the next year, a princely young cockerel to be reckoned with.

It's breakfast in the orchard for Mr. Draper, then on to woo a few ambivalent hens under the apple trees. Regardless of his efforts at fertilization, the eggs will continue to be laid and harvested in abundance.

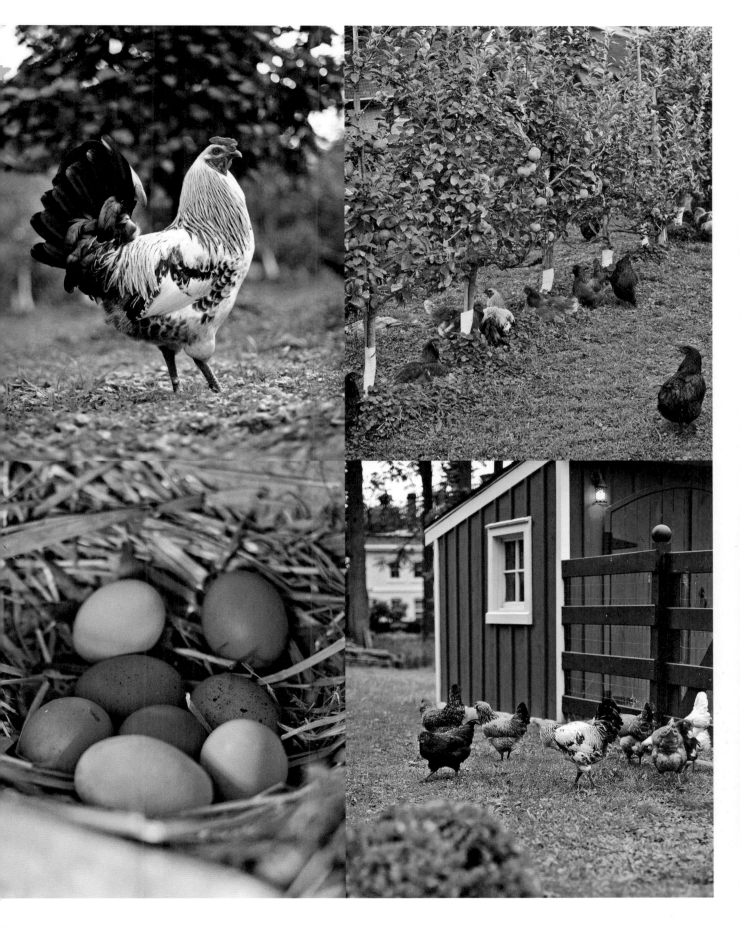

or chicken tractor. These usually have a coop on top, with an enclosed run underneath. This can be moved to a new spot in the garden every other day, where there's new turf for them to scratch and nibble. Moving your chickens around your property in a protected coop keeps them safe, gives them access to a varied diet, and evenly fertilizes your lawn.

The coop will need to have certain essentials to keep your hens happy. A clean, ventilated space is important, with plenty of fresh bedding (either straw or untreated wood shavings). You'll need nesting boxes, usually one for every three or four hens, a waterer (the larger the better), a feeder, and somewhere for chickens to roost. At night, chickens will want to roost on the highest spot in the coop, but make sure your roosts are not over the feeder or waterer or the device will be fouled by droppings.

An outlet in your coop is a good idea. Just be sure it has a protective outdoor-rated cover on it. A fan can be run in summer if temps are too hot, an infrared heat lamp and water warmer turned on in winter. The heat lamp can

be set on a timer to go on at night when temperatures drop. This will keep the coop comfortable and also keep the hens laying, as light triggers a hen's ovulating cycle. Hens will lay an average of one egg a day, so be sure to harvest regularly.

Because chickens are creatures of habit and like to roost and nest in the same spot every day, when you first move your month-old chicks to their new coop, give them a few days to imprint that this is their home. Begin by letting them free range only a few hours each day, then gradually increase their free time. This will keep them from getting lost or ending up in a neighbor's tree.

Maintaining the Flock

Chickens are social creatures and love to strut about together, chattering and pecking at bugs and dirt. They will watch out for each other and holler loudly when danger is near. They'll also squabble over eggs and nesting boxes, over roosts, or over some particularly tasty morsel. If a rooster is part of the flock, he'll tend to keep things in order, but chickens will fight over hierarchy regularly. (Ever hear of "pecking order"?)

A chicken's needs are pretty basic, but you will be responsible for meeting them. If they are sheltered with enough clean food and water and space, they will thrive. You will need to clean out the coop of droppings regularly (every month or so) or use a deep litter method, where at least 6 inches of straw or shavings are laid down and changed twice a year. This bedding can then be added to compost piles or tilled into the soil as an excellent nitrogen source.

Chickens love routine. To them, any change is loss, even the good changes. What they covet are the daily patterns of language they've learned since cracking out of the egg. Give them repetition, monotony even, and they seem content.

Chickens will begin laying at around 20 weeks. Once they do, you will need to change their feed to layer pellets or layer crumbles. These supply

the extra protein that hens need to lay. You can also supplement their regular feed with a tossing of scratch (a mix of corn and other grains) once or twice a day, but don't overdo it; this is a treat, not a staple. Your birds will also need grit, since chickens don't have teeth. They store coarse grit in a crop in their neck where it mashes their food like teeth. Grit can be bought from your feed supplier and mixed in with their feed. Or if your birds are free ranging, they're likely to ingest bits of stone or coarse sand on their own.

Chickens are über-omnivores: They'll sample, trial, and taste almost anything, even chicken (don't ask). They love scraps from the kitchen, and the more variety they eat, the better your eggs will taste. They love leftover rice and pasta, vegetable and fruit scraps, and greens. Avoid giving them citrus, onions, garlic, potato peels, bread, and meat. Generally, they know what's good for them, but it's best not to encourage a mistake.

They will get into all and everything, of course: raspberries, blackberries, tomatoes. I've watched them leap 3 feet in the air to snatch a raspberry, or balance on a tightrope of orchard wire to snack on currants, or peck incessantly through fencing to reach a tomato. They will also go after your greens, unraveling the beds into loose stitches, or decide, without much discretion, that your planting of fall spinach is a fine spot to take an afternoon siesta, so you find your coddled greens flattened here and there by the imprint of a settled hen. Just when a long-awaited apple, pear, or tomato is heavy with itself, it's pecked into nothingness. Prevention with netting and fencing will do wonders to keep your chickens in check.

There's no question that adding chickens to the garden ties us to another time, when they were an integrated part of domestic life. A farm livened up with the flutter and bustle of chickens—not to mention their usefulness—becomes a bigger, more fulfilling place.

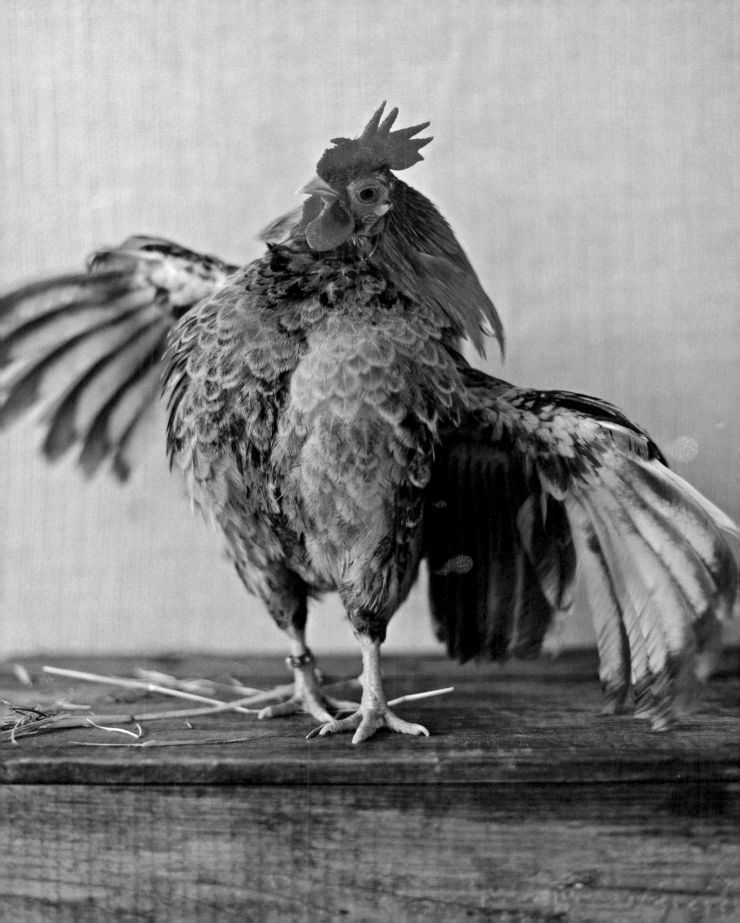

Health and Diseases

Although there are many problems that *can* affect chickens, it is entirely possible to maintain a small flock without a hitch. Start with healthy birds from a reputable source, have them vaccinated for Marek's disease (a highly contagious viral infection) before shipping, and offer them what they need to maintain their good health and vigor.

Given good nutrition, ample water, access to fresh air and exercise, protection from predators, and shelter that is clean, dry, and well ventilated, chickens can be reasonably trouble-free.

Provide food and water in containers that let the flock eat and drink without allowing them to foul the feed or water by standing in it. Keep the coop clean and change the straw or other bedding regularly to keep it fresh and dry. Good sanitation, applied regularly, keeps the proportions of the task manageable and avoids the buildup of droppings and moisture that can allow molds and bacteria and associated respiratory problems to develop in the

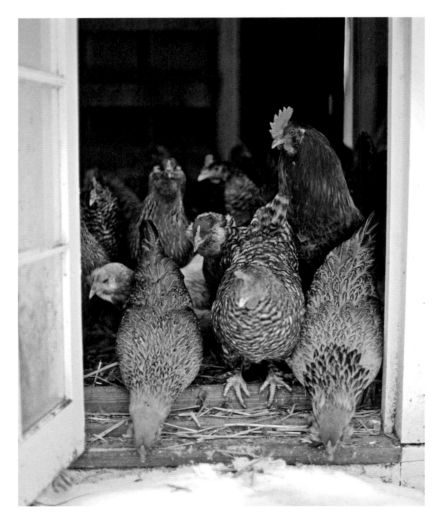

flock. Many problems arise from keeping chickens in crowded, dirty conditions, so it's vital to keep the coop clean.

Make sure there is enough room at the feeders and waterers for all chickens to gain access, and design the space to be comfortable and secure. Crowding, overheating, or other stressors can prompt chickens to pick at themselves or at the rest of the flock. The picking out of a few feathers can escalate quickly into a free-for-all of pecking and plucking that often leads to bloodshed. As soon as you identify an episode of picking, separate injured chickens from the rest of the flock. Offer a few handfuls of greens or other treats to distract the aggressors from the undesirable behavior. Clean wounds and apply an antipick material such as pine tar (sometimes called Stockholm tar), dilute vinegar, or dilute Listerine before reintroducing birds that have been "picked on" back into the flock.

Various species of lice and mites may infest chickens during their lives, inflicting various levels of irritation and distress. Dust baths are chickens' natural way of easing their discomfort and ridding themselves of tiny biting parasites, but populations of pests can sometimes escalate beyond the birds' ability to dust them away. Prevent external parasites with good sanitation. Keep wild birds from building nests in the chicken coop. Paint wood surfaces in the coop, including roosts and nest boxes, with linseed oil, and apply lime to the chicken run annually. Including cedar chips in the bedding material can help deter mites.

The intestinal disease coccidiosis is caused by parasitic protozoans. Chickens ingest the parasite eggs in fecal matter in soiled litter. Warm, wet conditions increase the risk of infection. Good sanitation, such as keeping the litter clean and dry (but not dusty) and

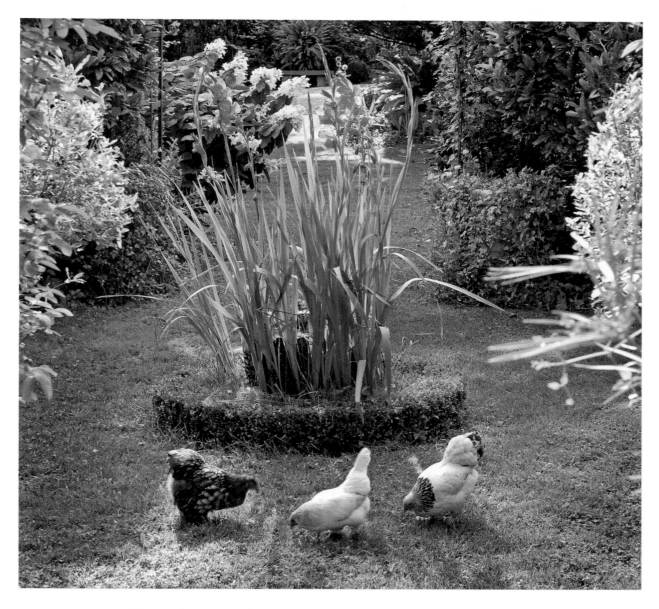

moving waterers around to avoid consistently wet areas, helps minimize coccidiosis. Chickens often host a few of the protozoans that cause coccidiosis without developing symptoms and can develop resistance to the disease, which tends to be most harmful to young birds. A few breeds of chickens are resistant to coccidiosis.

Most important, get to know the individual chickens in your flock and be familiar with their normal routines and behaviors. Make a habit of spending a few minutes observing each one daily. Besides being entertaining, this makes it easier to recognize when something's amiss with a member of the flock. Many common diseases first appear as listless behavior, reduced eating and drinking, and unkempt feath-ers. If you are uncertain about a diagnosis or unsure how to treat a bird's symptoms, seek professional advice. Spotting a problem early lets you isolate a sick chicken and increases the likelihood that proper care can restore a chicken to health and prevent illness from spreading through the entire flock.

Keeping Chickens Safe

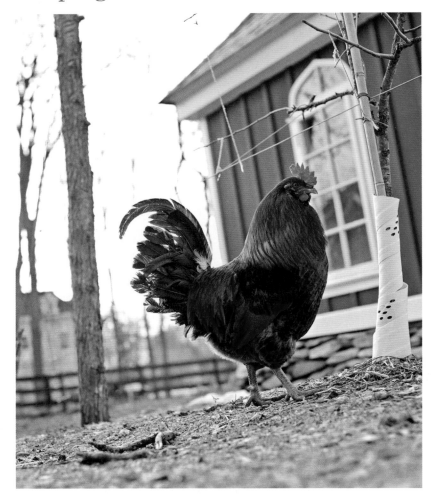

Free-ranging chickens in open space also opens them up to dangers. A determined and hungry fox, coyote, raccoon, weasel, or hawk will be a challenging adversary for your flock.

A hawk on the hunt is a magical, ominous sight: its silent wings cutting loose, slow wheels of menace across the sky. If you can hear the high-pitched *kee-eeeee-arr* of a hawk, you know your chickens have heard it too (chickens are genetically programmed to fear this sound), and they'll be warily seeking any cover they can find. They'll crouch under brambles or join the songbirds that have muted themselves in thickets.

All the mad, flitting bustle of life on the farm will come to an abrupt stop. The best defense is to try and herd chickens (like you'd herd cats) back into the coop and keep them in until the danger passes. Alternatively, you can make sure that they have a place to scurry and hide under when danger lurks, either a dense hedgerow with plenty of thorny brambles (blackberries are great for this, and this is where my birds hide when they're out in my orchard) or some other protective structure. You can build a simple twig and bramble teepee for chickens to scurry to when they're out in the open.

If you have a rooster, he will be a great help in protecting the flock and will alert them to danger. (Besides fertilizing eggs and flustering hens with his inexhaustible libido, flock protection is his business.) Hawks are bold and fearless and will not be deterred by your presence. We once lost a young Brahma hen that was foraging about 20 feet from us. A hawk swooped down silently from a perch where it had been keenly waiting, grabbed the terrified hen, and loped off with her, barely able to get off the ground. We found her later in a back field, her body opened like a book, with an assembly line of eggs still waiting to be hatched.

The best alternative to complete free ranging is to put in a sizable run (at least three times the square footage of the coop) with welded wire fencing around it that either goes into the ground a foot deep or skirts out a foot below the fenceline to keep digging predators from getting under your run. The top of the run can either be roofed or covered in netting or wire. Our run is covered in netting and clambered over by a vigorous grape vine, which adds shade and some support for the netting during snow. It's also great snacking for chickens when the grapes ripen.

Raccoons can be a particular challenge to flock security. They can rip through chicken wire as though it were a bag of pretzels and can even open latches with their dexterous hands. Double locks on the coop doors and hardware cloth over the windows will work as a reasonable deterrent.

In order for chickens to maintain their health, it is important that they get a rich and varied diet from forage. If you don't want to let them out to free range for fear of predators, you can bring in a daily supply of compost, weeds, and scraps. Scatter it in the run so that the chickens can dig through it to supplement their diet. Alternatively, you can range a small flock using what's known as a "chicken tractor."

Resources

There are many places to purchase chickens, from day-old chicks to year-old pullets. Feed stores and local farms will usually have chicks in spring, and online classifieds like Craigslist often offer chickens for sale right in your neighborhood. As backyard chickens have become increasingly popular, the number of online suppliers has skyrocketed. Purchasing through the Internet will offer the most choice of varieties and breeds, as well as supplies, although feed is best bought locally because of its weight. Some reliable Internet suppliers include Murray McMurray Hatchery (mcmurrayhatchery .com), Ideal Poultry (idealpoultry.com), and Privett Hatchery (privetthatchery .com). From large breeders, you will need a minimum order of 25 chickens, so splitting an order among a few people will work if 25 is too many. Smaller orders can be purchased from My Pet Chicken (mypetchicken.com) and Meyer Hatchery (meyerhatchery.com).

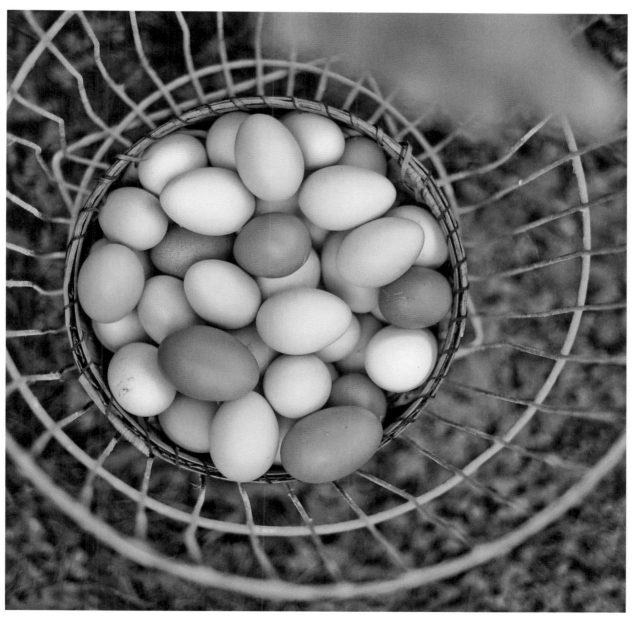

Magical Realism

It turns out our dizzy, mop-topped hen, Phyllis Diller, is actually Phil S. Diller, a transgender cockerel. He went from dulcet murmuring to an all-out strident crow in the space of a week. Give him some Spandex and he's like a relic from an '80s hair band.

Chickens are full of peculiar surprises, but this one I didn't see coming. We put him on Craigslist, and a very nice couple from Connecticut adopted him. Apparently they're into leather.

A new flock of fuzz (all female, I've been assured) arrived via the post office today. The promise of fresh farm eggs, along with these beautiful, warm April skies, has put dance back in our winter-weary bones here at Stonegate Farm.

Pulling a warm egg from beneath a broody hen is a magical thing: the ruffled murmur as she relinquishes; the egg's perfect, spherical warmth, its bone-smooth promise. And fitting so perfectly in the palm of the hand, as though the relationship between laying and gathering always was.

Compared to a supermarket dozen, and to the USDA's nutrient data on commercial eggs, our orchard-roaming hens will produce a vastly superior product. Their natural, free-range diet—including seeds, berries, insects, and greens, along with grain—will result in eggs with far less cholesterol and saturated fat and much higher levels of vitamin A, vitamin E, beta-carotene, and omega-3 fatty acids. Is it any wonder they taste better?

Even chickens labeled "free range" and "organic" at the Stop & Shop are usually fed a compromised diet of soy, corn, and cottonseed meal, laced with additives, with limited or no access to the outdoors. Jailbirds, basically.

When a new CSA member stopped by this week to say hello, I was unprepared for the power and imprint of memory that took hold on her visit. She had grown up on a farm in Iowa, and her connection to that time seemed to rill through her as we did our walkabout.

On the way out, we visited the hens in La Cage aux Fowl and, on putting a warm, just-laid egg in her palm, she began to cry softly. Clearly, the evocation was almost too much. There was some awkward silence as she held the egg—and her childhood—in her hand and struggled for composure. But she seemed grateful for the experience and what it summoned up.

There's something in our collective genome that ties us to a past when farming and growing food were everywhere and everyone took part. For most people, the relationship between a meal and its source was immediate. If I can offer up the occasional connection, how wonderful. If a farm can serve as a common metaphor for connecting to our past, our food, our deeper responsibilities to the planet, so be it.

Chickens come in all shapes and sizes, from fanciful bantams to plain but productive layers.

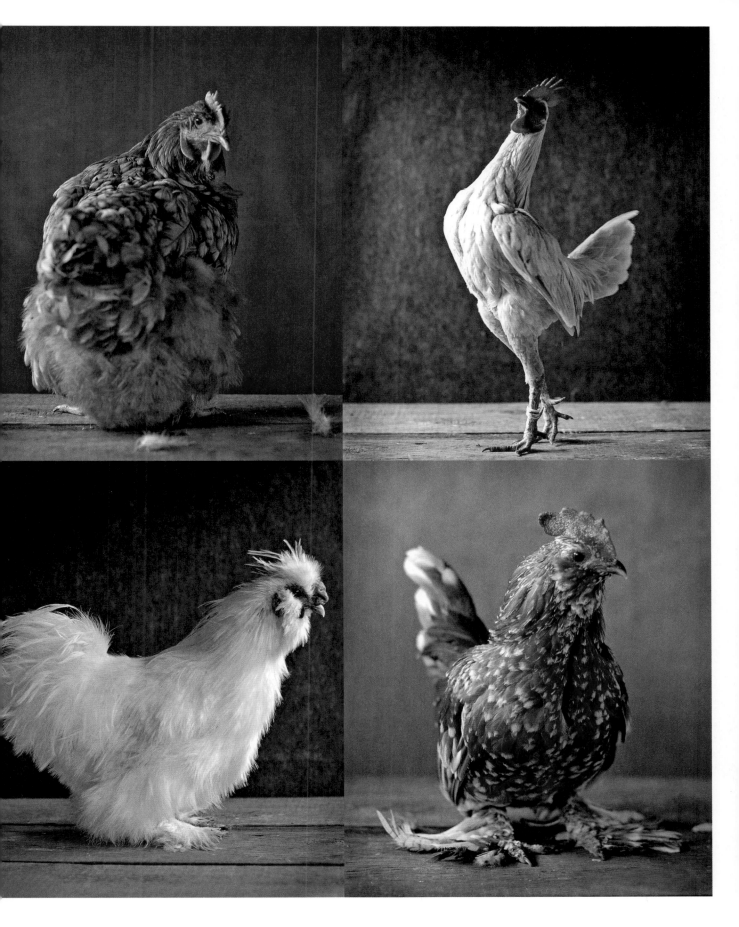

Bees, Hives
& Honey

KEEPING BEES SEEMS SO ESSENTIAL to the macroorganism of the farm that it's hard to imagine growing without them. Beyond their remarkable, ambrosial honey, they are our primary pollinators, responsible for 30 percent of the food we humans eat. There's also something wild and magical about them: how they distill honey from the inflorescent pollen and nectar of flowers, how tirelessly they wander and work for the good of the hive, how they structure and organize their lives. There's a lesson in selfless cooperation in there for all of us.

What they draw from the floral landscape, the raw honey we harvest, is one of nature's miracles. Honey is the only food that never spoils (archaeologists have found edible honey in the tombs of the pharaohs) and, in its raw form, is an excellent antibacterial, antiviral, and antifungal. (It can even be used topically to treat infection.) It's rich in antioxidants and a boost to your immune system. Local, raw honey (not the pasteurized yellow stuff at the supermarket) even helps with allergies: A tablespoon a day of raw honey from within a 100-mile radius of your home acts as an allergy immune booster, since the bees are processing the same pollen that's making you seasonably miserable.

Keeping bees is also an act of environmental preservation. Since bee populations have declined precipitously in the last decade in part due to the overuse of systemic pesticides, caring for a few of your own hives not only keeps you in delicious raw honey, but also makes a small contribution to the survival of this remarkable species.

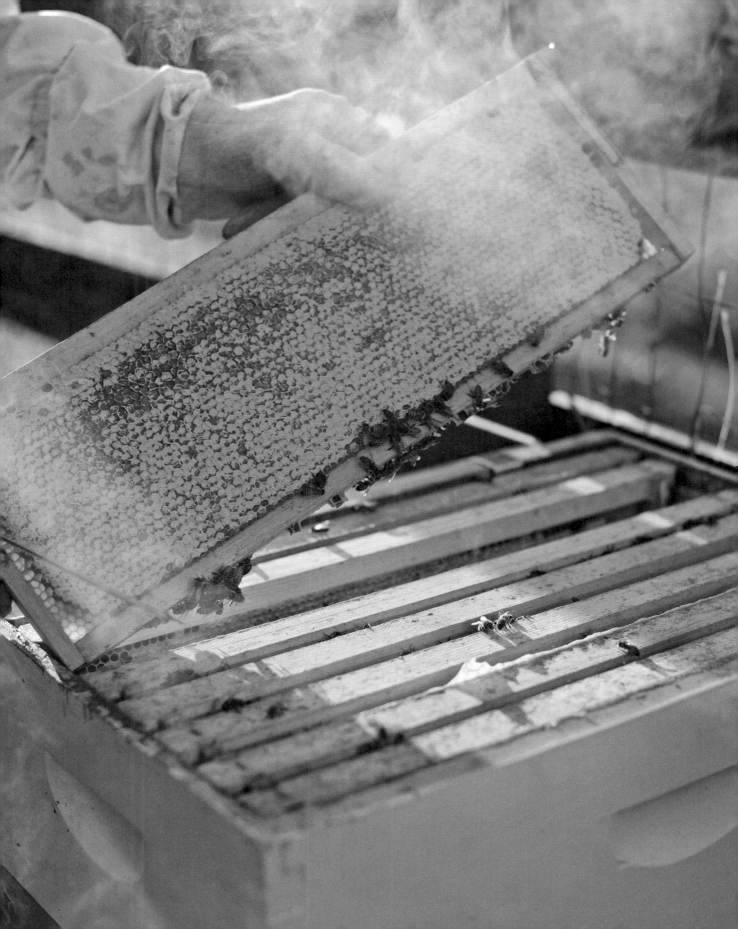

Getting Started

Nothing on the farm seems to work as hard—or with as much purposeful industry—as the honeybee. Sometimes, I'll just sit back on my elbows near my hives and watch the daily wandering bustle of their lives: their black-banded bodies freighted with nectar from thousands of obliging blossoms, their legs dusted in motes of pollen; so determined and ambitious, so organized. It's hard not to feel like a slacker around them.

The world would be bleak without bees, of course, so deciding to keep them is an act of conservation and environmental stewardship (and oh yeah, there's the reward of all that honey, too). The hive is an amazing macrocosm of activity, with bees all having a specific function and purpose; like parts of a sticky, buzzing brain, bees interact like neurons to create a healthy, productive ecosystem for themselves. But I learned the hard way that becoming an apiarist isn't just about setting up a few hives and letting the bees work their magic untended. Like anything on the farm, there's a fair amount of care involved.

So before you get going, consider how much time you have to manage a hive or two and whether you're comfortable around bees and willing to work with them. Also, before you think about keeping bees, check the local ordinances in your area to see what restrictions and rules there are (if any). Some communities limit the number of hives you're allowed to keep, while other ask you to register your hives and pay a small annual fee. Let your immediate neighbors know you're thinking about setting up a hive or two, and make sure that they don't have any serious allergies. The promise of local, raw honey will do wonders to placate concerns.

You may also want to see if there are other beekeepers nearby. It's one thing to study up on beekeeping, quite another to go through all the steps empirically with someone who's been there.

Building the Hives

Once you've gotten the all clear to keep bees, the first step is to order the hives. It used to be that honey, before we began to keep and culture bees, was gathered by plundering wild hives and destroying them in the process. When we learned how to collaborate with bees, specifically Western European (*Apis mellifera*) and Eastern (*A. cerana*) bees, we developed designs for hives, of which there are several. Langstroth hives are the stacked boxes you're likely to be familiar with and are the universal standard. Other designs include top-bar hives and Warré hives, both of which have their specific advantages, but it's the Langstroth we'll focus on. Ordering your hardware is easiest done through the Internet, as finding a local small apiary supplier can be a challenge. Hives are broken down into wooden components, and for each hive you'll need the following, from bottom to top: a stand, a bottom board, an entrance reducer, two large brood boxes, two supers, 20 deep frames with foundation, 20 shallow frames with foundation, an inner cover, and a top cover. A raised platform for the hive, about 1 foot off the ground, is also a good idea.

Frames are what the bees will use to build up the comb for their brood and honey stores. I prefer frames with a foundation board embossed with a plastic hex pattern rather than wire frames, as the former are easier for the bees to build up. (You want them making honey as soon as possible, not spending all of their energy on construction.) Spray the foundation with sugar water to encourage bees to draw it out. The two larger brood boxes and frames (imagine a wooden filing cabinet with 1-inch-thick hanging folders) are where the bees store their honey and lay their eggs. They are stacked, one atop the other, at the bottom of the hive. These are accessed from below by the bees through a narrow entrance above the bottom board. On top of the two brood boxes are shallower boxes called supers, which also hold hanging frames (usually 10). This is where the bees will store their extra honey and where you'll collect your harvest. On top of these are inner and outer covers that will protect the bees and boxes from the elements.

You can order hives fully assembled or find them used (although not knowing what pathogens may be lurking in an old hive is a worry). By ordering them disassembled, you'll save money on both the purchase and the shipping, which can be significant. The other things you'll need to order include a bee suit and veil, gloves, a smoker, a hive tool, and a bee brush. The bee suit, veil, and gloves will protect you when you're working the hive. The bee suit comes as a full-length body suit or as just a jacket. Both will accommodate a zip-on veil, which is usually ordered separately. The smoker will calm the bees when you're working the hive. (They think the hive's on fire and thus start gorging themselves on honey, assuming they'll need to evacuate; your meddling with their home thus becomes the least of their worries.) The hive tool is a small, flat chisel used to pry open the components of the hive, which the bees seal quite efficiently with a tough, sticky, resinous glue called propolis that they make from tree buds and sap flows. The brush allows you to gently brush the bees off of the frames when you inspect the hives.

Once you find a good Internet or mail-order source for hives and supplies, the time to order all of your components is whenever you have time—usually in winter, long before your bees arrive in spring. It's a pleasure to put together these wooden palaces for future queens and their thousands of fussy royal attendants when all the animation of the growing season is on hold. Besides ordering seeds in the bleak chill of

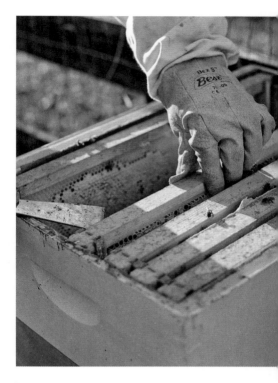

January, this is a winter chore that pays itself forward, allowing thoughts of future honey to dance sweetly in your psyche.

After assembling the hives, you'll want to paint them for protection from the elements. Choose several light colors (to reflect heat) that harmonize with the palette of your garden and property, then prime and paint the boxes in alternate colors so that when they're assembled, each hive has a different pattern. Bees, besides communicating chemically, are hypervisual. (That's why flowers put on such a chromatic show—so they'll attract pollinators. You didn't think it was all for us, did you?) Bees will easily distinguish the color pattern of their own hives.

Hive Location

Bees can be fussy about their location on the property, preferring a site that's open and accessible when they return from foraging but one that's not too exposed to the elements. The hive entrance should receive plenty of eastern sunlight so that it warms early and gets the bees out foraging for the day, but dappled light is ideal during the heat of the afternoon. If the shade is from deciduous trees, so much the better, because winter light after leaf fall will be welcome. Bees, it turns out, are very good at regulating the temperature and humidity inside the hive, regardless of exterior conditions. The right level of humidity inside the hive will give honey its protective quality, and it must be kept at certain levels. Temperatures inside the hive must also be kept constant at around 94°F (34°C). In summer, bees lower the temperature with their wings by fanning, sometimes even wetting their wings first. In winter, they raise the temperature by vibrating their flight muscles and forming large clusters around the queen to keep her warm. Those same clusters, or beards, can appear hanging outside the brood boxes on the hottest days of summer. HVAC specialists have nothing on bees!

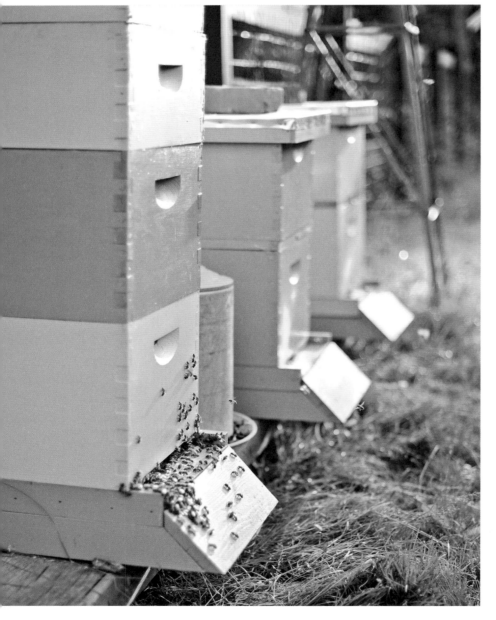

Try to avoid spots that are too wet or windy, but a source of nearby water is essential for bees in the hot summer months. They'll need access to good forage (any flowering plants and trees). Bees will gather pollen and nectar in a 2- to 3-mile radius from the hive, which can be both a good and bad thing. If you live in an area with plenty of domestic bloom, your bees will thank you, but if you live within a few miles of any agriculture using systemic pesticides that contain neonicontinoids (a neuroactive insecticide that's been linked to colony collapse disorder, or CCD), you may struggle with keeping your hives healthy or alive at all.

It's best to keep your hives easily accessible to your home so that they can be regularly checked and monitored. That said, bees will form flight paths—or beelines—to the hive as they forage back and forth, and you don't want to set up the hive so that you're regularly in their path. They have work to do and won't appreciate the cross traffic. I keep my hives in the far corner of my orchard, where they can forage on all the fruit blossoms and go about their day without too much interruption.

Ordering Bees

This is the scary part. Putting together pretty hive boxes and setting them up on your property is one thing, but coming face-to-face with thousands of frenzied insects is a whole other story. Bees can be ordered through the Internet or through a local apiary or bee club, and they should be scheduled to arrive in early spring, when the weather has warmed. When you order a colony online, or pick one up locally, it will consist of 3 pounds of female workers (about 10,000 bees) in a wood and wire box, called a package, and one queen in her own small, wired chamber. There are different strains of bees available, from Russian and Carniolan to Italian and Buckfast (English), all with various traits. Some are bred to be more gentle, some for honey production, some for their ability to overwinter well, others for their resistance to tracheal mites. Ask your ordering source what the best strain would be for your climate and needs. When they arrive (usually at the post office), you'll get a call from a frazzled postal employee telling you your bees have arrived and to *please* pick them up!

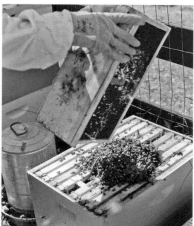

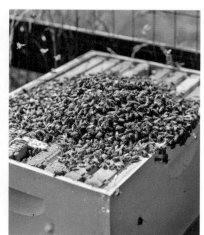

Installing the Colony

At this point, your hives and supplies should be set up on your property and ready for the new colony to move in. After you put on your protective clothing, you'll want to have only the two larger brood boxes ready with frames installed for now. Have the top box off so only the lower box is open. This bottom box is where you'll put the bees. Push the frames to the sides and leave a space between two frames in the middle of the box to make room for the queen.

Your box will be buzzing with thousands of travel-stressed bees, but the calmer you stay, the calmer the bees will be. (They seem to pick up on stress pheromones.) A spray of sugar water will distract them. After prying loose the box's small stapled lid with your hive tool, remove the feeder can in the center and replace the lid. You'll see a small plastic or metal tab stapled to the box top that holds the queen cage. Remove the staple with your hive tool and gently slide the queen in her small cage out of the box and, once again, temporarily replace the lid. On one end of the queen cage, you'll see a small cork covering a white candy plug. Remove the cork and pierce the plug with a small nail. Then insert the queen cage in the middle of the hive box, hanging at the top between the center frames. Her pheromones will become active and the workers will soon be eating away at the candy plug and freeing her from confinement. Now comes the fun part: Take the box-o-bees, remove the wooden lid, turn the box upside down, and shake out the thousands of bees on top of the queen and the frames. Firmly tap out as many as you can, then put the box to the side, leaving it open for any stragglers. At this point, you'll have a humming mound of bees, all trying to make sense of their new digs, on top of the open frames.

Using your hive brush, clear the edges of the hive of bees and gently brush them into the frames, then put on the second brood box and frames. On top of the second box, put on your inner cover. The bees will be hungry after their journey, and you'll want to feed them. I use small white feeder buckets that I've ordered online that have a mesh-covered hole in the lid. These get filled with a 1:1 solution of sugar and water and inverted over the central opening in the inner cover. I then place two frameless super boxes around the sugar water bucket to protect it and add a top cover with a brick on it. For 7 to 10 days after you've installed the bees in their new home, it's best not to disturb the hives. You can check on the sugar water supply, but there should be enough for the first week as the bees get acclimated.

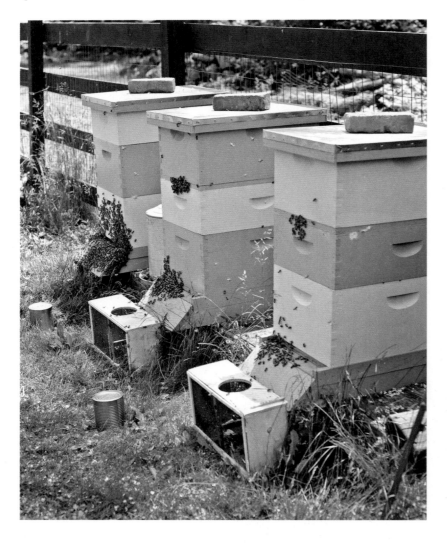

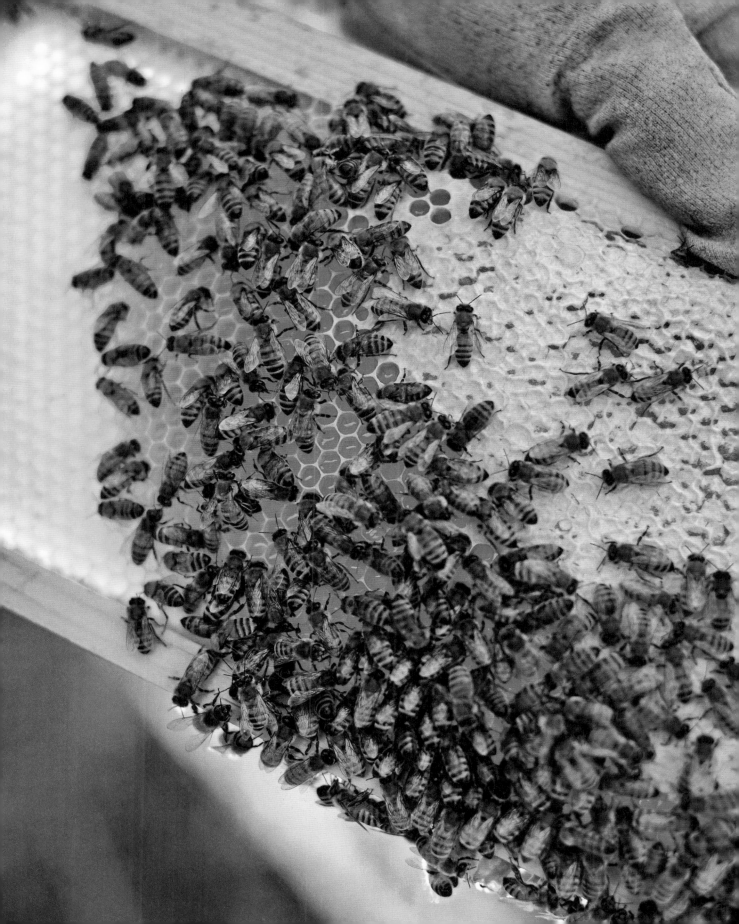

Maintenance

Until the bees have gotten used to their new surroundings and have mapped out their forage paths, check their sugar water to make sure they're feeding (particularly if you've installed your bee package in very early spring before bloom and nectar flow). After about 2 weeks, check the hive boxes to see if any comb has been drawn out or any brood has been laid. It's only after the bees have completely drawn out the foundation in the lower two boxes and stored honey and brood that you should add the upper supers.

Once the lower boxes are active and full, add one super at a time over a period of weeks or even months, after comb has been drawn out in each super. Bees tend to move upward through the hive, filling frames with honey as they go. It may take a whole season for a new colony to fully draw out comb in the lower boxes, so you'll need to be patient. Occasionally, a queen will move up as well and begin to lay brood in the upper supers where you don't want her to. You can add what's known as a queen extruder between the lower boxes and the supers to control the queen. This thin, narrowly slotted cover will keep the queen from laying brood in the upper supers by restricting her access so that only workers making honey can get through.

Once summer is in full swing, and the hives are busy building themselves up, you can let the bees just do their thing. A weekly inspection of the hive is a good idea. It's best to check the hive in the middle of the day, preferably when it's warm and sunny, when most of the bees are out foraging. After you've put on your protective clothing, start your smoker with some crumpled newspaper and a bit of tree bark or pine needles. Puff some smoke into the lower hive entrance to let the bees know you're coming. Remove the outer and top covers of the hive with the hive tool, breaking the propolis seal around the edges, and puff more smoke across the top of the hive frames to calm the bees and drive them down into the hive. Never work too fast or abruptly with bees; a slow, steady rhythm will keep them from getting too agitated. Pull out a frame on the outer edge and check to see if comb has been drawn out and that the queen is laying eggs, then set the frame down, leaving a one-frame gap in the box, and check each frame in sequence. The frames will often be a mix of pollen stores, capped honey, and laid eggs. The heavier the frames, the busier the bees have been, which is a good indication of the overall health of the hive. The center frames will be the first to be drawn out, and most of the brood will be there, while the outer frames will contain more honey stores. You can see how much brood the queen has laid by holding a frame up toward the sun and backlighting the cell: The larvae will appear as tiny, ricelike grains in each cell.

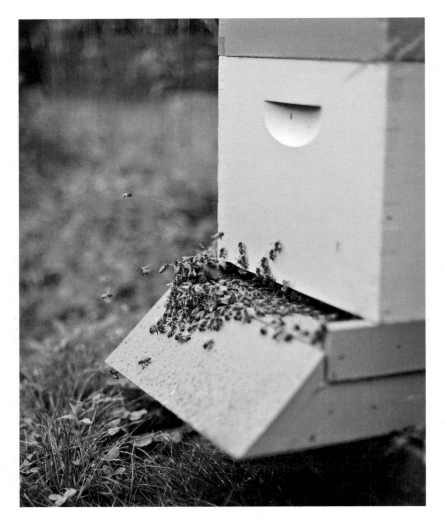

Honey Harvesting

Opening your hive supers and pulling out frames brimming and heavy with capped honey will give you a fantastic sense of fulfillment. It means that you did everything right—gave your bees a safe and comfortable home, cared for them as best you could—and can now harvest one of nature's most exquisite gifts: your own local, raw honey.

Your first year of beekeeping is mainly about establishing the hive and making sure the bees have enough honey stores to last them through winter. You may be able to harvest a few frames of honey in fall, after the last nectar flow, but to ensure a new colony has enough food to last the winter, I usually wait until the following spring to harvest more honey. You can have any capped honey that has overwintered, as the bees will be out looking for fresh pollen and nectar to feed their young. Harvestable honey will be in capped cells, while uncured nectar will appear as a clear liquid in open cells.

Try to harvest at midday, when most of the bees will be busily out and about. With your smoker going, puff at the lower entrance and the top frames of the opened hive. You'll be harvesting from the shallower upper supers, so take an empty shallow super box, if you have one, and remove the full—and heavy—capped honey frames and put them in the empty box. Use your bee brush to brush the capped frames free of lingering bees.

Once you're inside with your box of honey-heavy frames, take one frame at a time and uncap the sealed comb using an electric uncapping knife or metal-tined hive comb. Alternately, you can use a large, serrated bread knife or even a fork. The idea is to remove just the covering wax cap of the honey cells. If you can leave the drawn-out comb intact, it will mean less work for the bees in rebuilding the foundation.

When your frames are uncapped, you'll need to extract the honey. There are three methods I've used, which all work. If you have access to an extractor (a kind of spinning centrifuge for hive frames), this will be your best option. They're expensive, but bee clubs will often use one collectively. Frames are placed into the extractor and spun on a central spindle, either manually or via an electric motor, emptying the honey from the cells. The frames are then turned in order to extract honey from the other side.

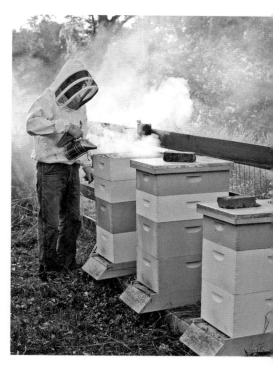

I've also uncapped my frames and placed them upright on a hard wire cover over a 10-gallon metal bucket in front of the woodstove; it's a slow-drip method, but over a day or two, most of your honey will have succumbed to gravity. If you're not using foundation on your hive frames, or you don't mind scraping off all the comb, you can cut off all the honey cells into a large bucket and mash them up using a spade. Then take that mash of wax and honey and empty it into a 5-gallon paint bucket that has holes drilled in the bottom and a paint-straining mesh bag on the inside. Place that bucket over another 5-gallon container with a spigot on the bottom. The honey will strain and drain over the course of a day or two.

Honey harvesting is hot, sticky, messy work, so plan accordingly: Work in a well-ventilated space, protect surfaces, and use a warm sponge to wipe down tools and equipment when you're done. Make sure that you're harvesting in an enclosed space; bees have a sixth sense of where their honey has been taken and will come after it (and maybe you!) if left in the open. After a successful harvest, all the work and worry of raising healthy bees will be diminished by dozens of jars filled with your own rich and deeply satisfying honey.

Health and Diseases

Though honeybees have evolved to take remarkably good care of themselves and have developed complex and effective systems for survival, they now face considerable environmental pressures that threaten their future as the planet's primary pollinators. Besides the devastating threat of colony collapse disorder, other issues that may disrupt a hive are bacterial and fungal infections that affect developing larvae (such as foulbrood and chalkbrood), nosema infection and dysentery, hive beetles, and—most destructive—the dreaded varroa mites, which are a serious threat to the hive. These small, parasitic mites attach themselves to the bees' backs and feed on them, shortening their life span and deforming the emerging brood. Untreated mite infestations can kill off an entire colony.

There are chemical treatments for varroa mite problems, but the organic method we prefer is one using powdered (confectioners') sugar. If you see mites on your bees (they'll appear as small, dark red specks attached to the bee's body), dust the infected bees with the powdered sugar. The dusting of sugar will encourage the bees to groom themselves, cleaning off the mites as they go. It also coats the mites themselves, making it harder for them

to hold on to the bees. New hives rarely have a mite infestation, but older hives will be vulnerable, and regular checkups are imperative. When you're done with your hive inspection, try to return the frames in the order in which they were removed, and close up the hive.

Trachea mites are another tiny but harmful pest of honeybees. Because they infest bees' insides, trachea mites are difficult to diagnose and hard to get rid of. Bees can survive trachea mite infestation, but the stress of these parasites shortens a bee's life span, reduces reproduction and honey production, and increases mortality during the winter months. Infested bees fly poorly and lack vigor, and an untreated trachea mite infestation can cause a hive to decline gradually and die out.

Patties made by mixing 1 part vegetable shortening and 3 to 4 parts powdered sugar may be used to treat trachea mites. Bees feed on the patties, which are placed on the top bars of the hive, and the shortening disrupts the mites' movement from infested bees to new hosts, gradually stopping their spread.

Brood diseases that affect only the larvae are trouble for beekeepers. While a healthy colony may be able to clean out dead larvae and recover from some infections, serious and hard-to-control diseases such as American foulbrood can quickly spread through a colony, wiping out the population as adult bees naturally die off and are not replaced. While workers clean out infected cells and dead larvae, they spread the spores throughout the hive. Antibiotic treatment can prevent foulbrood infection and stop the spread of the disease, but it must be continued to maintain protection. The disease spores are long lasting and very difficult to completely eradicate from the hive. In many cases, a colony that is widely infected must be killed; frames, combs, and dead bees

burned; and all other hive parts and equipment sterilized.

Nosema disease is an infection of bees' digestive tracts. It becomes a threat to the colony when bees are unable to leave the hive for cleansing flights to void their wastes. When an extended stretch of cold weather keeps bees in the hive, they may develop dysentery, which can be fatal. Where bees are likely to be confined by cold temperatures, problems with nosema and dysentery may be avoided by removing most of the honey from the hive in fall and feeding bees with more readily digestible sugar water.

Small, dark hive beetles are sap beetles that lay eggs in the cracks of hives. Their larvae feed on honey and pollen, causing damage to combs over a period of about 2 weeks, before they leave the hive to pupate in the soil below. Hive beetle activity spoils honey and can drive bees from the hive. Where hive beetles are known to be present, beneficial nematodes may be applied to the soil beneath the beehives to control the pests. Traps that use nontoxic oil to suffocate the beetles are also available. A healthy hive that contains few empty combs is less likely to be affected by hive beetles than one that is under other stresses.

Colonies that are in good health, that have access to nectar during the growing season and supplemental food when nectar is unavailable, and that have hives in suitably sheltered yet accessible sites are usually able to withstand and ward off pressure from parasites and diseases. Protect the hive from invasion by mice in winter by putting a metal entrance reducer in place early in fall to avoid the mess and harm caused by nesting rodents. As winter weather arrives, add an insulation board with an upper entrance on the top of each hive to help keep the bees snug while ensuring they can get in and out when conditions are favorable through the winter months.

Resources

For beekeeping equipment, there are a number of online and mail order suppliers. If you're starting up in beekeeping, you may want to begin with a single hive and plan to expand later. Online suppliers include Brushy Mountain Bee Farm (brushymountain beefarm.com), Betterbee (betterbee .com), Dadant & Sons (dadant.com), and Apple Blossom Honey Farm (abhoneyfarm.com). There may be a bee supply store near enough to you to purchase your own supplies directly, which will save on shipping, as the bulk and weight of hive parts and equipment will add up. Sources for packaged bees include Draper's Super Bee Apiaries (draperbee.com), Kelley Beekeeping (kelleybees.com), Rock Hill Honey Bee Farms (rockhillhoneybeefarms-inc .com), and Georgia Bee Supply (gabeesupply.com). Packaged bees can also be purchased locally from bee clubs and organizations. Place orders early in the year, as suppliers often sell out by spring.

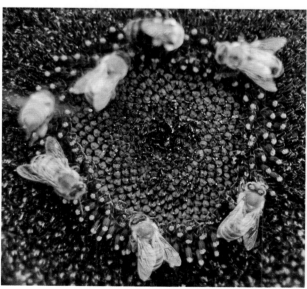

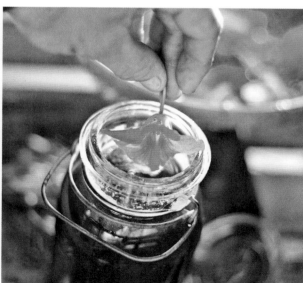

Where the Wild Things Are

If Hinduism has it right, and honey is one of the five elixirs of immortality, then I may be fated to a life everlasting, free of karmic debt; the fall honey flow at Stonegate Farm has been *that* good.

Unlike the spring harvest, which was translucent and sweet from the nectar of orchard blossoms, the fall forage from goldenrod, calendula, anise, cosmos, and borage has been transformed into a honey that is slow moving and dark; a 10W-30 shade of sweet, raw crude.

When we pulled heavy frames of comb from our hives last week, the long, liquid pour of deep amber that emerged was remarkable. It seemed to contain all of the sun's complex energy, elaborated by flowers and bees, and ambrosia for us.

The harvest begins with a smoke (a universal sedative, it seems) to distract the bees. They assume there's a fire and gorge on honey, and not you, as a survival instinct. Then frames heavy with honey are pulled from the upper hive boxes, or supers, and the comb is uncapped with a hot knife and spun in a centrifuge-like extractor until the cells are empty. The raw honey is then filtered of pollen, odd bee parts, and flecks of comb, and it's decanted into jars. Then you just stare at it for a while with slack-jawed wonder.

It's important to take only enough, of course. Though bees are terrific doomsday hoarders, they've stored all that honey for themselves, *not* for you. With autumn's transition into winter, it's requiem time at the farm, *lacrimosa*, and the bees know it. Taking their honey is a tacit but tense agreement between you and wildness: You manage the property and pay the bills, and they'll share the sweet stuff.

They are truly wild and miraculous things, honeybees, and have been cultivated and coveted by humans for thousands of years. With their organizational rigor, their mysterious chemical chatter, and the Euclidian symmetry of their hives, it's hard not to be impressed. Most amazing is their selflessness, their collaborative understanding of the common good (are you listening, Washington?). Even if the colony is a kind of macro "self" and individual bees are mere neurons, incapable of independent thought outside the hive's collective consciousness, they seem to have created a utopian survival mechanism worth envying. We should be so lucky.

Our cultured bees (*Apis mellifera*) not only create honey, of course, but they're also our primary pollinators, responsible for 30 percent of the food we humans eat. So their survival is linked closely to our own, not only for the fruits and vegetables they fertilize, but also for what they can teach us about working together to save our own hive.

The hives are first smoked to distract the bees, then frames of honey are removed from the supers and uncapped with a hot knife before being extracted and poured into jars.

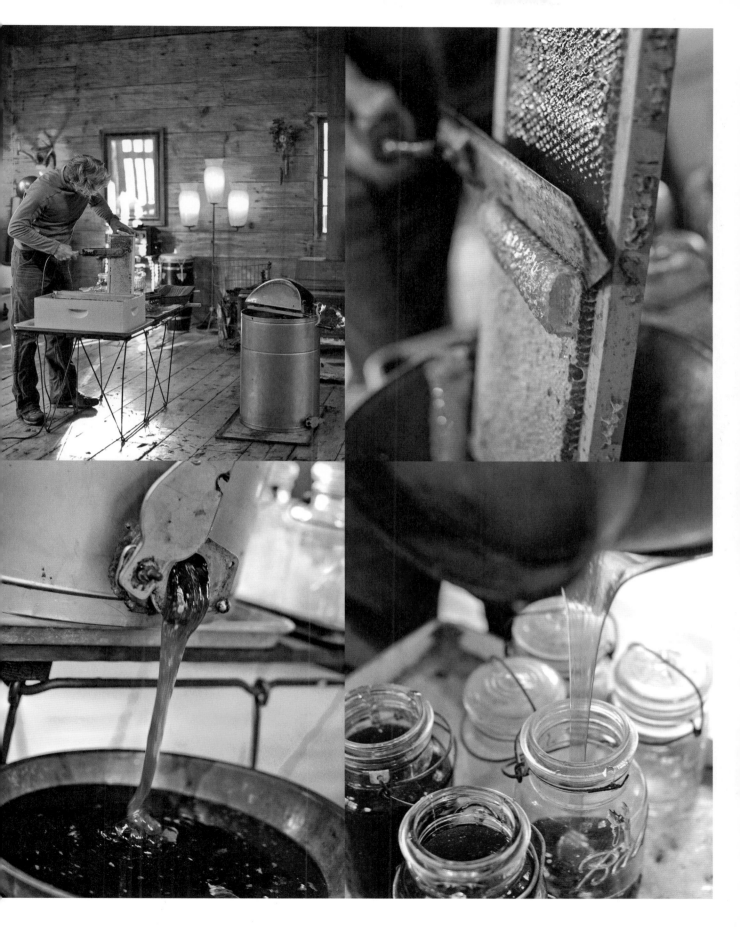

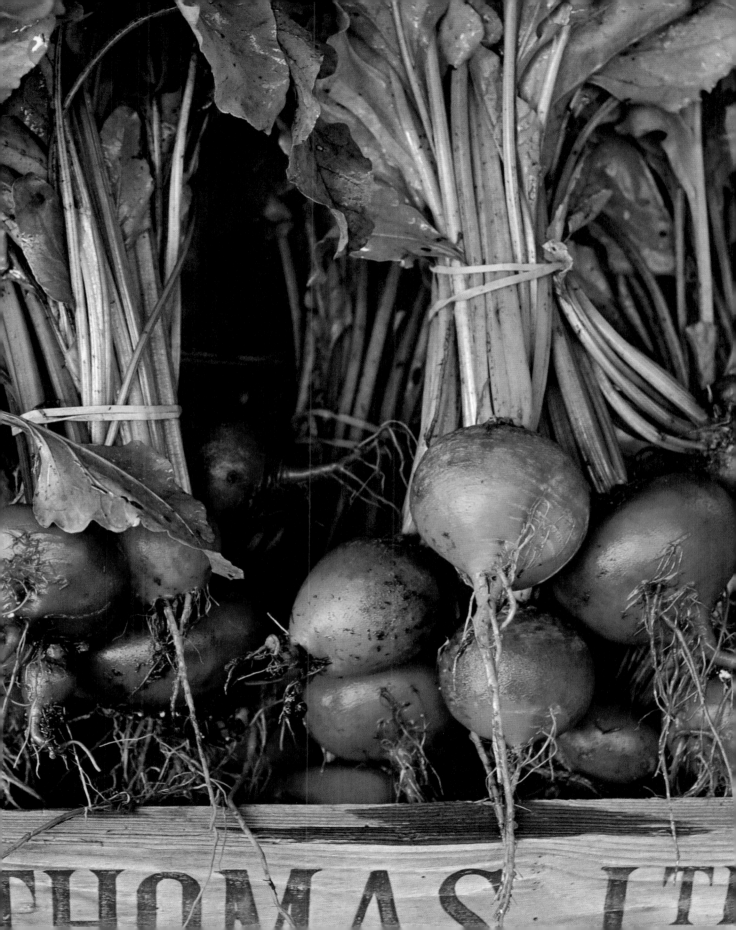

We must give more in order to get more. It is the generous giving
of ourselves that produces the generous harvest.

—ORISON MARDEN

GROWING IS GIVING

There's so much pleasure to be found in harvesting after a long season of growth: all of the anticipation of moving from seed to seedling; the patient, careful cultivation; the slow vegetal foreplay; and then—after months—abundance.

This is food with a pulse from a place you've nurtured intimately, and there is much joy and wonder in it.

Gathering what you've grown, with flavors that have seasoned in your own ground—the exhilaration of crisp greens, the aromatic warmth of garden tomatoes, the deep and complex sweetness of homegrown carrots and beets—will bring life to your table. It will also inspire family, friends, and community to come together around a common idea of what it means to live and eat well.

Cultivating food is about the intimacy and importance of sharing not only your garden and table, but also your heart. A person growing is a person giving, after all.

I started out by growing for my family, and once I'd failed and prevailed for a few seasons, I began to grow for others. My small farm now reaches out to my community in ways I couldn't have imagined.

And while I've built a working farm, I've also been lucky enough to build bonds outside of my gates. Transpose the acronym CSA, and you get ASC—agriculture supporting community—one of the less-hyped virtues of starting or joining a local farm. So when a neighbor comes by for a carton of eggs or just wants to see what's "growin' on" at Stonegate, those are the seeds of community. It's too easy in an age of instant, downloadable everything to live isolated among strangers, but if you grow food, your garden will become a gathering place.

Delicious organics may be the harvest, but so is a deep sense of happiness and well-being, and this will lead to a meaningful transformation. You will become more self-reliant, more fulfilled, *more free*. When your vegetables and fruit have ripened through the season, your honey is heavy in the comb, and chickens are laying daily, there's a kind of harmonic, balanced convergence of life around you. "Paradise is where I am," said philosopher/gardener Voltaire, and as you begin to grow—despite all of the fickle and exasperating moments of being a food-gardener—you will find paradise where you are.

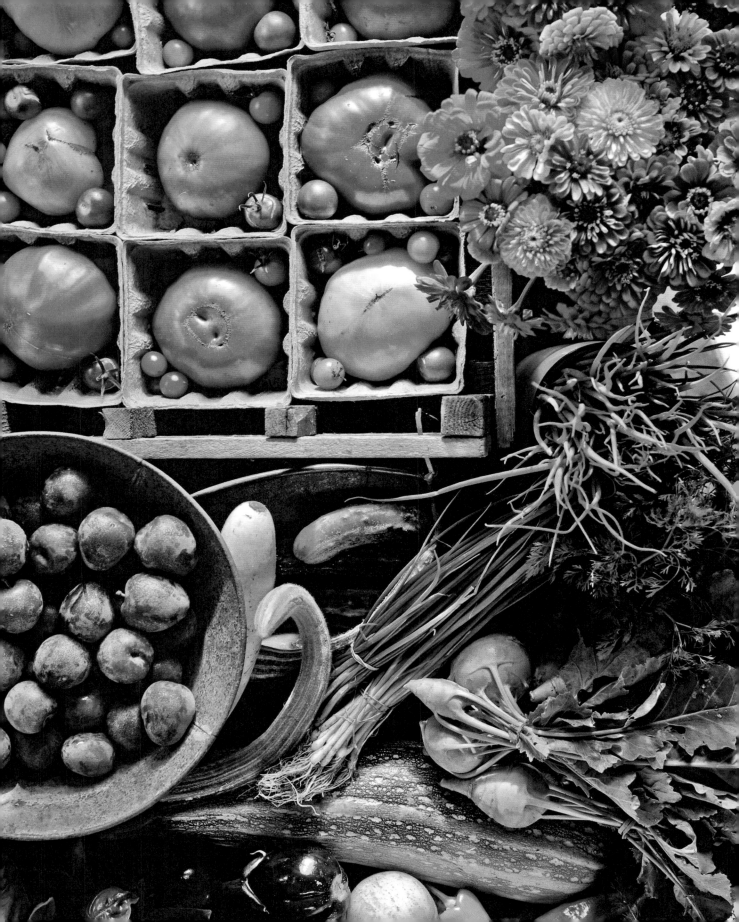

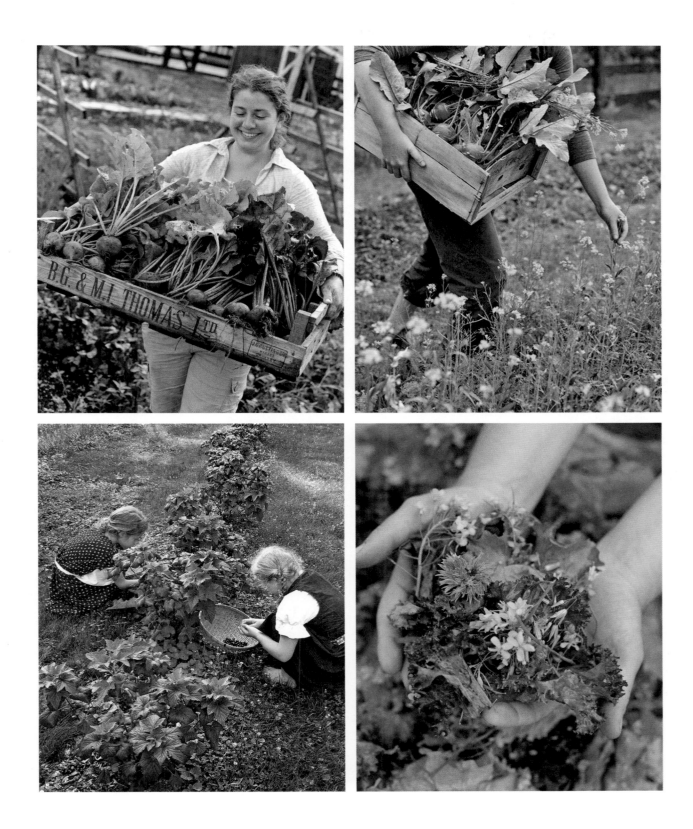

RECIPES

We eat seasonally at Stonegate, and what's ripe and ready is what ends up on the table. Like good art or design, we let the raw materials inspire us—harvesting fresh, gathering only what we need, and seeing what we can conjure from it. The more you sow and grow, the more your diet will align with the cycles and seasons around you.

When your produce aisle is just out back, the pole beans are straight off the vine, and crisp lettuce, fragrant herbs, or ripe fruit is literally within reach, your meals will begin to reflect that variety and freshness. Heading out to harvest with an empty basket and coming into the kitchen with one that's heavy with food and full of possibility is a thrill.

Most of the food we prepare at Stonegate is reasonably simple—defined by the flavor of the food itself, not by what's done to it—and reflects our interest in the intimate relationship between growing and eating. The recipes that follow are a few favorites from the farm.

Spinach and Berry Salad

PREP TIME: 5 MINUTES | TOTAL TIME: 15 MINUTES | MAKES 4 SERVINGS

Spinach season is spring and fall, and when you're growing your own organic varieties just beyond the back door, it's best eaten fresh to appreciate its full, locally grown flavor. Blackberries and gooseberries add a sweet tang to this recipe.

5 cups (5 ounces) spinach leaves, such as 'Red Kitten' or 'Tyee'

1 small 'Lemon' cucumber, halved and sliced into wedges

½ cup blackberries

½ cup gooseberries

2 tablespoons olive oil

1 tablespoon white wine vinegar

2 teaspoons minced fresh basil

⅛ teaspoon salt

⅛ teaspoon freshly ground black pepper

2 tablespoons basil flowers, for garnish

In a large bowl, toss together the spinach, cucumber, and berries.

In a small bowl, whisk together the oil, vinegar, basil, salt, and pepper. Drizzle over the spinach mixture and toss to combine. Transfer to a serving platter or bowl. Garnish with the basil flowers.

Kohlrabi and Apple Salad

PREP TIME: 15 MINUTES | TOTAL TIME: 20 MINUTES | MAKES 4 SERVINGS

Kohlrabi's physical weirdness is easily overshadowed by its wonderful crunchy, mildly spicy flavor. Mixed here with tart apples, sesame oil, and honey, this salad has a lot of sweet and savory crunch.

2 tablespoons rice vinegar

1 tablespoon local raw honey

¼ teaspoon sesame oil

2 bulbs purple kohlrabi, trimmed, peeled, and thinly sliced

1 crisp green apple, such as 'Granny Smith', core removed, thinly sliced

2 carrots, thinly sliced on the diagonal

1 scallion, chopped

2 tablespoons chopped mint

In a large bowl, whisk together the vinegar, honey, and oil until combined. Add the kohlrabi, apple, carrots, and scallion. Toss to coat well. Transfer to a serving platter and arrange the slices by layering or shingling on the platter, if desired. Top with the mint. Serve.

Herbed Salad

PREP TIME: 5 MINUTES | TOTAL TIME: 15 MINUTES | MAKES 6 SERVINGS

When the spring lettuce starts to bolt in the heat, we begin to get creative with the salad bowl. Herbs like parsley, tarragon, and chives mixed with the golden, inflorescent blooms of mustard and the tender young leaves of borage are a great midseason alternative.

½ cup loosely packed flat-leaf parsley

½ cup chives, chopped

½ cup loosely packed tarragon leaves

½ cup young borage leaves

¼ cup chive blossoms and mustard blossoms

2 tablespoons extra-virgin olive oil

1 tablespoon red wine vinegar

⅛ teaspoon salt

⅛ teaspoon freshly ground black pepper

1 tablespoon sunflower seeds

Toss the herbs and greens in a serving bowl.

In a small bowl, whisk together the oil, vinegar, salt, and pepper. Drizzle over the greens. Top with the sunflower seeds. Toss gently to coat. Serve.

Kale and Farro Salad

PREP TIME: 10 MINUTES | TOTAL TIME: 35 MINUTES | MAKES 6 SERVINGS

We grow three varieties of kale at Stonegate and can never seem to get enough of this versatile, delicious green. Our mainstays are the pink-ribbed 'Lacinato Rainbow', the dusty purple 'Scarlet', and the crimpled dinosaur, and they find their way into almost everything, including this salad complemented by the nutty chew of farro.

3½ cups water	1 tablespoon Dijon mustard
1 cup dry semipearled farro	½ teaspoon coarse sea salt or kosher salt
1 small bunch 'Lacinato Rainbow' kale, stems removed, cut into thin strips	½ teaspoon freshly ground black pepper
1 small bunch 'Scarlet' kale, stems removed, cut into thin strips	¾ cup heirloom cherry tomatoes, quartered
3 tablespoons olive oil	2 scallions, thinly sliced
3 tablespoons lemon juice, divided	1 tablespoon chopped chives

In a medium saucepan, bring the water and farro to a boil. Reduce the heat to a simmer, cover, and cook for 20 minutes, or until tender. Drain.

Meanwhile, in a large mixing bowl, add the kale and drizzle with the oil and 2 tablespoons of the lemon juice. Massage the kale for 5 minutes to soften the leaves. Set aside until the farro is done.

Add the drained farro to the kale. In a small bowl, whisk together the mustard, salt, pepper, and the remaining 1 tablespoon lemon juice. Stir into the farro mixture. Add the tomatoes, scallions, and chives and toss to combine. Serve.

Harvest Salad

A salad of fresh greens, herbs, and berries from your own garden is a seasonal delight, something you can only dream about in the off-season. This is one fusion that mixes sweet with heat, but there are almost as many combinations as there are ingredients.

2½ cups (3 ounces) arugula

2½ cups (3 ounces) loose leaf lettuce

2½ cups (3 ounces) Asian greens, such as bok choy, pak choy, and komatsuna

2 pears, thinly sliced

⅓ cup fresh blackberries

¼ cup nasturtium petals and blossoms

¼ cup olive oil

2 tablespoons red wine vinegar

2 teaspoons lemon juice

⅛ teaspoon sea salt

⅛ teaspoon freshly ground black pepper

2 tablespoons chive blossoms (optional)

In a large bowl, combine the arugula, lettuce, Asian greens, pears, blackberries, and petals and blossoms.

In a small bowl, whisk together the oil, vinegar, lemon juice, salt, and pepper. Drizzle the vinaigrette over the salad and toss to coat. Accent with the chive blossoms.

Tomato and Squash Salad

PREP TIME: 15 MINUTES | TOTAL TIME: 20 MINUTES | MAKES 6 SERVINGS

No matter how hard you try, there always seems to be more than enough summer squash to go around. This fresh, tossed-together mix of tender squash and tomatoes is midsummer in a bowl.

2 cups mixed colors cherry tomatoes, such as 'Sun Gold', 'Matt's Wild Cherry', and 'Black Cherry', halved lengthwise

2 summer squash, such as 'Costata Romaneso' (each 5" to 6" long), cut into ½" cubes

½ cup (3 ounces) crumbled feta cheese

3 scallions, sliced

2 tablespoons olive oil

1 tablespoon lemon juice

1 teaspoon finely chopped fresh parsley

1 teaspoon finely chopped fresh basil

½ teaspoon salt

In a large bowl, toss the tomatoes, squash, feta, and scallions.

In a small bowl, whisk together the oil, lemon juice, parsley, basil, and salt. Drizzle over the tomato mixture and toss gently to coat all veggies. Serve.

Dilled Cucumber Salad

PREP TIME: 10 MINUTES | TOTAL TIME: 1 HOUR 15 MINUTES | MAKES 4 SERVINGS

The varieties of cucumber available to the home grower are astonishing. From the long, serpentine Armenian to the sweet Indian 'Poona Kheera' and the rounded gold 'Lemon', there's a cuke out there for everybody. This fresh-off-the-vine salad celebrates their diversity.

1 medium cucumber, such as 'Striped Armenian', halved, seeded, and thinly sliced

1 medium cucumber, such as 'Poona Kheera', quartered lengthwise, seeded, and thinly sliced

2 tablespoons snipped fresh dill

½ teaspoon sugar

¼ teaspoon salt

¼ teaspoon freshly ground black pepper

2 scallions, thinly sliced

3 tablespoons olive oil

2½ tablespoons cider vinegar

1 tablespoon dill flowers, for garnish

Place the cucumber slices in a shallow bowl. Lightly sprinkle with the dill, sugar, salt, and pepper. Separate the scallion slices into rings and add to the cucumbers. Add the oil and toss until each slice is coated. Add the vinegar and toss again. Chill for 1 hour. Lightly toss with a fork and garnish with the dill flowers before serving.

Herbed Pole Beans

PREP TIME: 5 MINUTES | TOTAL TIME: 15 MINUTES | MAKES 6 SERVINGS

Pole beans, particularly colorful varieties, are a beautiful, clambering sight on the farm, but even more so on the plate. When picked fresh, they have a texture and flavor that's unbeatable. This dish is dazzling when topped with the bright blue, starlike blooms of borage.

1 pound mixed green, purple, and yellow pole beans, cut into 1" pieces

1 tablespoon olive oil

1 clove garlic, minced

2 tablespoons chopped parsley

1 tablespoon snipped chives

1 tablespoon borage blossoms + additional for garnish

⅛ teaspoon salt

⅛ teaspoon freshly ground black pepper

In a steamer, cook the beans for about 5 minutes, until tender-crisp. Drain and transfer to a serving bowl.

While the beans steam, heat the oil in a small skillet over medium-low heat. Add the garlic and cook for 1 to 2 minutes, or until fragrant and golden. Remove from the heat. Stir in the parsley, chives, and 1 tablespoon borage blossoms. Add to the cooked beans and season with the salt and pepper. Toss to combine and serve hot. Garnish with the additional borage blossoms.

Quitten Time

It's *quitten* time at Stonegate, not only because an early October frost took out the last of the leafy greens and brought a quick end to the season, but also because the quinces (or *Quitten* in German) have ripened to a phosphorescent yellow in the orchard and begun to *blette,* turning their bitter starch to sugar and rendering themselves finally, and sweetly, edible.

Bletting is a form of decay, really; the same transformation that turns sour and bone-hard medlars sweet and wine grapes into Sauternes. The French have a poetic word for this metamorphosis, of course: *pourriture noble,* or noble rot. Maybe something similar happens to the lucky few of us who sweeten as we age.

It's a beguiling transformation, one not missed by my former neighbor and local fruit aficionado Andrew Jackson Downing in the 1850s: "Fine fruit is the flower of commodities. It is the most perfect union of the useful and the beautiful that the earth knows. Trees full of soft foliage; blossoms fresh with spring beauty; and, finally, fruit, rich, bloom-dusted, melting, and luscious—such are the treasures of the orchard and garden."

Quince fruit begins as a pale, pleated blossom in early spring and evolves into an oblong sphere of hard, unforgiving firmness; its fleecy rind, its strange knobs and bumps, its astringent flesh don't hold much promise until late in the season when they transform themselves.

Or those that haven't been plundered do. I have a handful of quinces that survived the season, but many were plucked early from their boughs by vaulting chickens and the orchard's archenemy: the squirrel. For a few days in early October, winter-provisioning squirrels sacked and plundered the last of the orchard fruit, but they left me a few quinces. Maybe it's just too firm and heavy and oddly lumpy for their tastes, or their larder was already full of contraband fruit, so why bother?

I watched helplessly as they scampered down from treetop burrows and leapt in furry, frenetic arcs across lawn and fencerow to the orchard, where they grabbed any fruit they could, giddy and snickering to be sure, and buried it somewhere as a cache for a January pear gelato or some subzero treat.

The apples were the first to go. Small and firm and full of fall promise, most of them were pilfered by mid-August. So my CSA (Compulsively Sacked Apples) fruit never made it into the weekly shares, and the reliable ebb and flow of dearth and plenty at the farm goes on. From now on, there will be netting.

The few quinces I have I will covet and try to transform into an aromatic jam or jelly, or paste, something that's been done for centuries. In fact, quince culture long predates that of apples or pears, other pome fruit in the same family (Rosaceae), but somewhere along the way it lost favor and is now a rare find.

All the more reason to grow them here at Stonegate: where the obscure will always have a home, where quirky botanical history is relevant, and where the squirrels and chickens eat like kings.

Quinces hanging golden and ripe in the fall orchard, their aromatic flesh a temptation to all. We turn ours into preserves, mixed with pear and tart aronia berries.

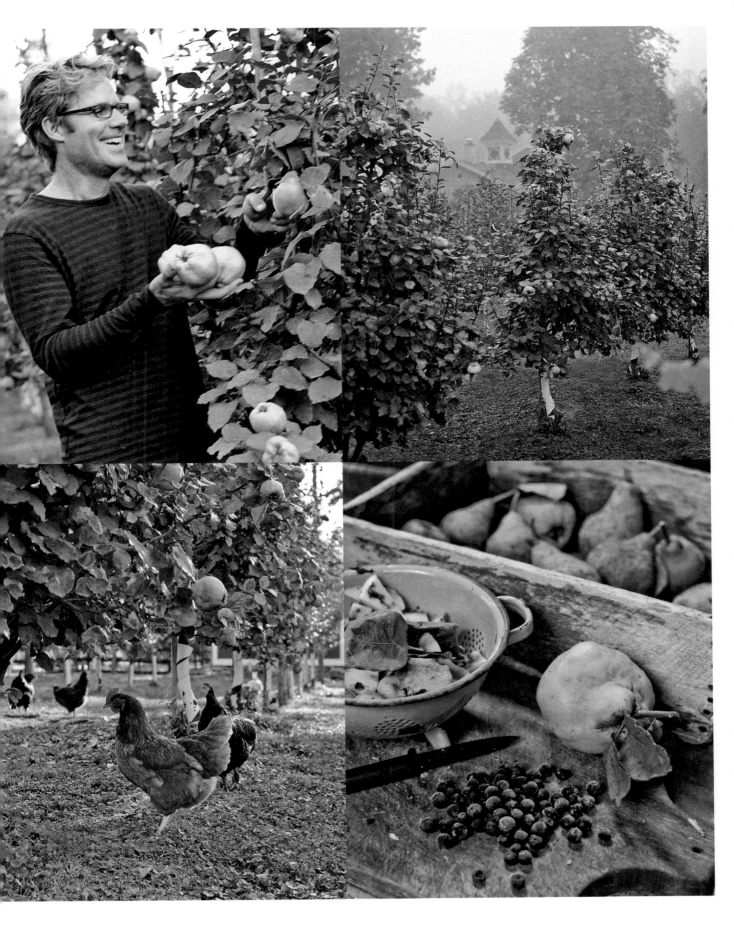

Broccoli Rabe with Ginger and Garlic

PREP TIME: 5 MINUTES | TOTAL TIME: 25 MINUTES | MAKES 4 SERVINGS

Broccoli rabe, with a distinctive flavor profile somewhere between turnip and kale, is always grown at Stonegate in spring. Its versatile, slightly bitter leaves, stems, and florets are all edible, as are the pretty yellow flowers.

1 pound broccoli rabe leaves and stems/florets, rinsed and tough ends trimmed

1 tablespoon peanut oil

2 scallions, thinly sliced on the diagonal

3 cloves garlic, thinly sliced

1" piece of fresh ginger, peeled and cut into matchsticks

1 teaspoon grated orange peel

½ teaspoon salt

3 tablespoons broccoli rabe flowers, divided

1 teaspoon toasted sesame oil (optional)

Fill a large bowl with ice water and place it next to the clean sink area. Bring a large pot of salted water to a boil over high heat. Plunge half of the broccoli rabe into the water and cook for about 2 minutes, until tender-crisp. Using tongs or a slotted spoon, transfer the broccoli rabe into the ice water to cool. Repeat with the remaining broccoli rabe. Drain and set aside.

In a large skillet, heat the peanut oil over medium-low heat. Add the scallions, garlic, and ginger and cook, stirring, for 2 to 3 minutes, or until the garlic is golden brown. Add the broccoli rabe and cook for about 1 minute to heat through. Transfer to a serving platter and toss with the orange peel, salt, and 2 tablespoons of the flowers. Drizzle with the sesame oil, if desired. Garnish with the remaining 1 tablespoon flowers.

Optional: Cook 8 ounces brown rice stir-fry noodles according to package directions. Serve the broccoli rabe recipe over the noodles.

Roasted Beets with Horseradish Vinaigrette

PREP TIME: 10 MINUTES | TOTAL TIME: 50 MINUTES | MAKES 6 SERVINGS

Beets have come a long way since my childhood, when they were habitually pushed to the side of the plate. Roasting homegrown varieties like 'Chioggia', with its candy cane–striped interior, or 'Touchstone Gold' is now my favorite way to enjoy their beauty and flavor.

6 red and golden beets,
such as 'Chioggia', 'Bull's Blood',
and 'Touchstone Gold' (about
1½ pounds), peeled and quartered

⅛ teaspoon sea salt

⅛ teaspoon cracked pepper

2 teaspoons olive oil

1 tablespoon yellow or white viola
blossoms, for garnish

Dressing

1 tablespoon lemon juice

1 teaspoon drained horseradish

½ teaspoon Dijon mustard

2 tablespoons extra-virgin olive oil

Preheat the oven to 425°F.

In a medium bowl, toss the beets with the salt, pepper, and just enough of the oil to lightly coat. Place on a baking sheet and roast for 40 minutes, or until fork-tender. Set aside to cool to room temperature.

To make the dressing: In a small bowl, whisk together the lemon juice, horseradish, and mustard. While whisking, add the oil in a slow stream to combine. Drizzle the dressing over the beets and toss to coat. Garnish with the viola petals and serve.

Balsamic Grilled Scallions

PREP TIME: 5 MINUTES | TOTAL TIME: 15 MINUTES | MAKES 4 SERVINGS

Slender scallions do fine in very tight quarters, and we interplant them regularly among other annuals throughout the season. The deep purple varieties are particularly pretty, especially when combined with the more common green cultivars, and both are delicious when grilled.

1 bunch 'Deep Purple Bunching' scallions, roots trimmed

1 bunch 'Parade' scallions, roots trimmed

1 tablespoon olive oil

1 tablespoon balsamic vinegar

⅛ teaspoon salt

¼ teaspoon freshly ground black pepper

Preheat the grill to medium.

Arrange the scallions on a perforated grill topper or grill basket. Brush lightly with the oil. Grill, turning frequently, for 5 to 7 minutes, or until the scallions are lightly charred and softened. Transfer to a serving plate. Drizzle with the vinegar and sprinkle with the salt and pepper. Serve.

Mashed Parsnips

PREP TIME: 5 MINUTES | TOTAL TIME: 25 MINUTES | MAKES 6 SERVINGS

Creamy, smooth, with an herbal sweetness somewhere between potatoes and carrots, parsnips are often overlooked in the garden in favor of flashier vegetables. But their distinct flavor and texture have won us over as a welcome substitute for the usual mashed spuds.

2 pounds parsnips, peeled and cut into 2" chunks

4 tablespoons (½ stick) butter

½ cup light cream

⅛ teaspoon salt

¼ teaspoon freshly ground black pepper

2 teaspoons chopped chives

In a medium saucepan, combine the parsnips with cold water to cover. Bring to a boil over high heat. Reduce the heat to low and simmer for 10 to 15 minutes, or until the parsnips are tender. Drain and transfer to the bowl of an electric mixer.

Meanwhile, in a small saucepan, combine the butter and cream and cook over medium heat for 1 to 2 minutes, or until the butter is melted. Add the cream mixture to the parsnips and mix on medium speed for about 1 minute, or until smooth. Season with the salt and pepper. Transfer to a serving bowl. Sprinkle the chives over the puree. Serve.

Baked Fennel

PREP TIME: 10 MINUTES | TOTAL TIME: 45 MINUTES | MAKES 4 SERVINGS

If you love the licorice-infused flavor of fennel, this dish is a celebration. Topped with fennel's delicate, feathered fronds and the blue blossoms of anise hyssop, it makes a beautiful show, as well. We grow bronze fennel for its lacy leaves and Florence fennel for its bulb.

4 bulbs fennel, trimmed (fronds reserved) and core removed, each bulb cut into 8 wedges

2 tablespoons olive oil

¼ teaspoon salt

¼ teaspoon freshly ground black pepper

1 tablespoon chopped fresh parsley

1 tablespoon anise hyssop petals

Preheat the oven to 400°F. Grease a large rimmed sheet pan (or a casserole dish large enough to hold the fennel in a single layer).

In a bowl, toss the fennel wedges with the oil, salt, and pepper. Arrange the wedges in a single layer on the sheet pan, loosely tilting or shingling the slices if necessary. Drizzle any liquid remaining in the bowl over the fennel. Bake for 20 to 25 minutes, or until the fennel is tender. Transfer to a serving platter. Top with the reserved fronds, parsley, and petals.

Poached Quince

PREP TIME: 15 MINUTES | TOTAL TIME: 3 HOURS 30 MINUTES | MAKES 4 SERVINGS

Quinces are the most beautiful trees I grow in my orchard, with pale pink blooms in spring that look like roses. The quince that ripens from those flowers in fall is a large, yellow, lobed fruit with a unique aromatic flavor and perfume.

4 cups water

½ cup sugar

1 cinnamon stick

1 whole clove

½ orange, cut into wedges

4 quinces (about 5 ounces each), peeled

¼ cup black currants, rinsed

¼ cup crème fraîche

In a large nonreactive saucepan, add the water, sugar, cinnamon stick, clove, and orange and bring to a boil over medium-high heat. Reduce the heat to a simmer and add the quinces. Cover. After 2 hours, partially cover the pan with the lid, leaving an opening for steam to escape; this will allow the liquid to thicken slightly as the quinces poach. Cook for 1 additional hour, or until tender. Transfer the quinces to individual serving bowls, top with the black currants and crème fraîche, and drizzle with the cooking liquid, if desired.

Grilled Spiced Plums

PREP TIME: 5 MINUTES | TOTAL TIME: 15 MINUTES | MAKES 6 SERVINGS

My plum harvest usually runs out long before I've exhausted ways to prepare them. When picked at their full, juicy prime, plums are exceptionally sweet. And when grilled, they take on a smoky, caramelized flavor that's hard to beat.

6 yellow plums, such as 'Shiro', purple plums, or Pluots, pitted and halved

2 teaspoons olive oil

⅛ teaspoon ground cinnamon

2½ cups plain nonfat Greek yogurt

2 tablespoons local raw honey

1½ tablespoons chopped lemon basil or lemon balm

Preheat the grill to medium-high.

Brush the flesh side of the plums with the oil and sprinkle with the cinnamon. Place the plums cut sides down on the grill rack. Grill for 2 minutes, or until lightly charred. Turn the plums skin sides down and grill for 2 minutes, or until softened. Transfer to serving bowls.

In a bowl, stir together the yogurt and honey. Top the grilled plums with the yogurt mixture and the basil or lemon balm.

Honey-Baked Pears with Black Currant Sauce

PREP TIME: 10 MINUTES | TOTAL TIME: 30 MINUTES | MAKES 6 SERVINGS

Between my heirloom pears and tart, earthy black currants, it's hard to imagine finer fruit to grow. This dessert celebrates summer in the orchard with the deep glaze of black currants covering the pale, luminous flesh of honeyed pears. This is as good as it gets.

6 firm-ripe pears, cored and sliced	¼ cup water
2 tablespoons local raw honey	1 tablespoon sugar
1 teaspoon vanilla extract	1 teaspoon lemon juice
2 tablespoons butter, cut into small pieces	1 cup low-fat plain yogurt
1 cup black currants	

Preheat the oven to 350°F. Butter a 9" x 9" baking dish.

Arrange the pears in attractive rows in the dish. In a small bowl, blend the honey and vanilla. Drizzle over the pears. Top with the butter. Bake for 10 to 15 minutes, basting frequently, until the pears are tender.

Meanwhile, in a small saucepan, bring the currants, water, and sugar to a boil, stirring frequently. Reduce the heat to low and simmer for 10 to 15 minutes, stirring frequently, until the sauce has thickened. Remove from the heat. Strain the juices through a sieve and into a bowl and discard the skins and seeds. Stir in the lemon juice.

Transfer the pears to a serving plate and drizzle the black currant sauce over the pears. Serve hot or chilled, topped with the yogurt.

Gooseberry Crisp

PREP TIME: 10 MINUTES | TOTAL TIME: 45 MINUTES | MAKES 6 SERVINGS

Most of us think of gooseberries (if we think of them at all) as an obscure, lip-puckering fruit that's almost impossible to find unless you cultivate your own. We grow a hybrid that ripens into a grape-size, deep purple berry that's much sweeter than most but still tart enough to be interesting.

Filling

5 cups ripe, sweet gooseberries, stems and husks removed, rinsed

¾ cup sugar

1 tablespoon lemon juice

1 teaspoon cornstarch

⅛ teaspoon ground ginger

⅛ teaspoon ground cinnamon

Topping

½ cup old-fashioned rolled oats

¼ cup unbleached all-purpose flour

¼ cup (½ stick) cold butter, cut into small pieces

¼ cup firmly packed dark brown sugar

¼ teaspoon salt

Preheat the oven to 375°F.

To make the filling: In a large bowl, combine the gooseberries, sugar, lemon juice, cornstarch, ginger, and cinnamon and toss well to combine. Spoon into a 9" x 9" baking dish.

To make the topping: In a food processor, combine the oats, flour, butter, sugar, and salt and pulse until well combined but still somewhat clumpy. Dot the top of the fruit with the oats mixture. Bake for 25 minutes, or until the topping is crisp and brown and the fruit is bubbling. Cover the pan loosely with foil if the topping turns golden before the fruit is bubbling. Serve warm or at room temperature.

Sour Cherry Crostada

PREP TIME: 10 MINUTES | TOTAL TIME: 1 HOUR 40 MINUTES + COOLING TIME | MAKES 8 SERVINGS

What could be more American than cherry pie? And by July Fourth, most of our dwarf cherries are jeweled in glistening fruit. If the birds don't get them first, they end up in desserts like this delicious, rustic, hand-shaped tart.

Single Crust

- 1¼ cups whole wheat pastry flour
- ¼ cup ground flaxseed
- 2 tablespoons toasted wheat germ
- ¼ teaspoon salt
- 3 tablespoons cold butter, cut into small pieces
- 3 tablespoons canola oil
- 2–3 tablespoons ice water

Filling

- 4 cups pitted, fresh sour cherries (pitted sweet cherries can be used as a substitute)
- ¼ cup local raw honey
- 3 tablespoons cornstarch
- 1½ tablespoons water

To make the single crust: In a large bowl, stir together the flour, flaxseed, wheat germ, and salt. With a pastry blender or 2 knives held scissors fashion, cut the butter and oil into the flour mixture until it resembles coarse crumbs.

Gradually add the ice water, 1 tablespoon at a time, until you can gather the dough into a ball. Flatten it into a disk and place on a sheet of floured waxed paper. Sprinkle a little more flour over the dough and top with another sheet of waxed paper. Refrigerate for at least 30 minutes.

To make the filling: In a large saucepan, heat the cherries and honey over medium heat. Gently stir the cherries to fully coat them in honey. In a small bowl, whisk together the cornstarch and water until smooth. Add an additional 1 teaspoon water if necessary. Add to the cherry mixture and stir to coat. Remove from the heat.

Preheat the oven to 425°F. Line a baking sheet with parchment paper.

On a lightly floured work surface, roll out the dough to a 12" round. Transfer the dough to the baking sheet. Spoon the filling into the center of the dough round, leaving a 2" border. Fold the edges of the dough toward the filling. Most of the filling will still be visible. Bake for 40 to 50 minutes, or until the crust is golden and the filling is bubbling. Cool for 15 minutes before serving.

Currant Jelly

PREP TIME: 5 MINUTES | TOTAL TIME: 40 MINUTES + 2–4 HOURS STRAINING TIME

MAKES APPROXIMATELY 3 JARS (8 OUNCES EACH)

Currants are truly beautiful, hanging off their multiple stems like translucent strands of pearls. They are usually sold dried in the store, but their unique flavor as fresh fruit is not to be missed. Tart, aromatic currants also make for great jellies, jams, and preserves.

2½ pounds fresh red currants (about 10 cups), rinsed

½ cup water

2¼ cups sugar

In a large pot, combine the currants and water, cover, and simmer over medium-low heat, adjusting the heat if necessary, for about 15 minutes, or until the currants have released their juices. Strain the mixture through a dampened jelly bag over a large bowl. This may take up to 4 hours. You will get more juice if you squeeze the bag, but it will make a cloudy jelly. If you prefer this method, strain the mixture twice. Measure the juice. The amount of currants used should yield about 2¼ cups juice.

Pour the juice into a large saucepan. The amount of sugar used should equal the amount of juice, so adjust accordingly. Add the sugar and bring to a boil, stirring continuously. Boil until a good jelly test is obtained (see "Testing for Jelling Point"). Ladle into hot sterilized jelly glasses, adjust the seals, and process for 10 minutes in a boiling water bath (see "Using a Water Bath Canner").

Testing for Jelling Point. A well-made jelly holds its shape when released from a mold yet is tender enough to cut with a spoon. Also, good jelly has a fresh fruit flavor, never a caramelized sugar taste. To determine when a jelly has reached the jelling point, use one of these three tests.

1. *Temperature test.* This is probably the most accurate test, but to get a reliable reading, it is essential that you know the boiling point for water in your area. Check the temperature of boiling water shortly before making the jelly, then cook the jelly mixture to a temperature 8°F higher. At this point, the mixture should jell nicely when cool.

2. *Sheet test.* This test requires a watchful eye. It is very popular but not entirely dependable. With a cool metal spoon, scoop up a small amount of the boiling jelly mixture and raise it about a foot above the pot, away from the steam. Quickly tip the spoon and let the jelly run off the edge. If the syrup forms 2 drops that flow together and fall from the spoon as a sheet, the jelly is probably done. If it slides from the spoon as separate drops, cook the mixture a little longer, then test again.

3. *Freezer test.* The hot jelly mixture should be removed from the heat during this test. Put a few drops of the jelly on a cold plate, then chill in the freezer for a few minutes. If the mixture jells, it is done.

Using a Water Bath Canner. A boiling water canner is useful for processing foods high in acid: fruits, tomatoes, pickles, jams, and jellies. For all other foods, use a pressure (steam) canner. Place the rack on the bottom of the canner, then fill the canner half full with hot water. Over high heat, bring the water to a boil for hot-packed foods and almost to a boil for raw-packed foods. Next, lower all the jars to the rack, leaving enough room between the jars for the water to circulate. Add boiling water until the jars are covered by 1" to 2" of liquid, but do not pour the water directly onto the jars. Cover the canner and return the water to a gentle boil. Start timing the processing when the water begins to boil, and add more boiling water as needed to keep the water 1" to 2" above the jars.

As soon as the processing is complete, remove the jars.

Oblivion

He was glad that he liked the country undecorated, hard, and stripped of its finery.
He had got down to the bare bones of it, and they were fine and strong and simple.

—KENNETH GRAHAME, *The Wind in the Willows*

Now that a few frosts have left Stonegate "stripped of its finery"—its green, biomolecular skin turned to mush—the farm has begun its swift and certain journey toward oblivion.

The lurking cold has crept into beds of greens, transforming tender leaves and stalks into slack ribbons of decay. Once-radiant stands of cut flowers that persisted all season have been hung up and dried, vibrant Jezebels of seductive color forced to put on their veils.

It's reassuring to see that the bees, despite their roving wildness, have done some good cognitive mapping of the property and know where their food and shelter are. They're now huddled in the walled, hexagonal darkness of the hive, forming winter clusters around their queens.

The chickens, too, are spending more time cooped up, heading out only occasionally to peck at fallen fruit or frozen bugs. On cold days, besides the wood smoke curling into the sky or drifts of brittle leaves scattering about, they're the only thing moving.

November is postmortem time. Time to sort through the pathology of what did or didn't work this season, what grew well, what failed to deliver.

Seed packets are always as full of promise as they are seeds.

Flower and vegetable annuals live out a lifetime in a few months—birth, growth, decline, death. A nicely framed physiological snapshot compared to us. Plants may not have consciousness as we know it, but they can tell us something deep about living. Free from the existential burden of defining themselves, they just *are*.

We, on the other hand, are obsessed with self-definition—more than ever in a hyperconnected social-media world, where fretting about online likes, tweets, and posts is a form of virtual affirmation and seems to give distorted value to it all.

Just *being* used to be enough, to "tramp a perpetual journey," as Whitman said, but sit in an airport, a bar, or a café, or even walk down the street these days, and you'll see that everyone is somewhere else, drifting in a virtual trance. No one is present.

Wherever we go, it seems, there we *aren't*.

One thing farming asks of you, besides considerable patience and humility, is to be present, to be deeply engaged in the physical world. There's no other way to do it. For me, this little farm keeps it real.

Bouquets of celosia and gomphrena hung to dry; flowers from the cutting garden, like anise hyssop, dried for teas; chickens out for a scratch in the frozen orchard; cut flowers drying in the stable.

INDEX

Boldface page numbers indicate photographs.

Acknowledgments

BESIDES MY SMALL FARM, which has taught me so much about patience and humility and wonder, I'd like to thank my wife, Heidi, and my children, Daisy and Miles, for allowing the time and space to write. I want to thank Ethne Clarke for her encouragement and wit throughout this process and editor Karen Bolesta, art director Carol Angstadt, and senior project editor Hope Clarke at Rodale for their faith and flexibility in seeing this book through. Finally, I want to thank all the interns, volunteers, and CSA members at Stonegate Farm who've supported the idea of small-scale, suburban farming over the years and have helped to ensure that it has a future.